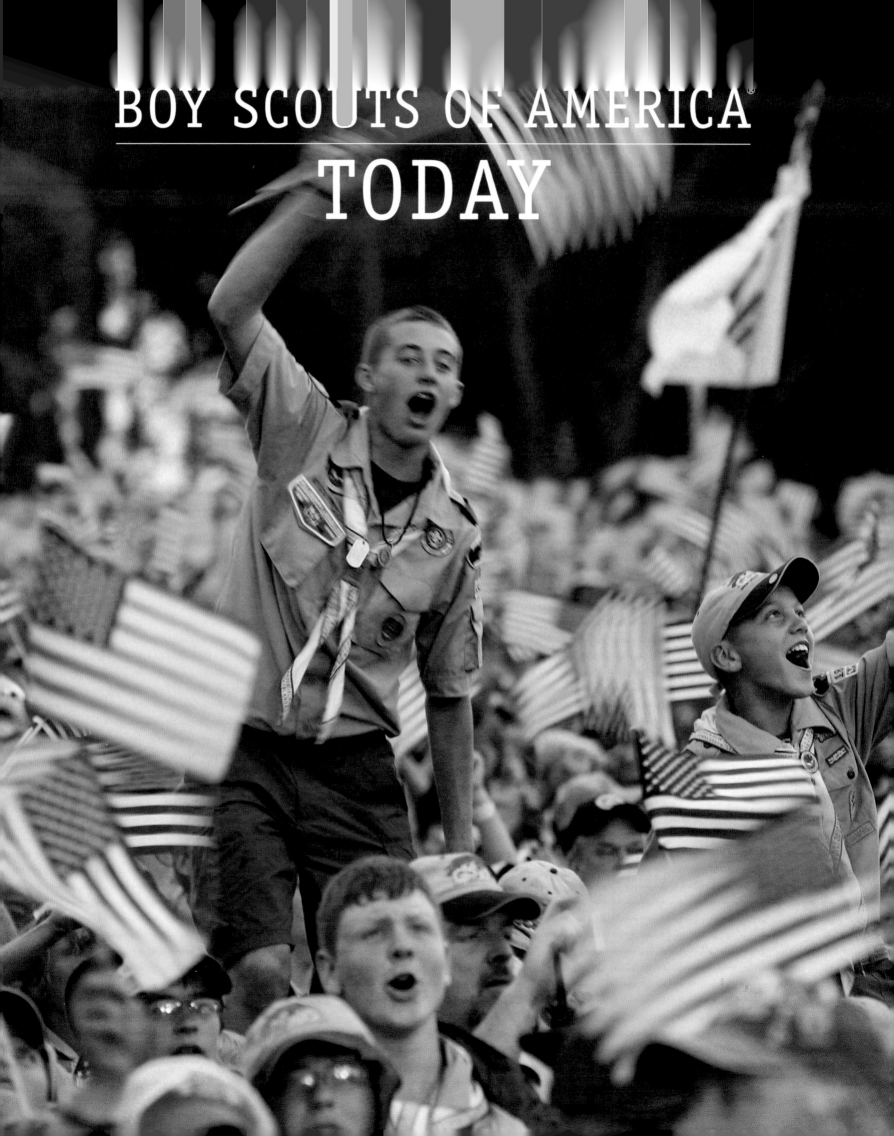

# BOY SCOUTS OF AMERICA
## TODAY

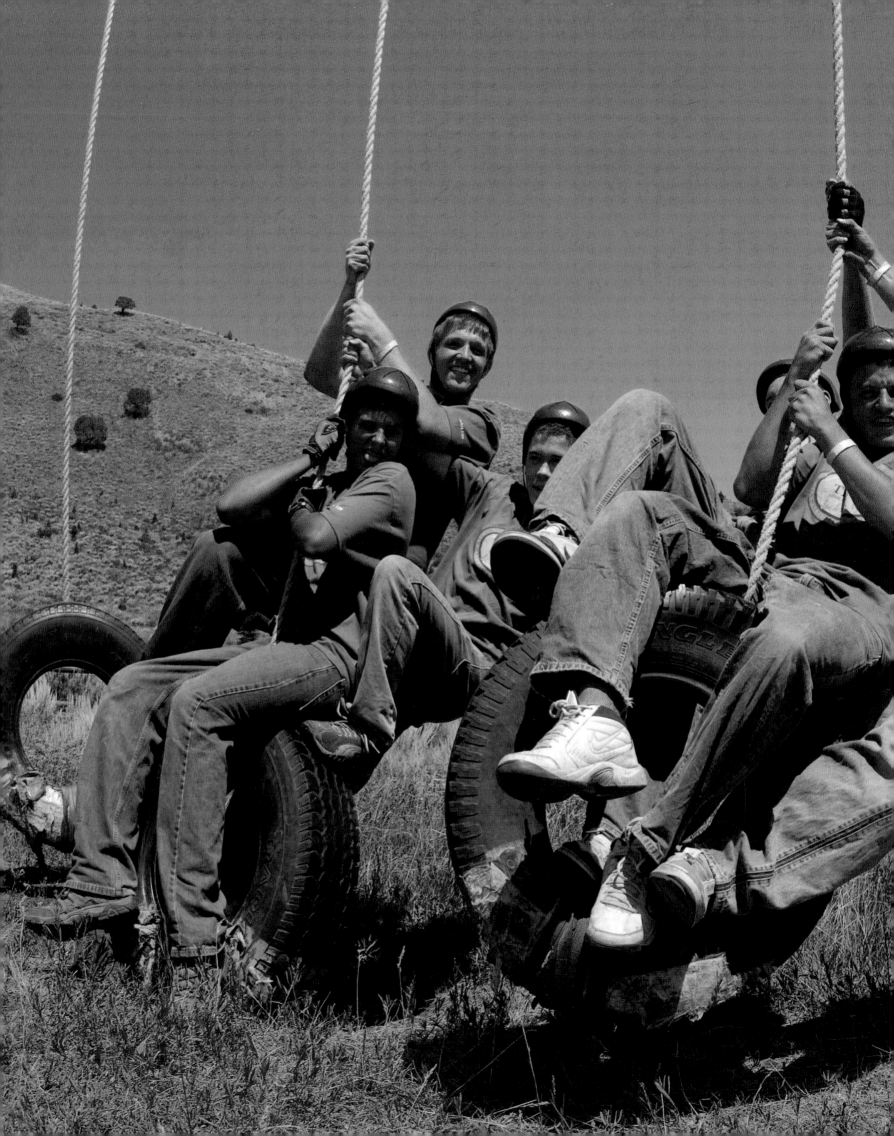

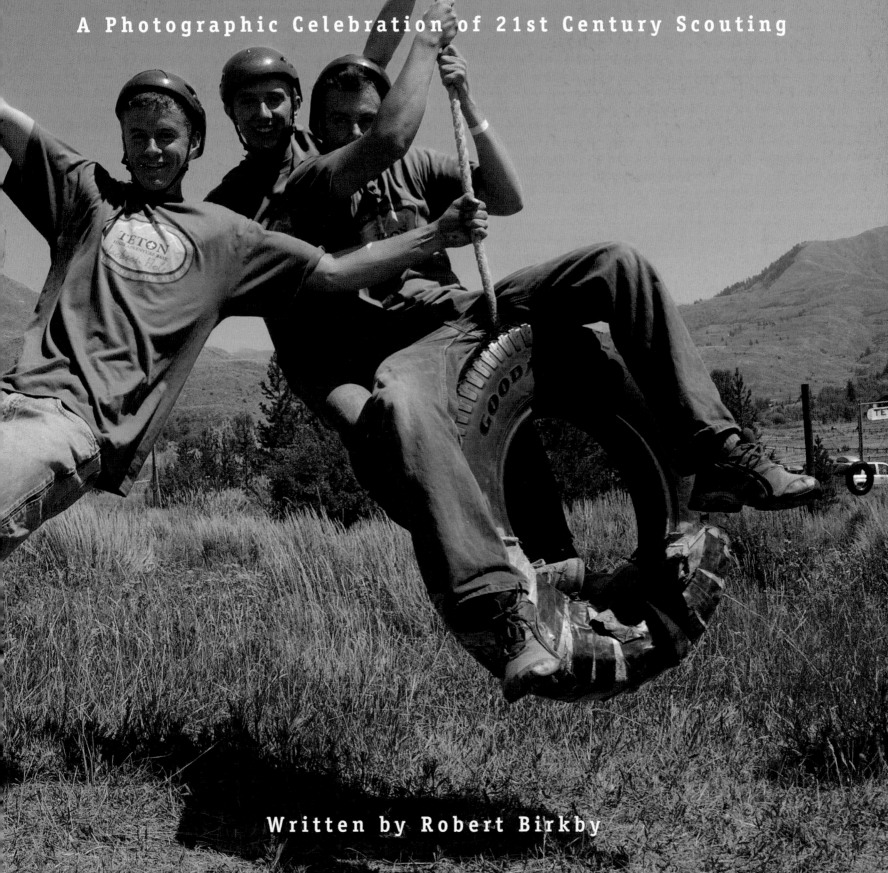

# BOY SCOUTS OF AMERICA®
## TODAY

### A Photographic Celebration of 21st Century Scouting

Written by Robert Birkby

LONDON, NEW YORK,
MUNICH, MELBOURNE, DELHI

Text written by Robert Birkby
Book design by Stuart Jackman and Richard Czapnik
Editor Sophie Mitchell

First American Edition 2010

Published in The United States by DK Publishing, Inc. 375 Hudson Street, New York, New York 10014
10 11 12 13 14 10 9 8 7 6 5 4 3 2 1
Copyright © 2010

www.scouting.org
A cataloging-in-publication record for this book is available from the Library of Congress
ISBN 978-0-7566-7227-0

DK books are available at special discounts for bulk purchases for sales promotions, premiums, fund-raising, or educational use. For details, contact: DK Publishing Special Markets, 375 Hudson Street, New York, NY 10014 or SpecialSales@dk.com

Printed and bound in the U.S.A. by Lake Book Manufacturing, Inc.

Discover more at
**www.dk.com**

### Boy Scouts of America

The mission of the Boy Scouts of America is to prepare young people to make ethical and moral choices over their lifetimes by instilling in them the values of the Scout Oath and Scout Law. The programs of the Boy Scouts of America—Cub Scouting, Boy Scouting, Varsity Scouting, and Venturing—pursue these aims through methods designed for the age and maturity of the participants.

### Cub Scouting

Fun with a purpose, Cub Scouting is an activity-filled, quality experience for boys 7 to 10 years old (first grade through fifth grade). Adult family members are encouraged to play a strong supportive role in their Cub Scout's success. Tiger Cubs are first-graders. Webelos are fourth- and fifth-graders getting ready to cross over into Boy Scout troops. Cub Scouting helps all its members grow into good citizens who are strong in character and personally fit.

### Boy Scouting

Based on the values of the Scout Oath and Scout Law, Boy Scouting is for boys ages 11 through 17. (Boys may also become Boy Scouts if they have earned the Webelos Arrow of Light Award or have completed the fifth grade.) With outdoor adventures, leadership, service to others, and achievement through rank advancement, Boy Scouting's vigorous program achieves the BSA's objectives of developing character, citizenship, and personal fitness.

### Varsity Scouting

An active, exciting program for young men ages 14 through 17, Varsity Scouting is built around five fields of emphasis: advancement, high adventure, personal development, service, and special programs and events.

### Venturing

The BSA's opportunity for women and men ages 13 through 20 years of age, Venturing includes challenging high-adventure activities, sports, leadership, service, and career exploration as ways for young people to mature into responsible, caring adults. (Sea Scouting is a segment of Venturing that promotes maritime skills and heritage.)

**For more information about the Boy Scouts of America or its programs, visit www.scouting.org**

# Contents

# Foreword from the Chief Scout Executive

I love books of photographs, especially those packed with the excitement and meaning of Scouting. With many of the pictures taken by youth and leaders themselves, the book you are holding is an insightful exploration of the Boy Scouts of America as we complete our Centennial Year and turn our attention to a very promising future.

And what a year it has been! With the theme *Celebrating the Adventure, Continuing the Journey*, we've had a 12-month birthday party, a remarkable tribute to the history and heritage of our great organization. It began on New Year's Day with a float honoring Scouting in the Tournament of Roses Parade and continued through local and regional events to the National Scout Jamboree, where 45,000 Scouts, adult leaders, and staff joined together to share the fellowship and fun of Scouting at its best.

Throughout the Centennial, we have reintroduced Scouting to America by sharing highlights of the organization's first century of service to youth and to the nation. Now we are laying out a clear vision for building on that legacy in the years to come.

We frequently hear that people who take a look at Scouting like what they see. They realize our country and the world need Scouting now more than ever. We need young people who are impassioned about service to others, about achieving at the height of their abilities, and about accepting the values embodied in the Scout Oath and Scout Law. Scouting provides young people with a place where the principles of honor, integrity, respect, faith, and kindness still matter.

The Boy Scouts of America is on solid ground, and we are growing. We

are blessed with exceptional volunteer leadership. Nearly 3 million young people and 1.1 million adults, now involved in the program, know that Scouting offers terrific opportunities for adventure, learning, and growth. Approximately 50 million living alumni can bear witness to the lifelong impact their experiences as Scouts have had upon them.

Scouting has a terrific story to tell, a story that begins to unfold in the pages of this book. The five pillars of the BSA's Centennial—Leadership, Achievement, Community Service, Character, and The Outdoors—highlight what we are all about. The smiling faces of Scouts everywhere show that the BSA is as vital today as at any time in the past.

*Chief Scout Executive Bob Mazzuca*

Scouting's journey into the next hundred years starts right now. The benefits and values of our programs are strong and as essential as ever for America and for generations of Scouts as they move forward into a new century of scouting. There is much we can point to with pride, and much work still to do. I hope you enjoy this book as a vibrant picture of where Scouting is today and of the tremendous possibilities before us as we embark on the second century of the Boy Scouts of America.

Robert J. Mazzuca
Chief Scout Executive
Boy Scouts of America

# Introduction

Advertisements in the back pages of the first *Boy Scout Handbook* featured the Brownie, a boxy amateur camera that promised to be easy to carry and simple to operate. "Ideal for the equipment of every detachment of Boy Scouts," the text proclaimed. Elsewhere in that 1911 manual, the requirements for the new Photography merit badge encouraged boys to take, develop, and print portraits, landscapes, and "instantaneous action photos."

Take photos they did, millions of them. Scouts through the decades pointed cameras at campouts, flag ceremonies, canoe trips, service projects, and meetings. They snapped pictures of the places they traveled, of wildlife that came close to their campsites, and of one another. Their faces peer out from the pictures of the past, sometimes dusty

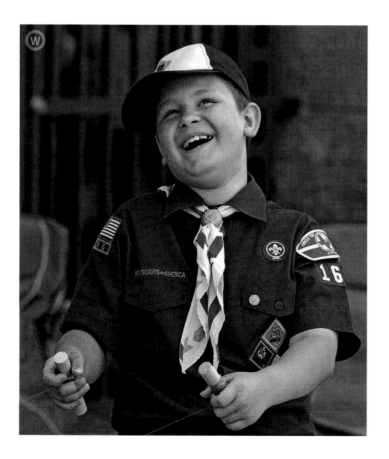

from a long hike, sometimes with serious looks as they lined up for a group shot, but always glowing with satisfaction and always with grins ready to break loose.

Digital cameras have replaced the Brownies and other film cameras, bringing the satisfaction of taking those "instantaneous action photos" to even more Scouts. Like generations of Boy Scouts before them, they are glimpsing through their viewfinders the richness of the Scouting experience. At a hundred years and going strong, the Boy Scouts of America continues to be jam-packed with adventures, friendships, skills training, leadership development, and service to others.

*Photography merit badge*

During its Centennial celebration, the BSA hosted a nationwide photo contest. Scouts, leaders, and friends of Scouting were invited to submit photographs with the goal of publishing the best as a view of the BSA seen by those who are currently wearing the uniforms and helping the program grow. Brought together on the pages of this book, the winning images create a visual montage that captures the meaning and excitement of being a Scout right now. (Winning photographs are marked with the symbol ⓦ.)

From ships rolling on the high seas to tents near mountain meadows, and from America's bustling cities to small towns, council camps, and wilderness areas, the settings of the photos confirm that

modern Scouting is as big and robust as America itself. Photographers explore small moments with local dens, troops, and crews and with the huge gatherings of the national Scout jamboree. With youngsters buttoning up Cub Scout uniforms for the first time and a BSA leader in his 90s reflecting upon the lifelong importance of the values of Scouting, the pictures validate the power of the BSA in guiding members to make the most of their lives.

These are photographs of Scouts by Scouts, and by their parents and friends. Some show boys who are not in their full uniforms. You might spot a Scout saluting with the wrong hand, and you'll see a lot of happy faces that could use some soap and water. The result is an honest photographic record of the fun and camaraderie of Scouting that help teach character and values for tomorrow's leaders, and that more than make up for a few shirttails not quite tucked in.

Scouting has always been a pathway to adventure with the mission of preparing young people to make ethical and moral choices. Throughout its first century, that ideal has been fulfilled for nearly 150 million youth and leaders. In years to come, millions more will find in Scouting the trailhead to possibilities.

Of course, much has changed during the BSA's first hundred years. Boys in those early Brownie camera photos wore broad-brimmed campaign hats, woolen jackets, and tight leggings. Photos at midcentury show Scouts

in khaki shirts and overseas caps, their skills taking them farther into the outdoors to meet increasingly demanding challenges. Today's members continue to push back boundaries, achieve more, and revel in the opportunities of the BSA.

As you turn these pages, the message of Scouting emerges as clearly in today's rich color prints as it did in the grainy black and white snapshots of long ago. Be Prepared. Do a Good Turn daily. Obey the Scout Oath. Those ideals have never shifted by even a single syllable. If you truly wish to know the Boy Scouts of America, look to those ideals and to the 12 points of the Scout Law—trustworthy, loyal, helpful, friendly, courteous, kind, obedient, cheerful, thrifty, brave, clean, and reverent. That is the ultimate lens through which to understand Scouting, and through which all Scouts come to understand themselves.

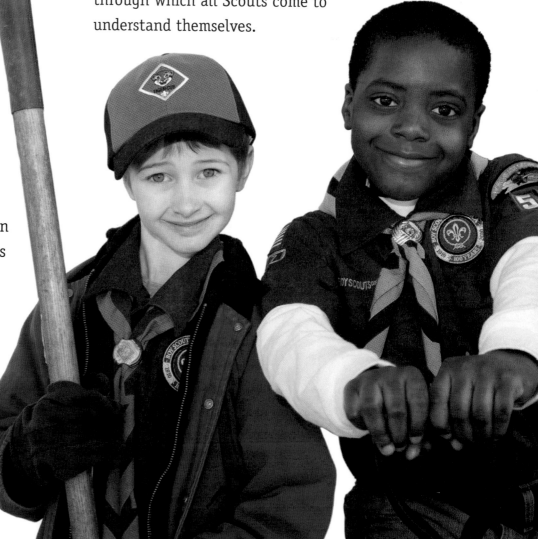

# The Scout Law

*A dozen simple words with the power to change lives—that's the Scout Law, backbone of the Boy Scouts of America. The Scout Law's 12 points also organize this book of photographic evidence that Scouting today is as exciting as ever. With challenge, adventure, and opportunities to learn and lead, the BSA offers a blueprint for building futures that are, in all the best ways, everything from trustworthy to reverent.*

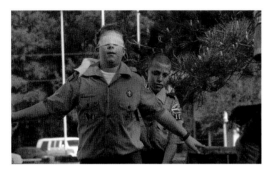

## A Scout Is **TRUSTWORTHY**

A Scout tells the truth. He is honest, and he keeps his promises. People can depend on him.

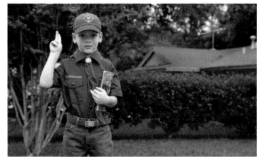

## A Scout Is **LOYAL**

A Scout is loyal to those to whom loyalty is due.

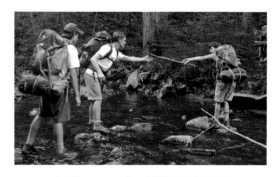

## A Scout Is **HELPFUL**

A Scout cares about other people. He helps others without expecting payment or reward. He fulfills his duties to his family by helping at home.

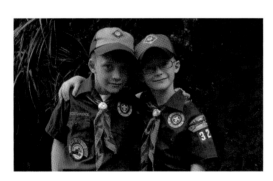

## A Scout Is **FRIENDLY**

A Scout is a friend to all. He is a brother to other Scouts. He offers his friendship to people of all races, religions, and nations, and respects them even if their beliefs and customs are different from his own.

## A Scout Is **COURTEOUS**

A Scout is polite to people of all ages and positions. He understands that using good manners makes it easier for people to get along.

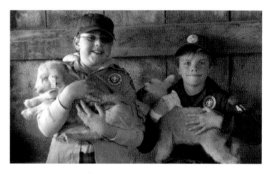

## A Scout Is **KIND**

A Scout treats others as he wants to be treated. He knows there is strength in being gentle. He does not harm or kill any living thing without good reason.

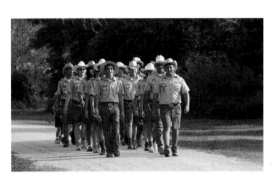

## A Scout Is **OBEDIENT**

A Scout follows the rules of his family, school, and troop. He obeys the laws of his community and country. If he thinks these rules and laws are unfair, he seeks to have them changed in an orderly way.

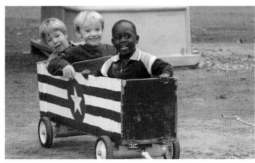

## A Scout Is **CHEERFUL**

A Scout looks for the bright side of life. He cheerfully does tasks that come his way and tries to make others happy, too.

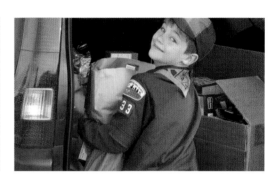

## A Scout Is **THRIFTY**

A Scout works to pay his way and to help others. He saves for the future. He protects and conserves natural resources. He is careful in his use of time and property.

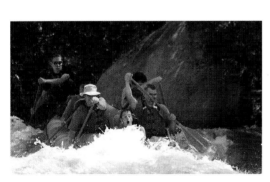

## A Scout Is **BRAVE**

A Scout faces danger even if he is afraid.

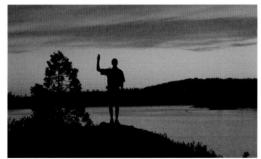

## A Scout Is **CLEAN**

A Scout keeps his body and mind fit. He chooses friends who also live by high standards. He avoids profanity and pornography. He helps keep his home and community clean.

## A Scout Is **REVERENT**

A Scout is reverent toward God. He is faithful in his religious duties. He respects the beliefs of others.

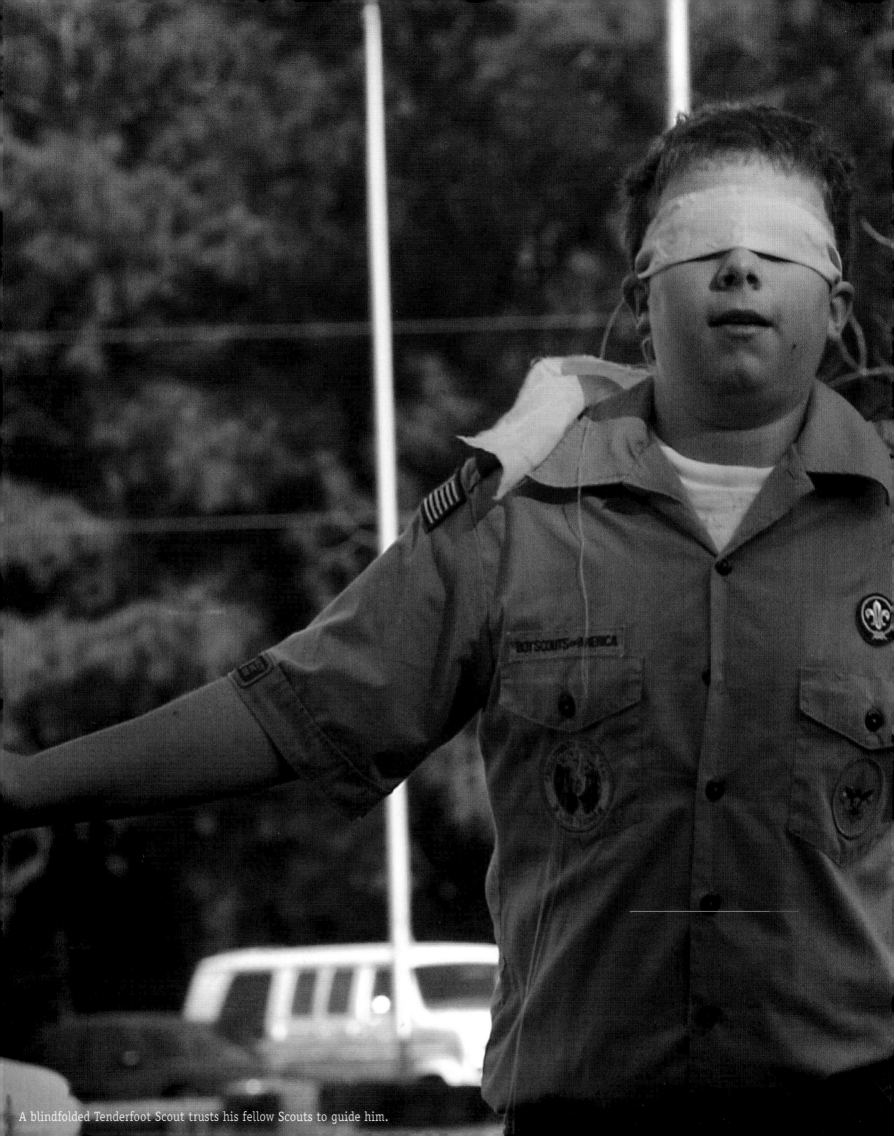

A blindfolded Tenderfoot Scout trusts his fellow Scouts to guide him.

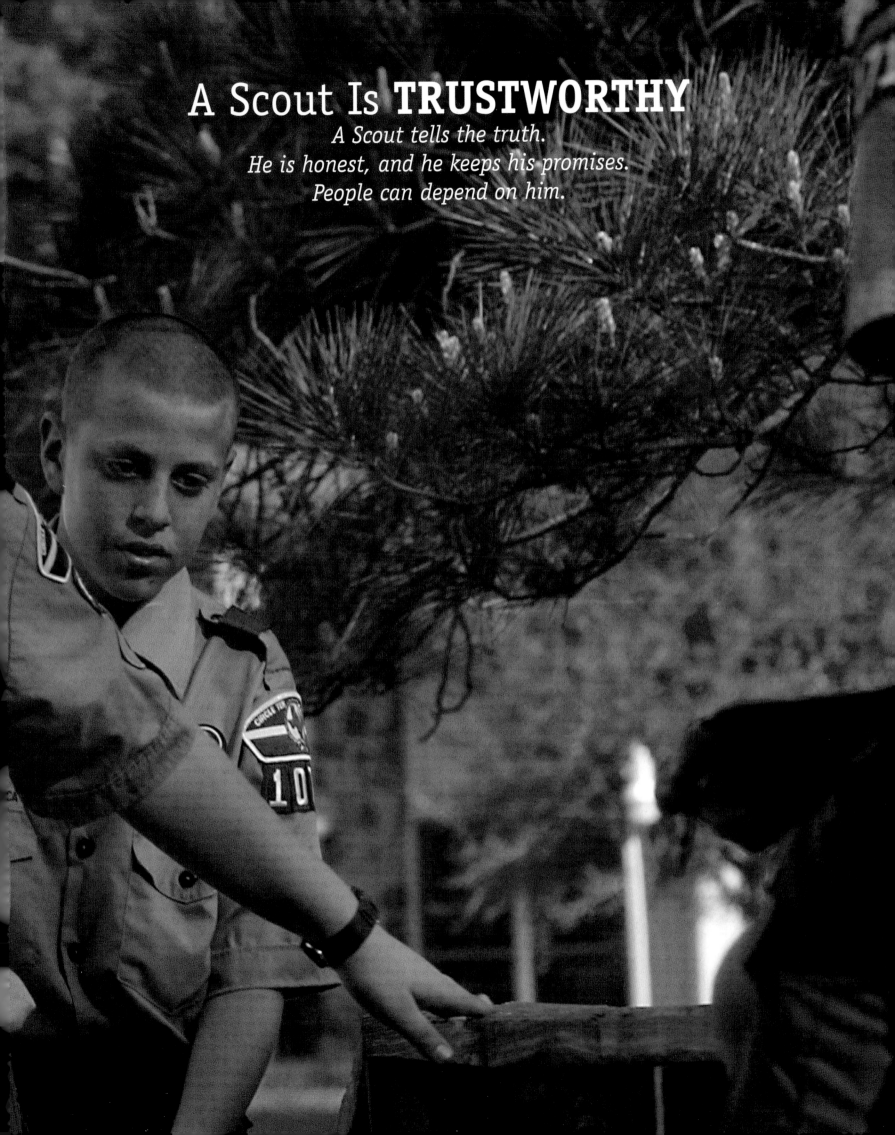

# A Scout Is **TRUSTWORTHY**

*A Scout tells the truth.*
*He is honest, and he keeps his promises.*
*People can depend on him.*

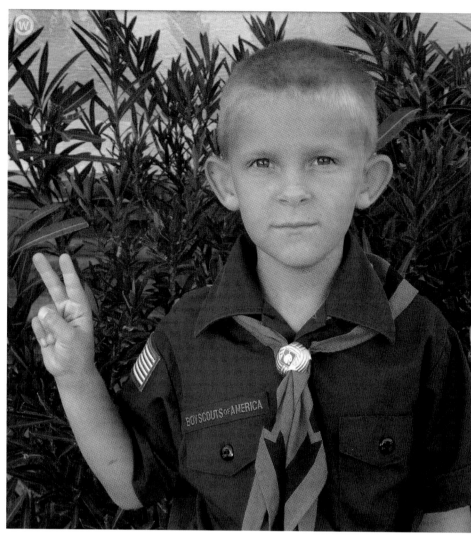

▲ **Ready to go**
Putting his trust in Scouting, Cub Scout Michael Smith of Las Vagas, Nevada, proudly prepares for his first den meeting.

▲ **Right on target**
Life Scout Sydnor Kerns tests his accuracy throwing target tomahawks during a mountain man rendezvous at Philmont Scout Ranch.

**All together, now!** ▶
A challenge course competitor leaves his fate, and the success of his team, in the hands of his fellow Scouts.

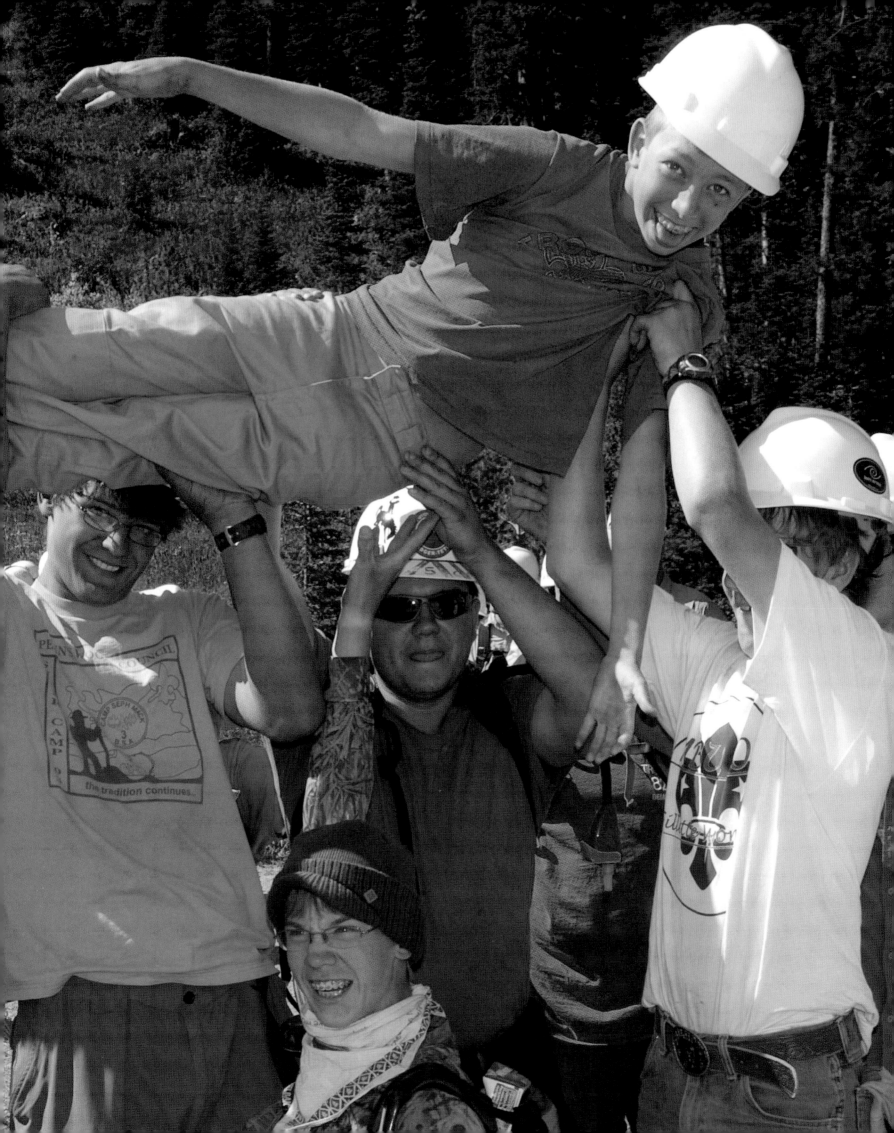

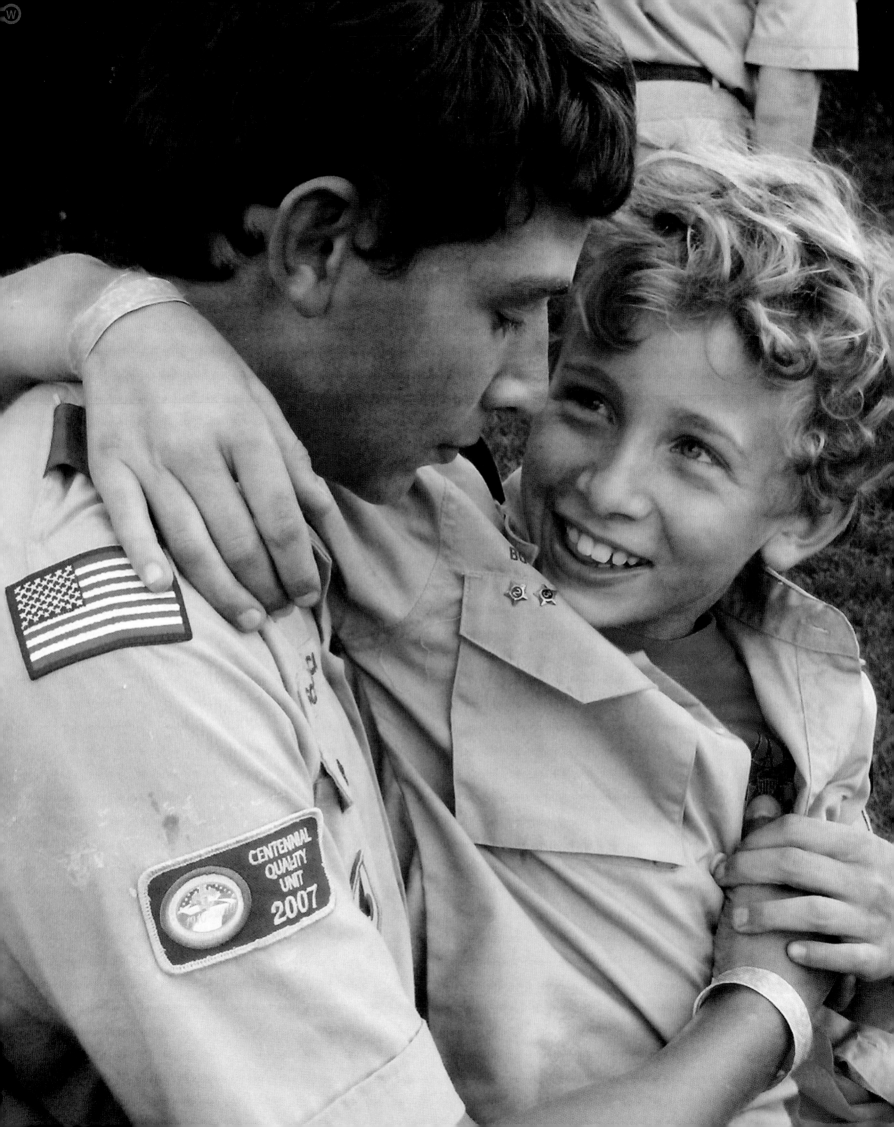

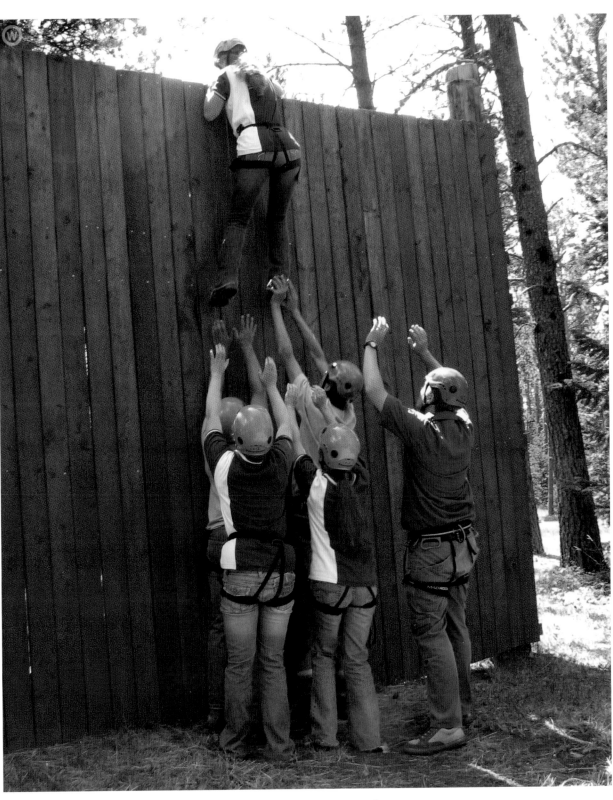

**◄ Brothers in arms**
Preston Bures of Troop 462, Medina,
Ohio, visits his brother Leo's first Webelos
camping adventure.

**▲ Over the top**
Venturing Crew 861 from Fort Peck, Nashua, and
Glasgow unites to hoist everyone over the challenge
course wall at Montana Council's K-M Scout Ranch.

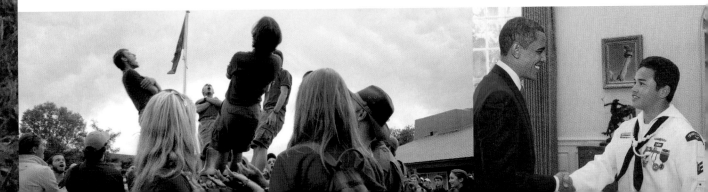

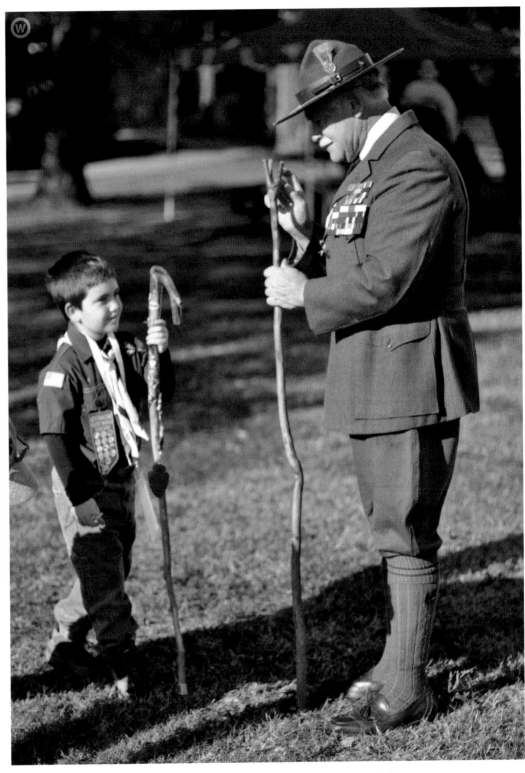

**◄ Written large for all to see**
Banners proclaiming the 12 points of the Scout Law greet Scouts at the National Capital Area Council's Centennial Camporee.

**▲ From out of the past**
Veteran Scouter Hal Yocum's portrayal of Robert Baden-Powell brings Scouting's founder to life for Oklahoma Cub Scout Phoenix Stamp.

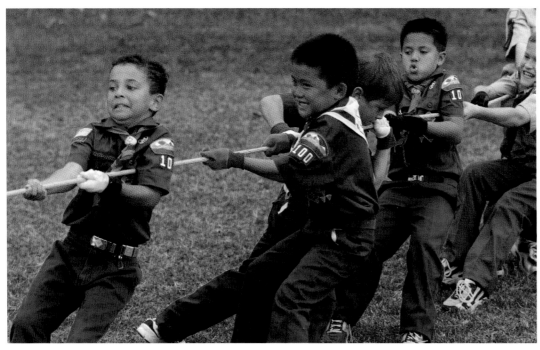

**▲ Giving it their all**
Cub Scouts dig in for a spirited tug-of-war during a picnic in Lewisville, Texas. Games offer opportunities for learning teamwork while having fun.

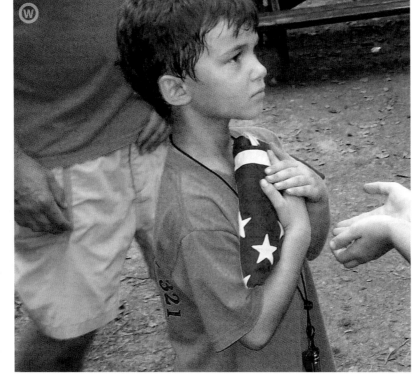

**Doing it right ▷**
With honor and respect, Scouts follow the guidelines of the United States Flag Code for the correct way to greet, display, and fold the American flag.

**The last salute ▷**
American Legion Post 341 and Cub Scout Pack 341 of Bella Vista, Arkansas, bid a solemn farewell to worn-out flags.

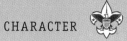

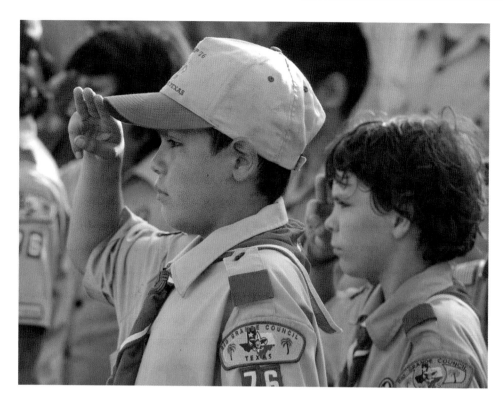

◄ **A gesture
of character**
Rio Grande Council
Scouts use the Scout
salute to greet leaders
and honor the American
flag. Extended fingers
represent the three
points of the Scout Oath.

**Pushing back boundaries** ▶
Life Scout Kevin Murphy of
Annandale, Virginia, steels
himself for the bold traverse
that will prove that
confidence and pride are
within reach.

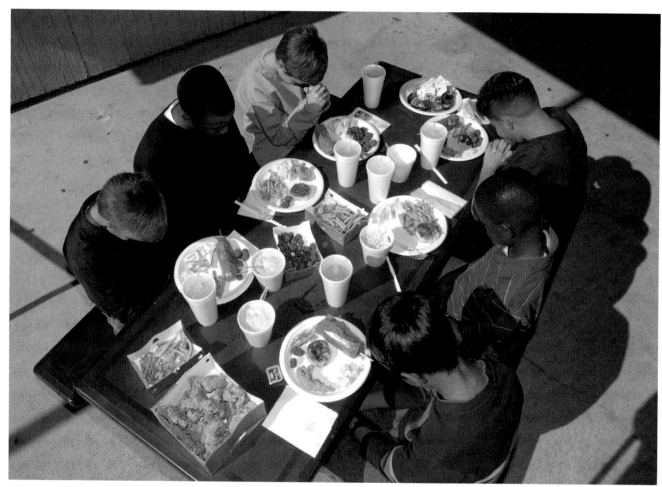

**A moment of grace** ▶
Pausing before meals,
Scouts give thanks
for what is before
them and for the
opportunities
that lie ahead.

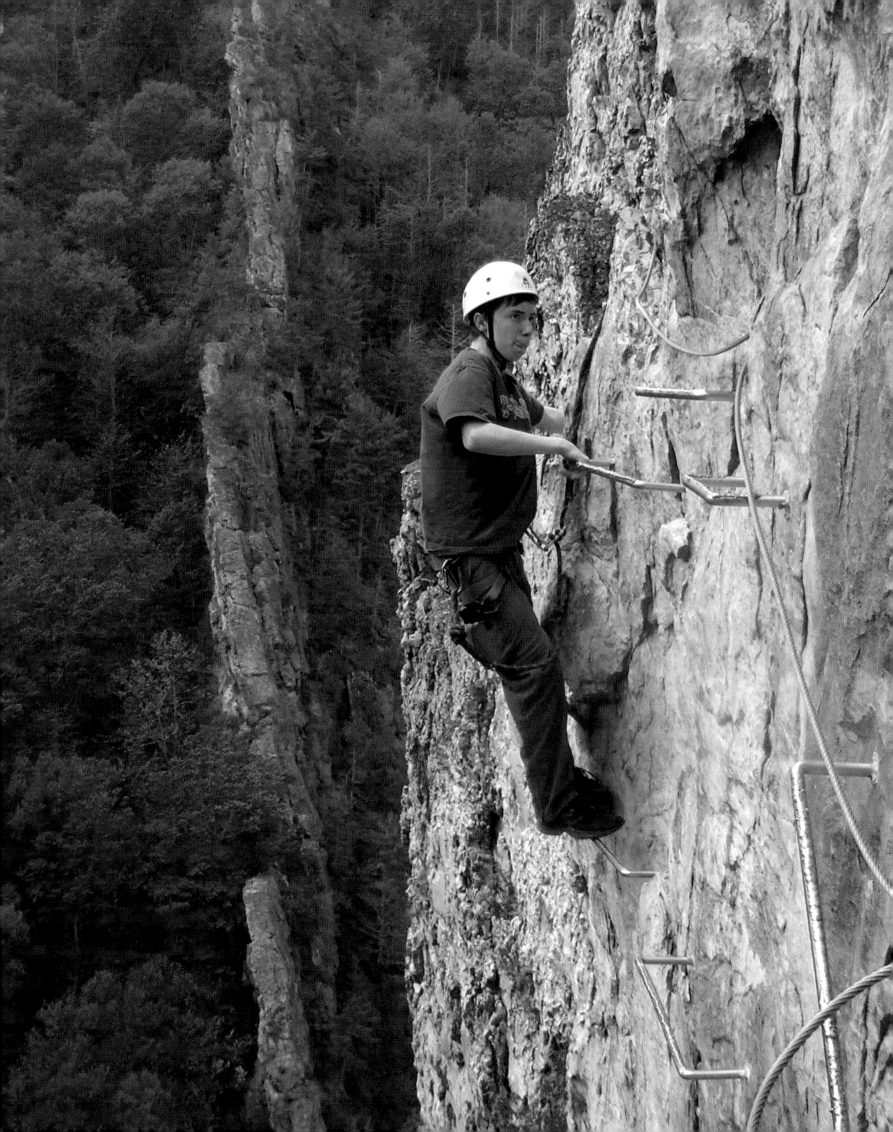

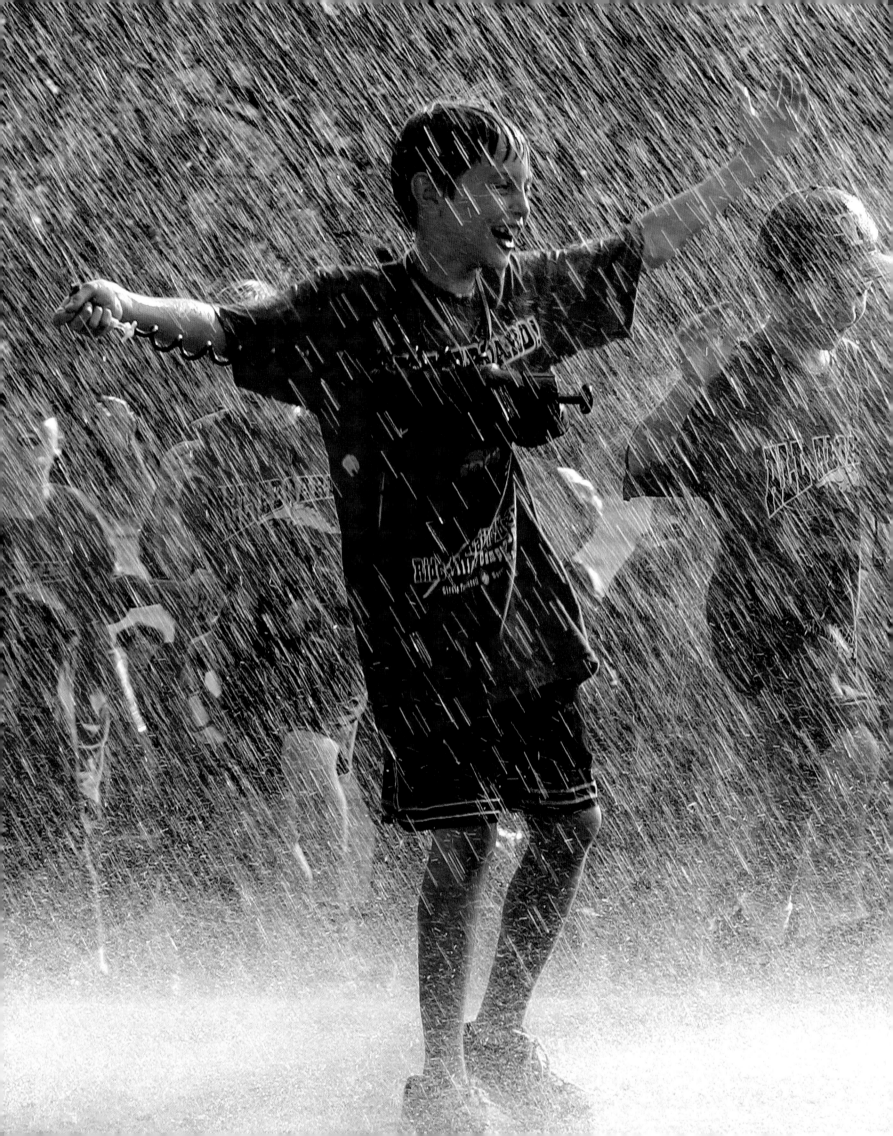

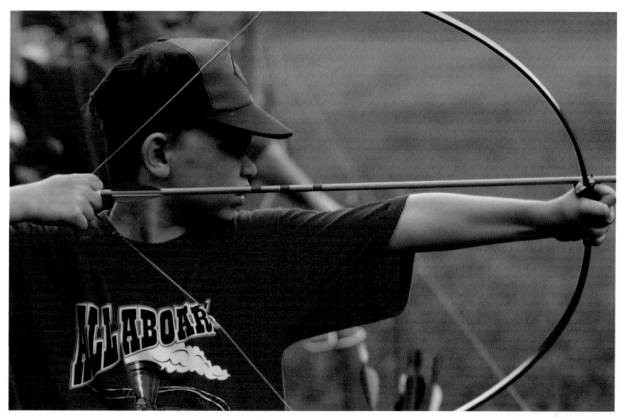

**▲ Pulling for possibilities**
Aiming to do things when they join the BSA, Scouts find the adventure of Scouting takes flight outdoors.

**◄ Scouting is cool!**
Summer heat invites Scouts to splash into BSA events perfect for fun and friendship.

**▲ Shelter from the storm**
Year-round camping enlivens the BSA's outdoor program with adventures for every season, and for Scouts and leaders of every age.

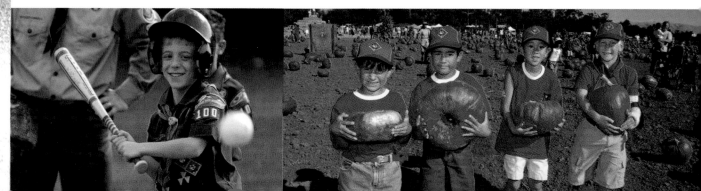

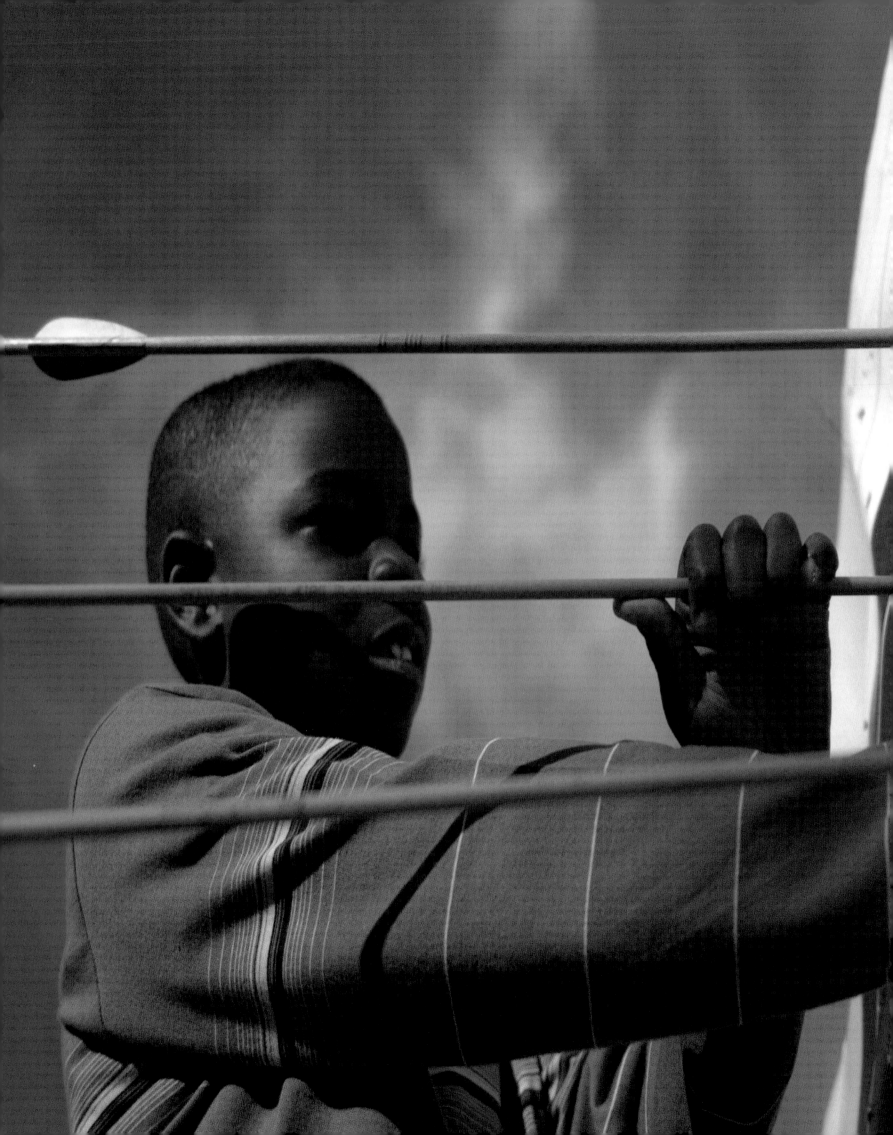

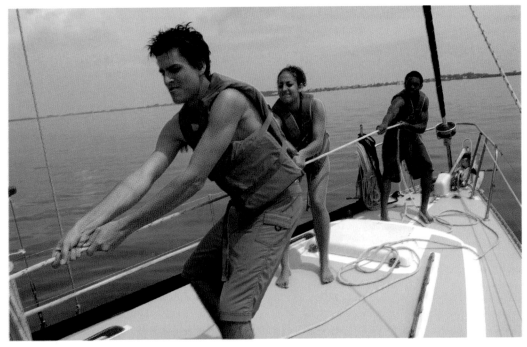

**▲ Hoisting the mainsail**
Venturers set sail from the BSA's Florida National High Adventure Sea Base to navigate Bahamian waters and explore the coral reefs of the Keys.

**◀ Closing in on perfection**
The more Scouts learn, the greater their opportunities to be part of increasingly challenging outdoor activities.

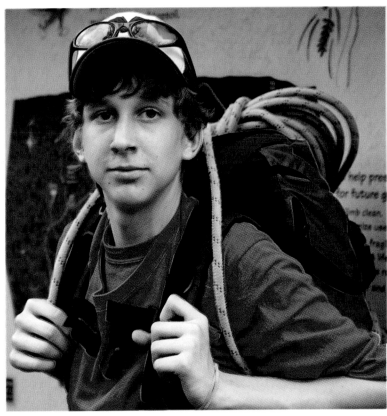

**▲ Being prepared matters**
With the right equipment, training, and the support of friends and leaders, Scouting puts safety first.

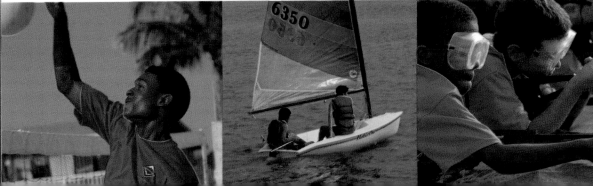

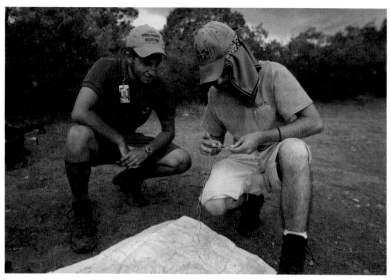

▲ **Finding the way**
A ranger at Philmont Scout Ranch passes on his knowledge of using a map and compass to chart routes through the backcountry.

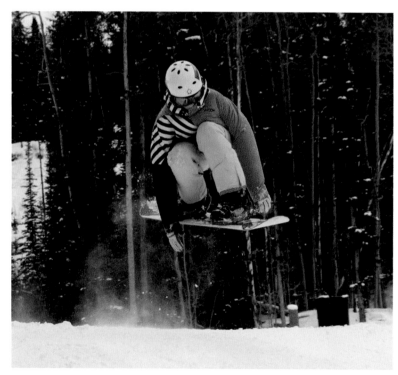

▲ **Grabbing some air**
The BSA adds to traditional Scouting skills with the latest outdoor interests of its members.

**Shelter from the storm** ▶
Scouts at Camp Yaw-Paw in the Ramapo Mountains try out a rustic shelter built by Troop 49 of Milton, New Jersey.

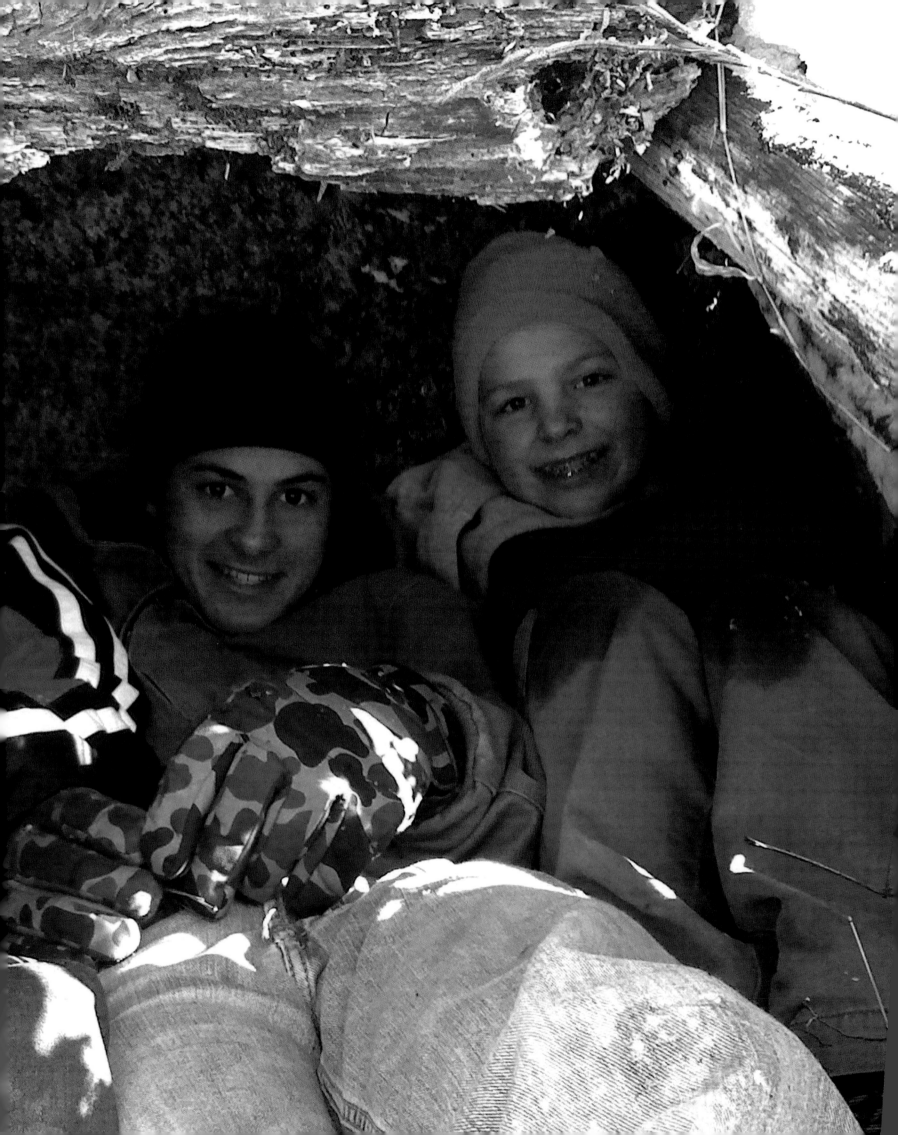

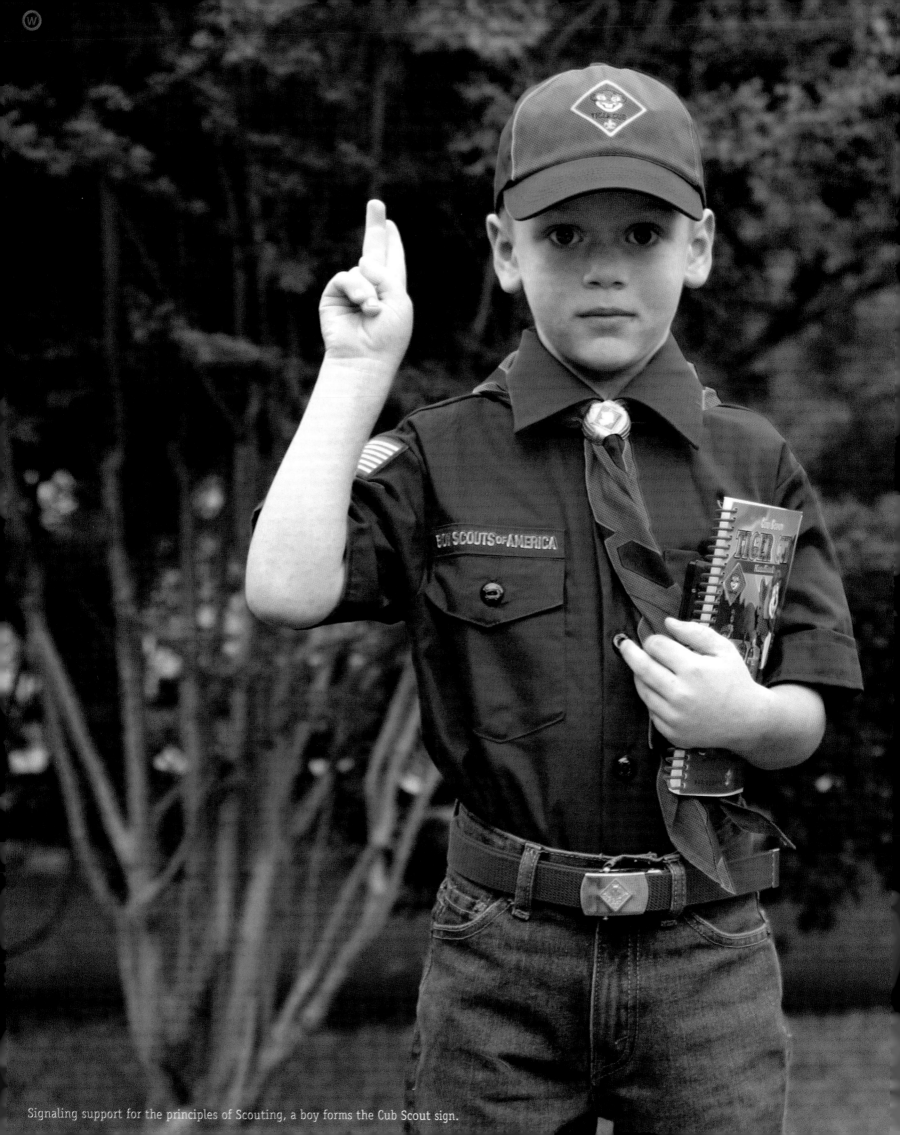

Signaling support for the principles of Scouting, a boy forms the Cub Scout sign.

# A Scout Is **LOYAL**

*A Scout is loyal to those to whom loyalty is due.*

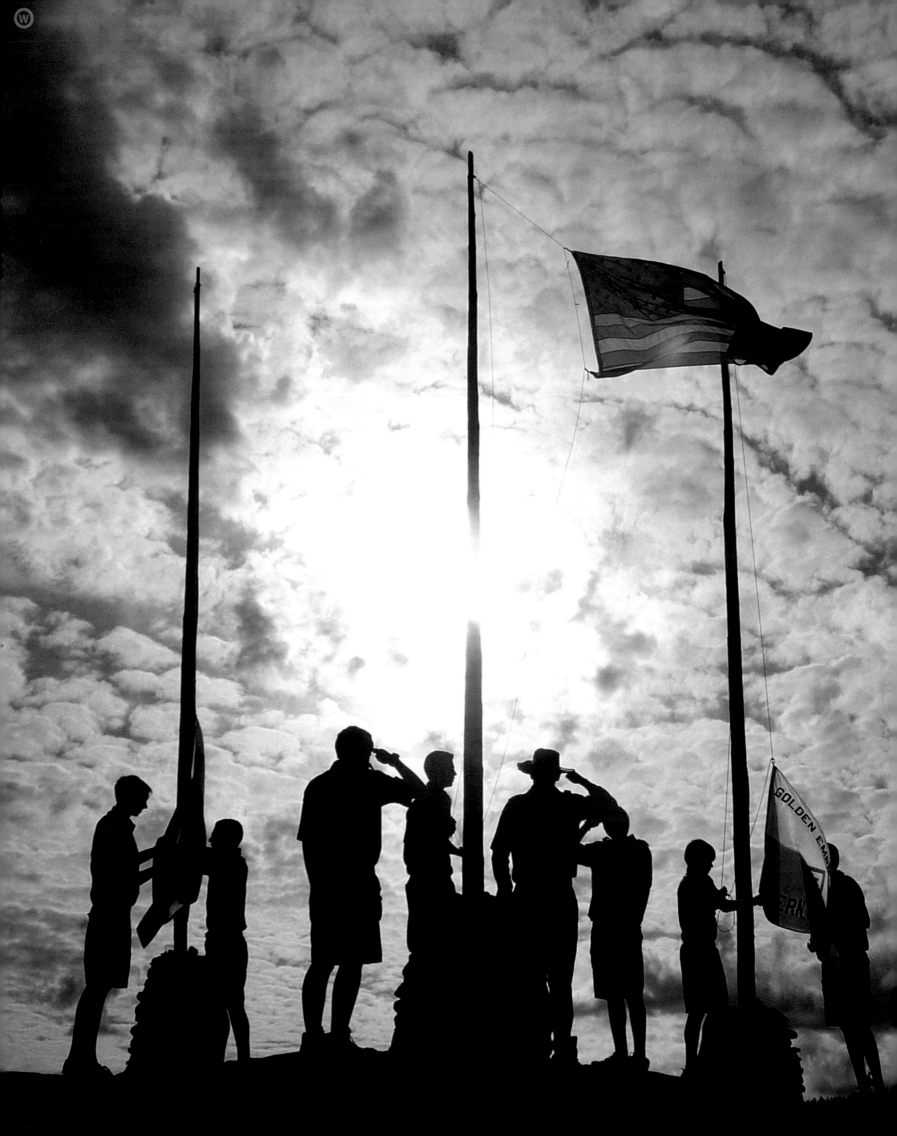

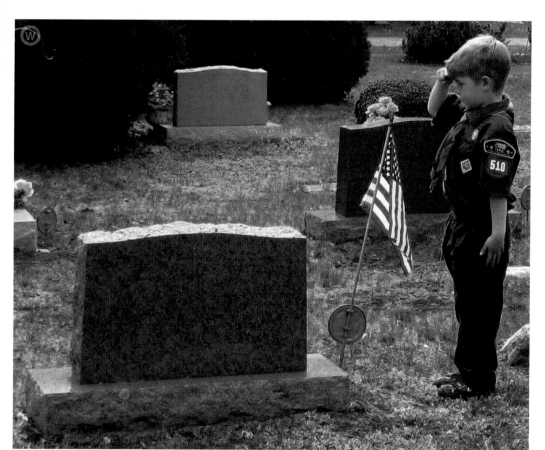

**◀ Honoring the past**
A Quinnesec, Michigan, Scout salutes the grave of an American veteran on Memorial Day.

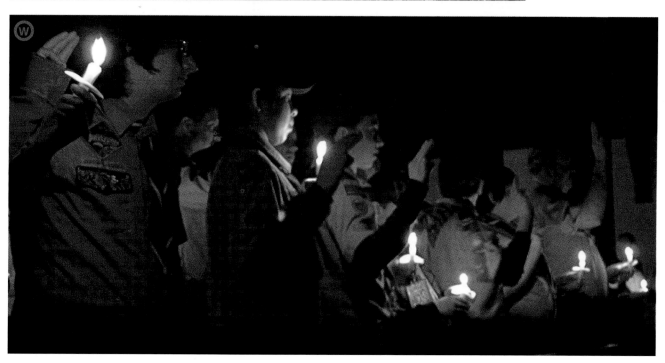

**◀ Before the light fades**
At the close of day, an honor guard from Northern California's Golden Empire Council retires the nation's flag.

**▲ On my honor...**
Reciting the Scout Oath and Scout Law reminds Scouts of the high standards guiding their daily lives.

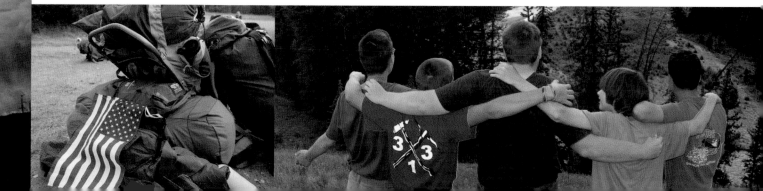

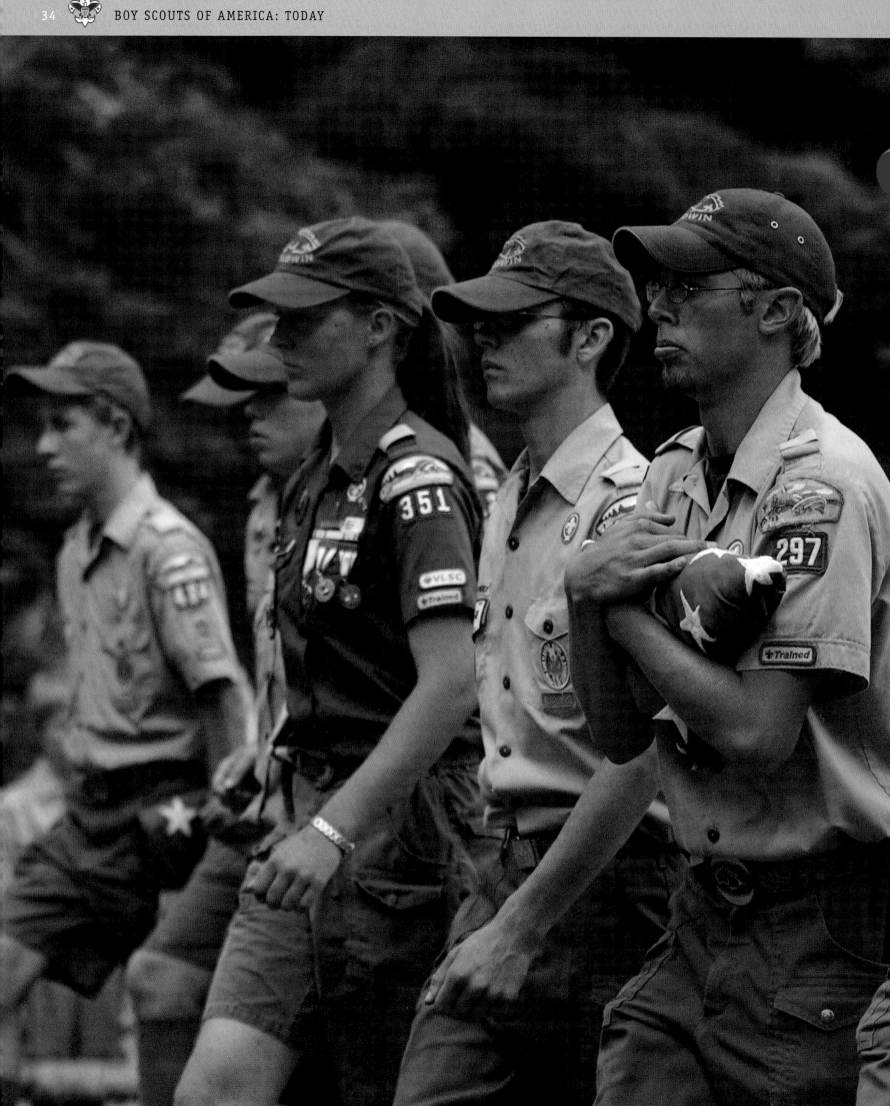

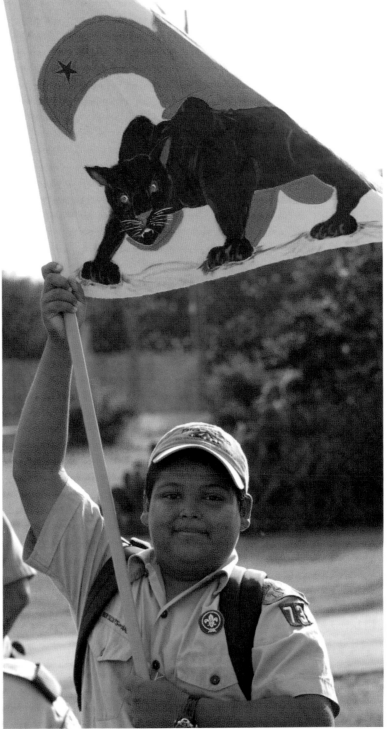

**◄ Home is where the patrol is**
Eager to lead, a Louisiana Scout hoists the banner of the Panther Patrol.

**◄ Patriotic possibilities**
With vision and purpose, Venturers and Boy Scouts fulfill the promise they have made to do their duty to their country.

◀ **Finish line for fun**
Cub Scouts of Pack 47,
Menomonie, Wisconsin,
celebrate the success of their
annual Pinewood Derby.

**Growing together** ▶
Pride fills the faces
of Scouts preparing
for a Webelos crossover
ceremony at
Camp Brorein near
Odessa, Florida.

◀ **Head for the
high country!**
Backpackers from Kansas'
Quivira Council hike
through morning mists
on the third day of their
80-mile Philmont Scout
Ranch trek.

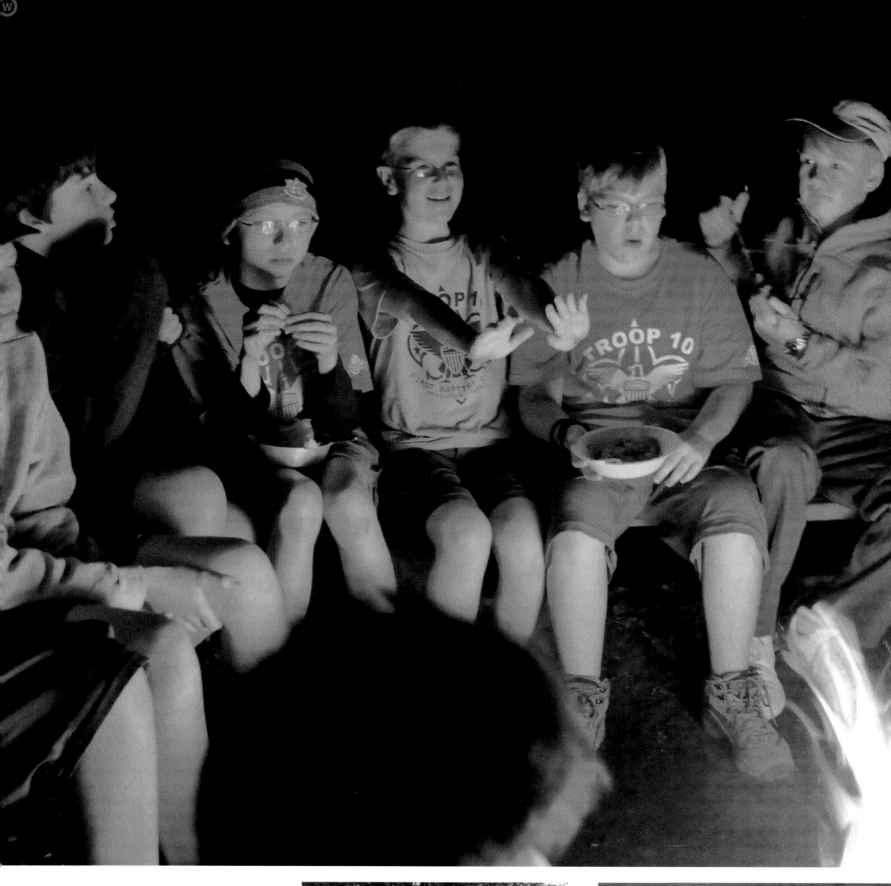

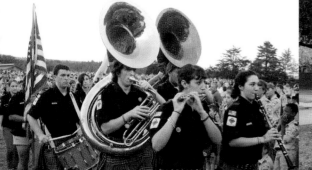

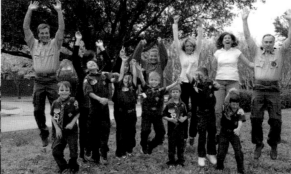

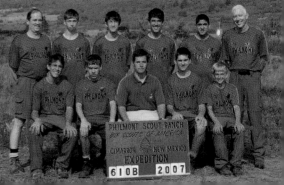

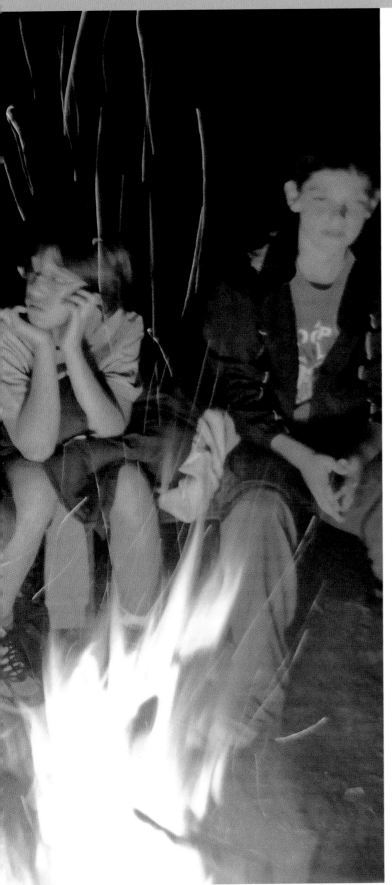

**▲ Behind every Scout**

With guidance of dedicated leaders, Scouts find the support and space to expand their skills and imagine what is possible.

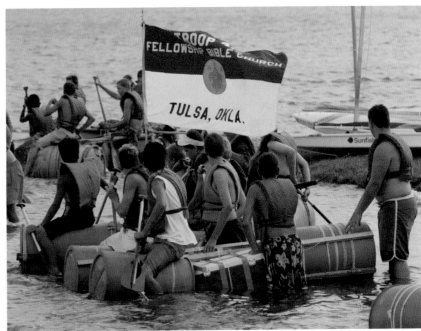

**◄ The best of times**

A campfire at the Gulf Coast Council's Camp Euchee shines the light of fellowship on the Scouts of Troop 10, Pensacola, Florida.

**▲ A raft of fresh ideas**

Ingenuity, lashings, and more than a few odd parts go into watercraft wonders constructed by Scout patrols working as teams.

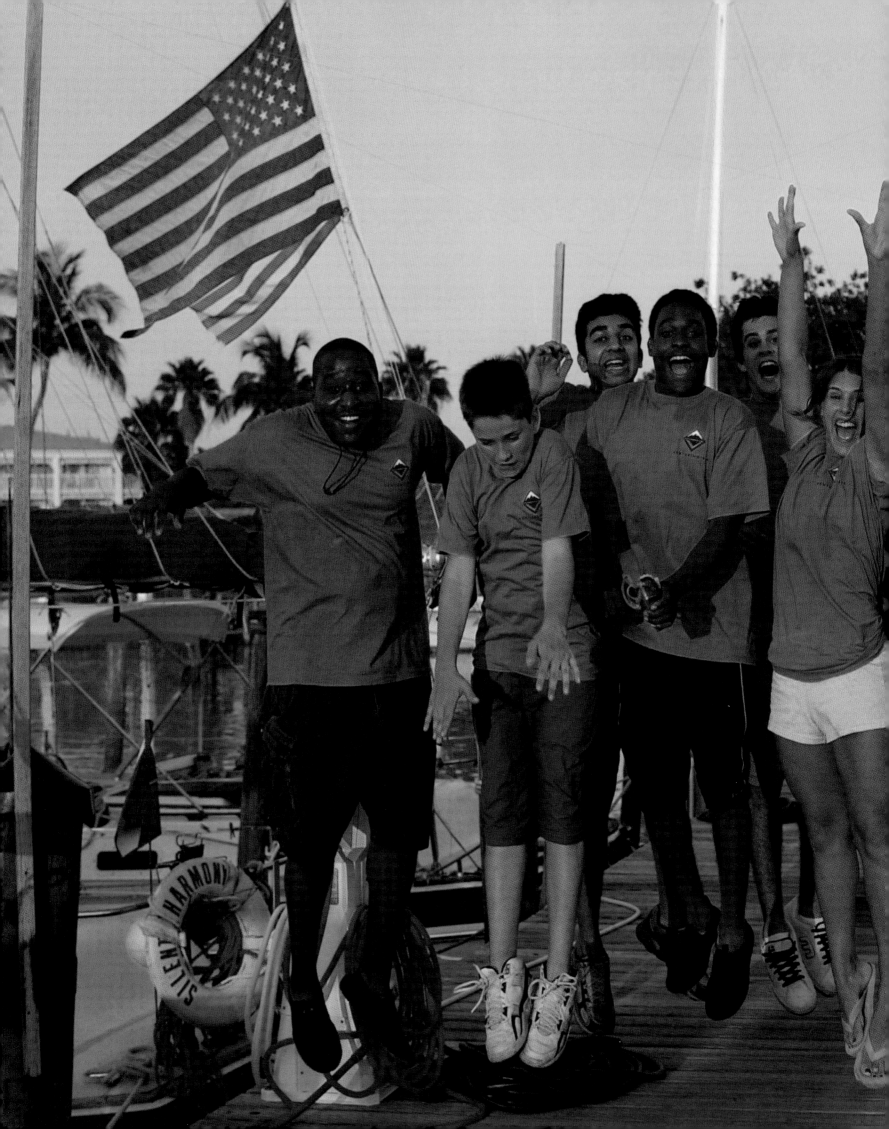

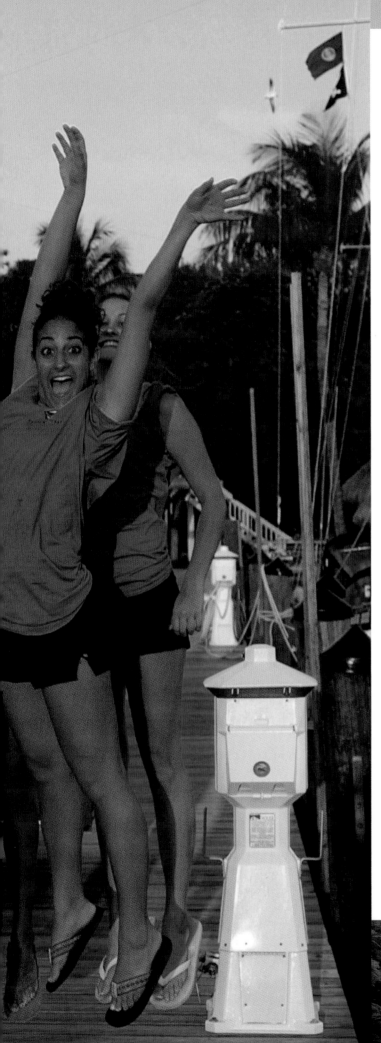

▲ **Starting out right**
Involving Tiger Cubs and their parents or guardians in lively activities brings Scouting values to the BSA's youngest members.

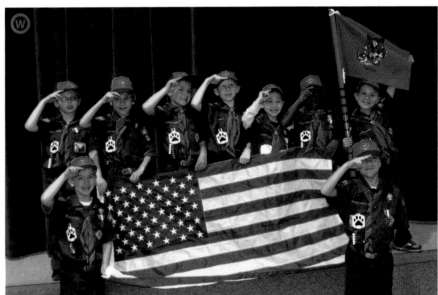

◀ **Reach high for adventure**
Venturers at the BSA's Florida Sea Base leap at the chance to sail the waters of the Bahamas and the Keys.

▲ **A powerful connection**
Cub Scouts of Pack 241, Den 9, Bluffton, South Carolina, salute the flag sent by American troops serving in Afghanistan to whom the boys had written letters of support.

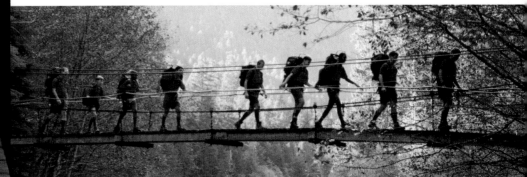

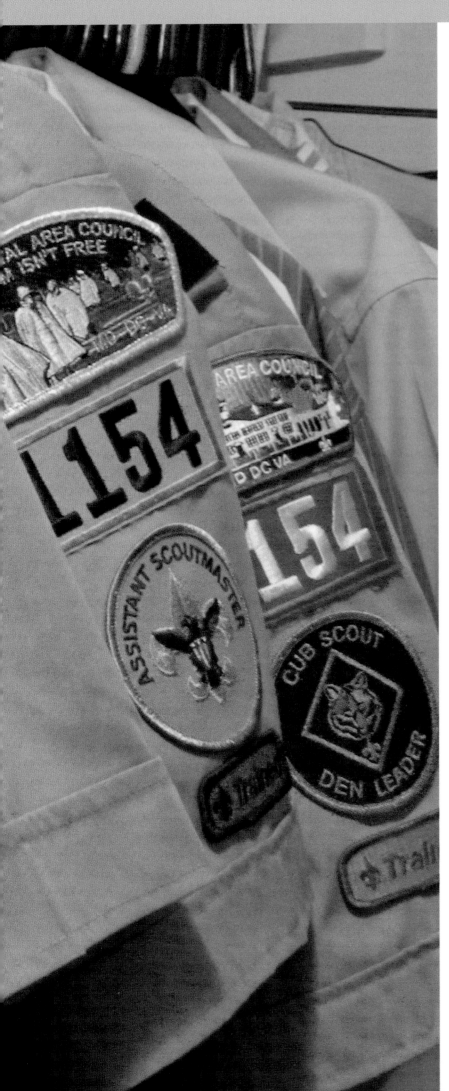

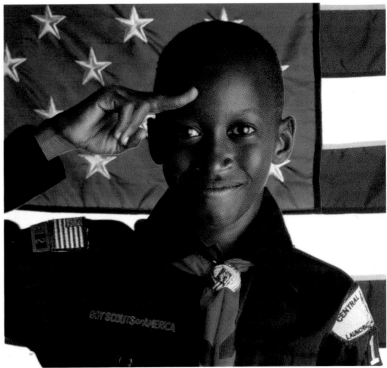

**◄ Badges of position and place**
Shoulder patches of the National Capital Area Council's Birsic family yield a colorfully embroidered record of leadership.

**▲ The heart of Scouting**
Uniforms identify Scouts as young people striving to live by the ideals of the BSA.

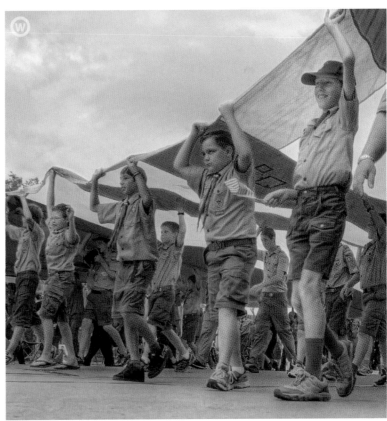

**▲ Broad stripes and bright stars**
Scouts of the Last Frontier Council carry an enormous American flag in the Libertyfest Parade in Edmond, Oklahoma.

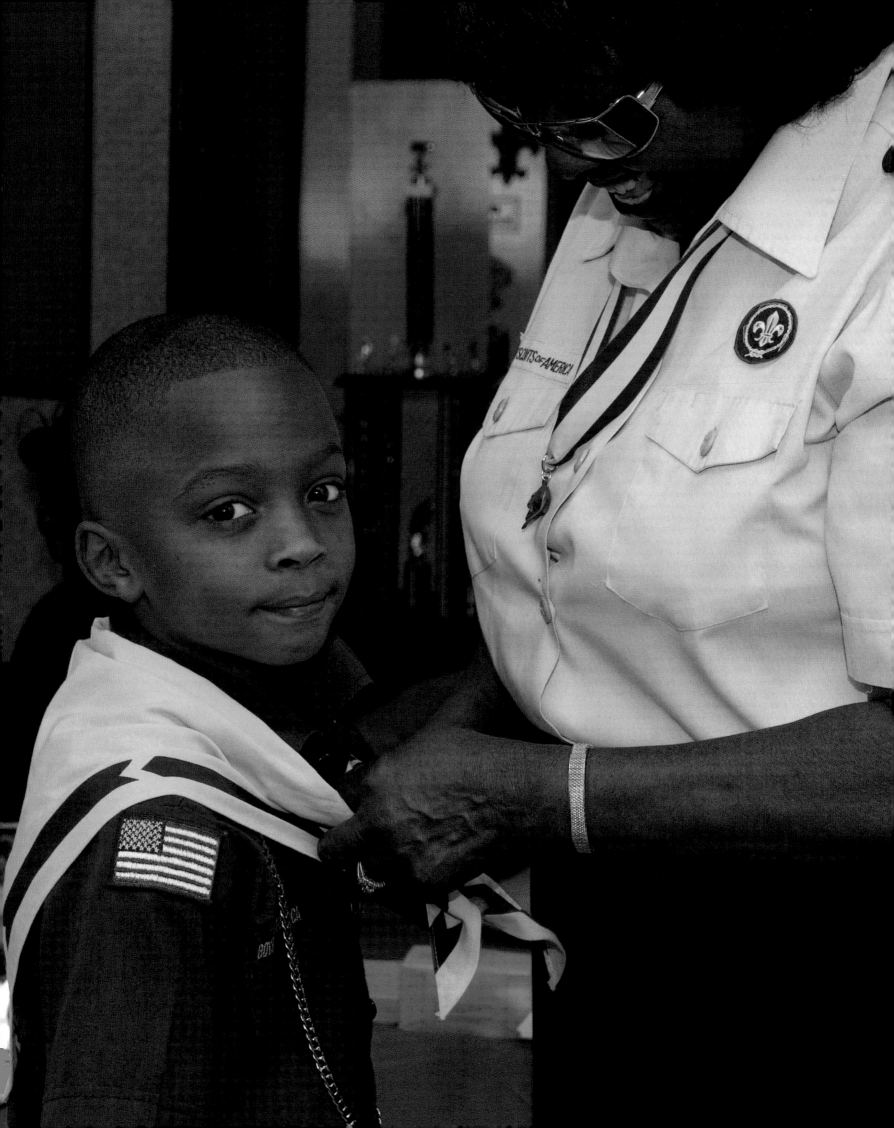

◀ **Passing on the pride**

Conveying the traditions of the BSA from one generation to the next carries Scouting's message through the years.

▲ **Smiling all the way**

A gap-toothed grin shines out Ty Hess's feelings of acceptance and joy in his South Carolina Cub Scout pack.

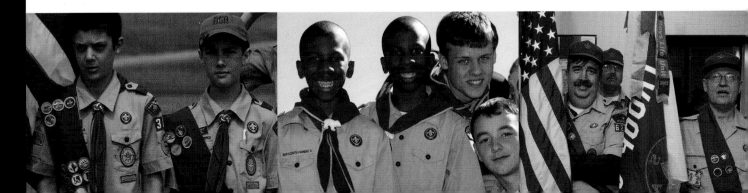

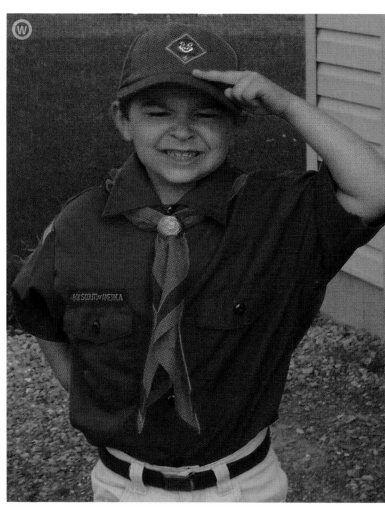

▲ **It all starts here**
Radiating pride, Tiger Cub Jeffery Lentz
of Annville, Pennsylvania, eagerly begins
his Scouting career by learning the salute.

**Appreciating the big picture** ▶
Eagle Scout Phil Smart Sr., age 91, salutes
a lifetime of adventure, leadership, and
service with the Chief Seattle Council.

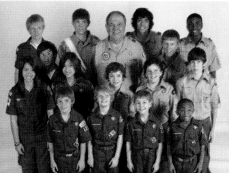

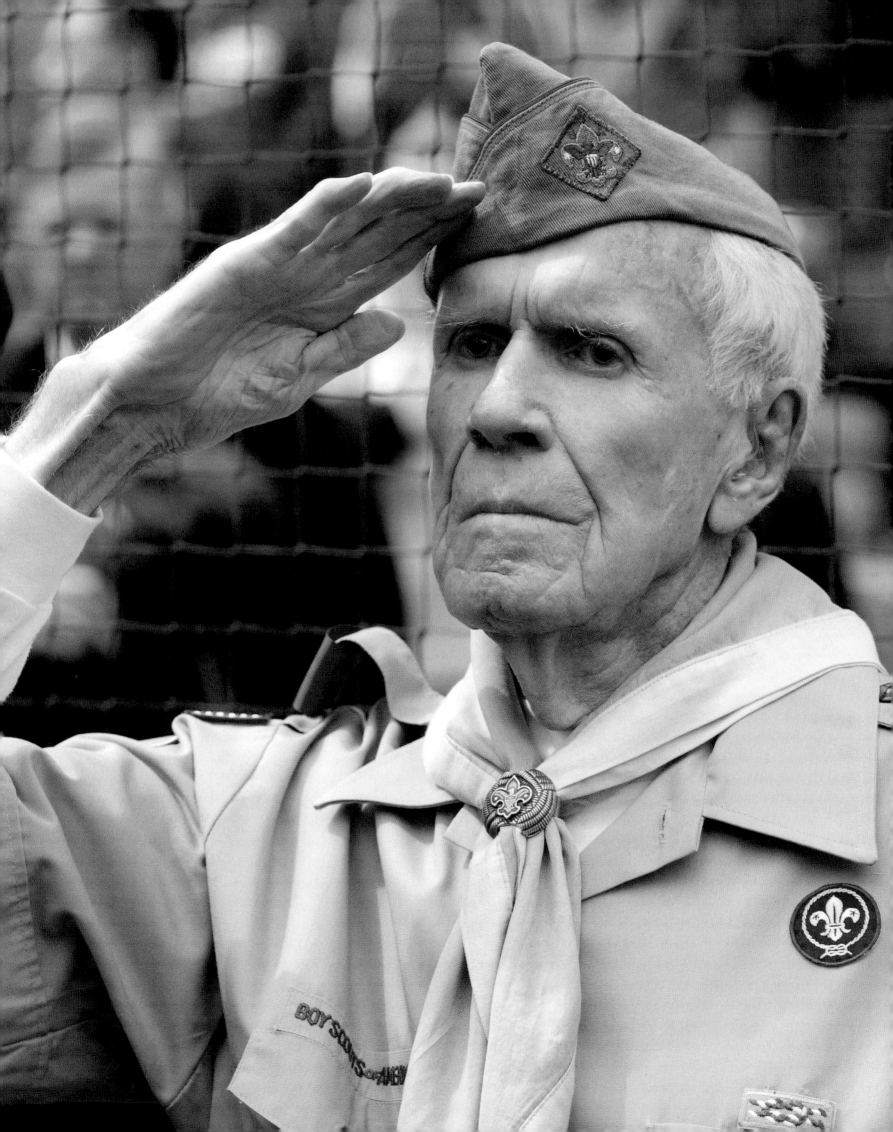

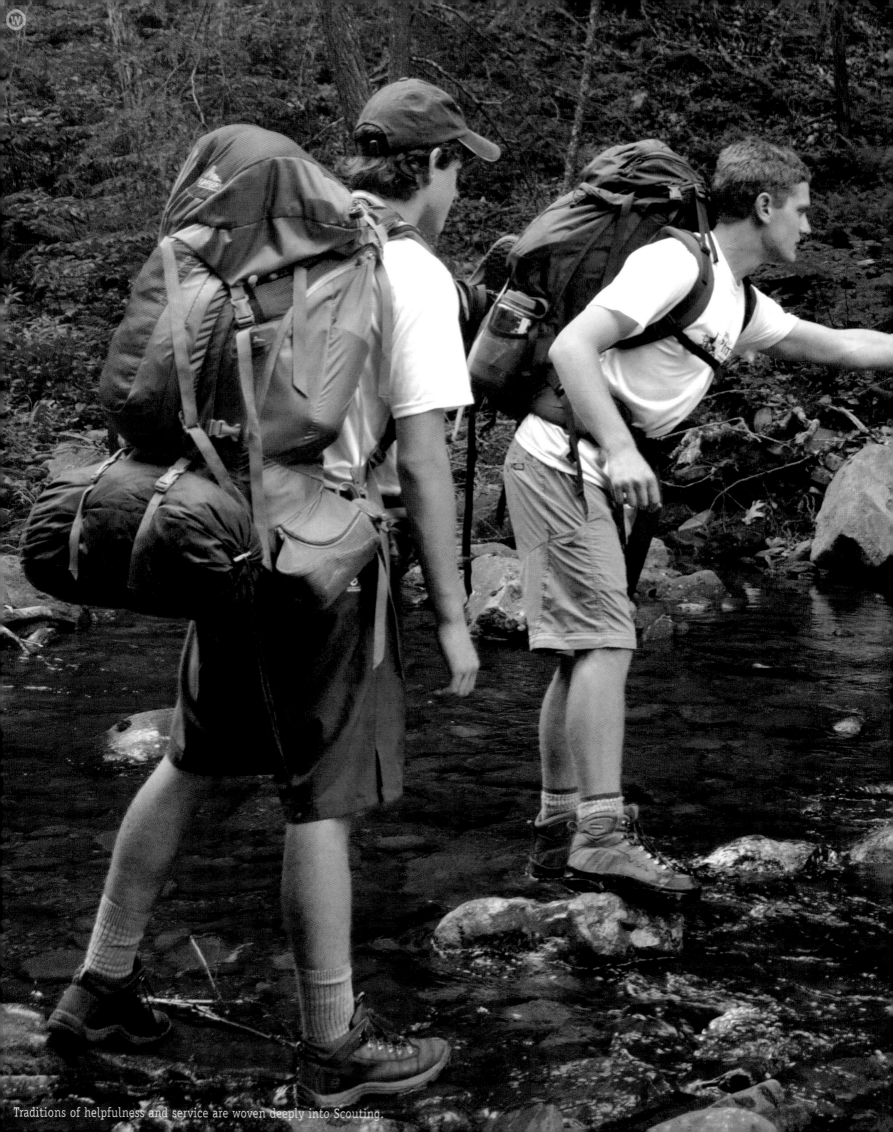
Traditions of helpfulness and service are woven deeply into Scouting.

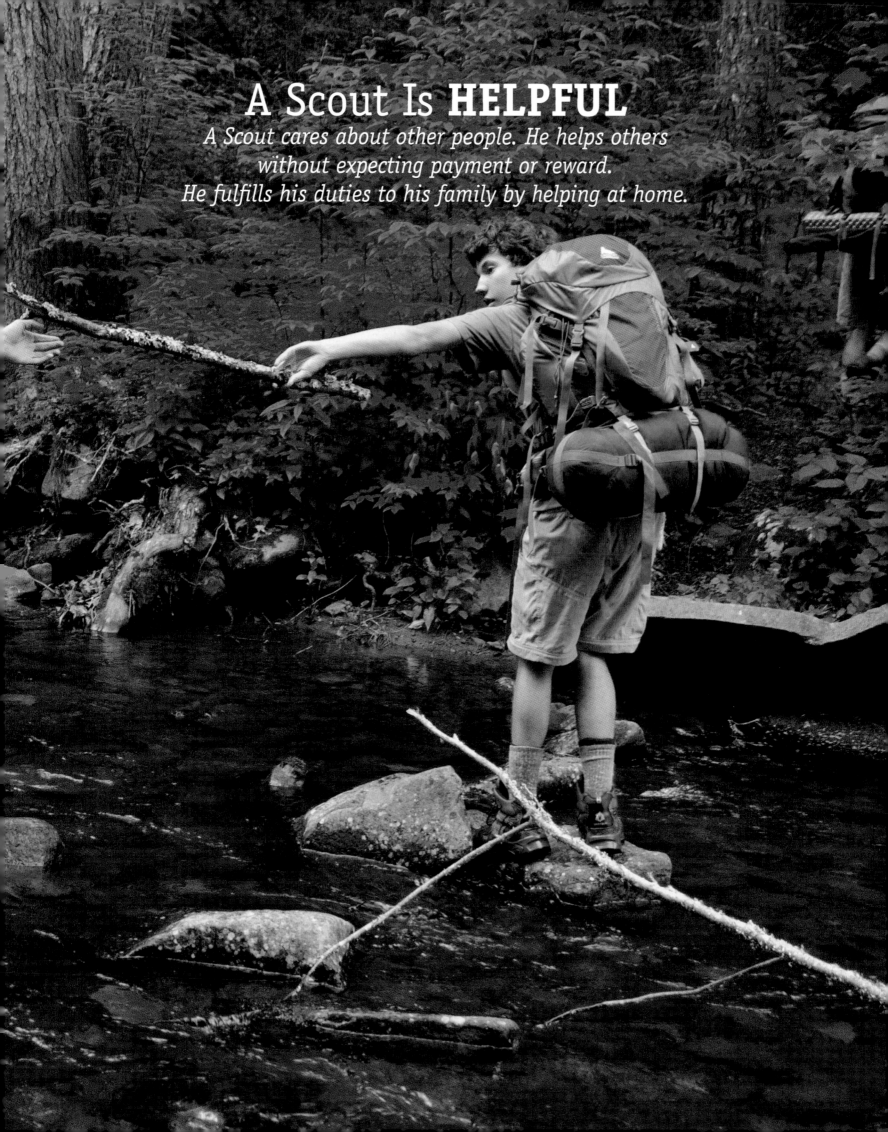

# A Scout Is **HELPFUL**

*A Scout cares about other people. He helps others*
*without expecting payment or reward.*
*He fulfills his duties to his family by helping at home.*

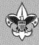

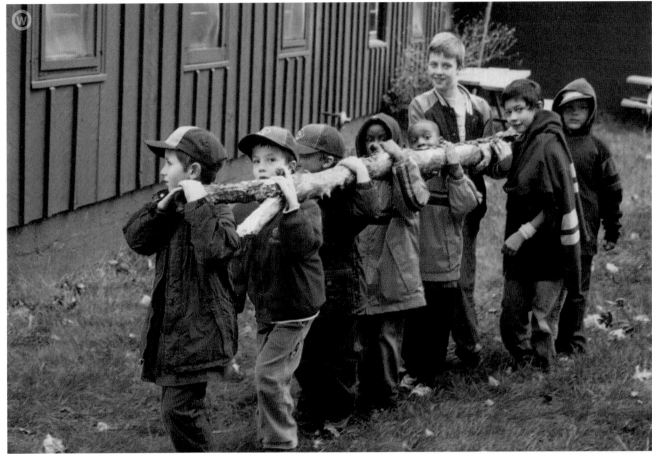

**▲ Many hands make light work**
Shouldering a load together, Cub Scouts of
Pack 881, Westland, Michigan, share the
satisfaction of a job well done.

**Pulling for others ▶**
Nicholas Golden and Parx F. Shearer deliver
groceries collected in Plano, Texas, during a
Scouting for Food drive.

**◀ Scouting service goes global**
Far from her Minnesota home, Rachel Roberts
of Venturing Crew 1202 helps lay the
foundation for a school in Moshi, Tanzania.

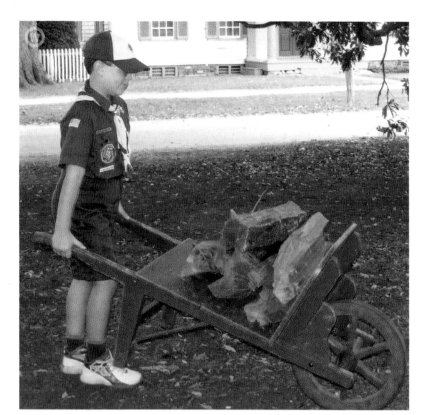

**◄ Strong work ethic**
Cub Scout Jack Edwards of Franklin, Virginia, helps with Colonial-era chores at historic Williamsburg.

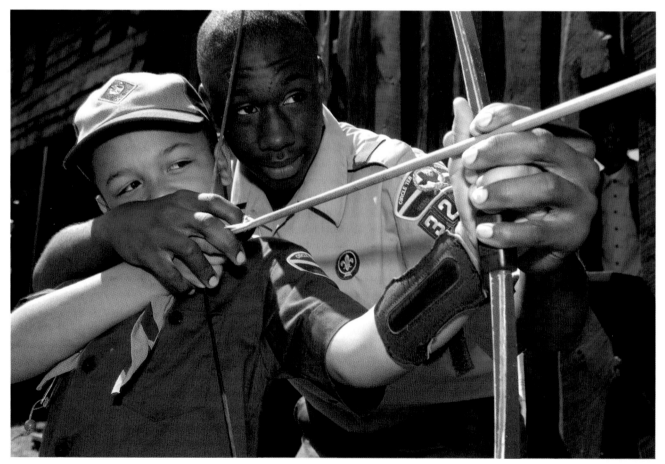

**▲ The Teaching EDGE**
Explain, Demonstrate, Guide, Enable—that's the Teaching EDGE Scouts use as an effective means for sharing skills with others.

**Getting it done ▶**
"How do you eat an elephant?" asks an old Scout joke. "One bite at a time!" Small steps lead to reaching other big goals, too.

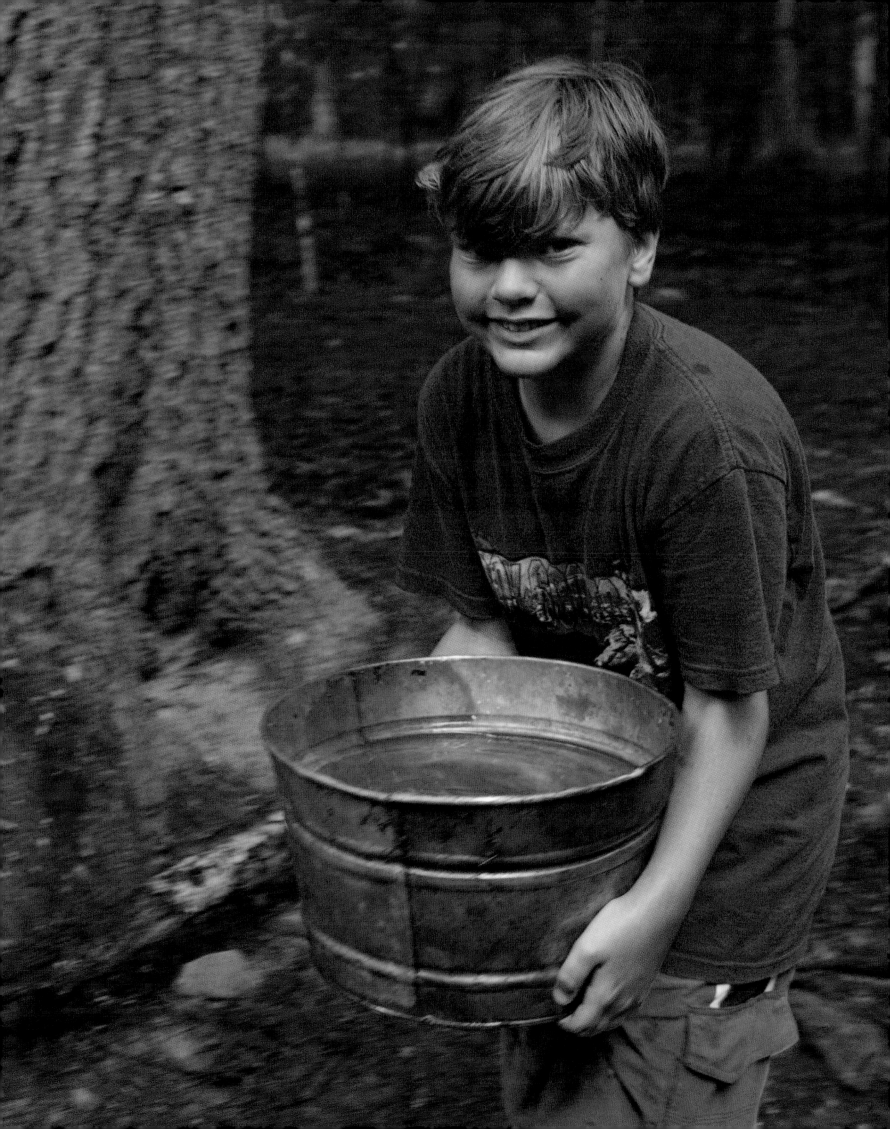

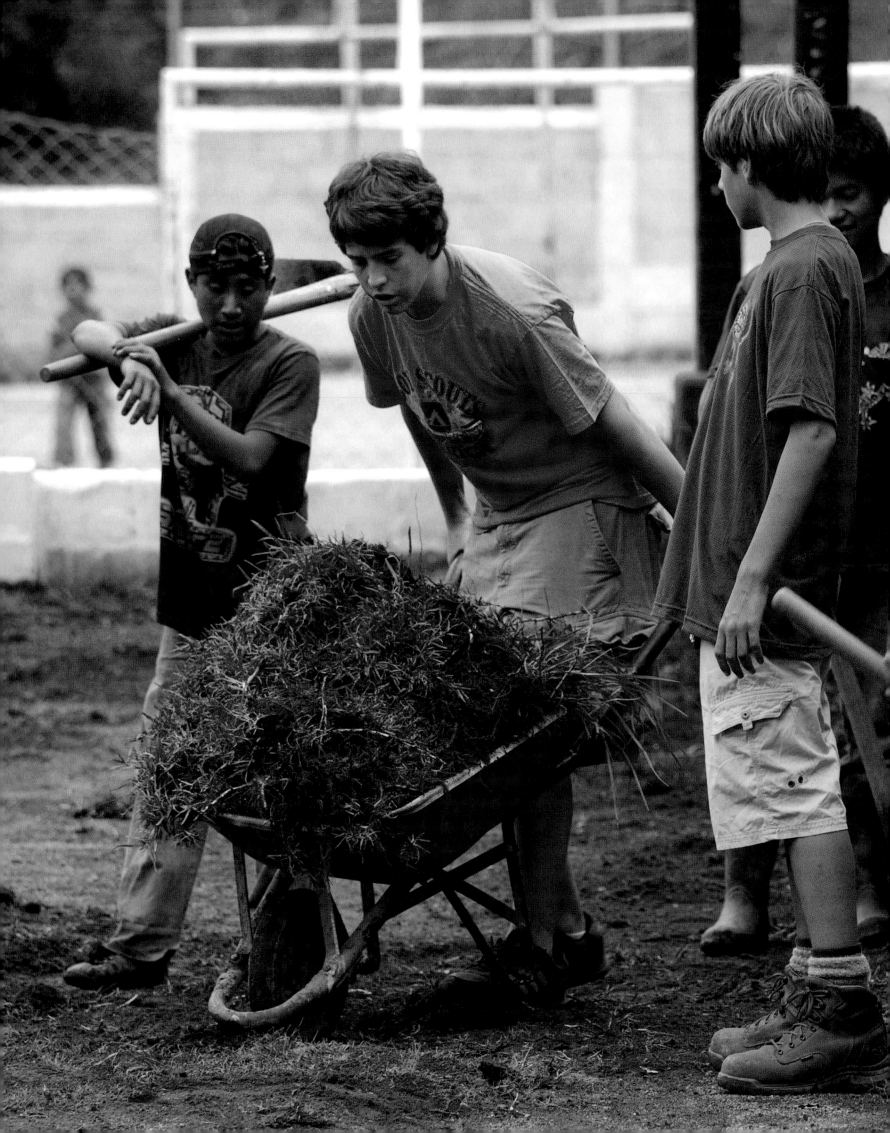

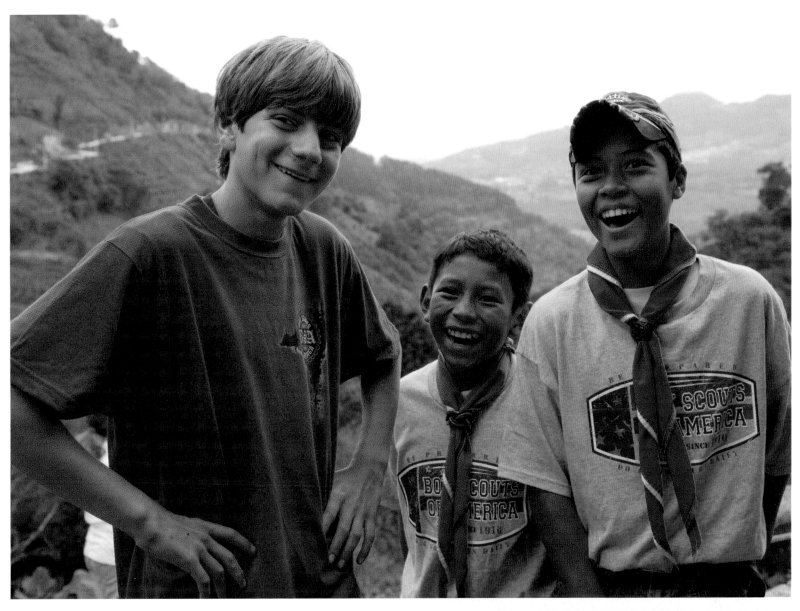

**▲ Eagle service project**

Will Troppe (left) planned and led an expedition of 28 people from Troop 167, Arlington, Virginia, to the Guatemalan village of Vuelta Grande.

**More than mortar and stone ▶**

Helping others can cement the building blocks of friendship and turn Scouting's Good Turns into much more.

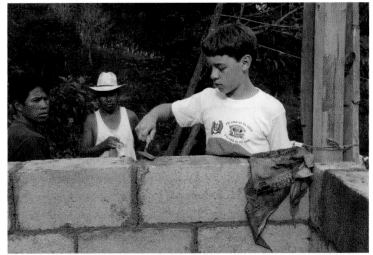

**◀ The real work**

Members of Troop 167 joined Guatemalan Scouts to fight erosion, install a water-filtration system, paint school classrooms, and set up a library.

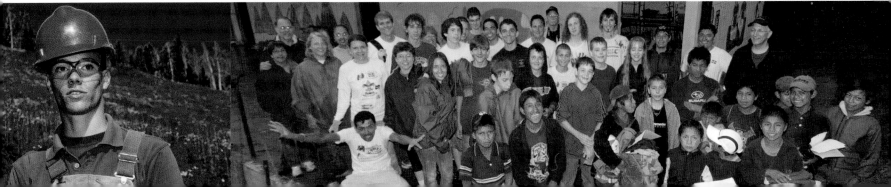

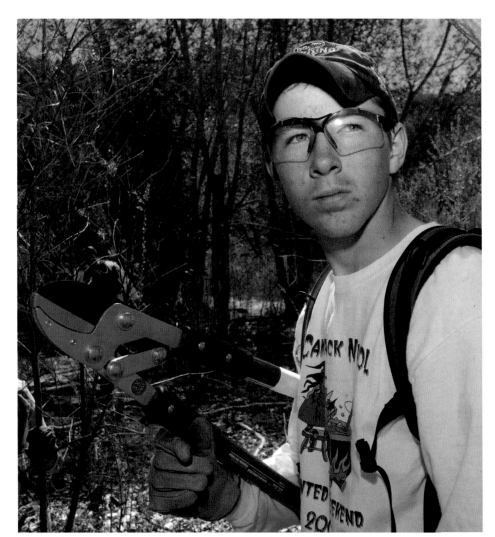

**◀ Doing it right**
Scouts organizing projects and matching tools to the task at hand learn the skills of planning and leadership.

**Extending the spirit of Scouting ▶**
Scouts in Guatemala share the load and the enthusiasm with Arlington, Virginia, Scouts who are helping out with environmental projects in Guatemala.

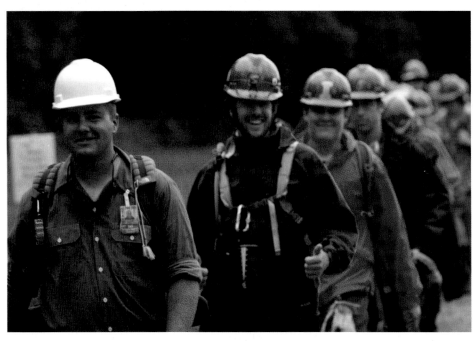

**◀ A legacy for the land**
An *ArrowCorps*[5] national service project crew joins thousands of Order of the Arrow brothers completing a week of conservation work in America's public parks and forests.

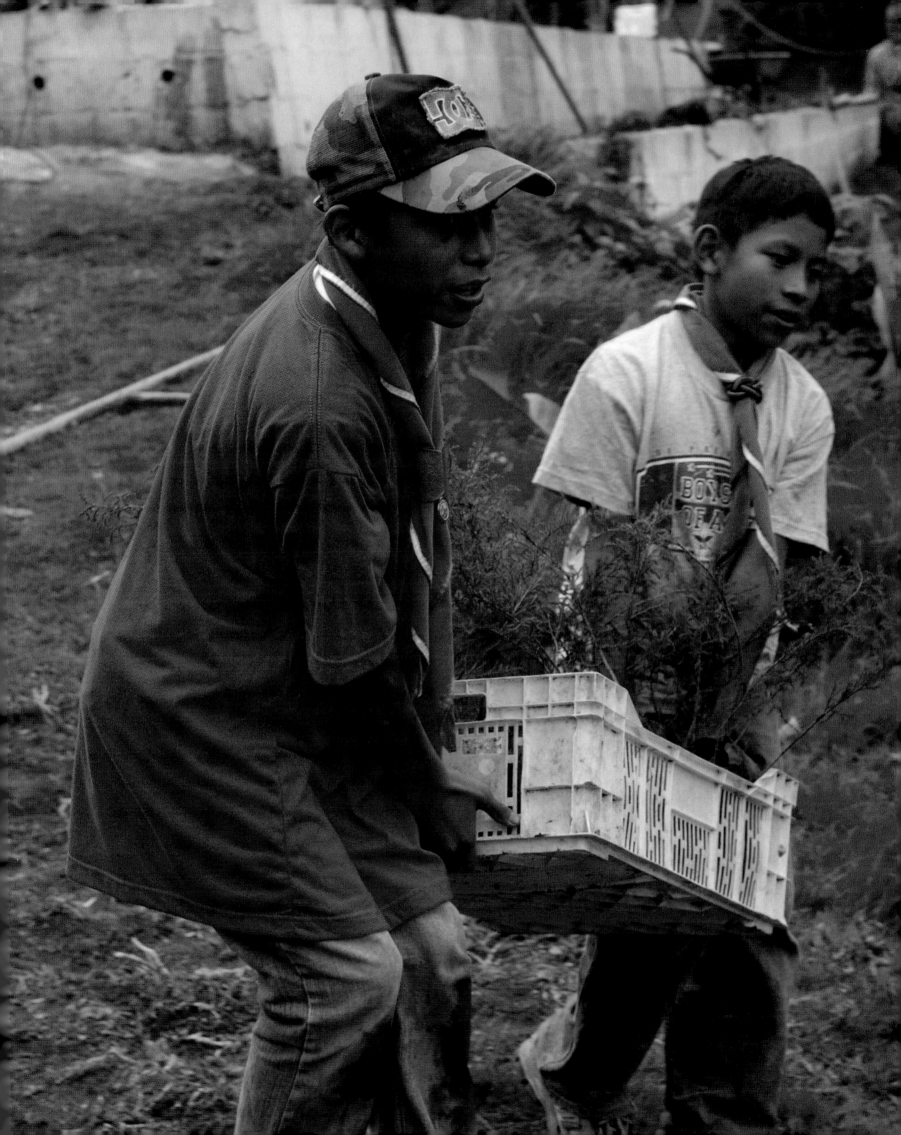

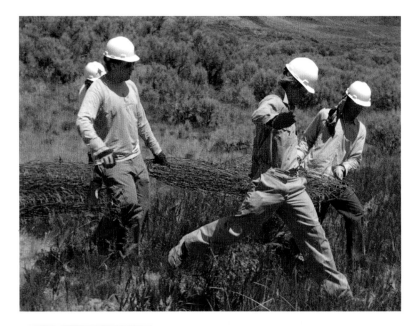

▲ **Making a difference**
Scouts giving back to the land through hands-on
environmental projects are building an ethic
of responsible stewardship that will last a lifetime.

**Promises for the future** ▶
Assisted by Scouts from Troop 566, Kyle Langton of
Carleton, Michigan, completes his Eagle Scout project by
landscaping a community youth activities center.

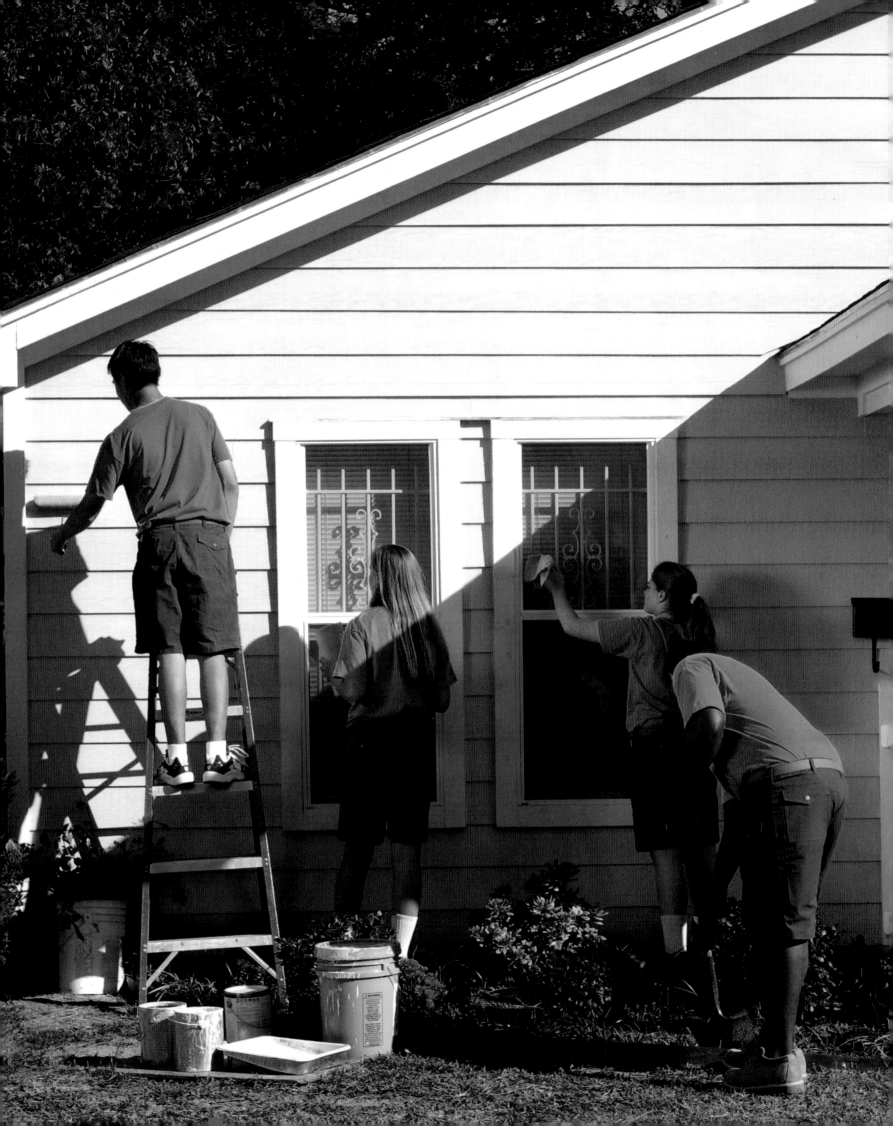

**▲ Tools of service**
Saws and loppers await the willing hands of Scouts eager to play their part.

**◄ One in 2.9 million**
Volunteering to make good things happen, members of the BSA are a force of remarkable numbers and potential.

**A fresh coat of optimism ▶**
Neighbors helping neighbors—that's the Scouting way, as Venturers pitch in with paint and brushes to brighten their community.

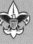
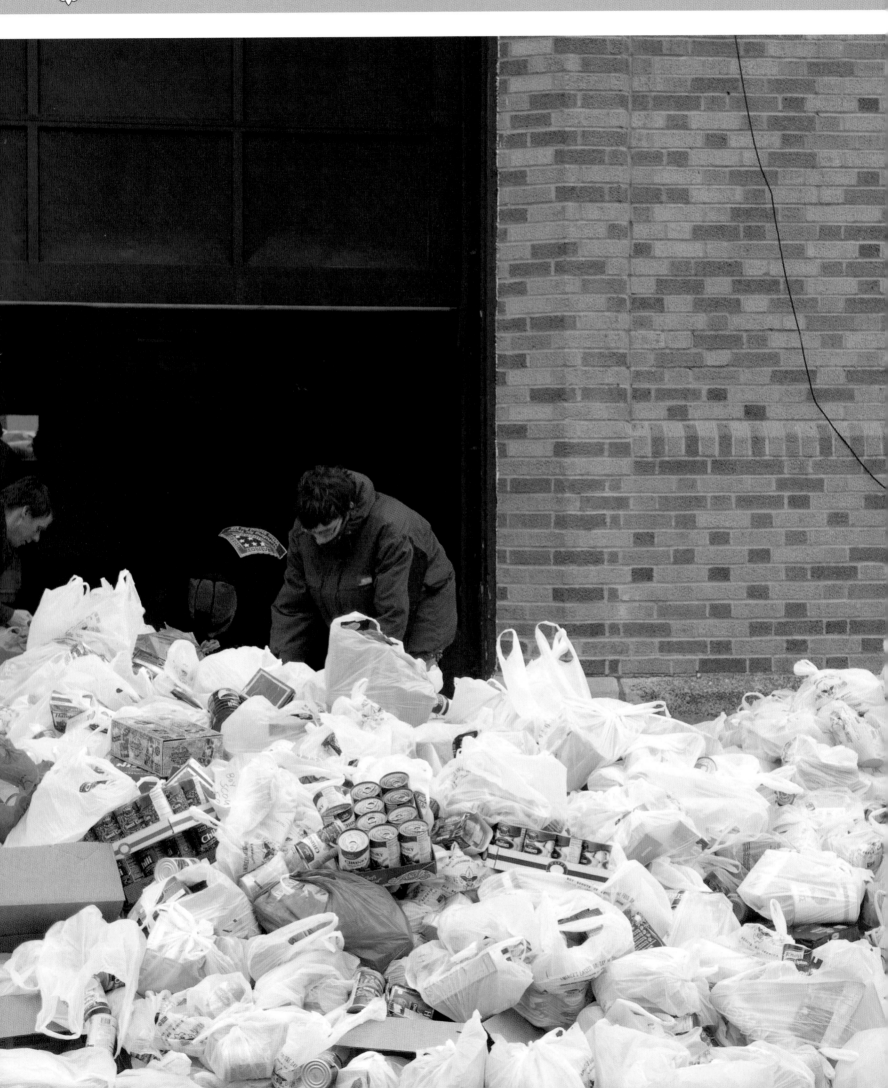

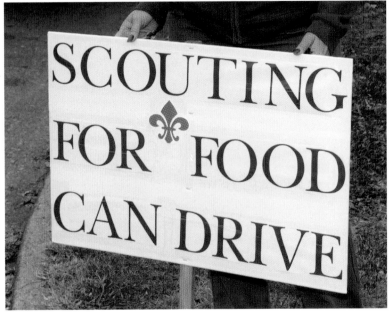

**▲ Signs of service**
Scouting today continues a hundred-year tradition of helping out in neighborhoods, communities, and the nation.

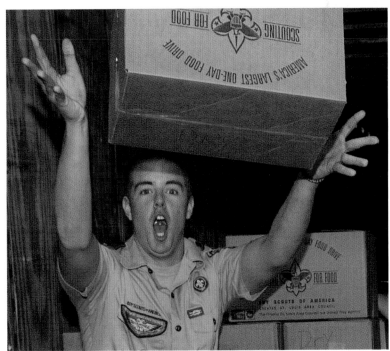

**▲ Pitching in**
Young people finding ways to make a difference for others discover that their own lives are enriched, too.

**◄ Good Turn for America**
The annual Scouting for Food campaign mobilizes Cub Scouts, Boy Scouts, and Venturers to collect millions of cans of food for those in need.

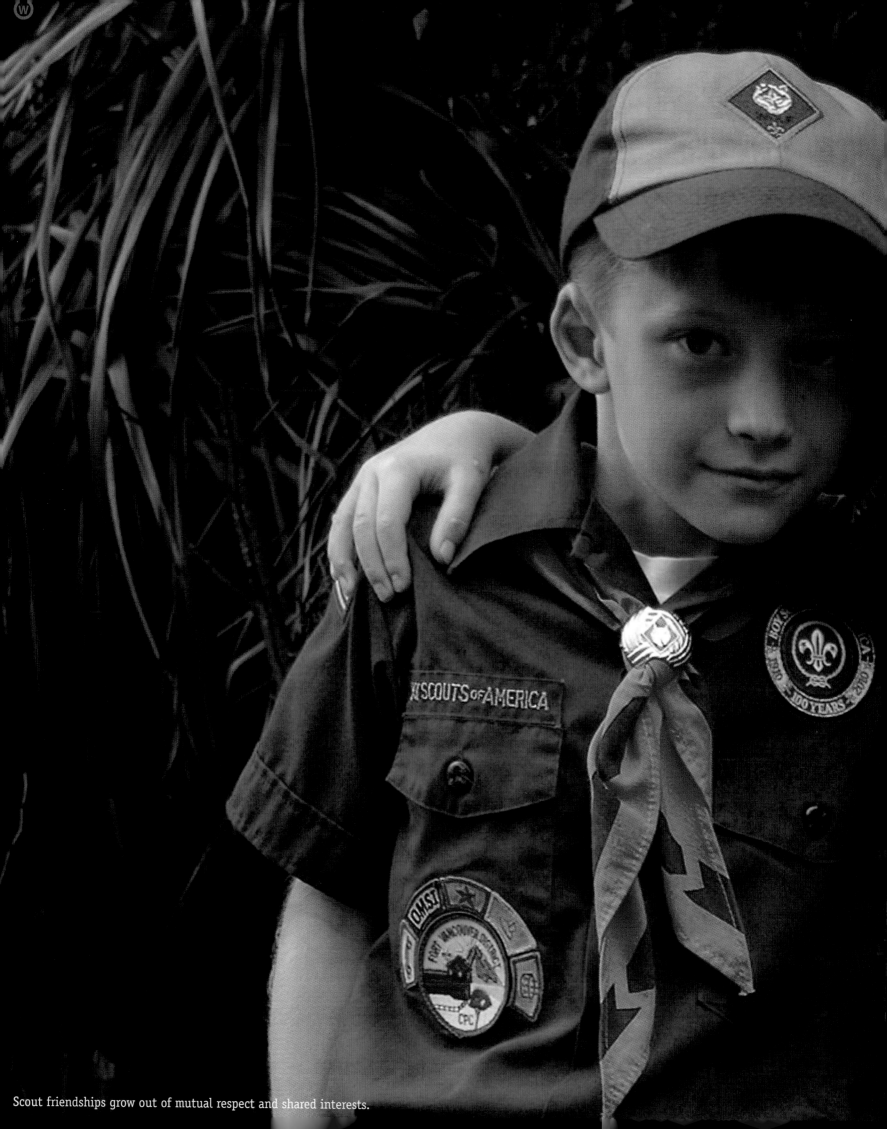

Scout friendships grow out of mutual respect and shared interests.

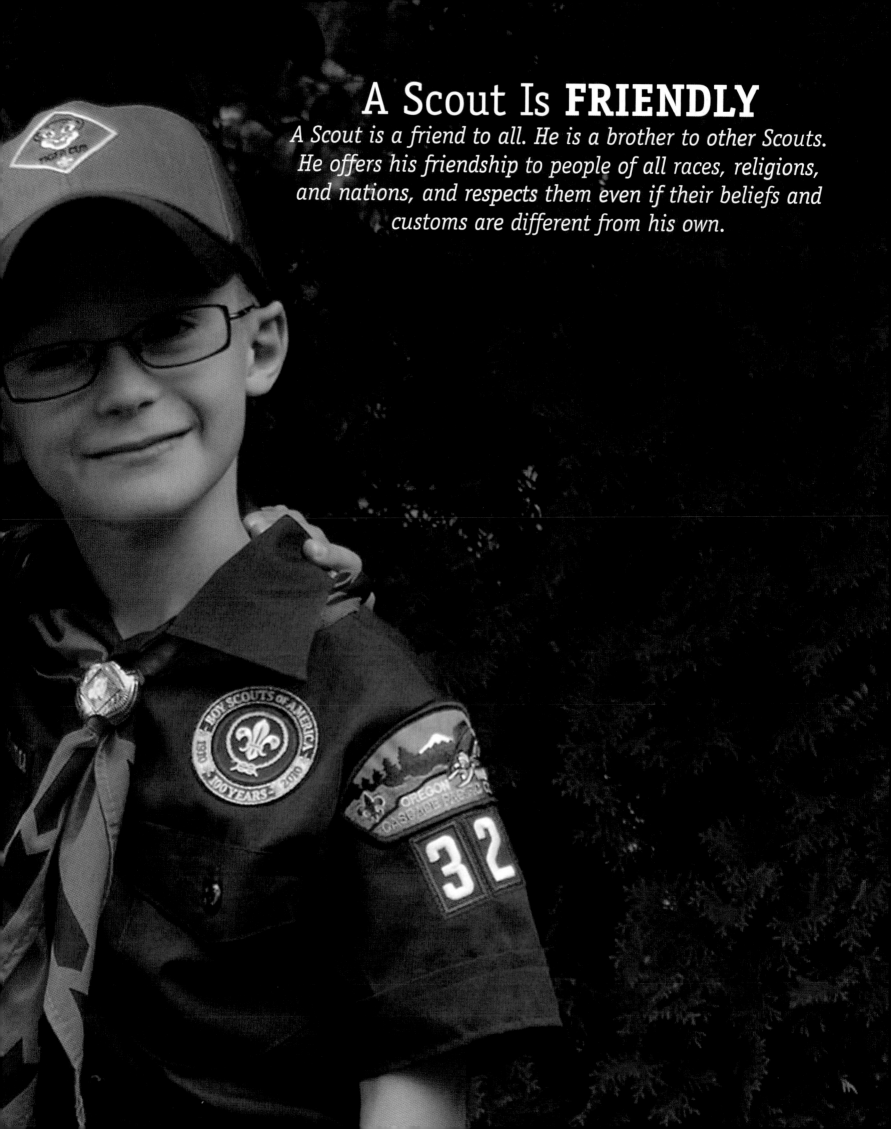

# A Scout Is **FRIENDLY**

*A Scout is a friend to all. He is a brother to other Scouts. He offers his friendship to people of all races, religions, and nations, and respects them even if their beliefs and customs are different from his own.*

▲ **Leading oneself**
Ty' Quon Watson of Panama City,
Florida, gains confidence and
self-worth through Scouting.

▲ **Many as one**
Boys of varied backgrounds join
one another for the shared experience
of being in the Boy Scouts of America.

**A circle of friends** ▶
Cub Scouts from Glendale Heights,
Illinois, quickly discover they
are linked together for the fun
and challenge of Scouting.

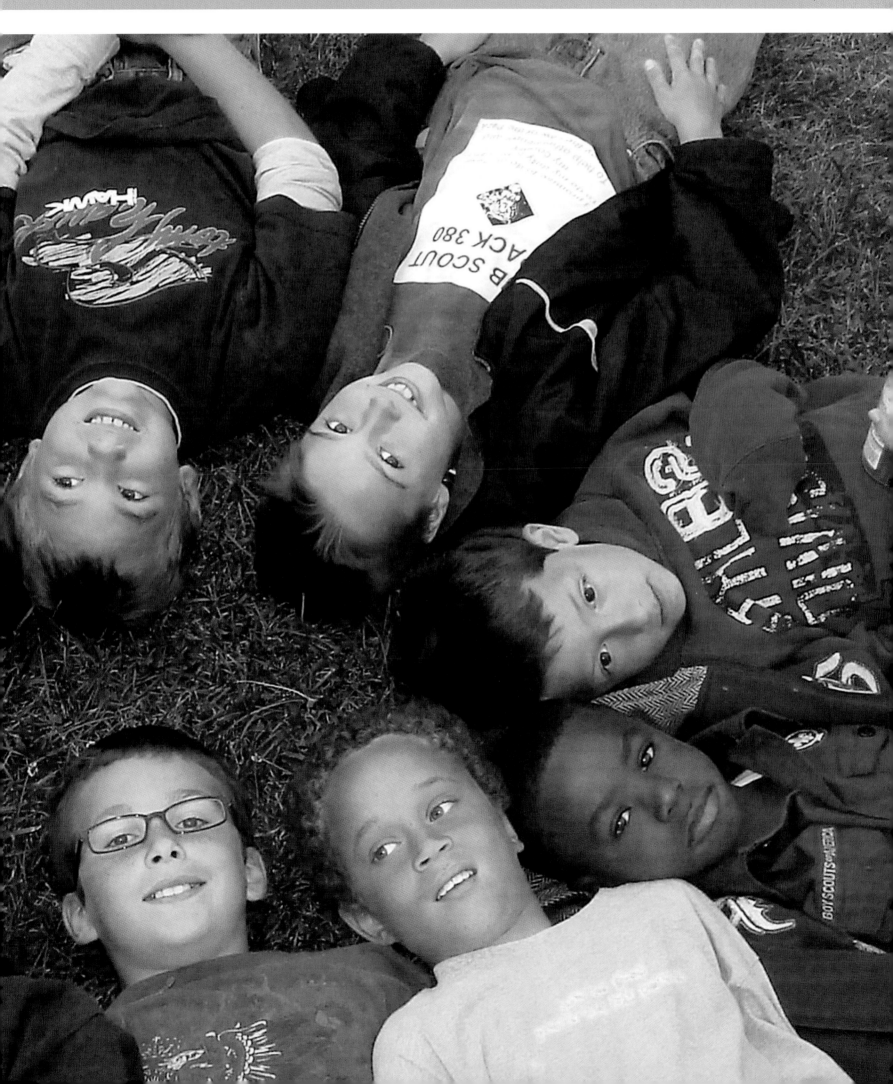

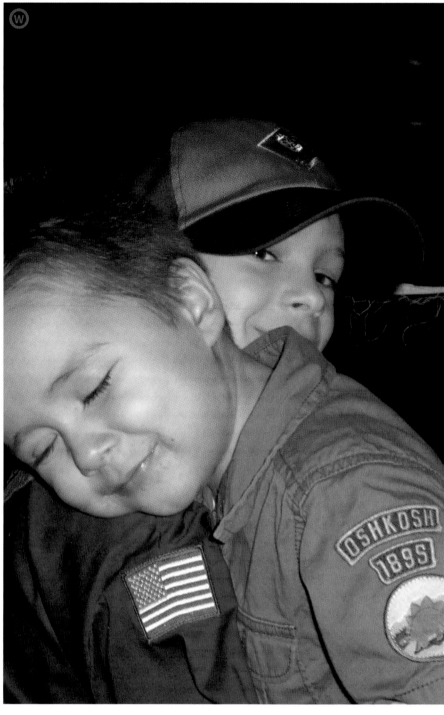

▲ **Lean on me**
Brothers and fellow Scouts in
Greensburg, Indiana, support each
other through thick and thin.

**Unity in action** ▶
Three Somerville, New Jersey, Scouts
set out to discover the joys of a
warm summer day at camp.

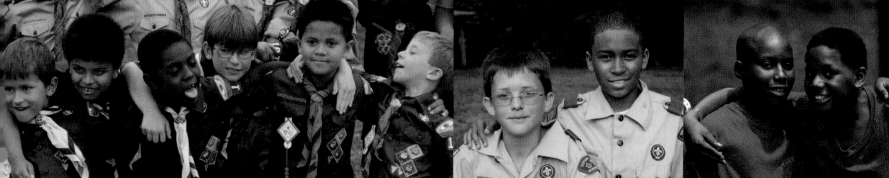

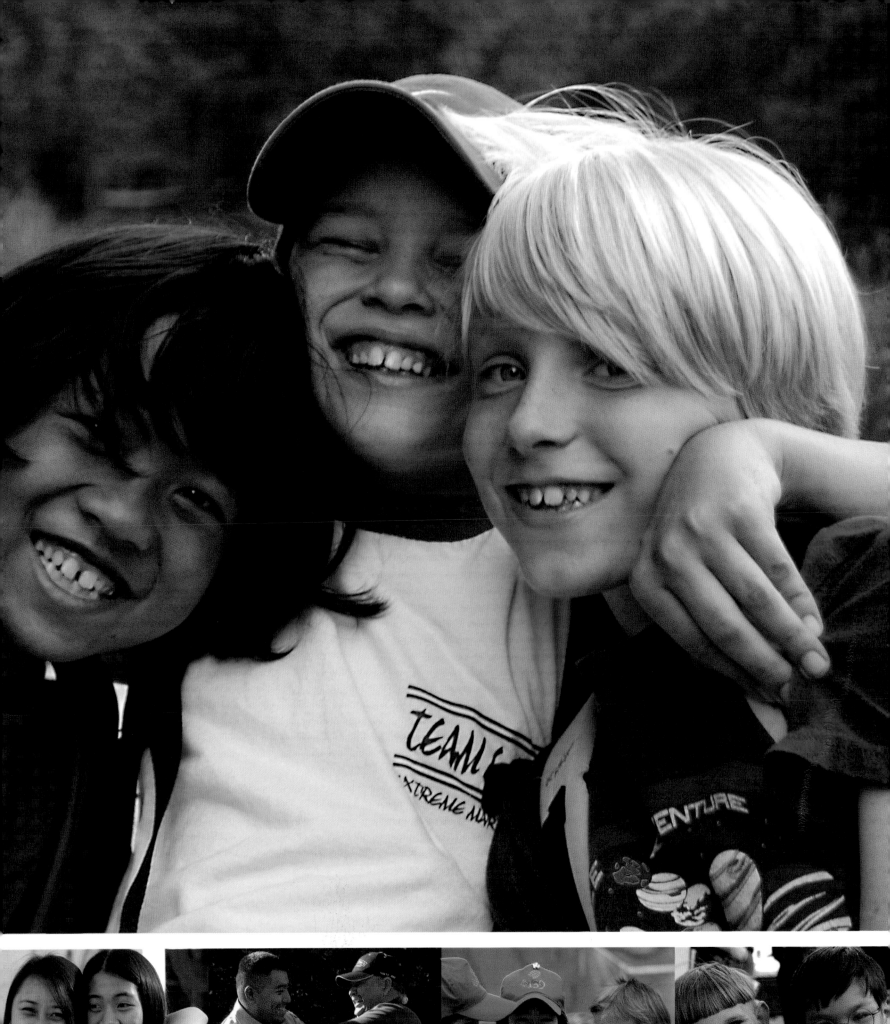

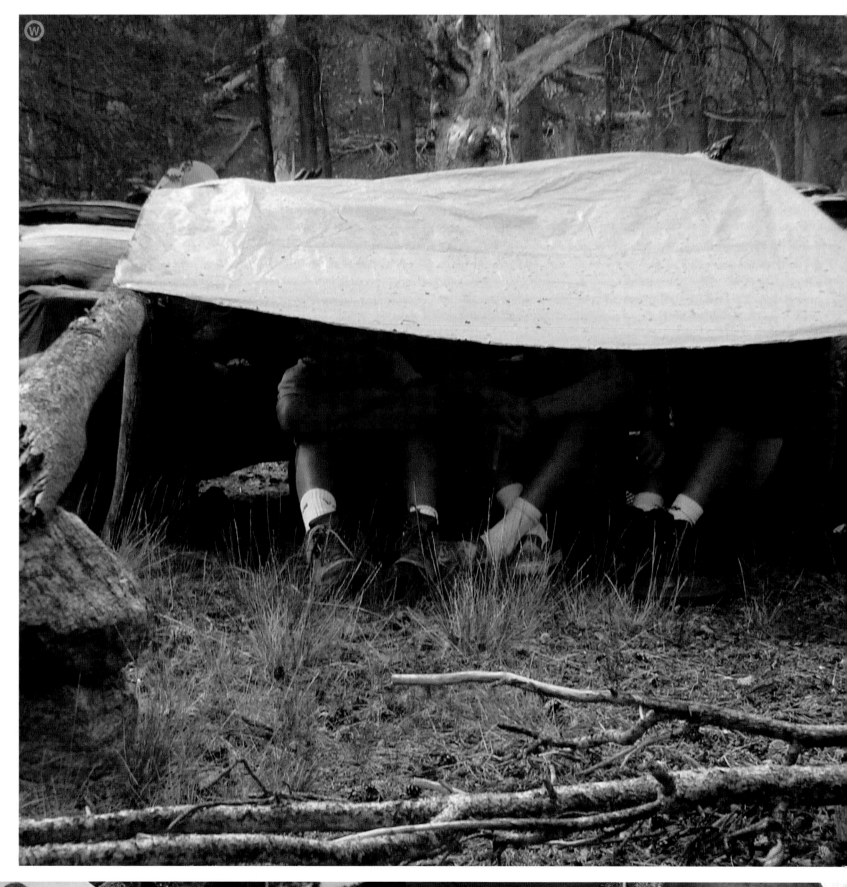

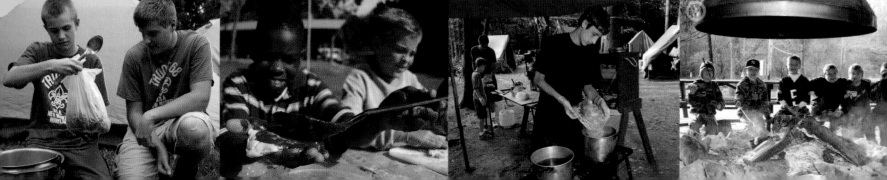

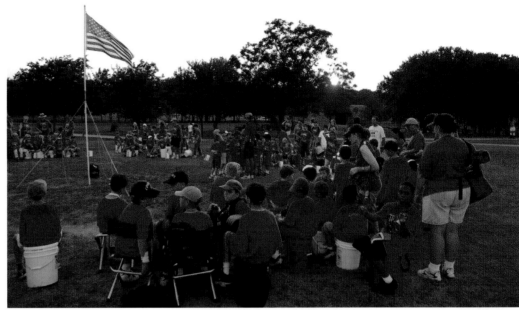

**▲ Reflecting on good times**
Scouts gathering around a camp flagpole relax and think back on an action-packed day.

**◄ Quick thinking and fast action**
Scouts of Troop 652, Rancho Cucamonga, take shelter from a sudden thunderstorm on southern California's San Gorgonio Mountain.

**Signs of success ▶**
A Scout troop flies its colors to let everyone know that members take pride in camping out often and well.

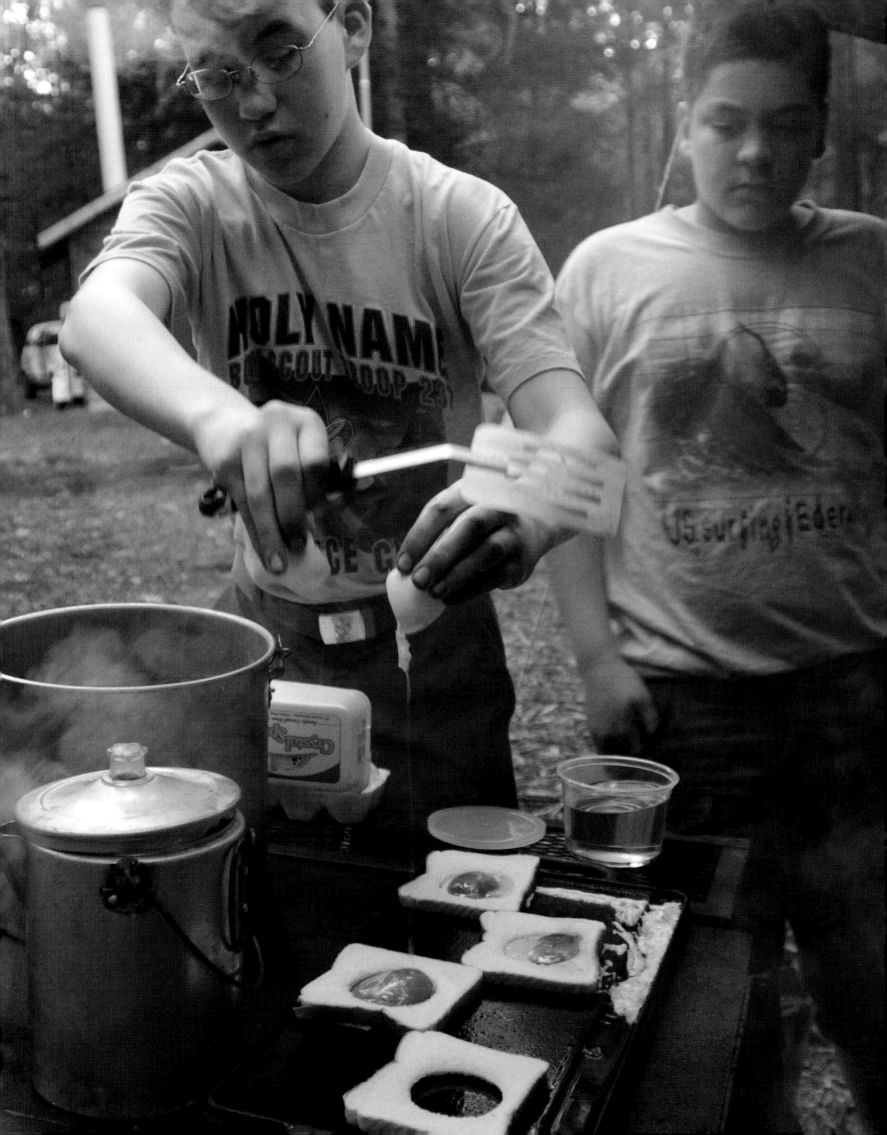

**▲ Adventure that lasts a lifetime**
Scouts paddling in the wilderness
of a Northern Tier National High
Adventure Base fashion a kitchen on
the keels of their overturned canoes.

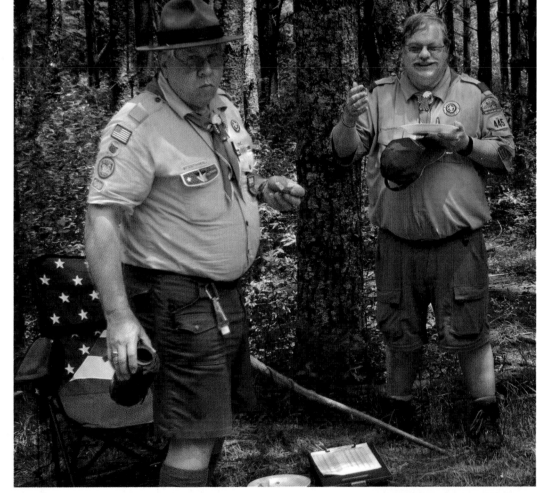

**◄ Flipping over outdoor cooking**
Call it cowboy eggs, moon toast, or
toad-in-a-hole, Scouts at Ten Mile
River Scout Reservation get cracking
with a favorite outdoor breakfast treat.

**Looking ahead ►**
Adults review ways to support their troop's
youth leaders during a National Capital
Area Council Centennial Camporee at
Goshen Scout Reservation.

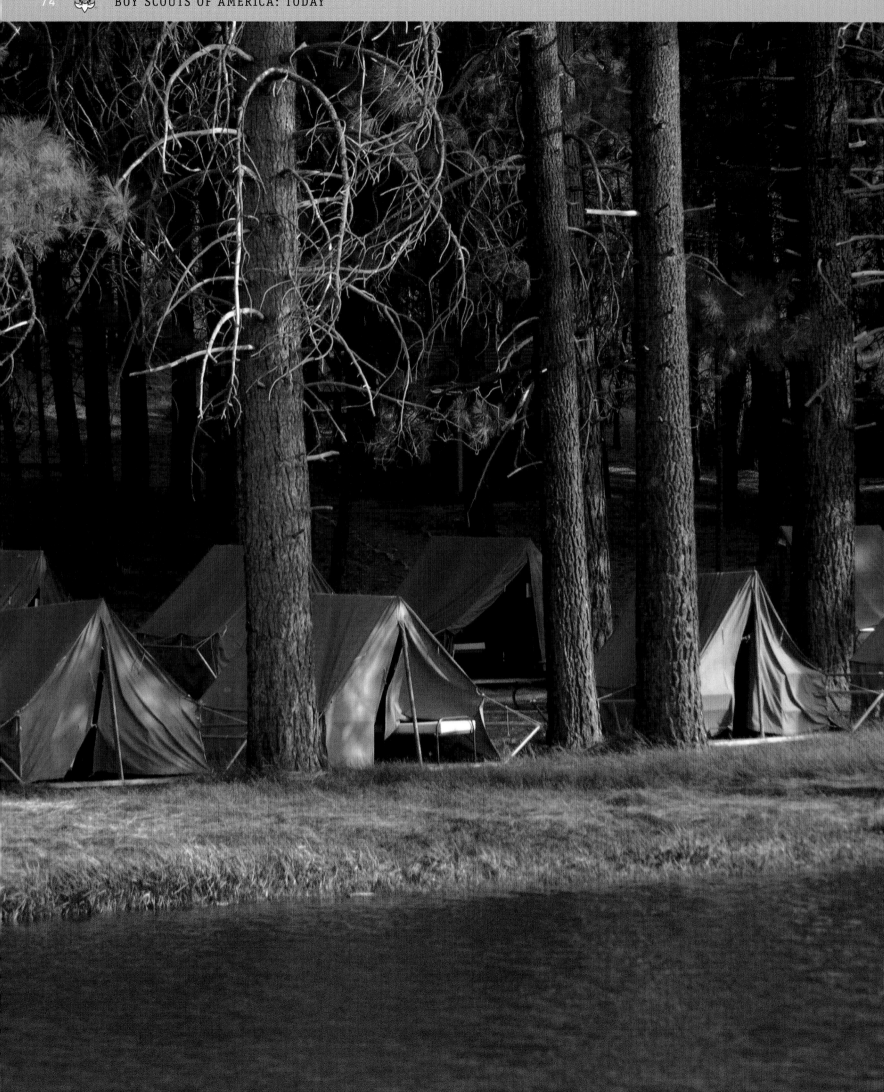

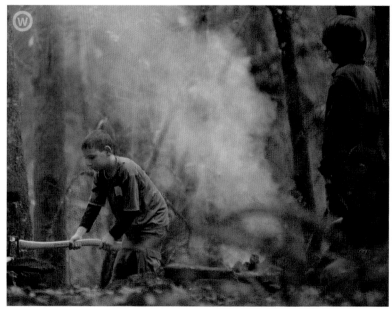

**▲ Splitting the difference**

An experienced Scout offers tips on technique to a Vancouver, Washington, troop member learning to split firewood.

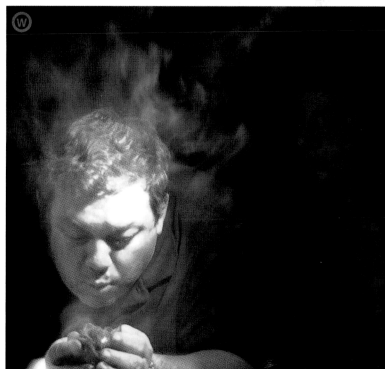

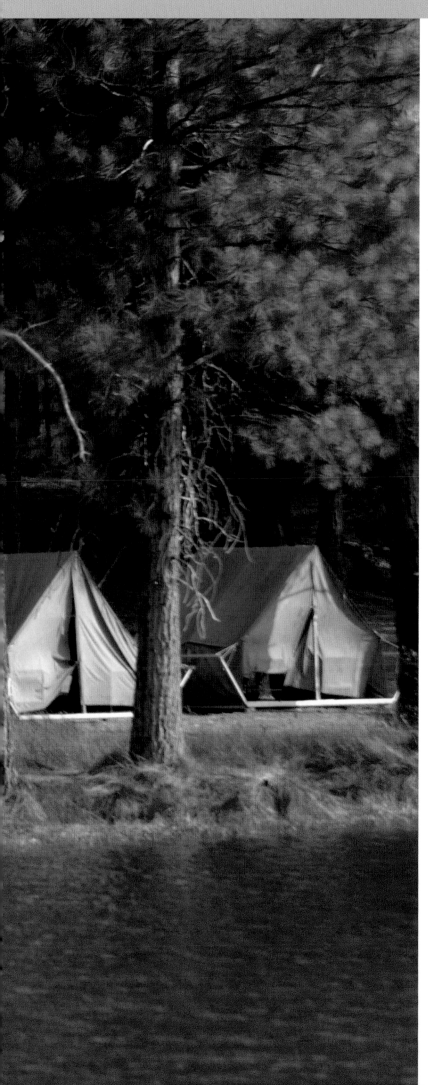

**◄ Tucked in the trees**

The wall tents of Camp Whitsett serve as the base for Western Los Angeles County Council Scouts eager to explore Sequoia National Forest.

**▲ Spark of a fresh idea**

Kindling an interest in starting fires with flint and steel, Assistant Scoutmaster Bruce Raleigh of Troop 533, South Weber, Utah, nurtures an ember into flame.

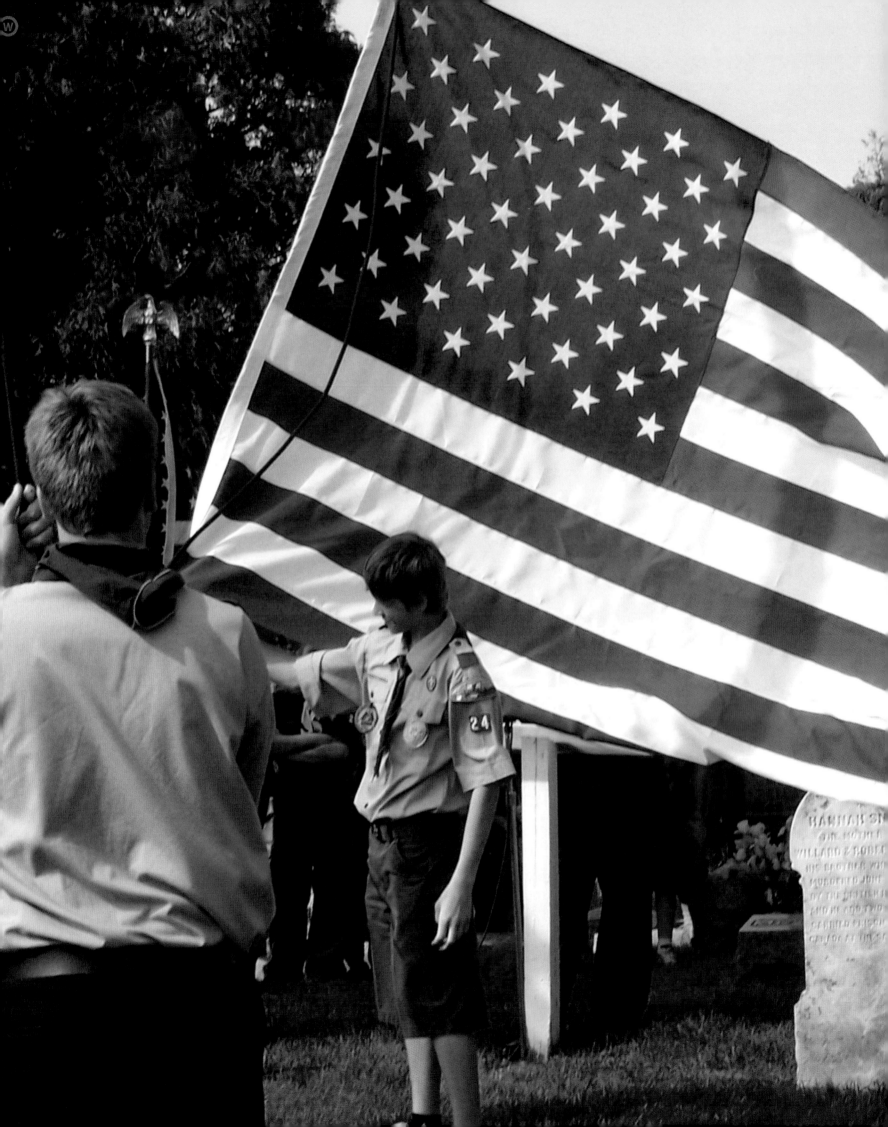

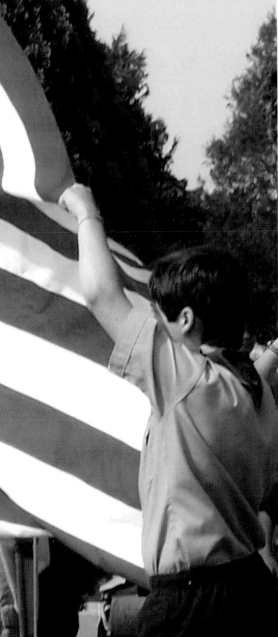

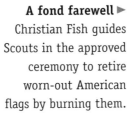

**Duty to country** ▶
Love of America reflects in the faces of Scouts taking an active role in the processes of democracy.

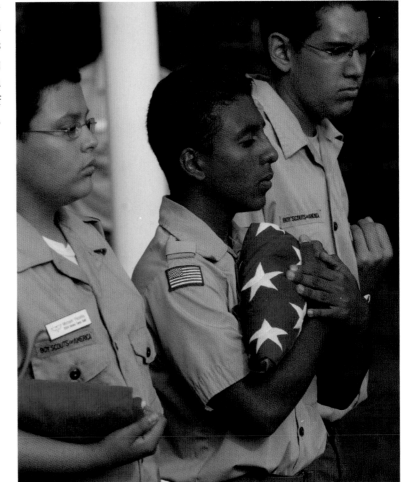

◀ **Remembrance of past sacrifice**
Troop 24 Scouts raise the Stars and Stripes during a Memorial Day ceremony in Castalia, Ohio.

**A fond farewell** ▶
Christian Fish guides Scouts in the approved ceremony to retire worn-out American flags by burning them.

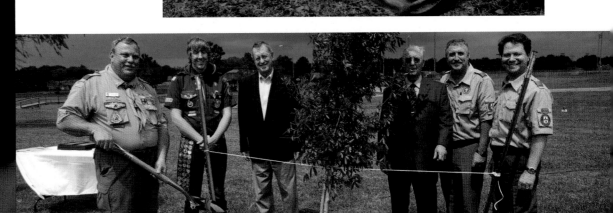

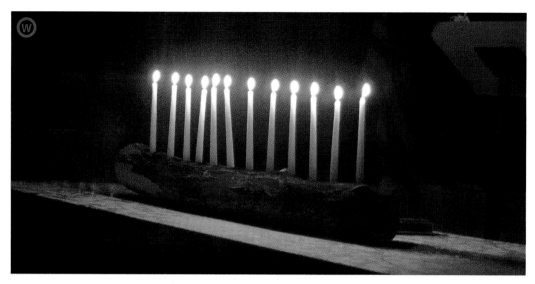

**▲ Luminous landmarks of the Scouting life**
Twelve candles burn as bright reminders of the 12 points of the Scout Law during a court of honor for a Moraga, California, troop.

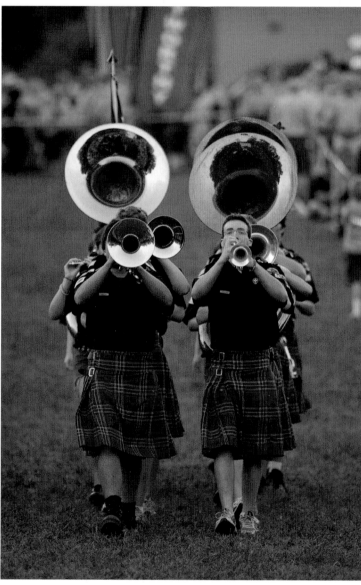

**Facing the consequences ▶**
Cubmaster John Huft kept his promise to be a good-natured recipient of a cream pie when his Panama City, Florida, Cub Scouts earned a den award.

**◀ Blowing their horns for Scouting**
A drum and bugle corps leads the parade at a Boy Scout camporee—a large gathering of Scouts sharing the fun and fellowship of the BSA.

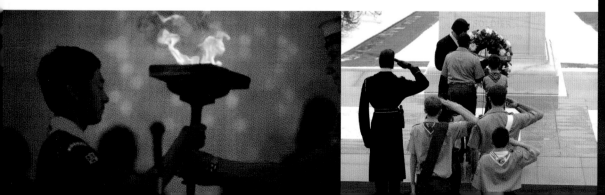

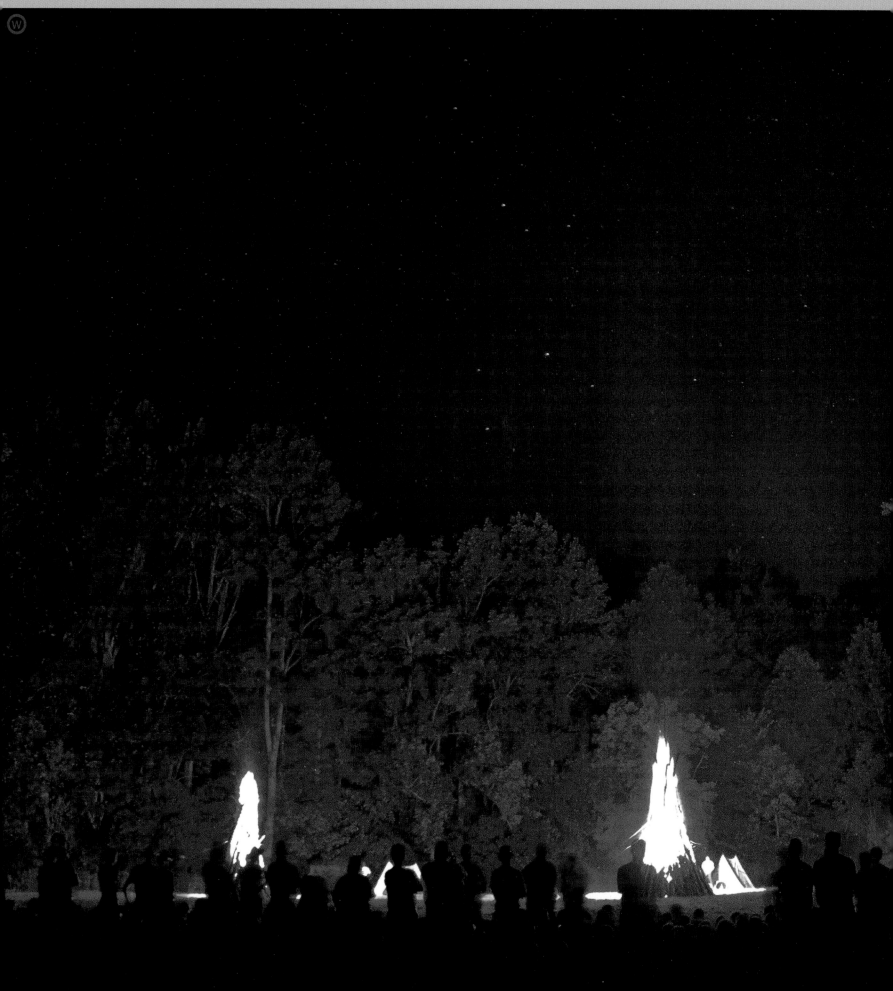

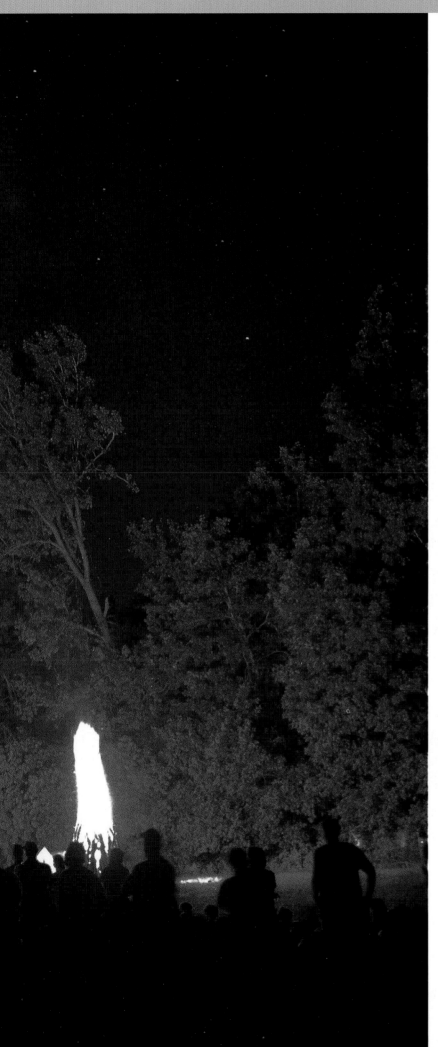

**▲ It was a dark and stormy night...**
Glowing embers draw California Scouts together for stories, songs, and spooky tales worthy of their Death Valley campsite.

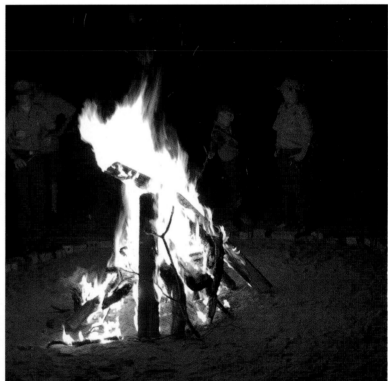

**◄ Where memories are made**
Campfires light up the night during the close of another great week at camp in the Heart of America Council, Kansas City, Missouri.

**▲ Lighting the way the right way**
The principles of Leave No Trace help Scouts understand when fires are appropriate and when they are not.

Scouts link hands at the close of the National Order of the Arrow Conference.

# A Scout Is **COURTEOUS**

*A Scout is polite to people of all ages and positions.*
*He understands that using good manners makes*
*it easier for people to get along.*

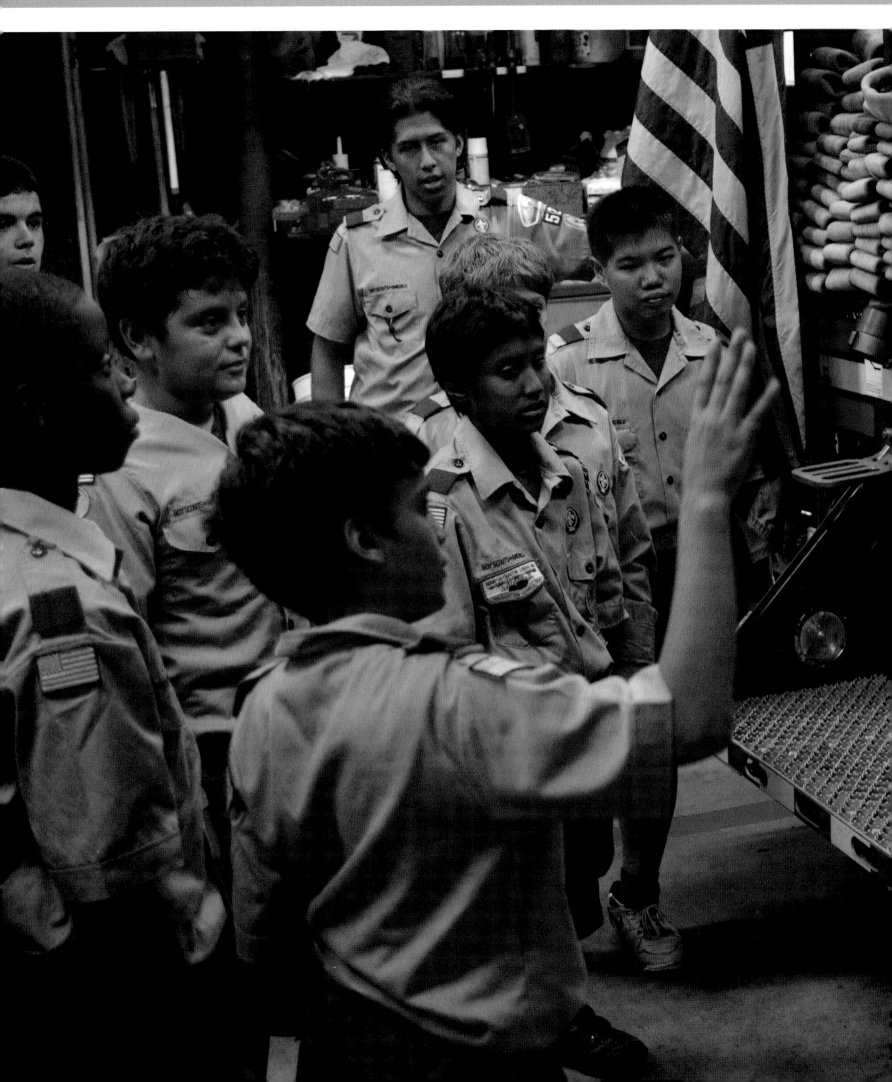

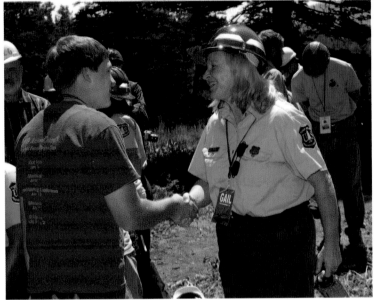

**◄ Raising a hand of respect**
Respect finds connection
during meaningful encounters
between Scouts and worthy
teachers and role models.

**▲ Work well done**
A Scout volunteering on an
*ArrowCorps⁵* environmental
work crew chats with former
USDA Forest Service Chief
Gail Kimbell.

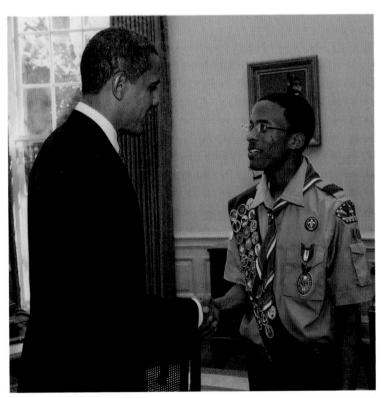

**▲ Oval Office welcome**
President Barack Obama, honorary
president of the Boy Scouts of America,
warmly greets youth delivering the BSA's
annual Report to the Nation.

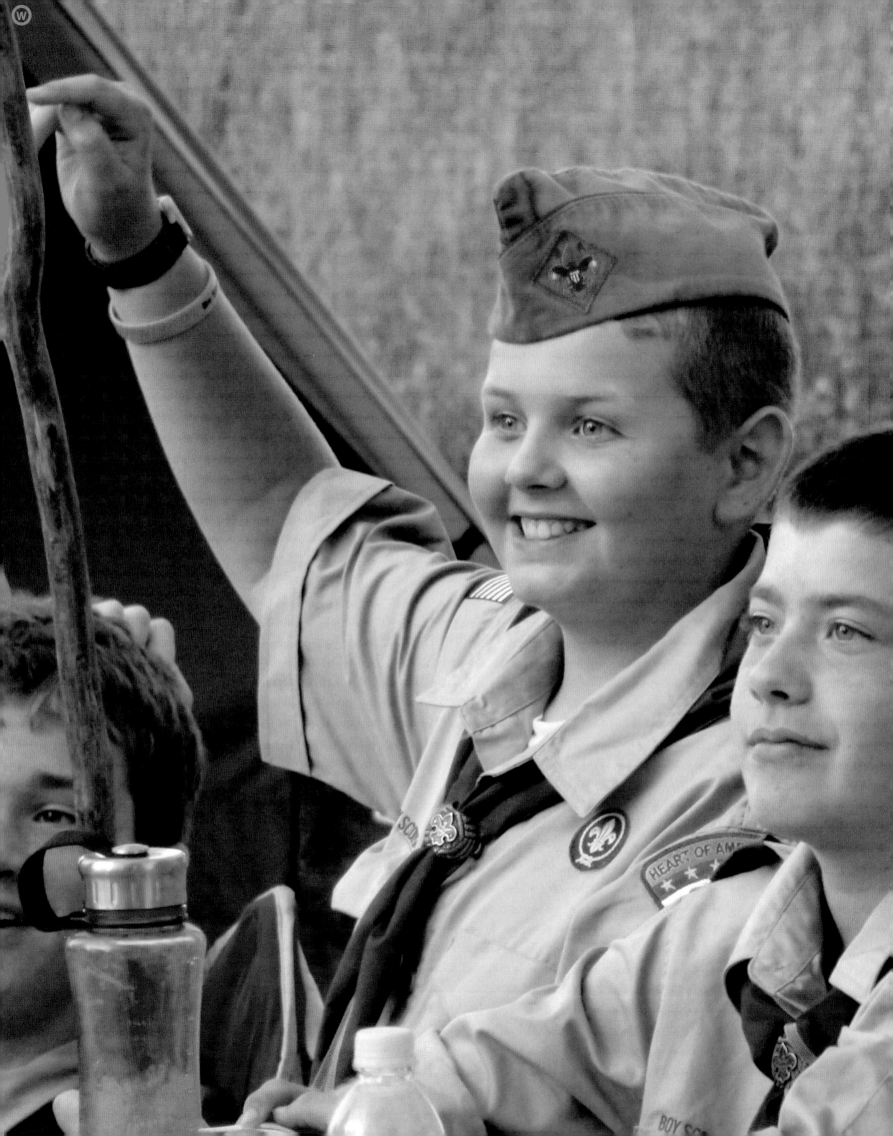

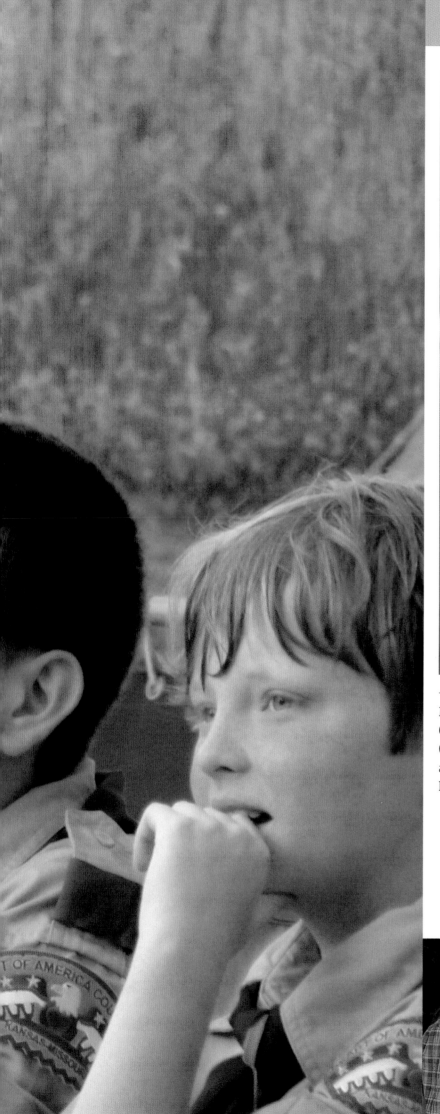

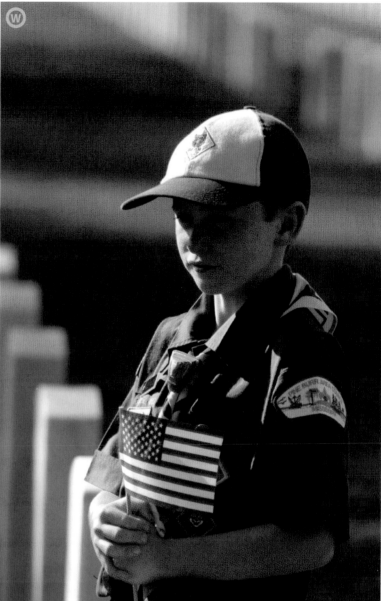

◄ **Achievement recognized**
Michael Gates, Alex Tharp,
Connor Nichols, and Carter
Claxton give their full
attention during a court of
honor awards ceremony.

▲ **The courtesy of respect**
Mississippi's Biloxi National
Cemetery is a setting for Scouts
placing American flags at the
graves of military veterans.

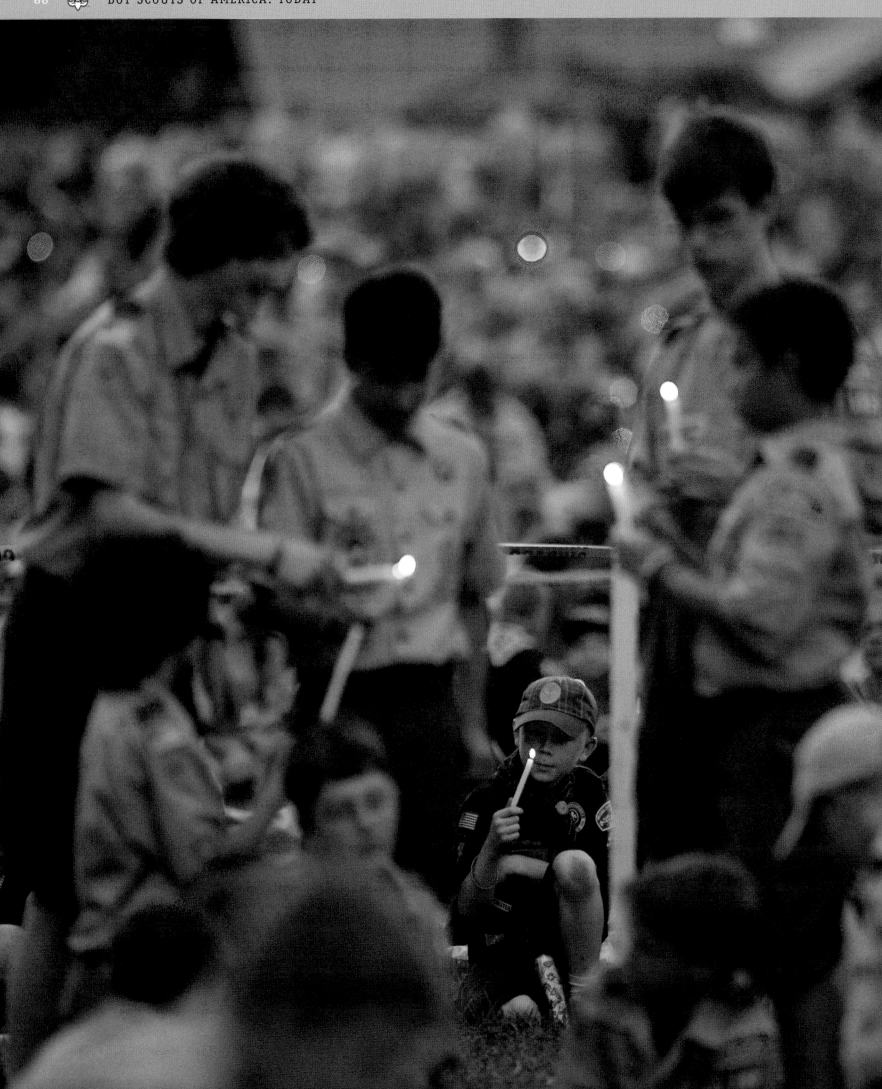

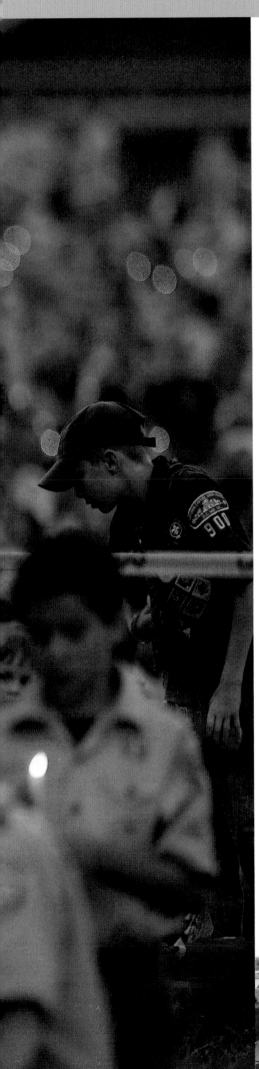

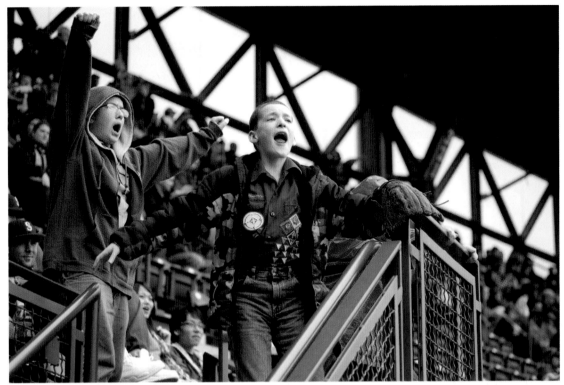

**▲ Take me out to the ballgame**
America's pastime gains special
meaning when Scouts who play
baseball themselves get to cheer
the hometown team.

**◄ Burning through the night**
A Cub Scout at the National Capital
Area Council Centennial Jamboree
lends the light of his candle to
Scouting's brilliant flame.

**Cornering excitement ▶**
Boys share solutions as they
scramble across the low-angle
wall of a challenge course.

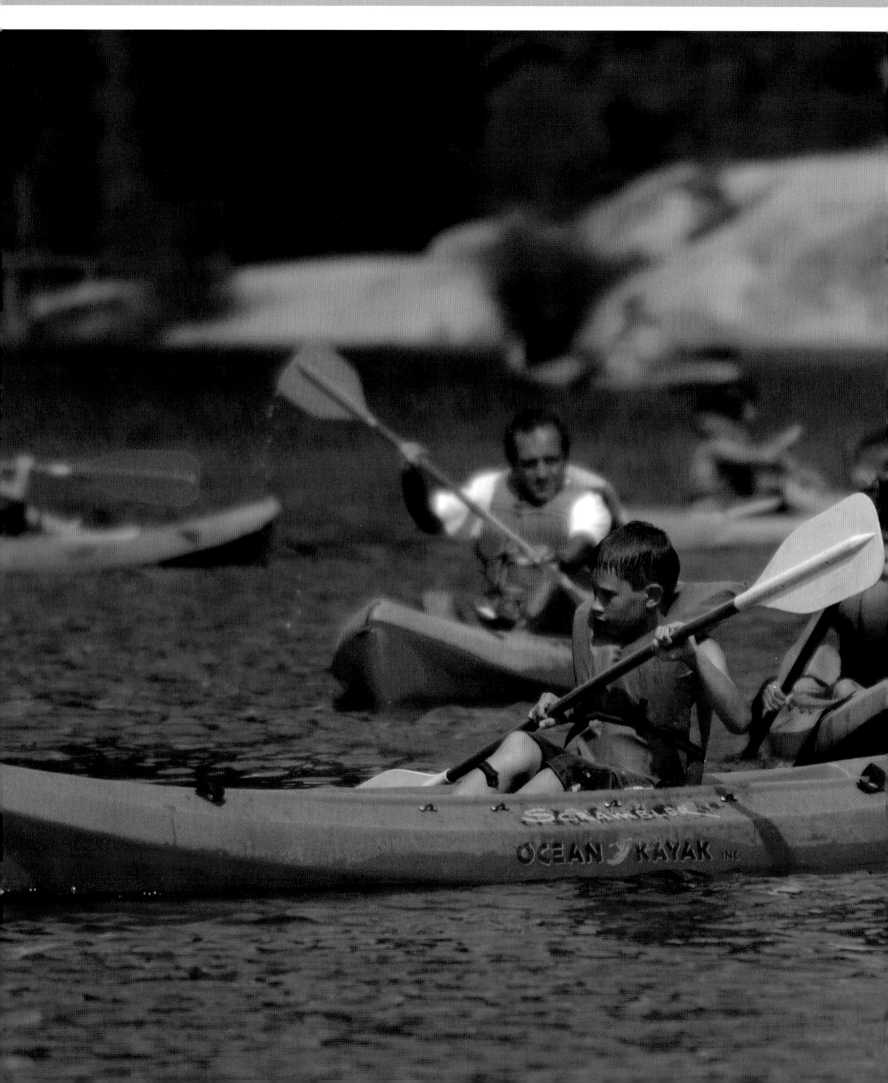

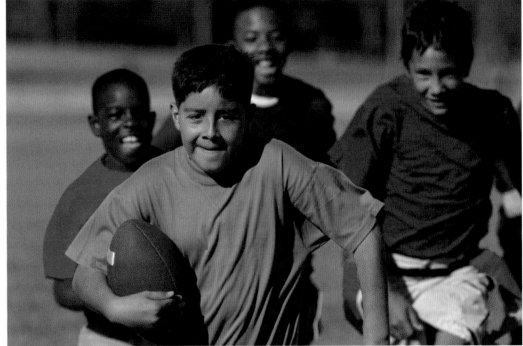

**▲ First and goal for Scouting**
The BSA's mission of preparing young people to make ethical and moral choices plays out even in the exciting disorder of a troop's spontaneous game.

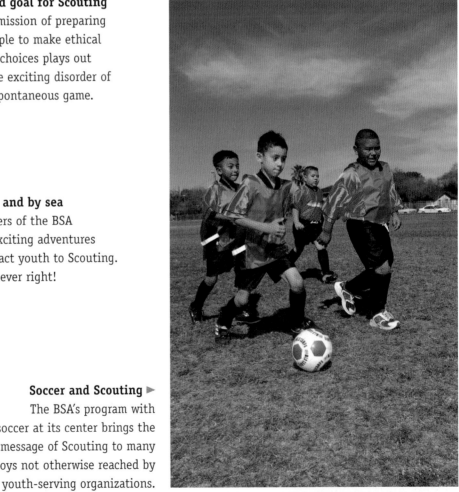

**◄ By land and by sea**
The founders of the BSA believed exciting adventures would attract youth to Scouting. Were they ever right!

**Soccer and Scouting ►**
The BSA's program with soccer at its center brings the message of Scouting to many boys not otherwise reached by youth-serving organizations.

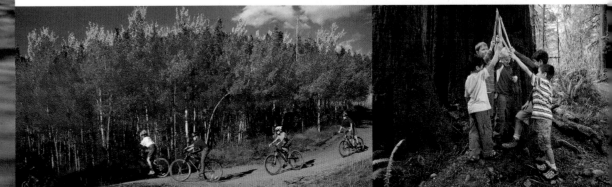

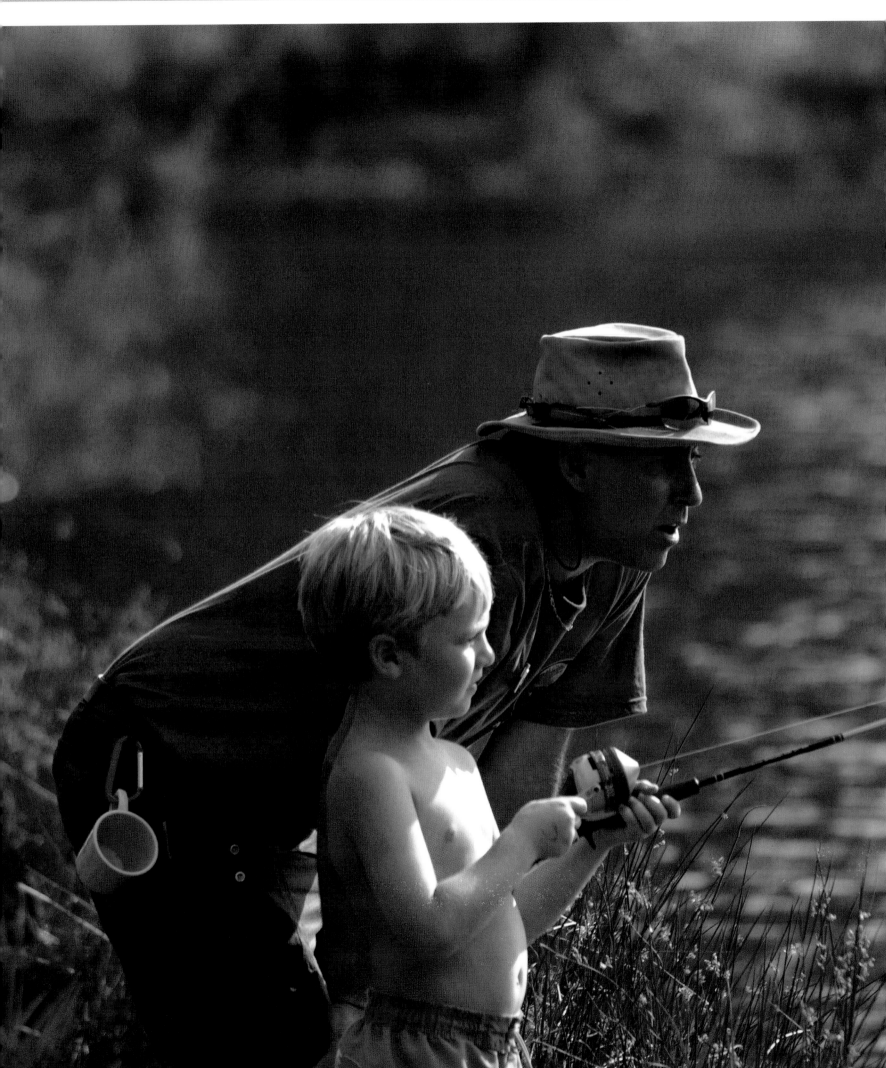

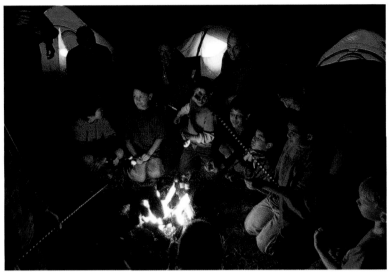

**▲ A golden crust and gooey center**
There might be no greater emblem of evening campfires than Scouts toasting marshmallows over glowing coals.

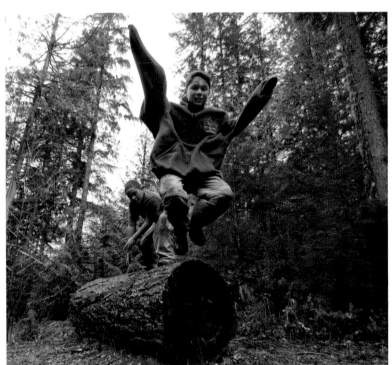

**◄ Casting summer's spell**
Joys of a quiet afternoon passed from father to son—and from leaders to Scouts—enrich the lives of everyone involved.

**▲ Scout-sized imaginations**
A big log and giant jump are all it takes for an exuberant flight of fancy in the woods.

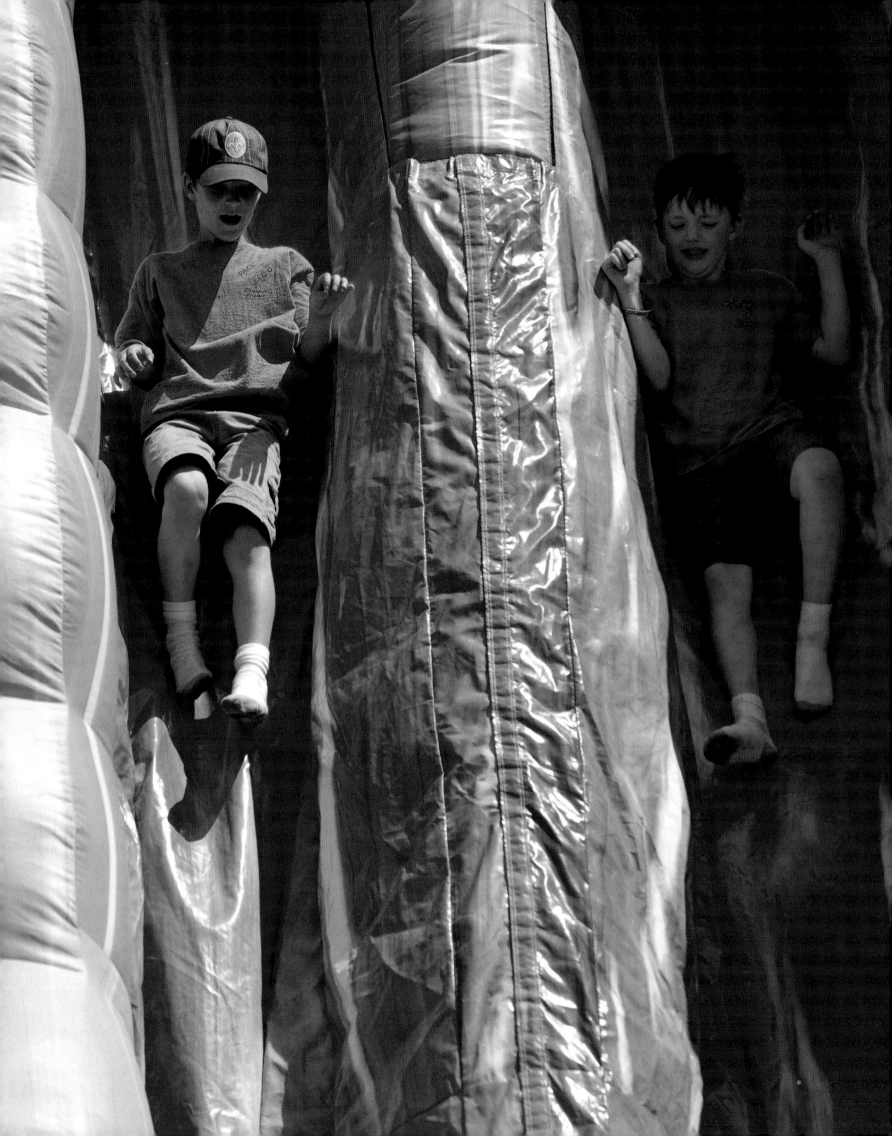

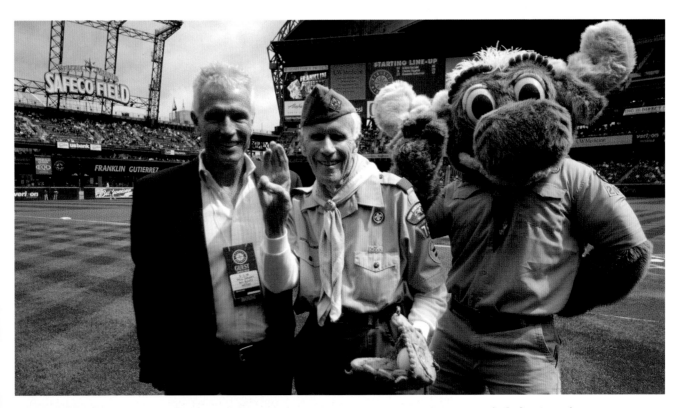

**▲ Pitch for Scouting**
The BSA enjoys strong
support and valuable visibility
at community events and
among civic organizations
and athletic teams.

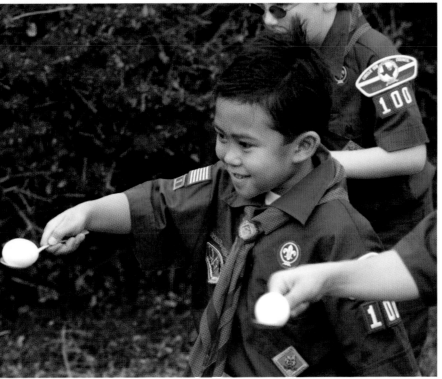

**◄ Maintaining the balance**
From an egg-and-spoon race
to living by the Scout Oath
and Scout Law, the BSA offers
tried-and-true ways to play,
learn, and grow.

**◄ Together all the way**
Scouting uses a buddy system that asks
two Scouts sharing adventures to watch
out for each other.

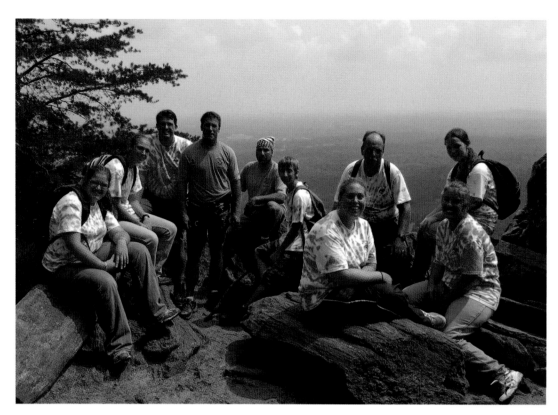

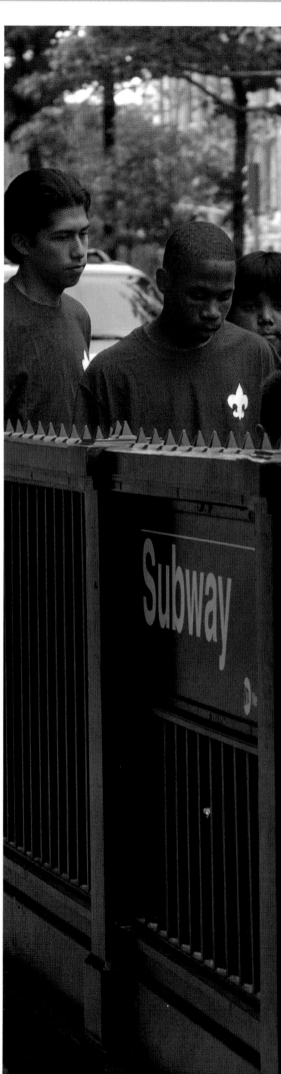

▲ **Off belay**
Members of Venturing
Crew 250, Fort Mill/Tega Cay,
South Carolina, relax after
a satisfying day of climbing
and rappelling.

**The express to success** ▶
Scouting thrives wherever
young people are hungry
for adventures and leaders
are passionate about the
possibilities of the BSA.

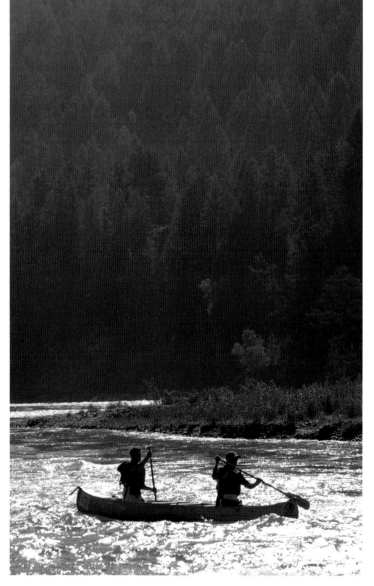

◀ **Paddling into the past**
Scouts canoe the Snake River
near Jackson Hole, Wyoming,
long ago the site of American
Indian camps and mountain
man rendezvous.

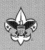

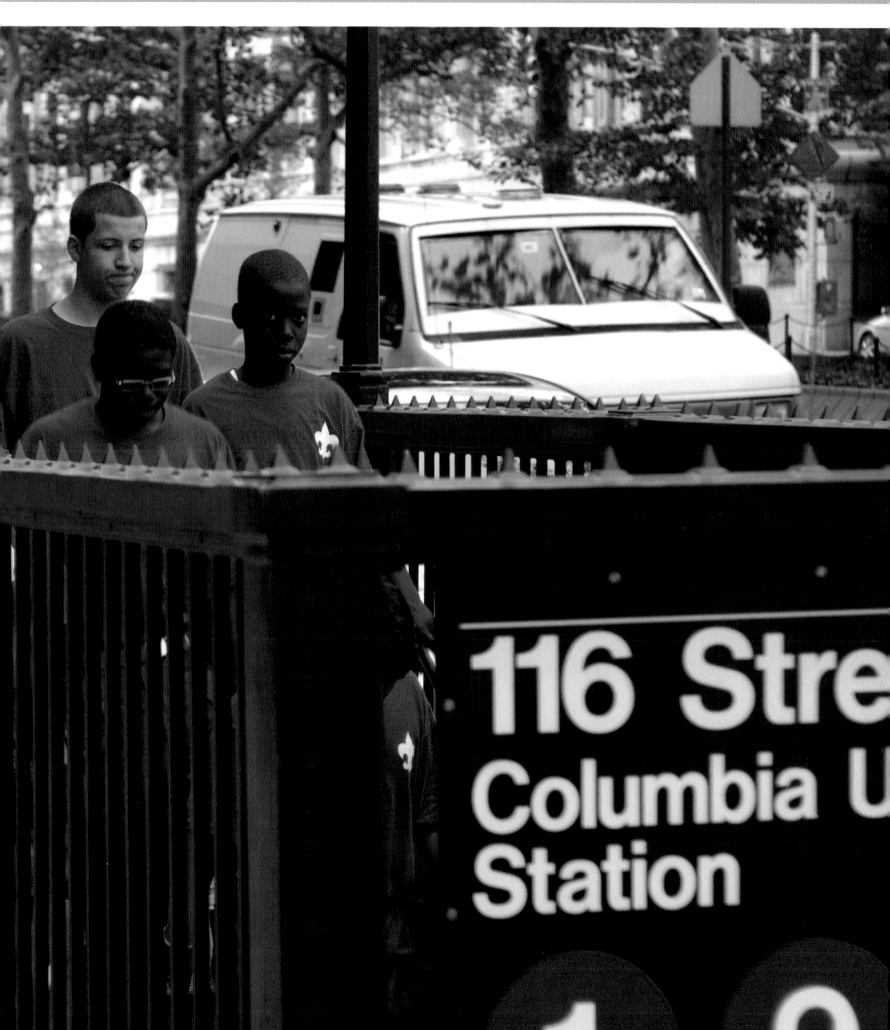

116 Stre
Columbia U
Station

1 9

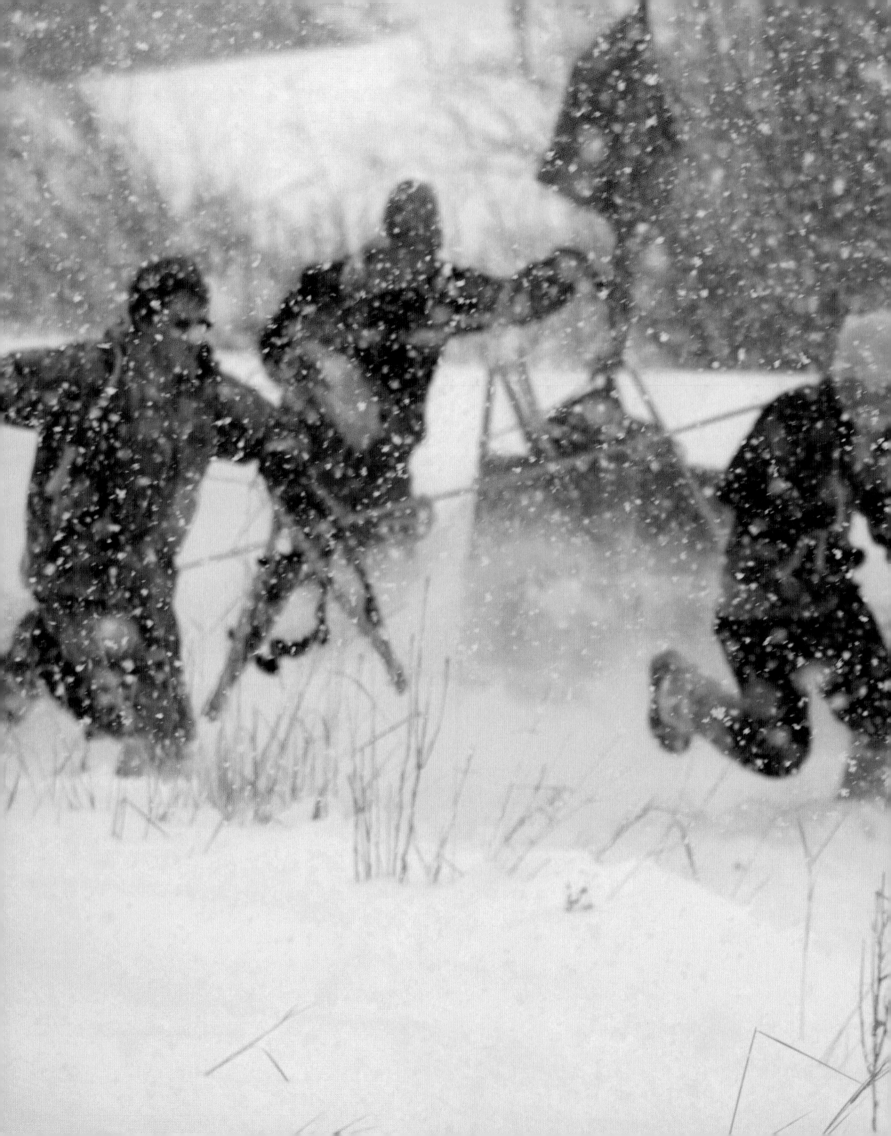

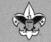

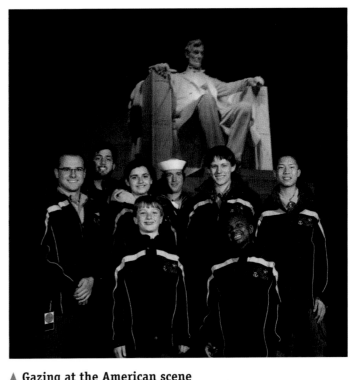

**▲ Gazing at the American scene**
Scouts visiting Washington, D.C., as part of the annual
Report to the Nation delegation represent a cross-section
of BSA membership, programs, and hometowns.

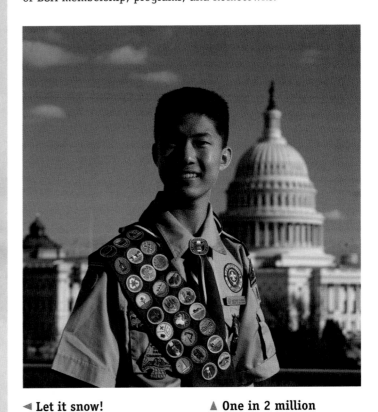

**◄ Let it snow!**
With the thermometer
hovering near zero, a
hotly contested sled race
energizes Scouts to storm
the finish line.

**▲ One in 2 million**
The 2 millionth Scout
to earn the rank of
Eagle, Anthony Thomas
of Lakeville, Minnesota,
represents a century of
Scouting achievement.

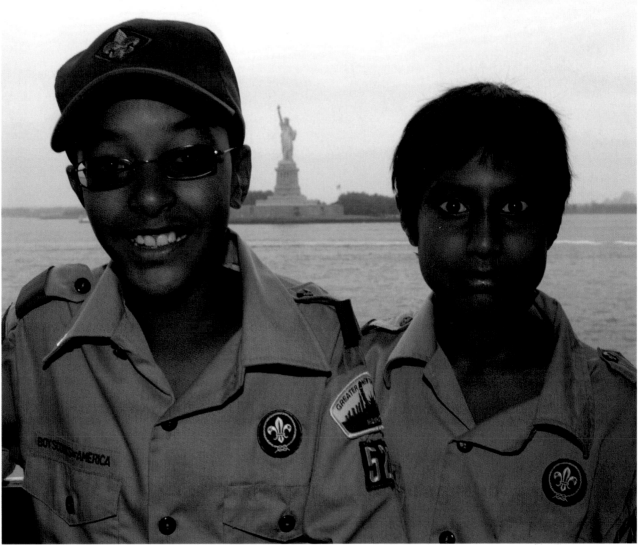

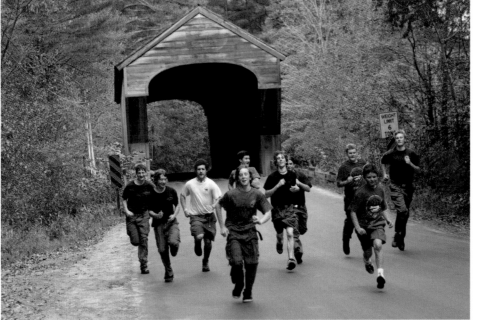

**▲ Patriotism made real**
A visit to the Statue of Liberty gives two Scouts a heightened awareness of the history of their nation and their duties as citizens.

**◀ A bridge far enough**
An autumn hike through New England's color-splashed countryside turns into a spirited sprint for Scouts returning home.

**◀ Doing what needs to be done**
The Boy Scouts of America lends real support, and tens of thousands of volunteer hours, to community efforts throughout the land.

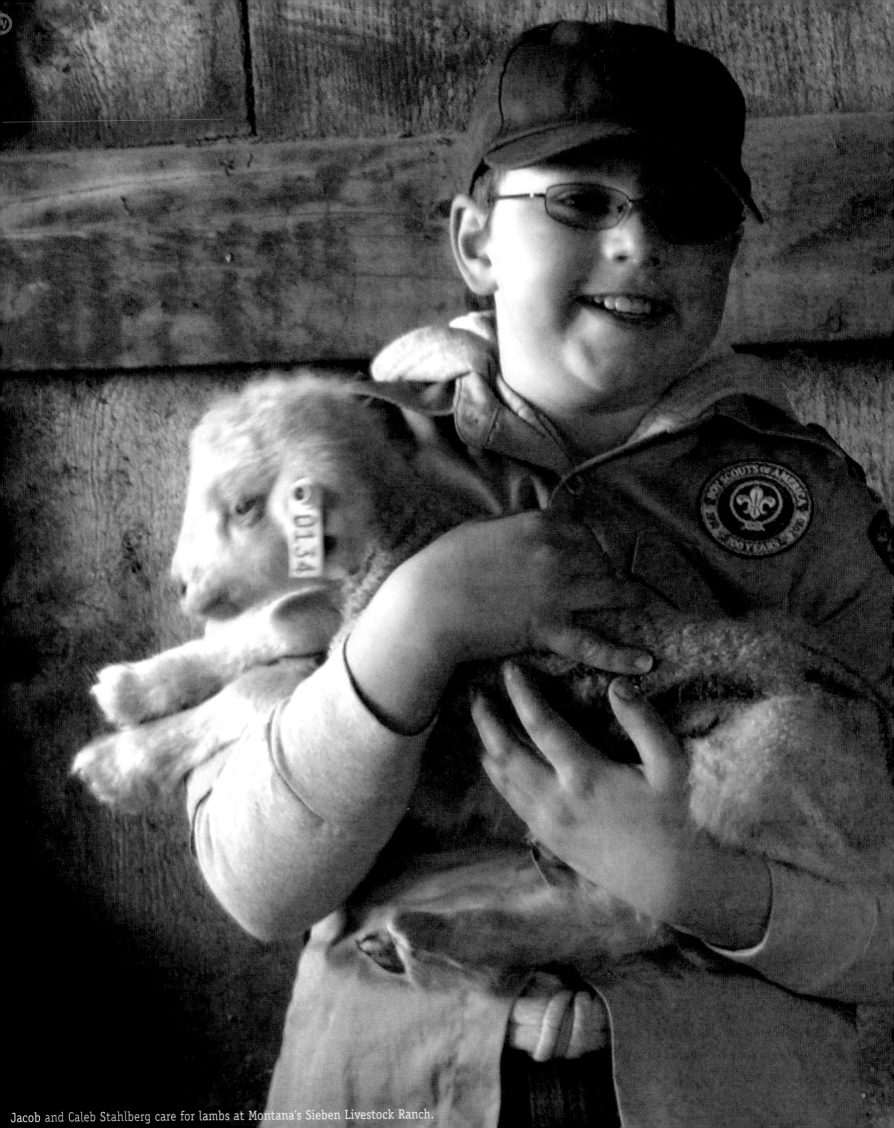

Jacob and Caleb Stahlberg care for lambs at Montana's Sieben Livestock Ranch.

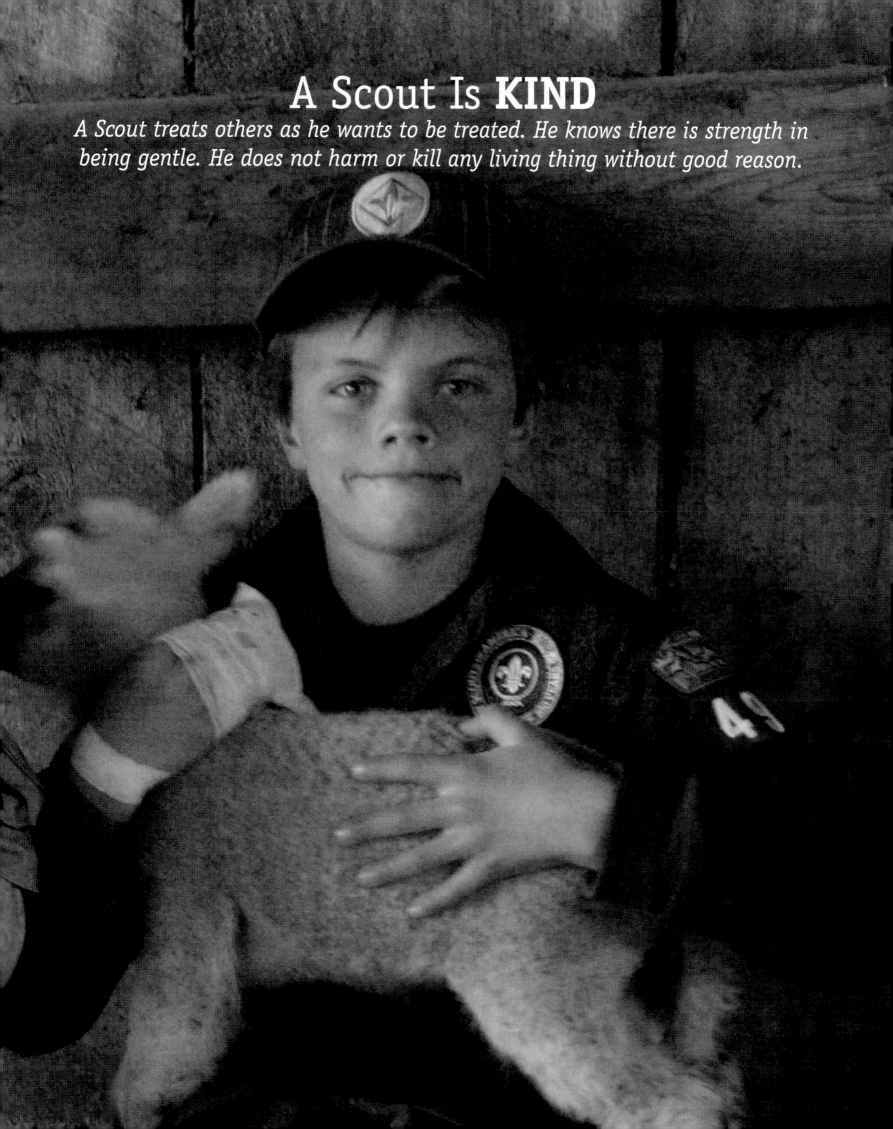

# A Scout Is **KIND**

*A Scout treats others as he wants to be treated. He knows there is strength in being gentle. He does not harm or kill any living thing without good reason.*

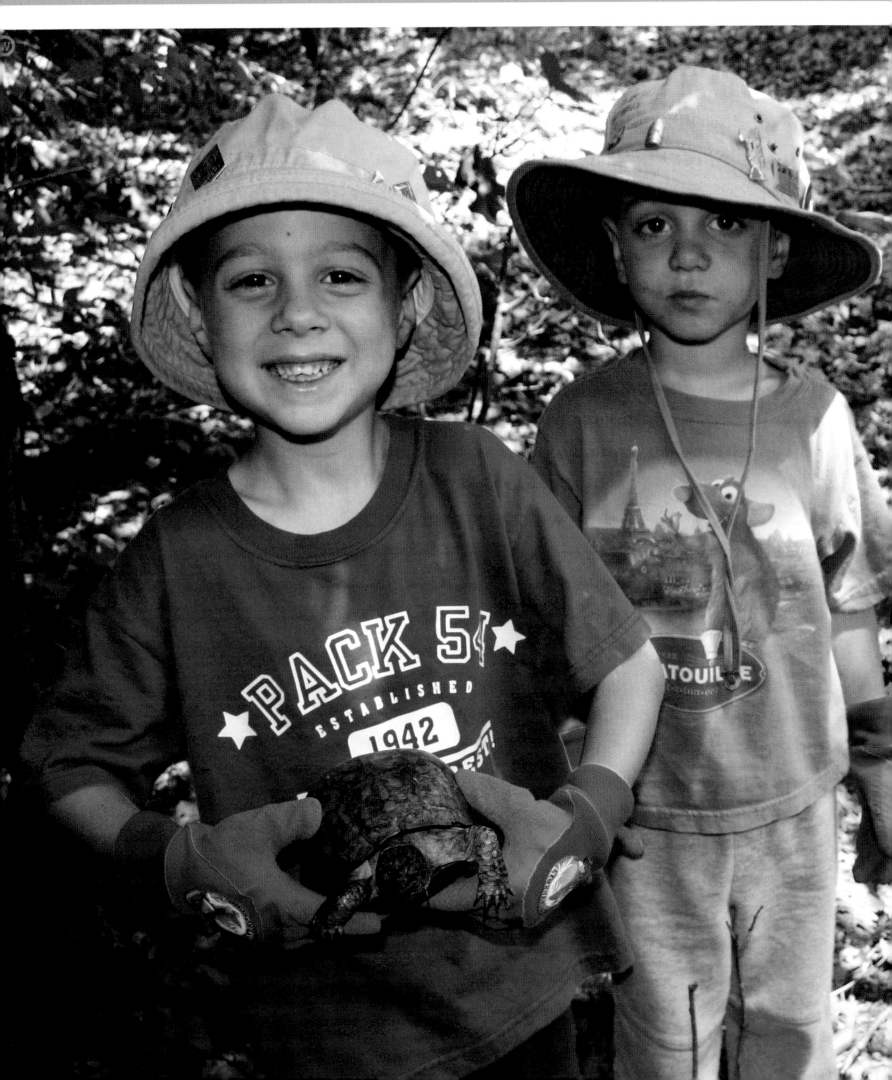

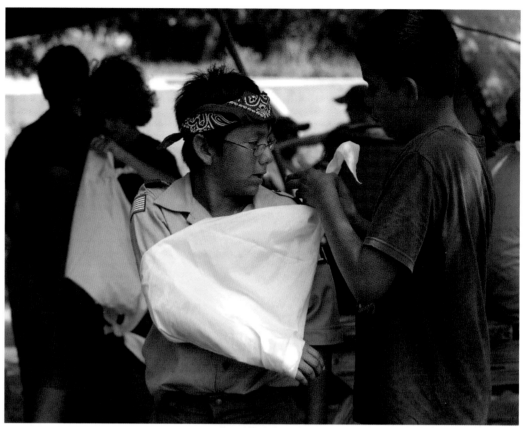

**▲ The skills of kindness**
First-aid practice prepares Scouts to fulfill their promise "to help other people at all times."

**◄ Looking out for little ones**
New Cumberland, Pennsylvania, Tiger Cub Alex McQuade and his brother Colin gently move a box turtle to a safer site off the path of the Appalachian Trail.

**To the future together ▶**
Lending each other support, two Georgia Tiger Cubs take their first steps on a Scouting trail that will carry them through years of adventure and achievement.

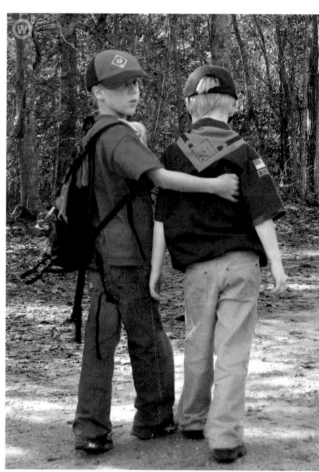

**Plenty to go around ▶**
Scouts preparing for a day
on the trail load up on fluids
they'll sip along the way to
ward off dehydration.

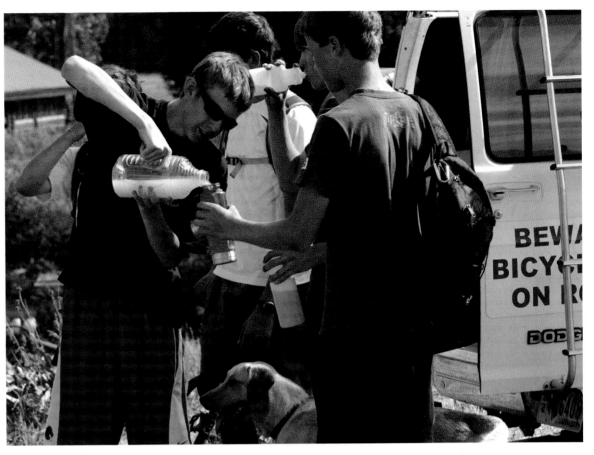

**◀ Looking good!**
Thomas Cottrell, a Virginia
Star Scout, helps Stephen
Tate adjust his neckerchief
as the two get ready for
summer camp events.

**Greetings from the Chief ▶**
Chief Scout Executive Bob Mazzuca
extends a warm handshake of
friendship and support to Scouts
in Atlanta, Georgia.

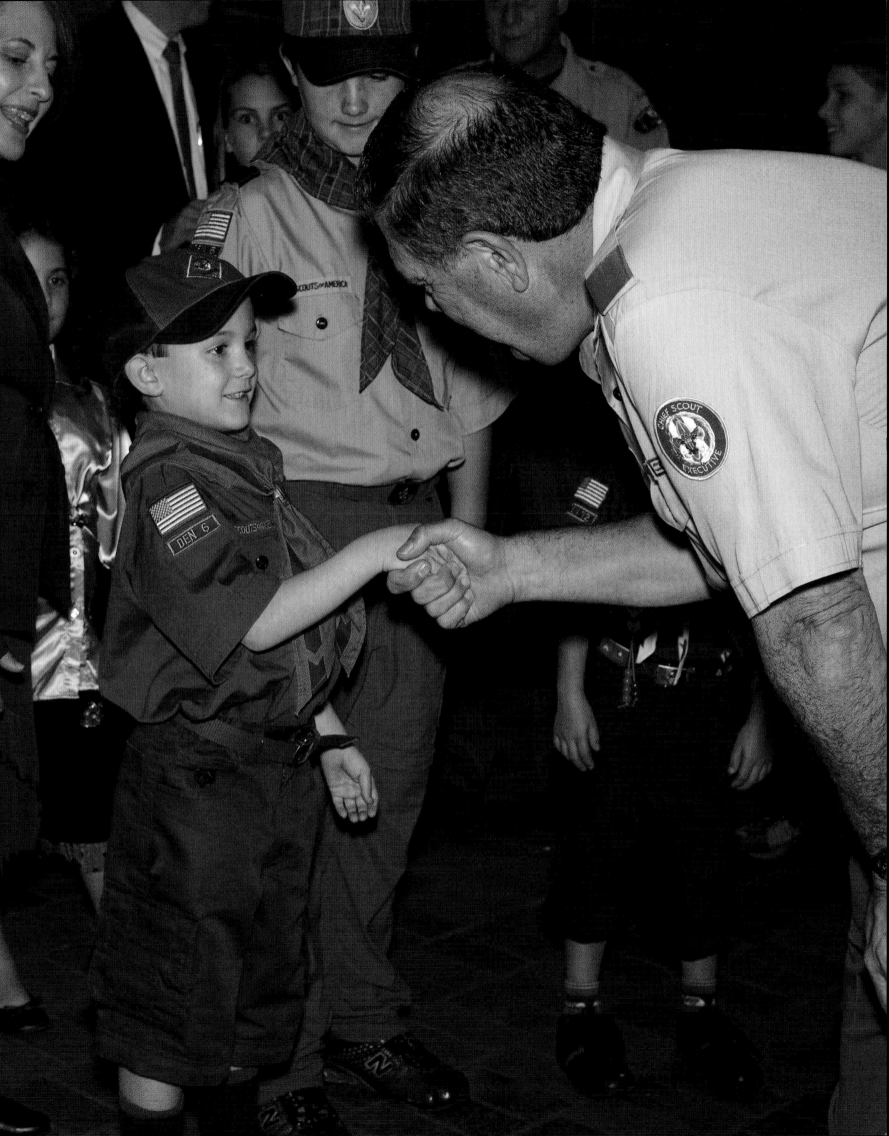

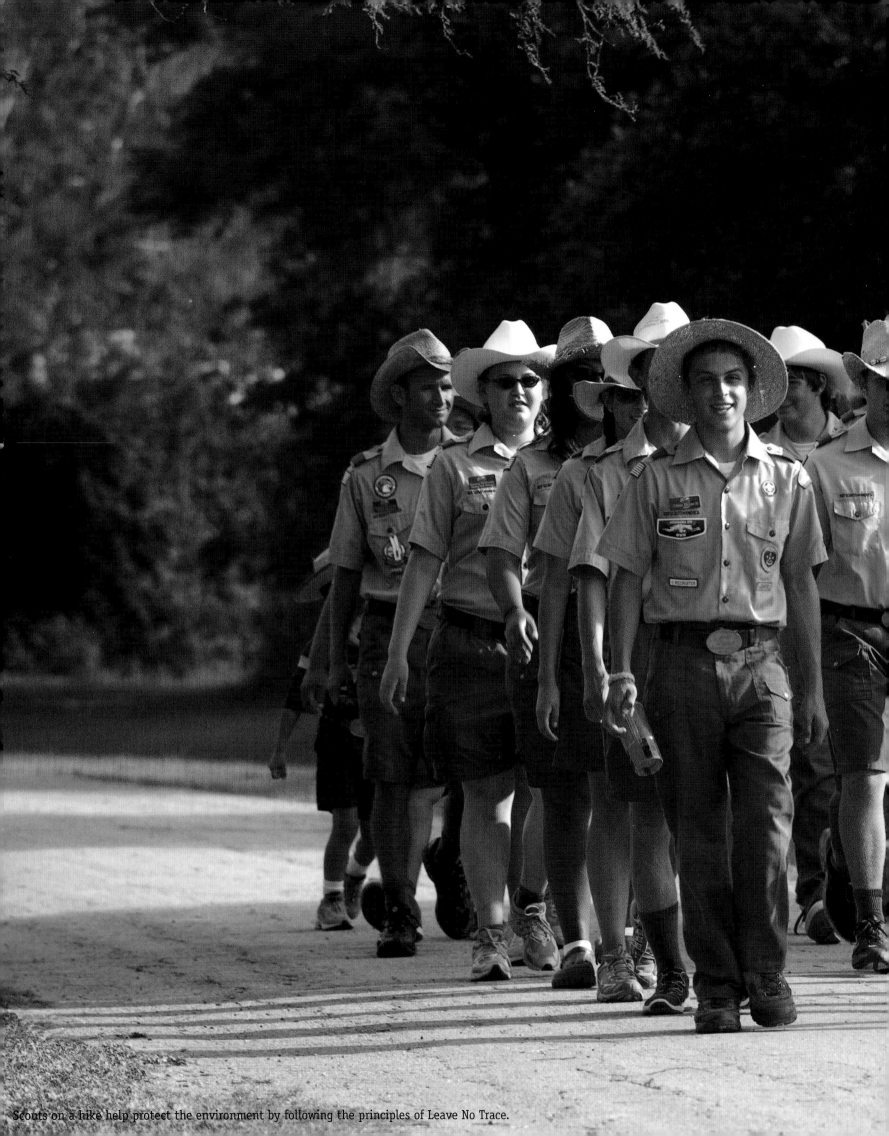
Scouts on a hike help protect the environment by following the principles of Leave No Trace.

# A Scout Is **OBEDIENT**
*A Scout follows the rules of his family, school, and troop.
He obeys the laws of his community and country. If he thinks
these rules and laws are unfair, he seeks to have them
changed in an orderly way.*

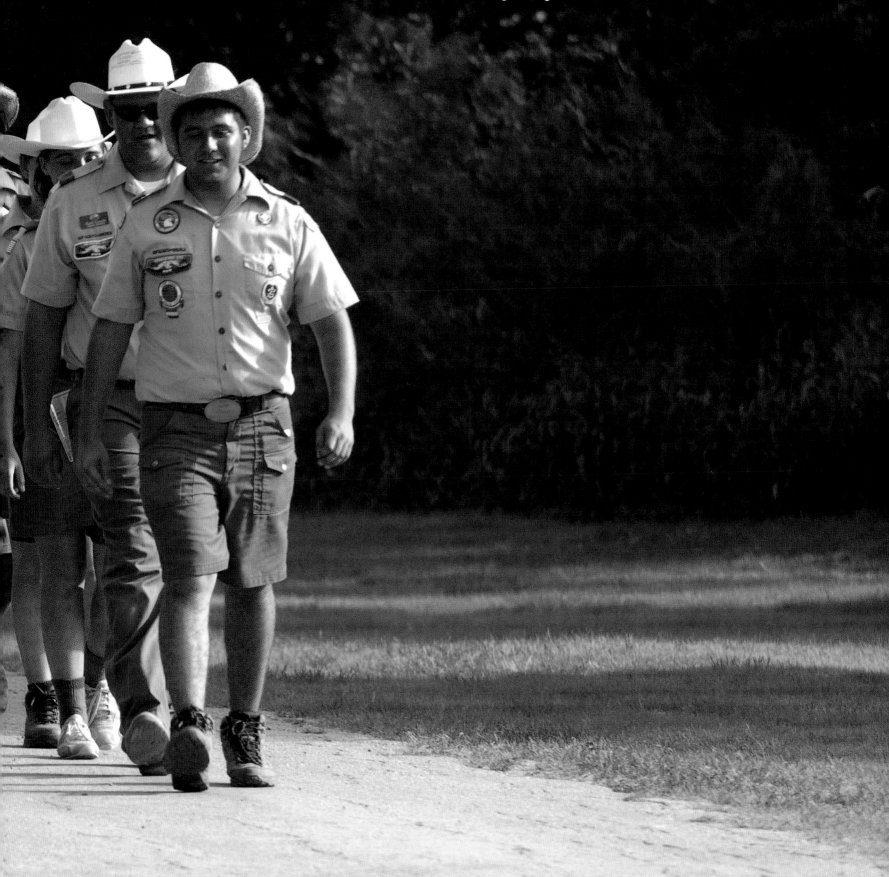

**▲ Giving meaning to the moment**
Boy Scouts and Venturers reflect on everything they've done during an eventful day at Tahosa High Adventure Base near Ward, Colorado.

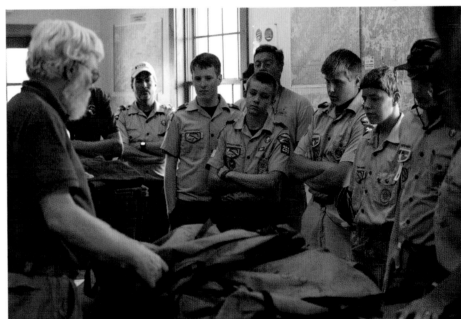

**◄ High adventure for all**
Venturing brings exciting BSA opportunities to young men and women age 13 through 20.

**▲ Gear for great times**
Scouts gather equipment for their wilderness canoe trip at a BSA Northern Tier National High Adventure Base.

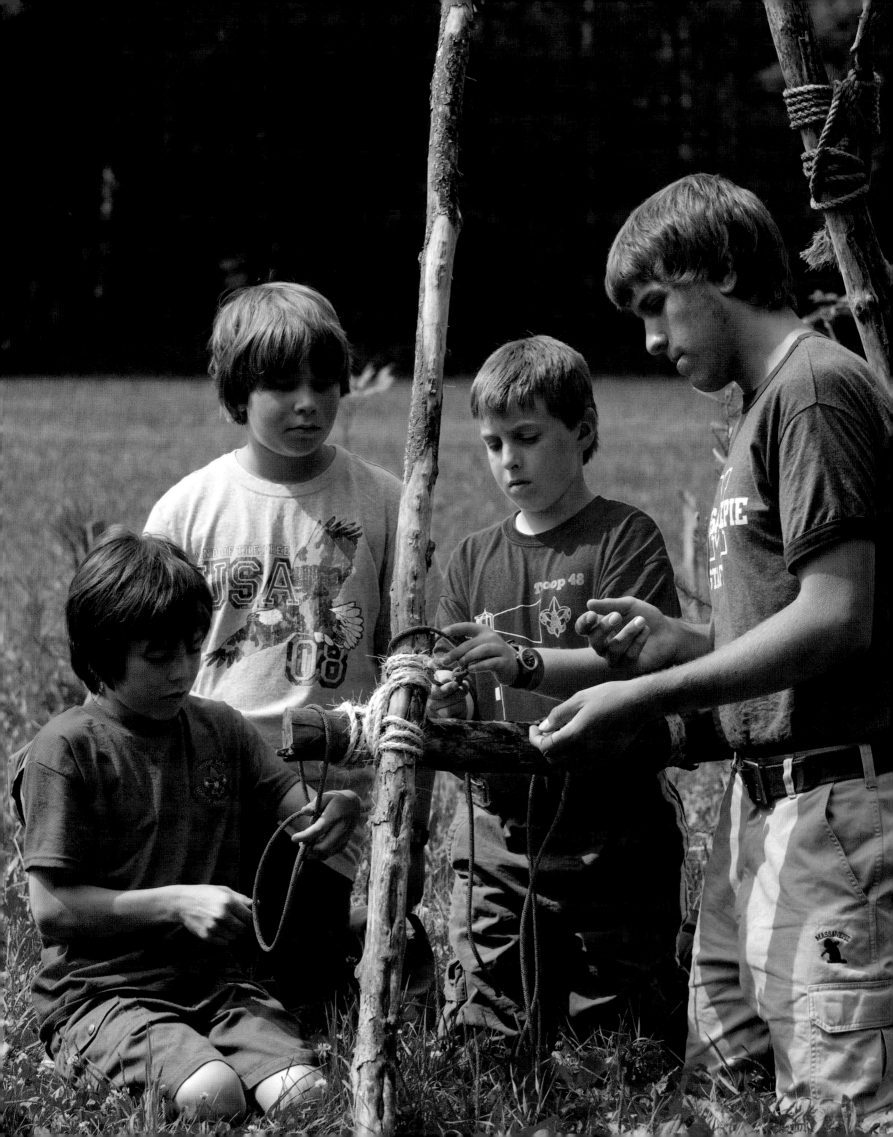

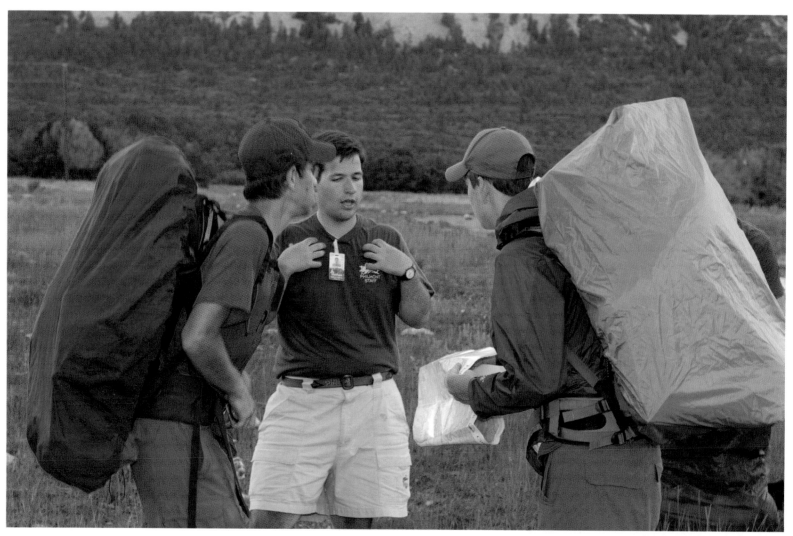

**▲ Charting a pathway to the future**
Leadership honed in the face of weather, distance, and navigational challenges carries over from the field to classrooms and careers.

**◄ "Right over left, left over right"**
Since the founding of the BSA, tying knots has been a skill taught by all generations of Scouts, and these at Massawepie Scout Camp are no exception.

**I want to go back to Philmont! ▶**
Philmont Scout Ranch rangers complete advanced leadership training before guiding Scouts into the backcountry.

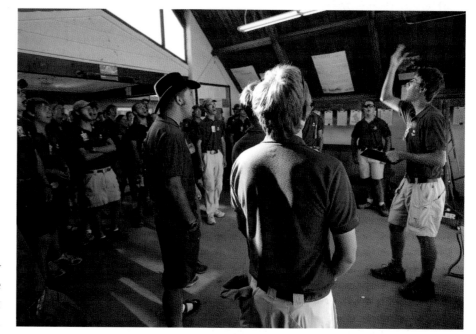

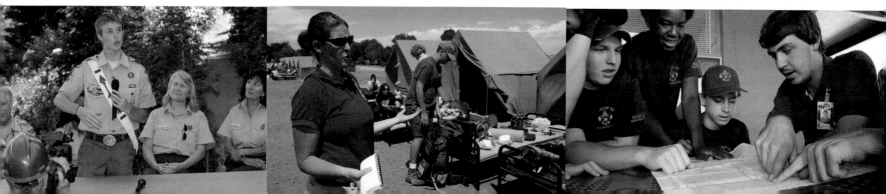

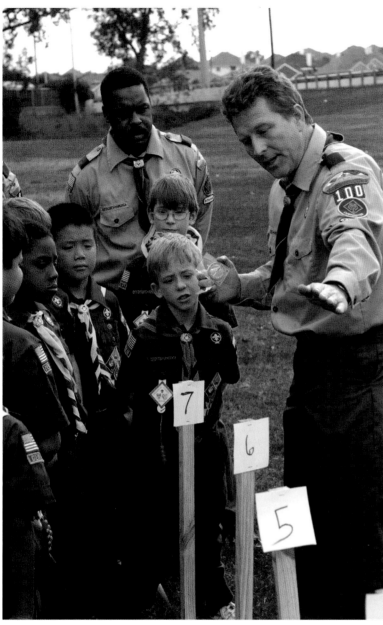

**▲ Enabling leadership**
Leaders clearly explain a Cub Scout
challenge, provide support along the way,
and celebrate the success of every boy.

**Planning, goals, and vision ▶**
*Planning* prepares Scouts to reach *goals*,
the manageable steps for fulfilling their
*vision* of success.

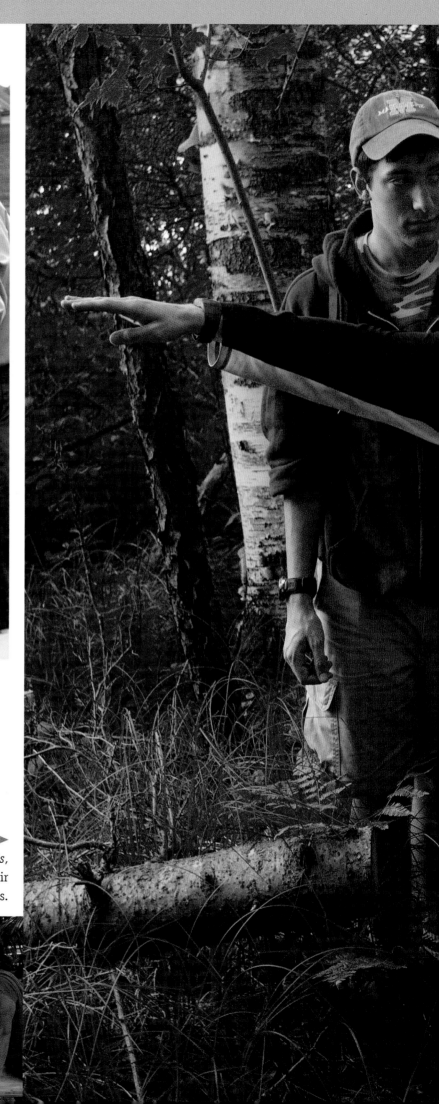

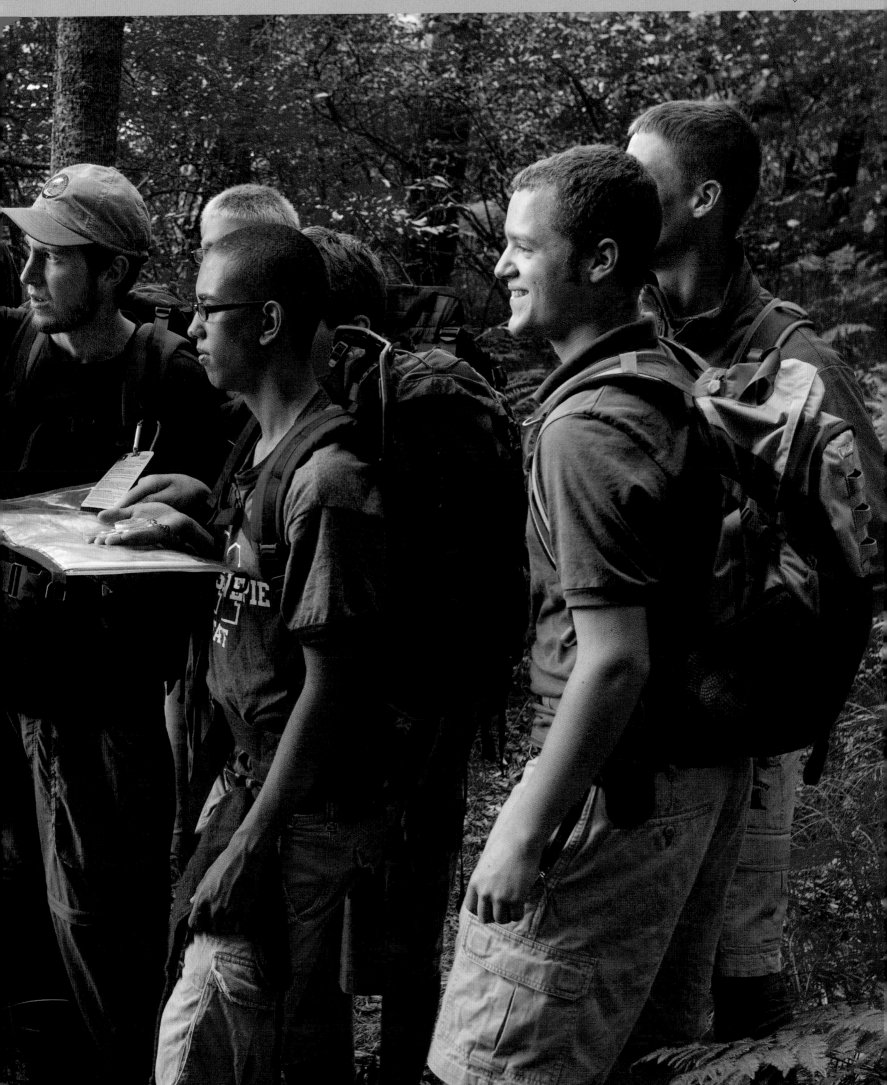

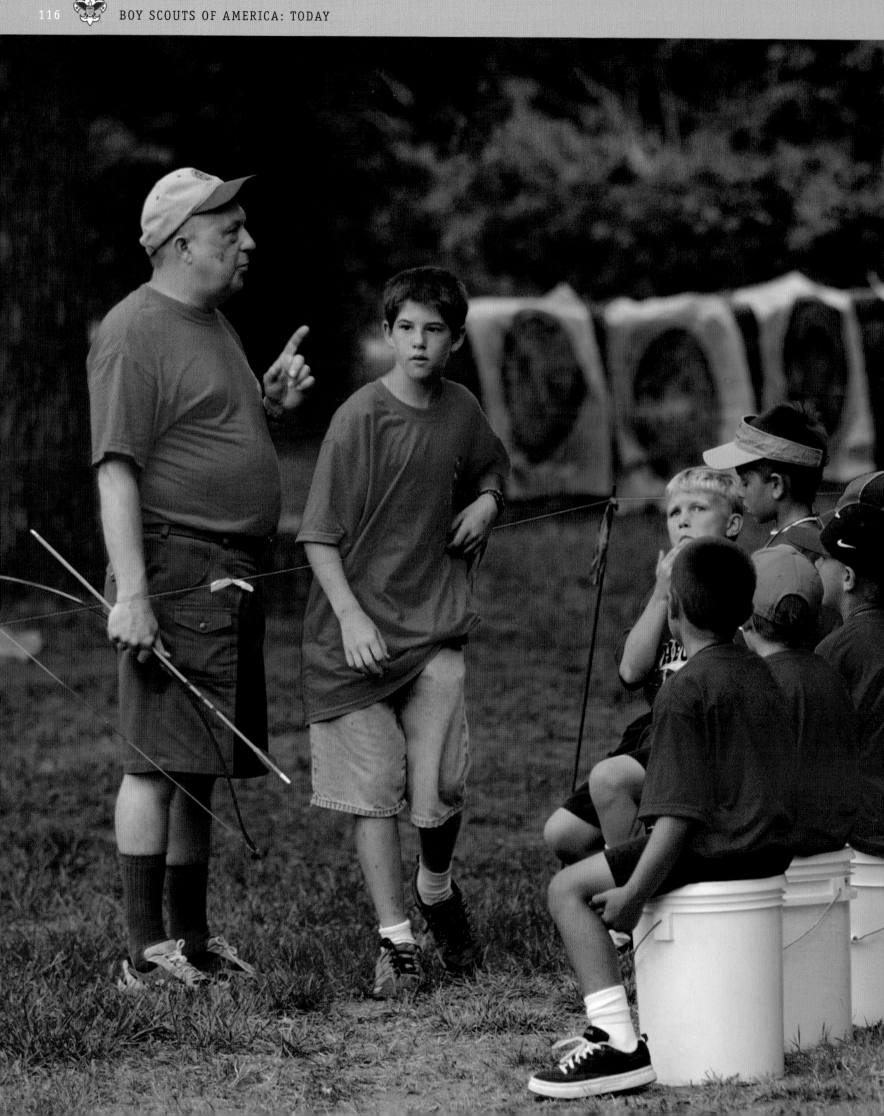

**▲ Soccer and Scouting™**

Adult leaders provide guidance and leadership to help boys learn the life-long values taught in the Cub Scouting program, and help them learn soccer skills while participating in exciting competitions.

**▲ Showing the way**

Scoutmasters stand tall as role models and mentors for Scouts of all ages.

**◄ Clear boundaries**

Scouting helps members understand there is a right way to do things, from obeying the rules at an archery range to making wise decisions in life.

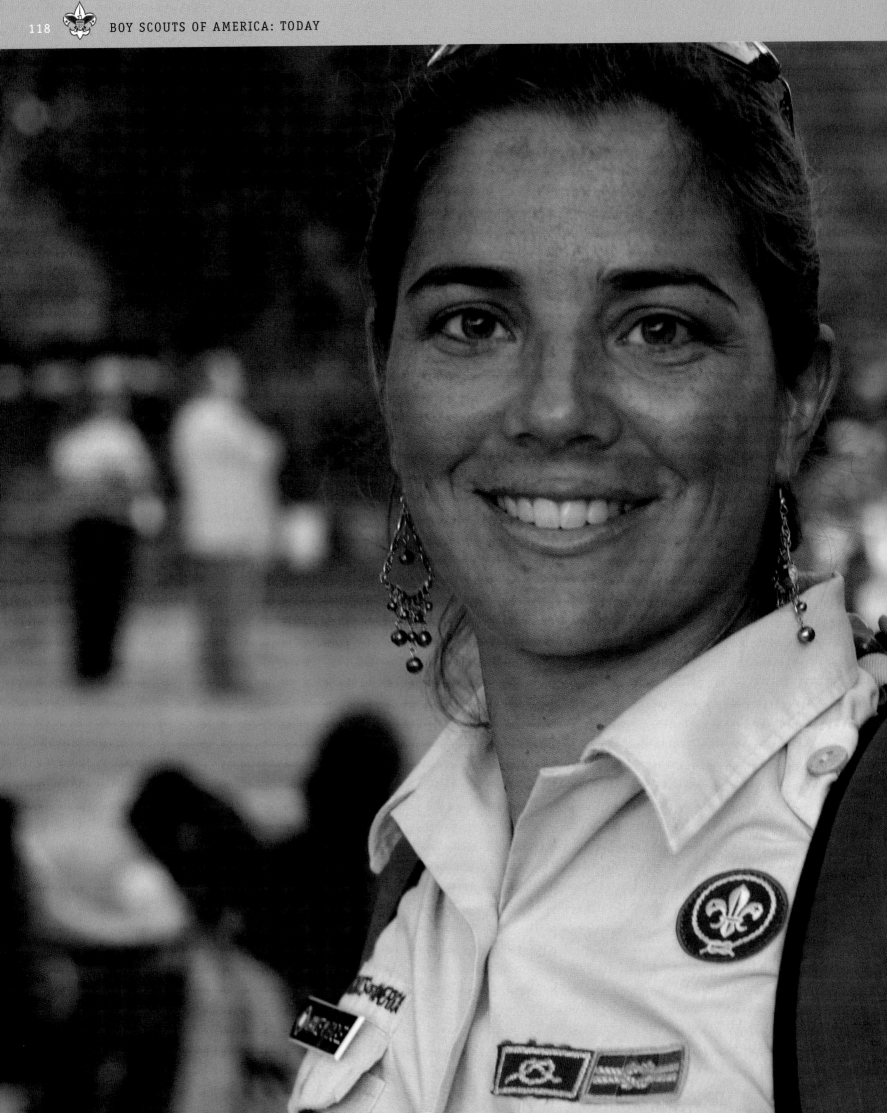

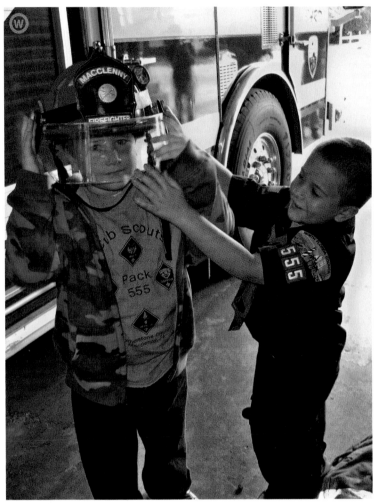

**◄ Precious cargo**
A Rio Grande Council Scout of tomorrow delights in being outdoors today. The BSA encourages family involvement with Scouting.

**▲ Fit for the future**
Cub Scouts trying on a helmet discover the dream of growing up to be firefighters—or exploring many other careers— is well within their grasp.

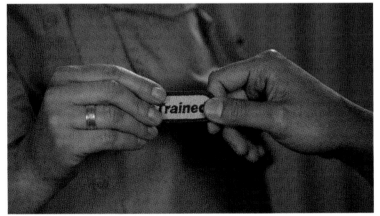

**▲ Recognition that matters**
*Trained* patches acknowledge that adult leaders have completed BSA training to prepare them for their positions in Scouting.

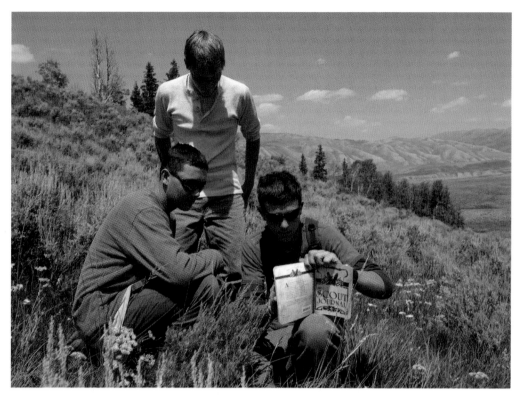

**▲ A bloom of understanding**
A couple of friends, the *Boy Scout Journal*, and a hillside of vegetation transform a hike into a journey of discovery.

**Achieve more with more ▶**
Like the expansive terrain they explore, older Scouts accept increasing responsibility for guiding others.

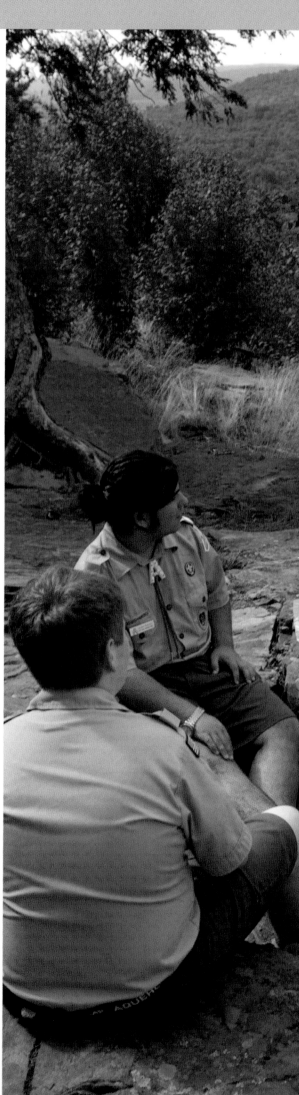

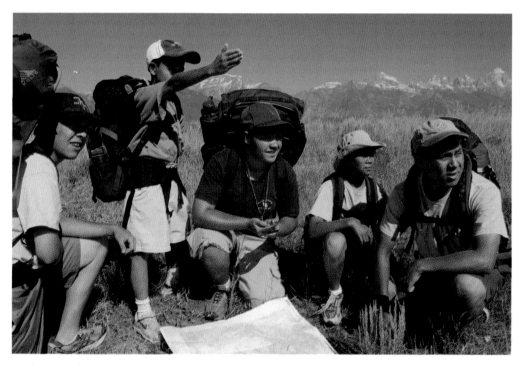

**▲ The way forward**
Scouts passing on their knowledge sharpen their abilities as teachers and find satisfaction in watching others succeed.

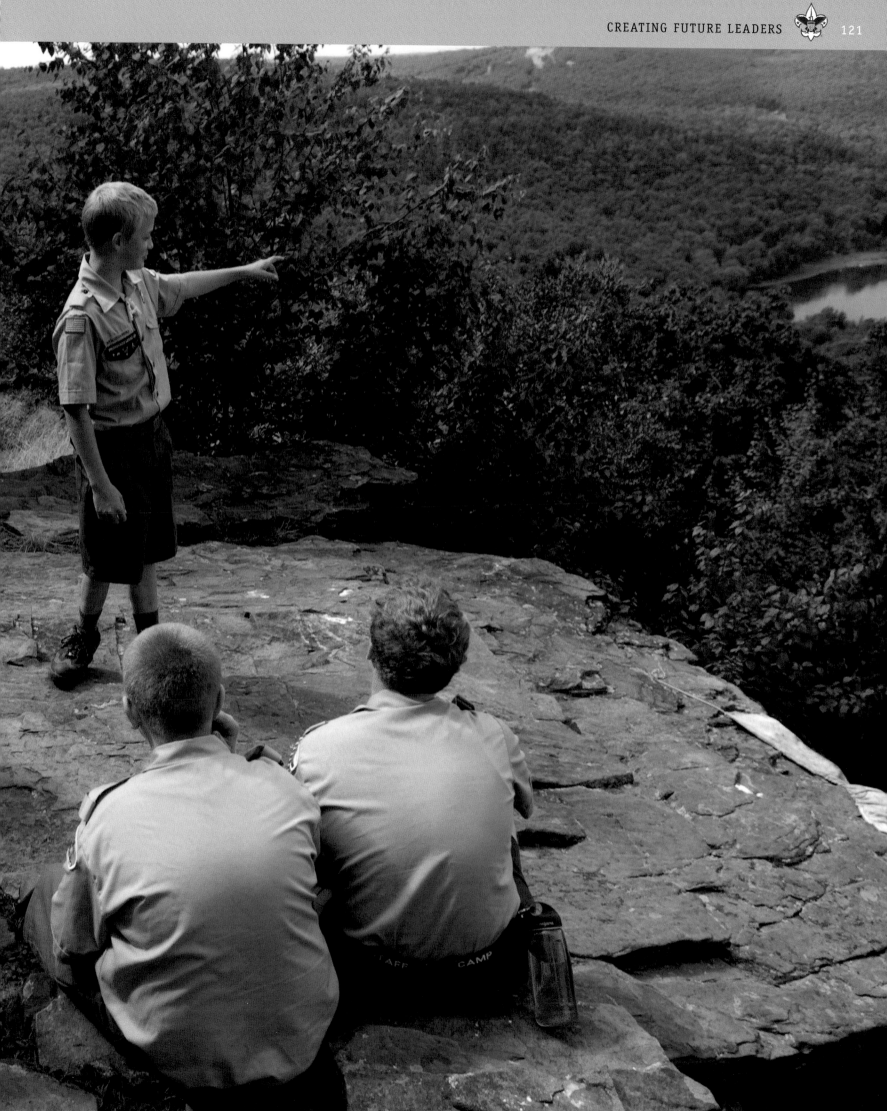

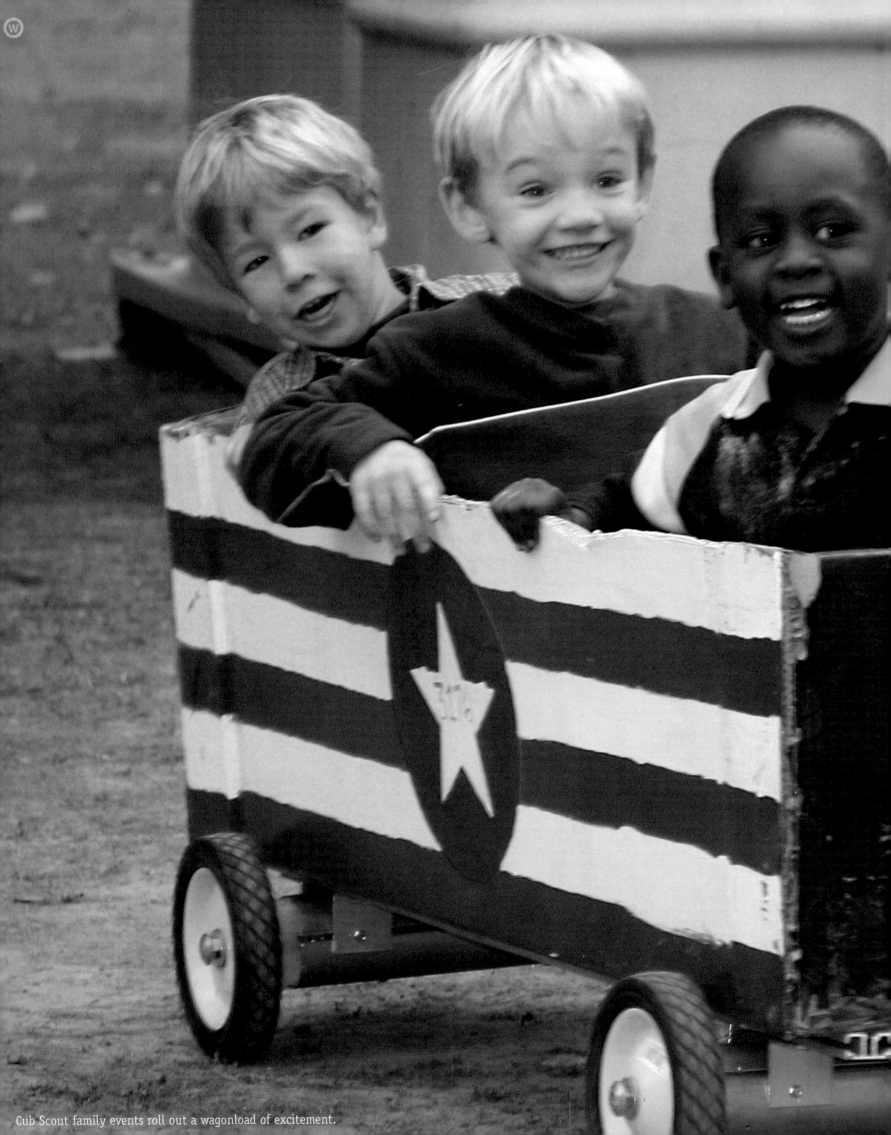

Cub Scout family events roll out a wagonload of excitement.

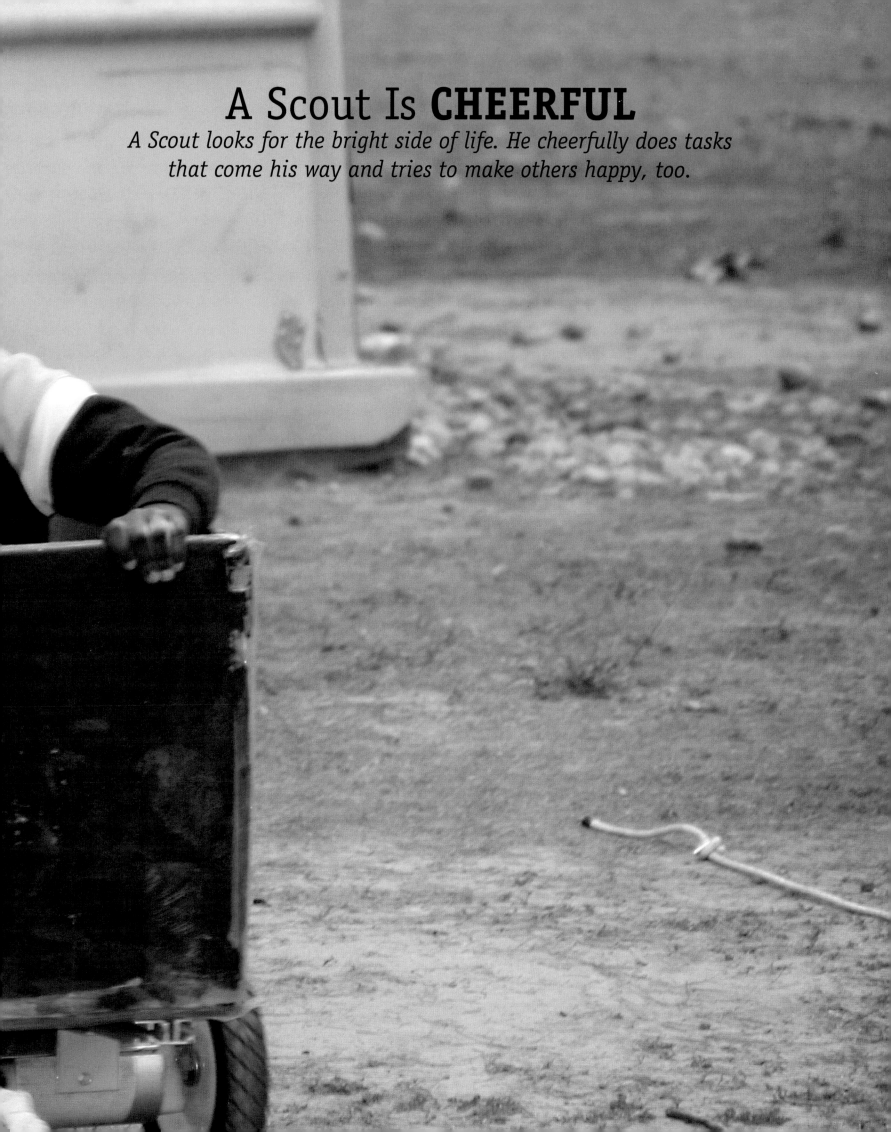

# A Scout Is **CHEERFUL**

*A Scout looks for the bright side of life. He cheerfully does tasks that come his way and tries to make others happy, too.*

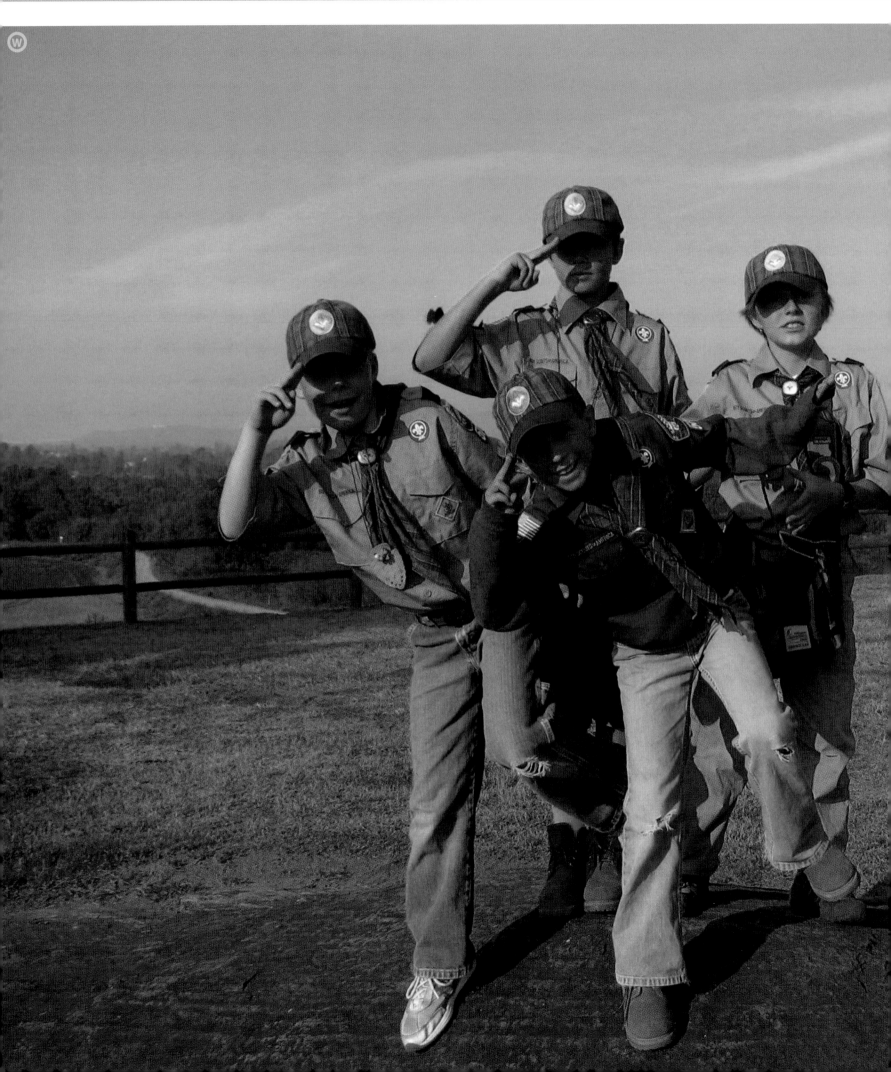

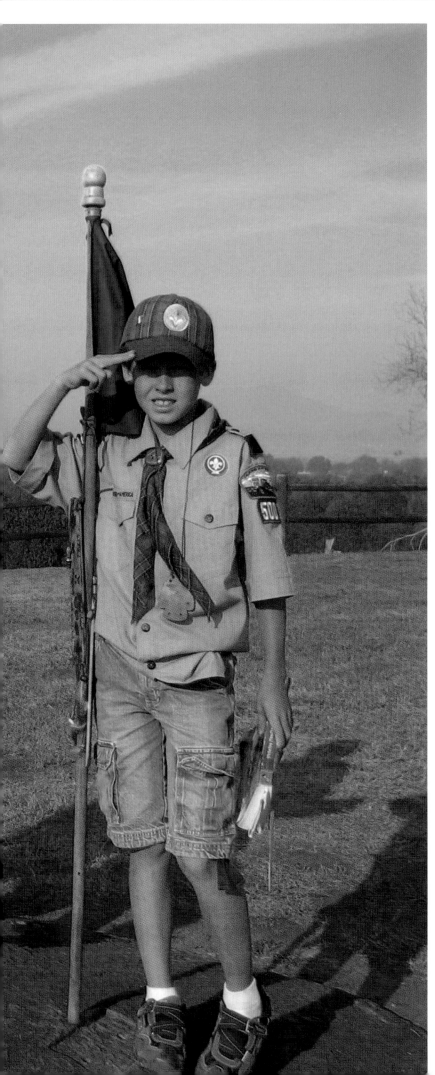

▲ **Enlightening experiences**
Aglow at the closing of his first camporee, a Cub Scout
thinks back on all he has learned and been able to do.

◄ **Happy together**
Scouts of Pack 500, Murrieta,
California, salute adventures
shared during a Webelos
camping trip.

▲ **Bonds of fellowship**
Friendships forged by Scouting
can strengthen through the
years as boys grow into men
leading boys.

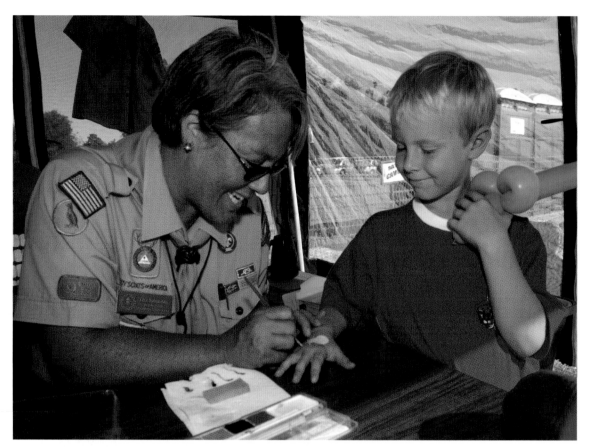

**◄ Artistry of autumn**
Pumpkin carving, beanbag tosses, and paint-on Scout emblems headline a Tiger Cub fall festival.

**◄ Recipe for a cheerful Scout**
Mix activities, achievement, and friendships with supportive adult leadership and watch learning grow.

**Flake catcher ▶**
Tip-of-the-tongue tasty, fresh snow entertains a Scout helping with a Toys for Tots event in Camp Hill, Pennsylvania.

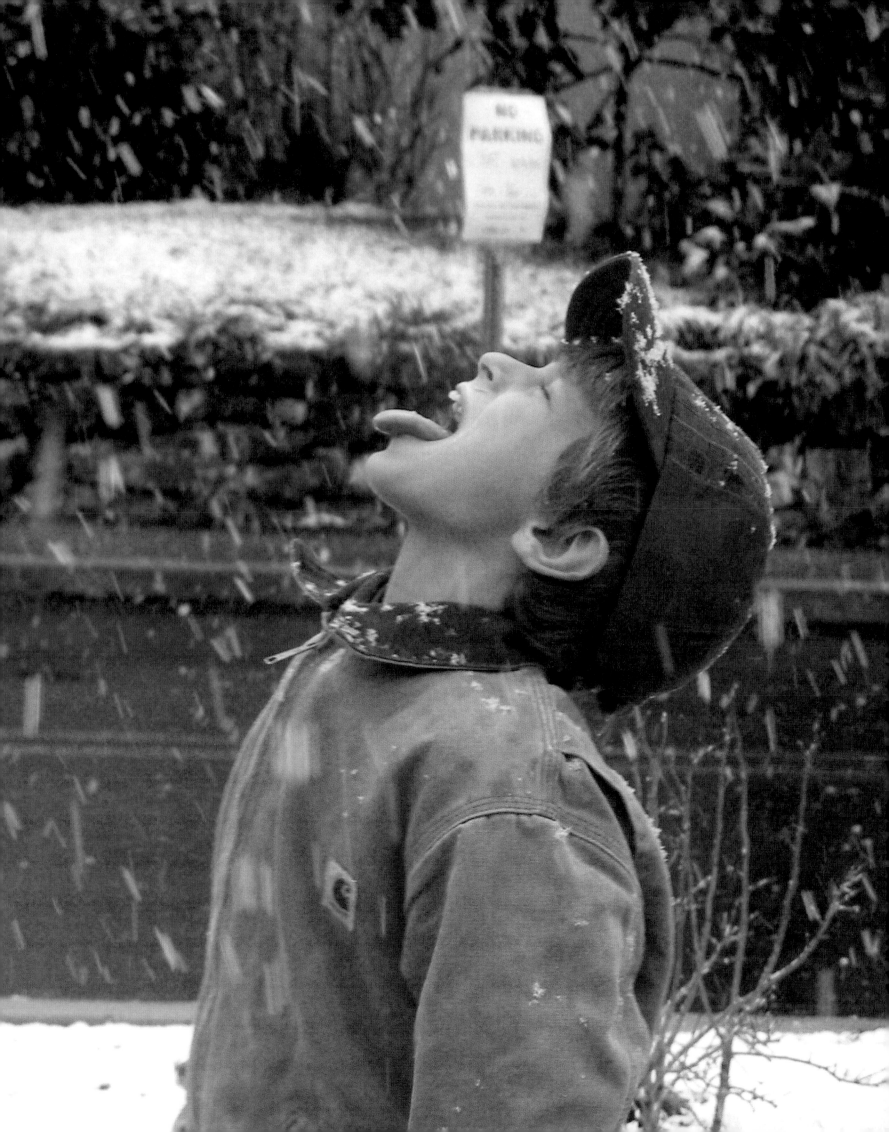

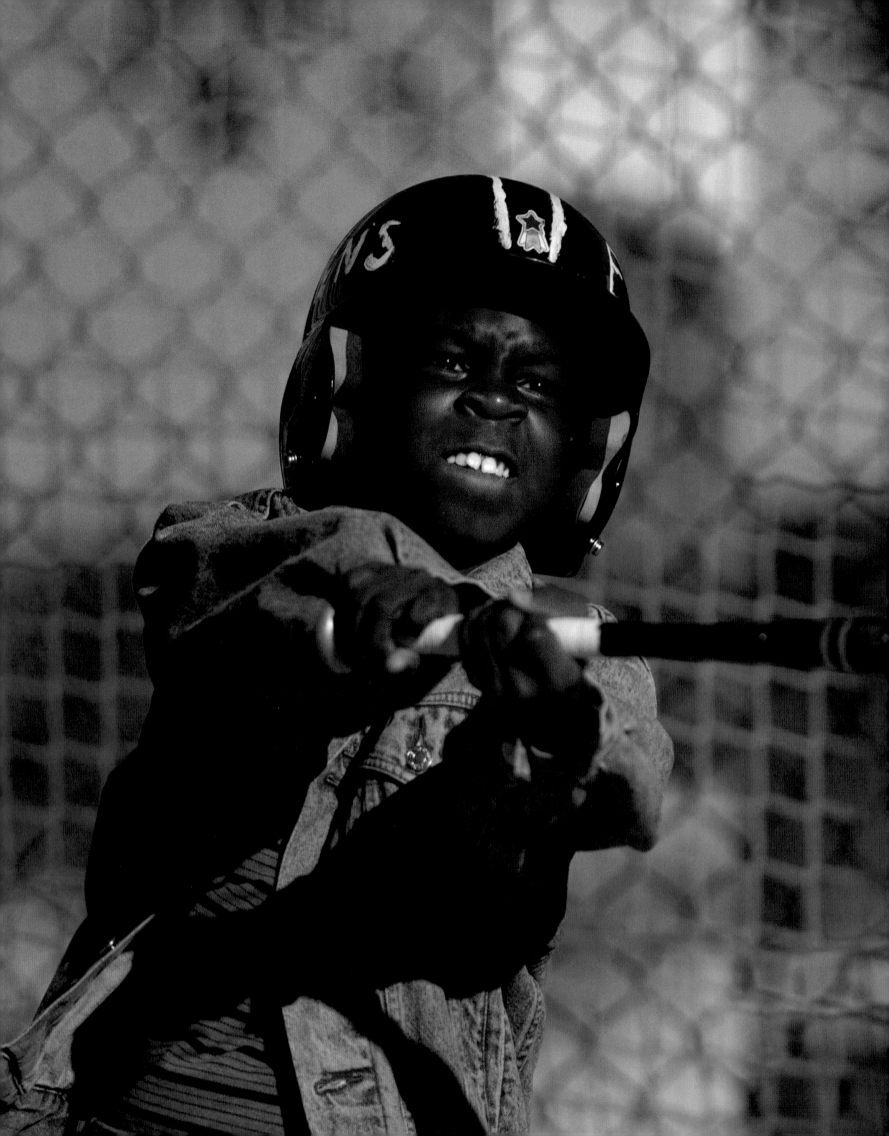

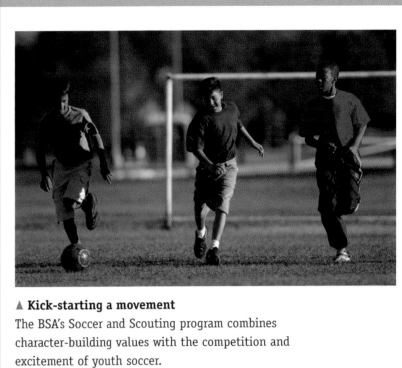

**▲ Kick-starting a movement**
The BSA's Soccer and Scouting program combines character-building values with the competition and excitement of youth soccer.

**◄ Keeping an eye on the ball**
The crack of a bat is a true sound of summer as boys across the land team up with fellow Scouts and swing into action.

**▲ Fit for the long run**
Staying healthy through the years begins with the Scout Oath promise "to keep myself physically strong."

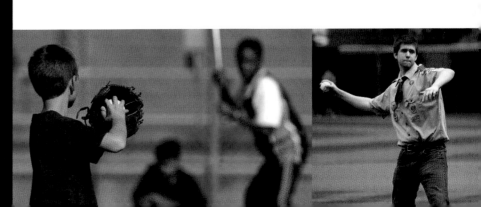

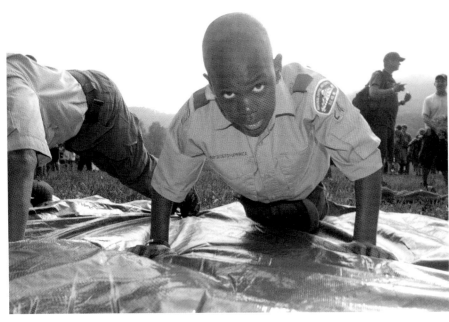

▲ **Pushing up to the challenge**
The power of shared events unites Scouts to try more and achieve on a higher scale than many would have thought possible.

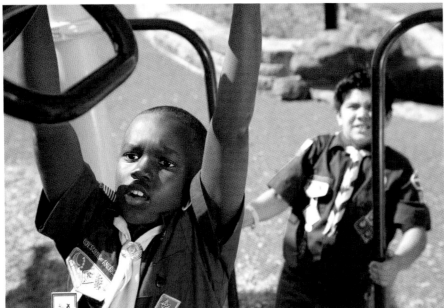

▲ **Pinning their hopes on success**
Earning the Fitness pin rewards Cub Scouts for doing their best in taking active steps to get in shape and then stay there.

**Stretching the limits** ▶
With an eye toward good technique, a Scout training for the Personal Fitness merit badge loosens up before a workout.

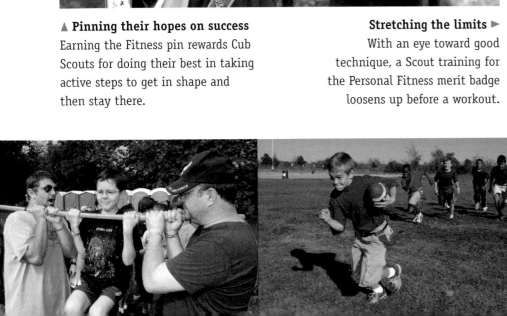

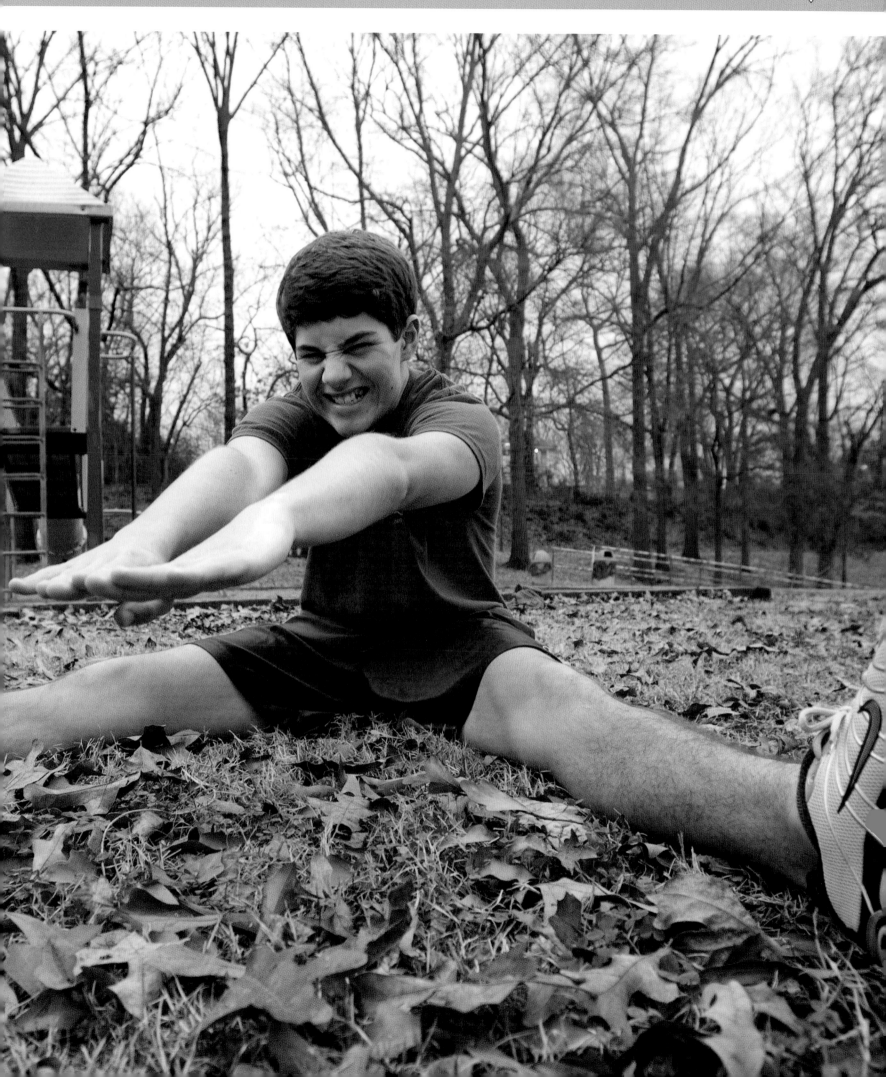

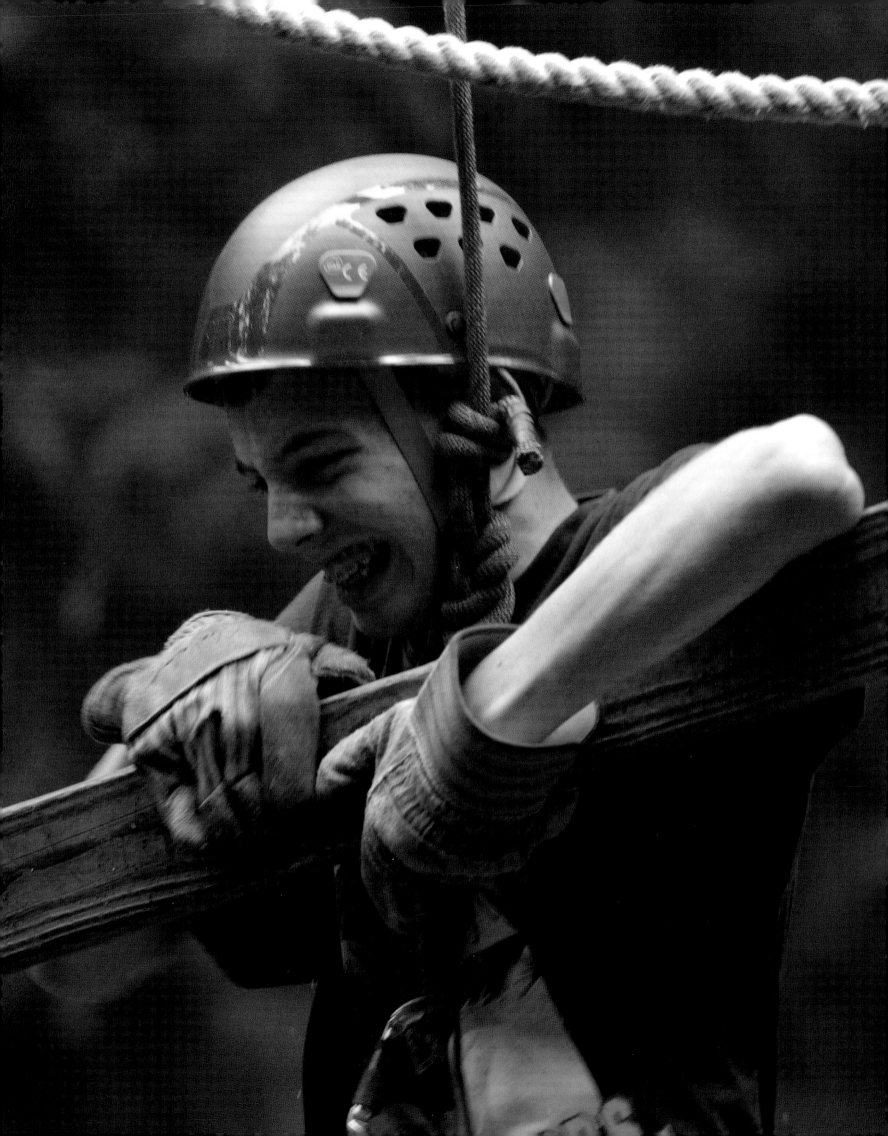

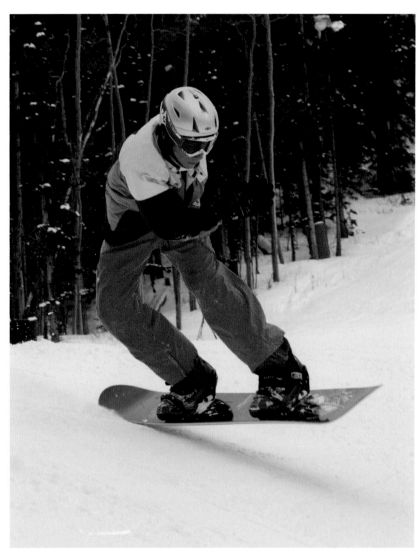

**▲ Year-round adventure**
Wintry conditions transform the outdoors
into a snowy playground for Scouts with skis,
snowshoes, and snowboards.

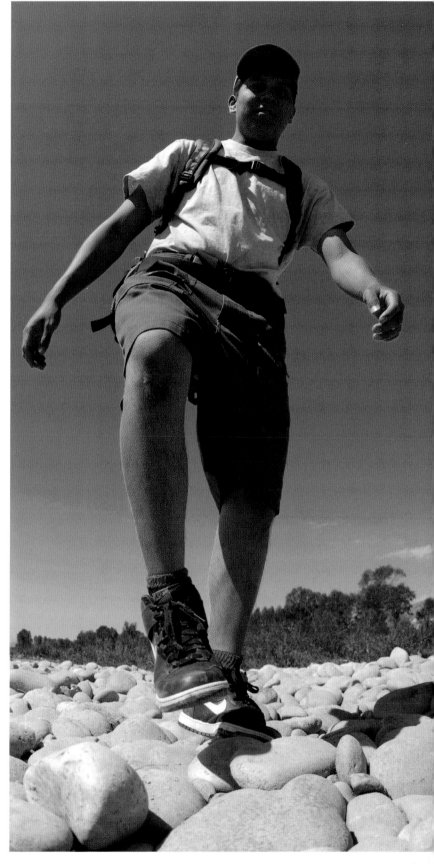

**◄ The final 10 percent**
A Scout with everything on
the line reaches deep for the
inner strength to make the
moves that will get him over
a tough obstacle.

**One foot at a time ►**
Scouts have been hiking since
the beginning of the BSA.
While footwear has improved,
finding happiness on the trail
is still as strong as ever.

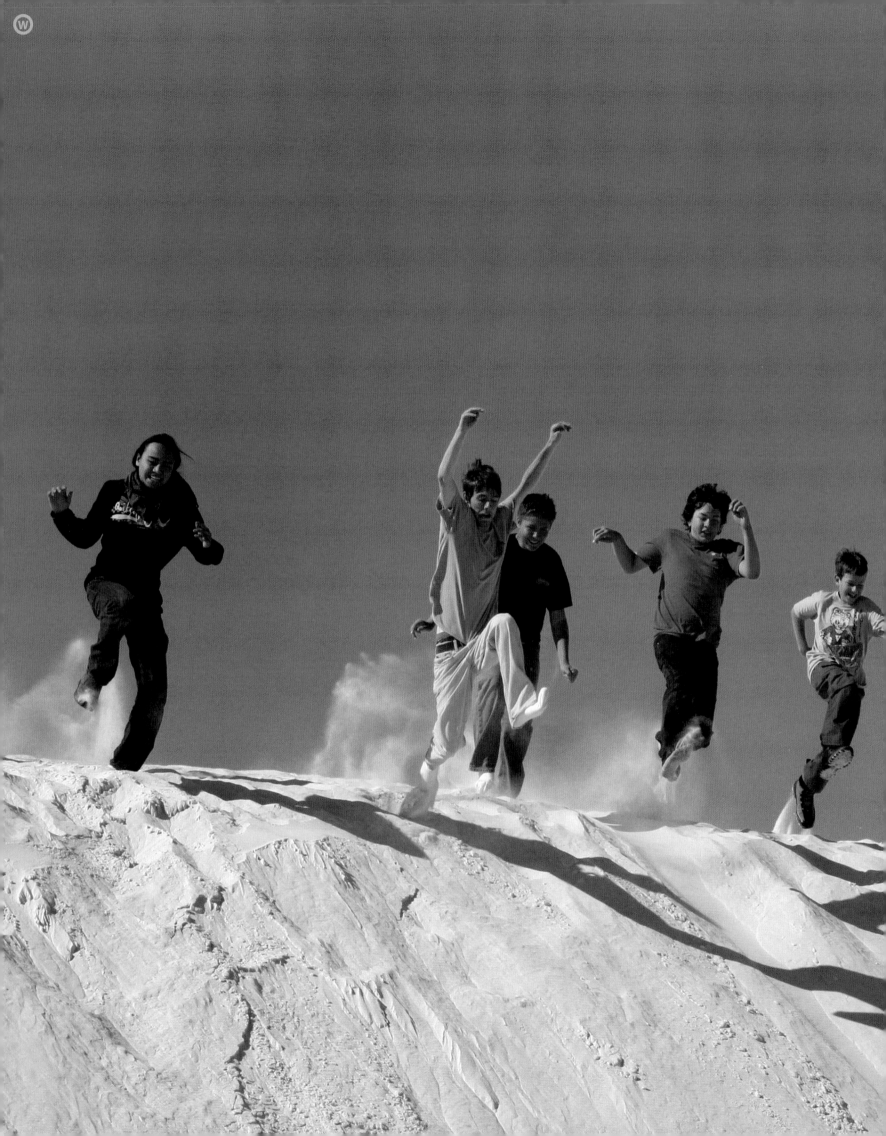

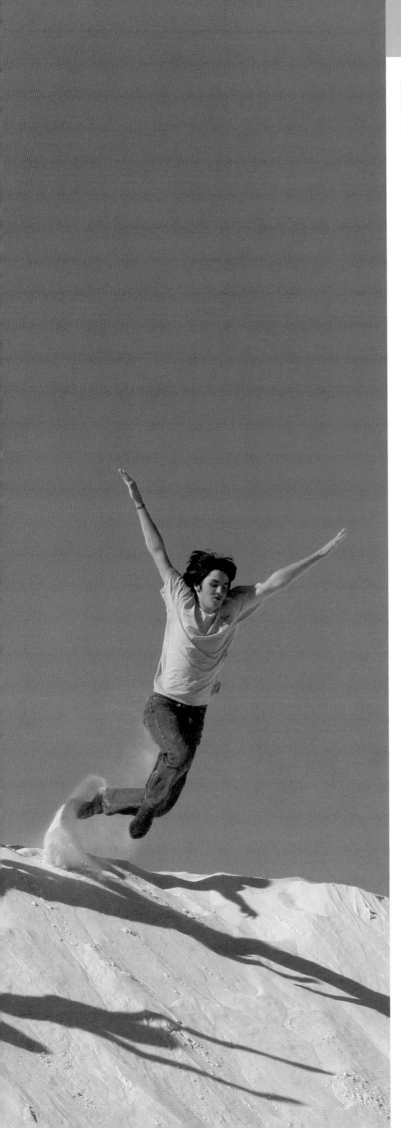

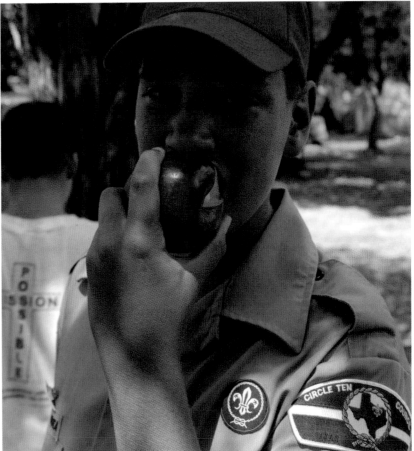

**◄ Leaps of faith**

Physically strong members of Troop 253, Bosque Farms, New Mexico, and Albuquerque's Venturing Crew 762 jump from dunes at White Sands National Monument.

**▲ An apple a day**

A Scout at Circle Ten Council's Camp Constantin knows a good diet can be delicious, juicy, and crisp.

**▲ Healthy habits begin right now**

BSA literature encourages smart food choices and plenty of daily exercise in camp, at home, and during school.

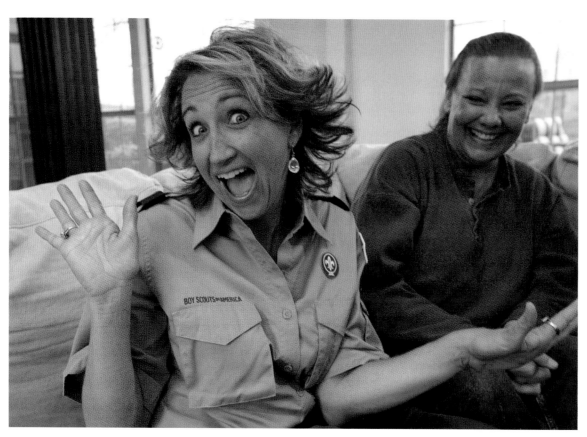

▲ **Joy of Scouting**
Adult leaders find great satisfaction and delight as they join one another to build successful programs for Scouts of all ages.

**A challenge accepted** ▶
Rappelling builds trust in the belayer above and reliance on one's own ability to find a route to success.

◀ **The heart of the matter**
Learning the warning signals of a heart attack readies Scouts to respond if they come upon someone with health difficulties.

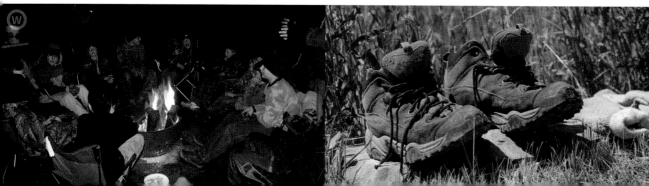

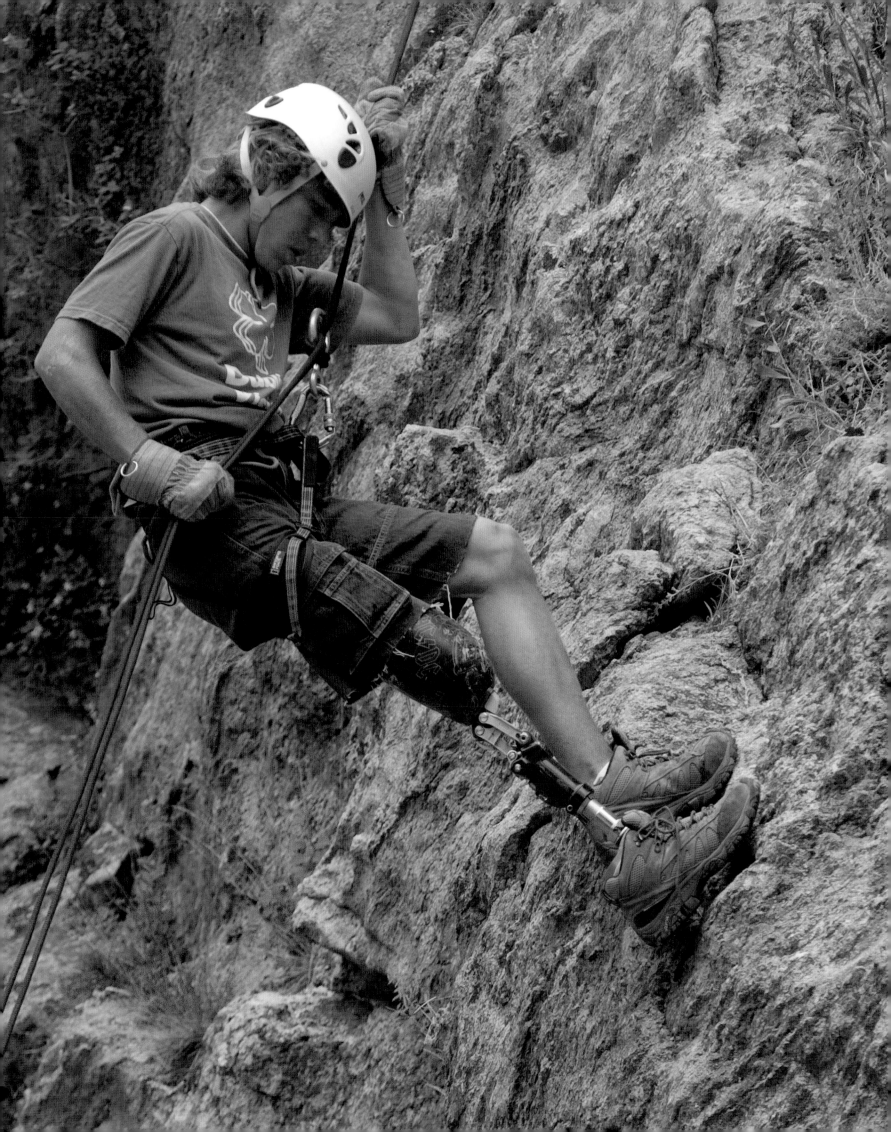

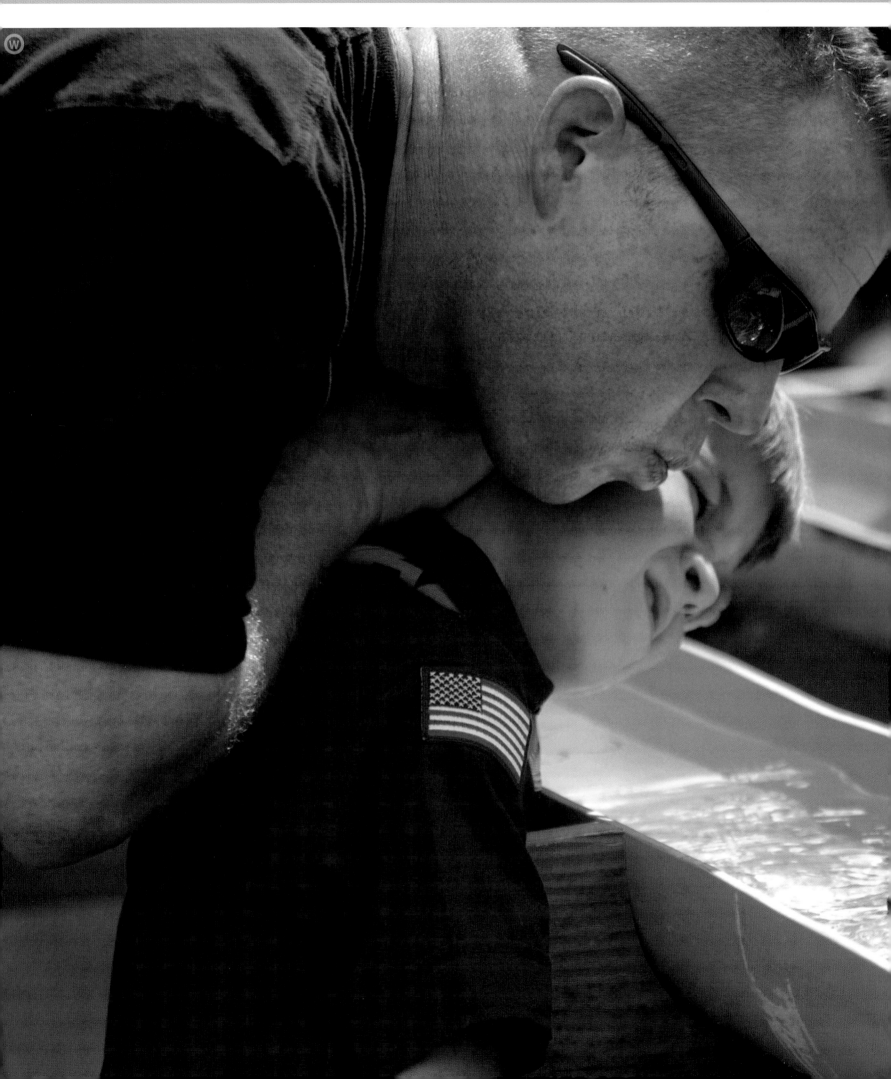

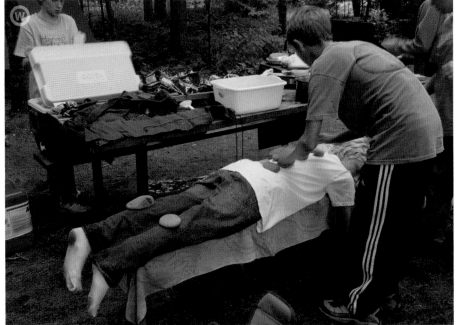

◀ **Like father, like son**
Aiden Eagle shares a breezy
moment with his dad as they race
the boat they built for a Cub Scout
Raingutter Regatta.

▲ **Easing the effort**
At the end of a long day of
hiking, Scouts try out warm rock
therapy by placing stones on
sore legs and backs.

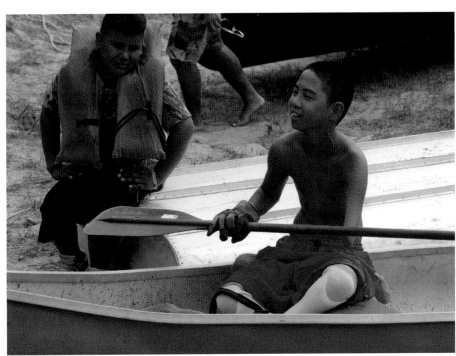

▲ **Canoeing with confidence**
Boys join together to embark on terrific Scouting
adventures matched to their interests and capabilities.

Lifting his share of the load, a Scout wisely uses his effort and hours.

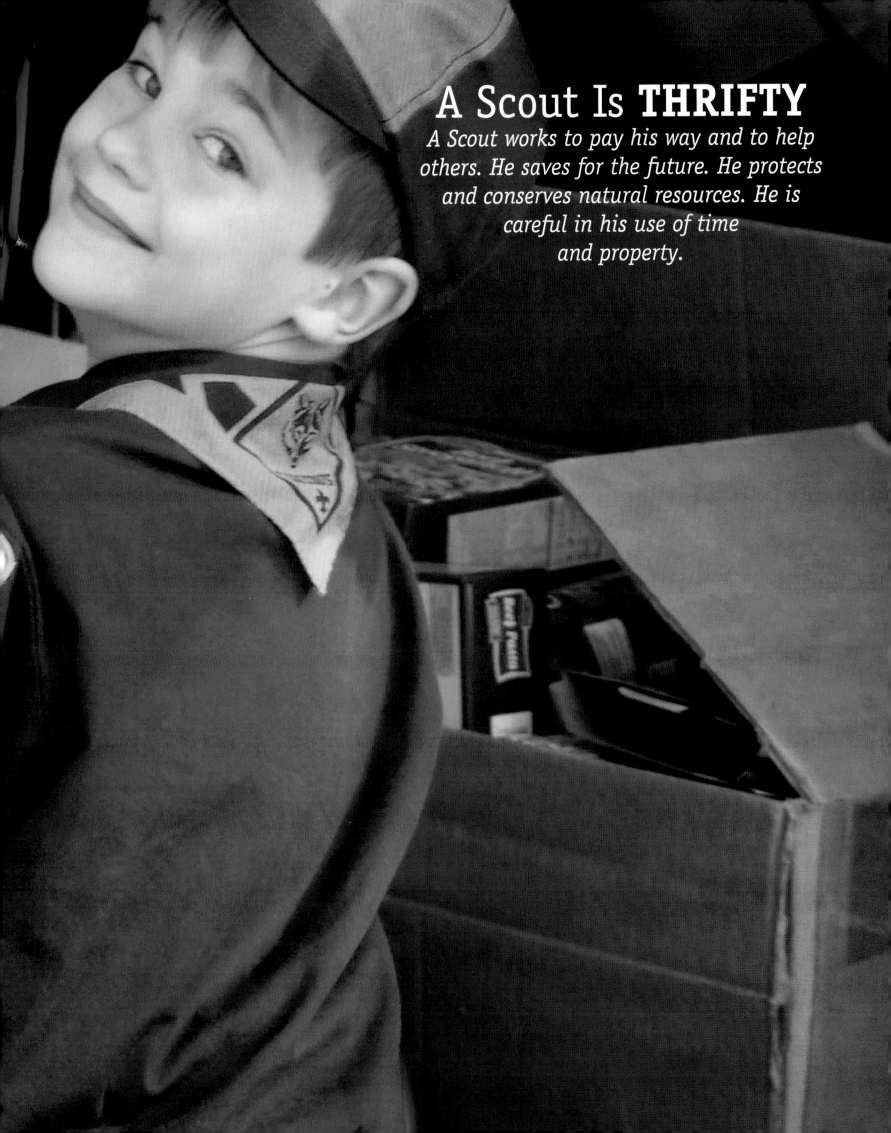

# A Scout Is **THRIFTY**

*A Scout works to pay his way and to help others. He saves for the future. He protects and conserves natural resources. He is careful in his use of time and property.*

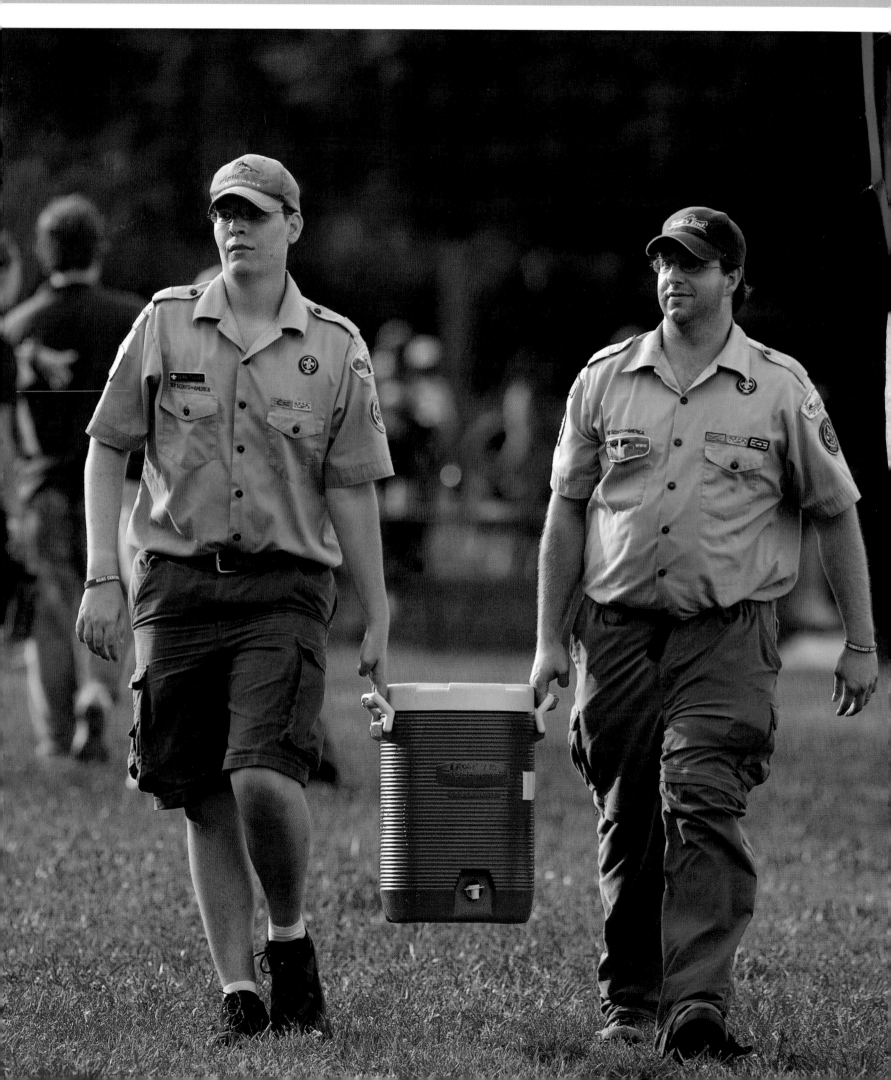

**◄ Refreshments on the move**
Leaders deliver water to Scouts
at a sunny Centennial Camporee.

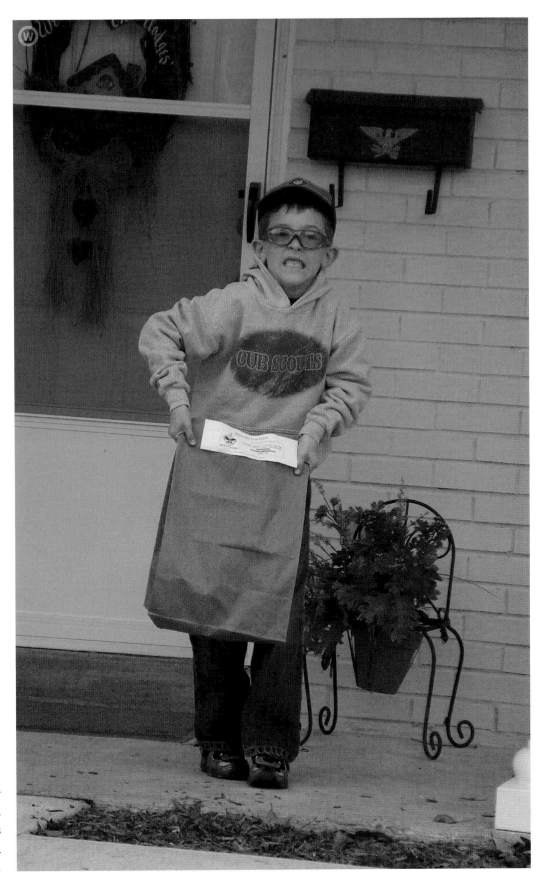

**Hoisting a bag of hope ▶**
Caring for others starts with
a simple gesture of kindness
during a Scouting for Food
drive in Huntsville, Alabama.

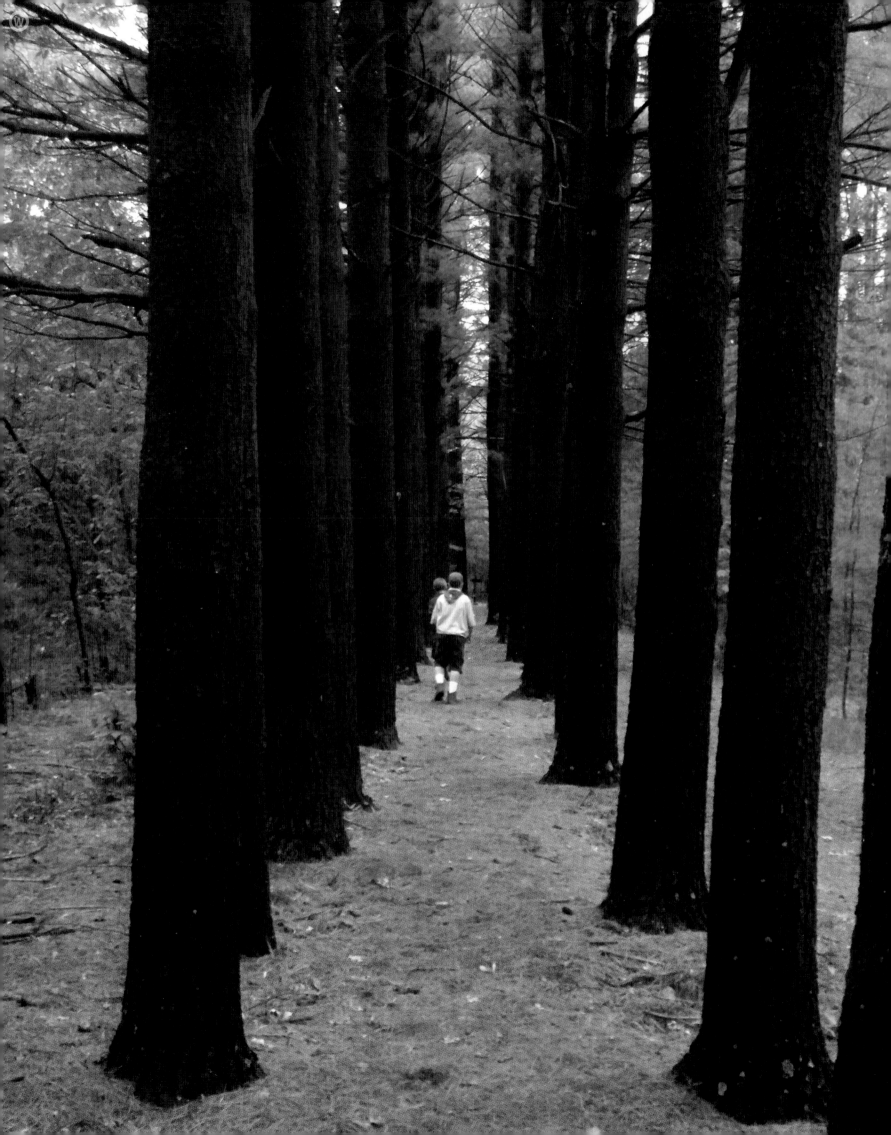

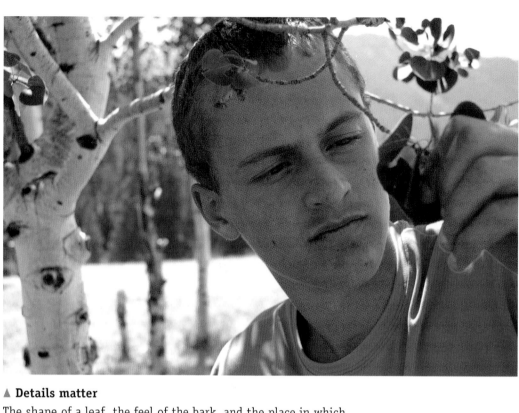

▲ **Details matter**
The shape of a leaf, the feel of the bark, and the place in which a tree grows are all clues for a Scout learning to identify trees.

◄ **Setting the tone**
Illinois and Wisconsin Scouts hike the forested entry to the Chapel in the Pines at Des Plaines Valley Council's Camp Shin-Go-Beek.

▲ **Appreciating nature**
With time to wander and a BSA introduction to the outdoors, Scouts exploring a summer trail have a good understanding of their surroundings.

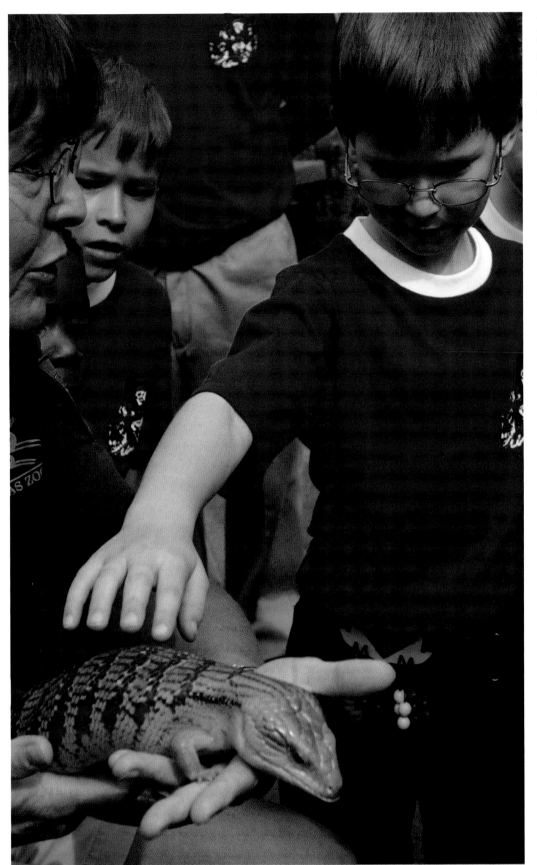

◄ **Touching the wild**
Boys and their families share the wonder of getting to know reptiles during a Tiger Cub outing at the Dallas Zoo.

**Leap toward learning** ▶
A boy and a frog share a slippery moment at Massawepie Scout Camp, a gem of the Seneca Waterways Council near New York's Tupper Lake.

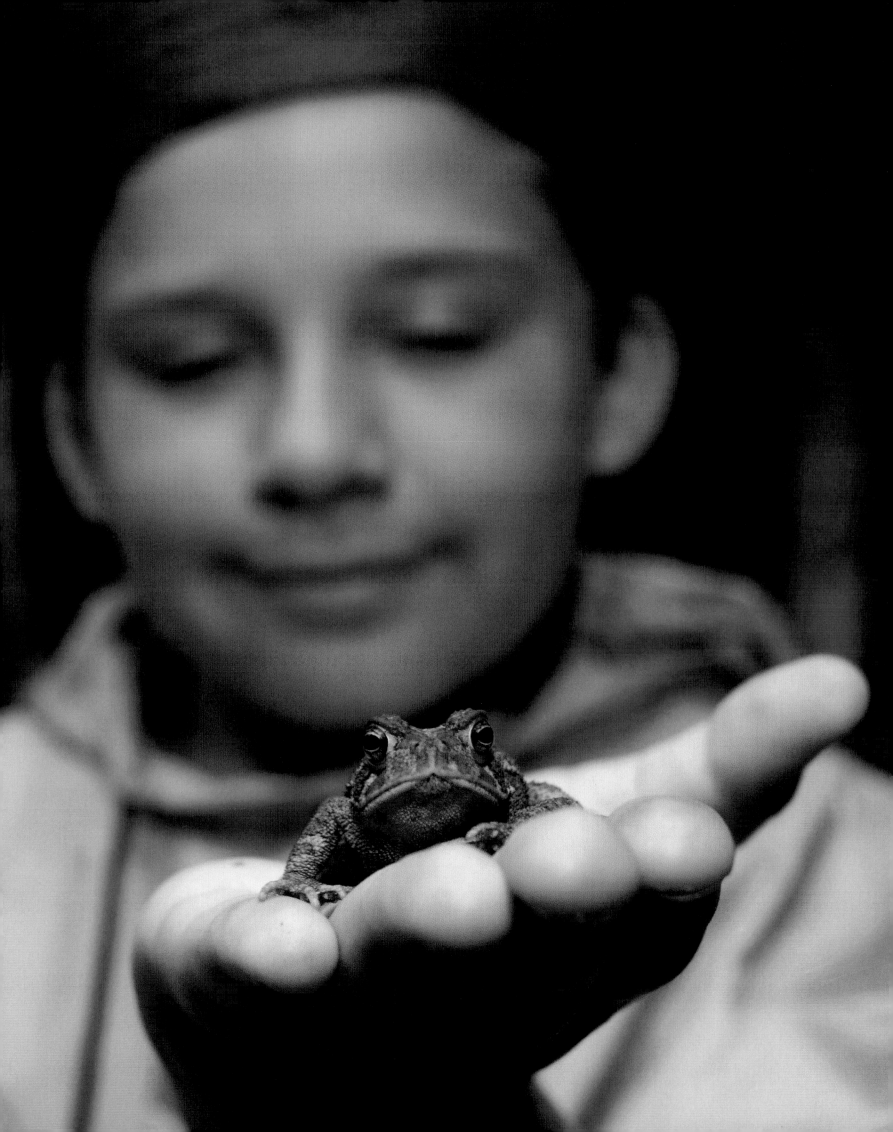

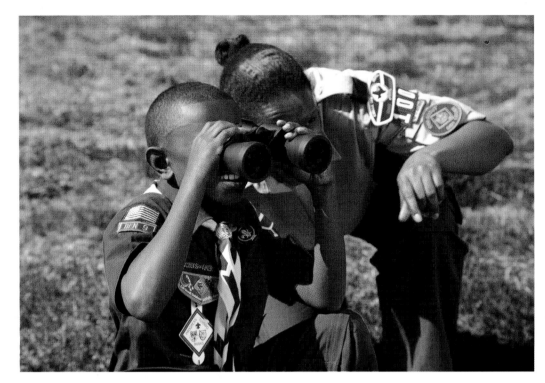

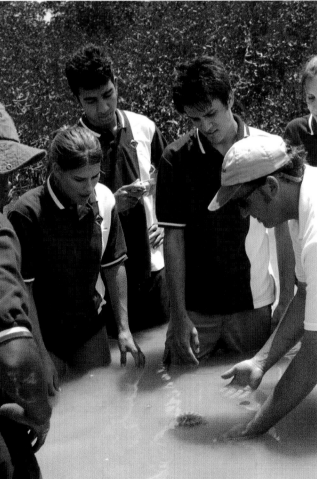

**▲ Taking the long view**
BSA programs build
environmental awareness
through the years,
encouraging Scouts
to become responsible
stewards of the land.

**Running with the wind ▶**
Fresh breezes in their faces
and the feel of leaves rushing
by give Cub Scouts a taste of
being folded into nature.

**◀ Waist-deep in wonder**
An instructor at the Florida
Sea Base guides a crew of
Venturers eager to understand
the science behind protecting
marine wildlife.

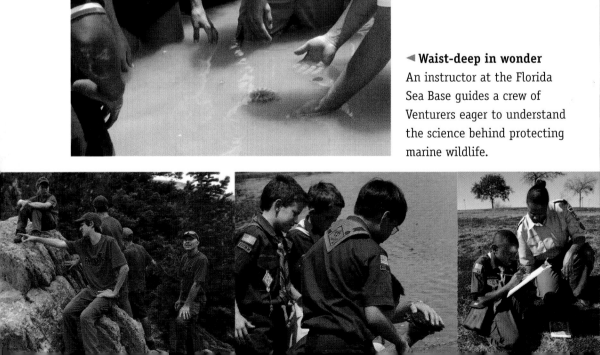

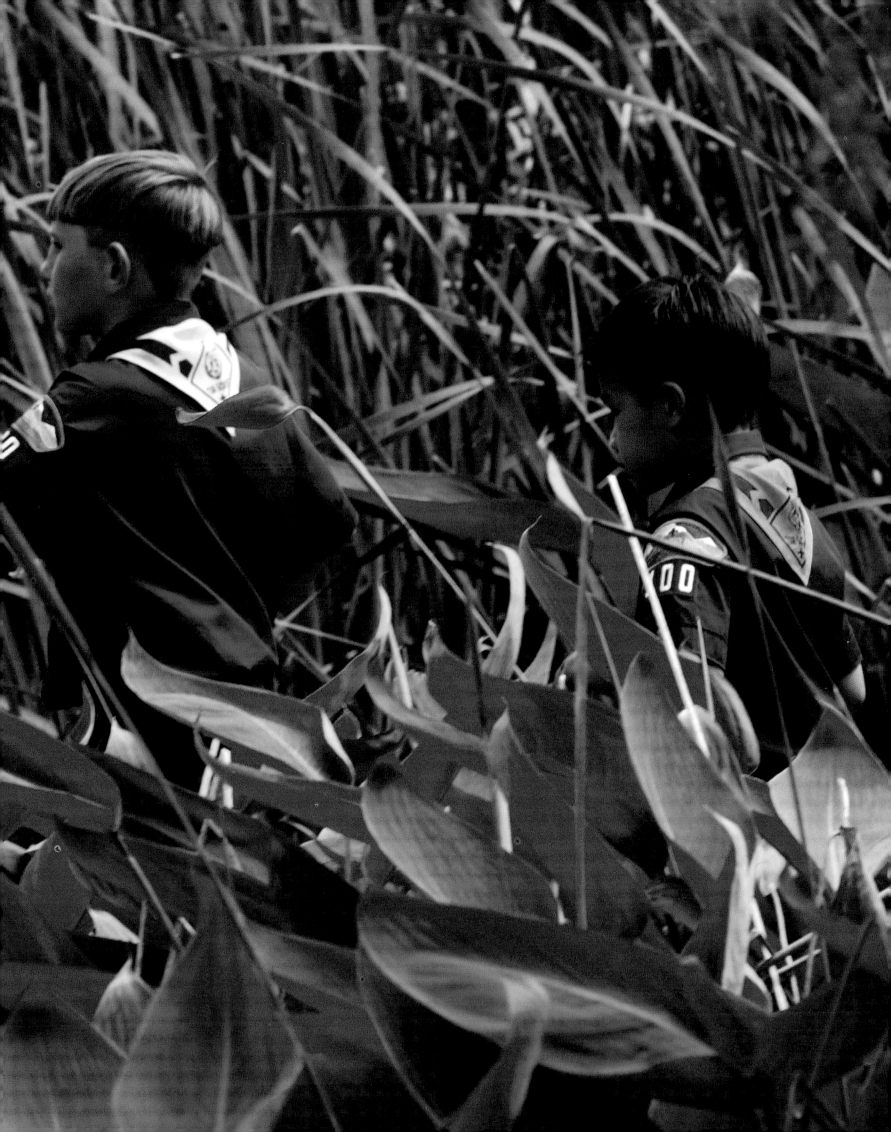

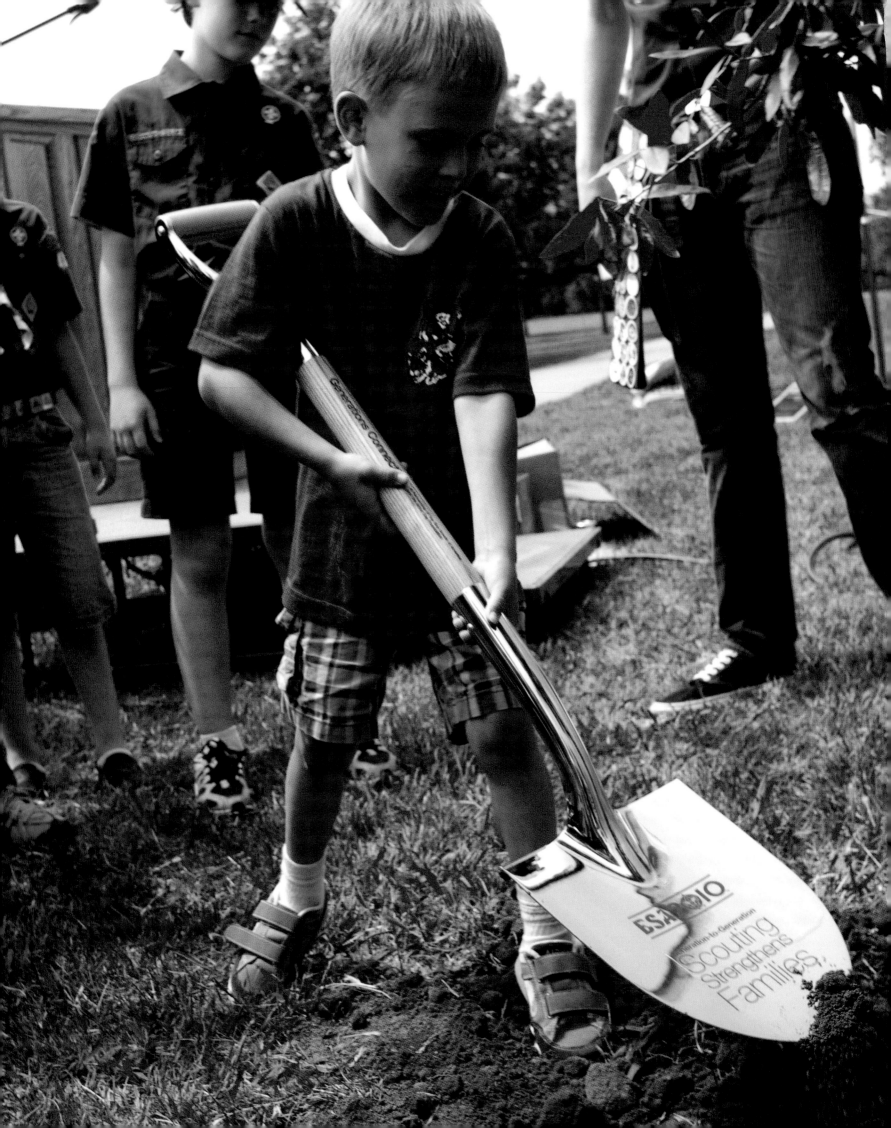

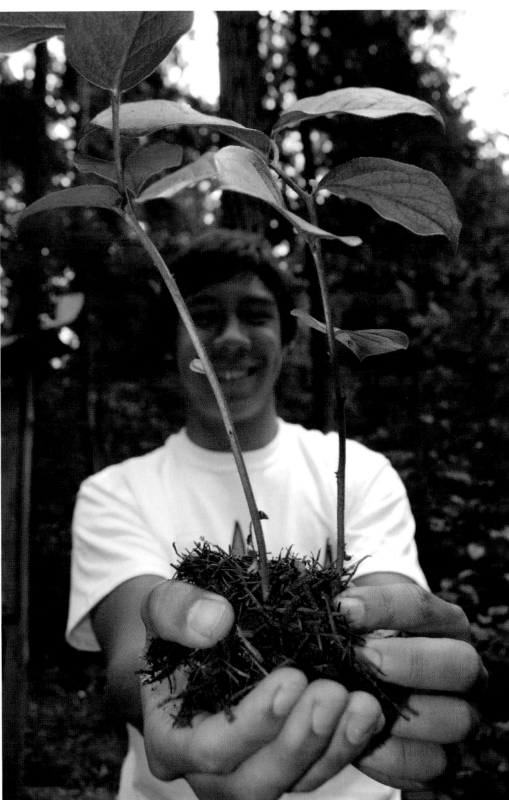

◀ **Rooting for the future**
A Tiger Cub wielding a shovel etched with the legend "Scouting Strengthens Families" celebrates the message by planting a tree.

▲ **Small acts with big results**
On a day he will long remember, a Scout transplanting native vegetation slows erosion in a damaged meadow.

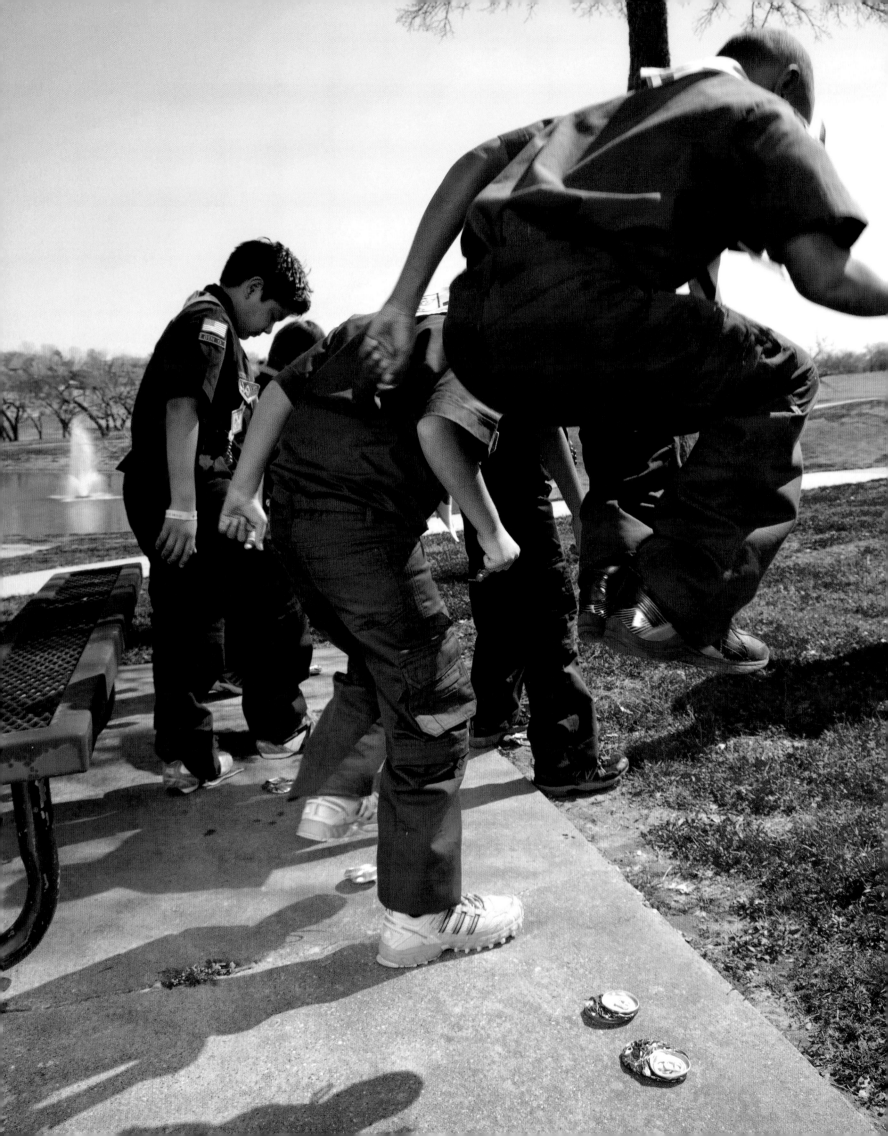

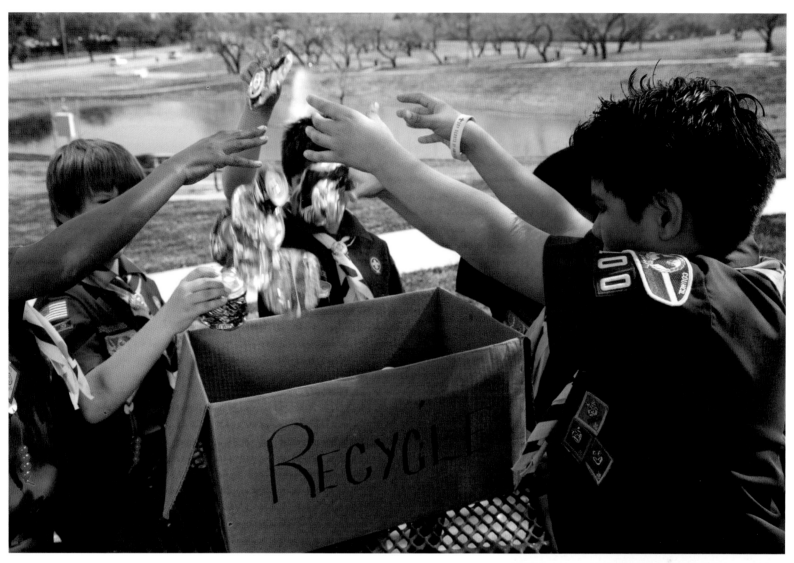

**▲ What goes around comes around**
Recycling cans, bottles, and paper is an easy way for Scouts to play a positive role in the health of the planet.

**For humanity's sake ▶**
BSA volunteers with Habitat for Humanity benefit in spirit as they play their part in providing a deserving family with a new home.

**◀ Stomping out complacency**
Scouts find caring for the Earth can be fun—a good lesson for deepening their dedication to doing the right thing.

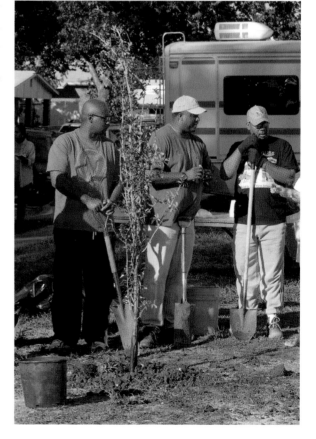

**Shovel loads of stewardship** ▶
Cub Scouts pitch in with friends to see a community tree planting project through to completion.

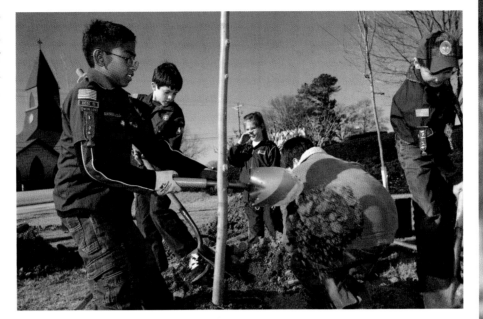

**Going the distance** ▶
Good habits formed when they are young can stay with Scouts for a lifetime of environmental awareness and positive action.

◀ **Local heroes**
Downtown Snellville, Georgia, looks better than ever thanks to the efforts of young citizens from a local Cub Scout pack.

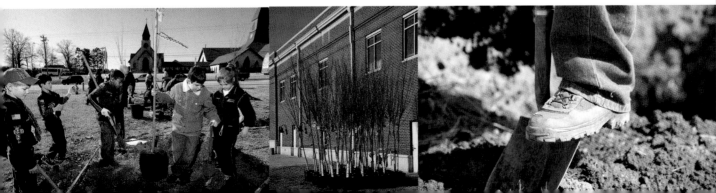

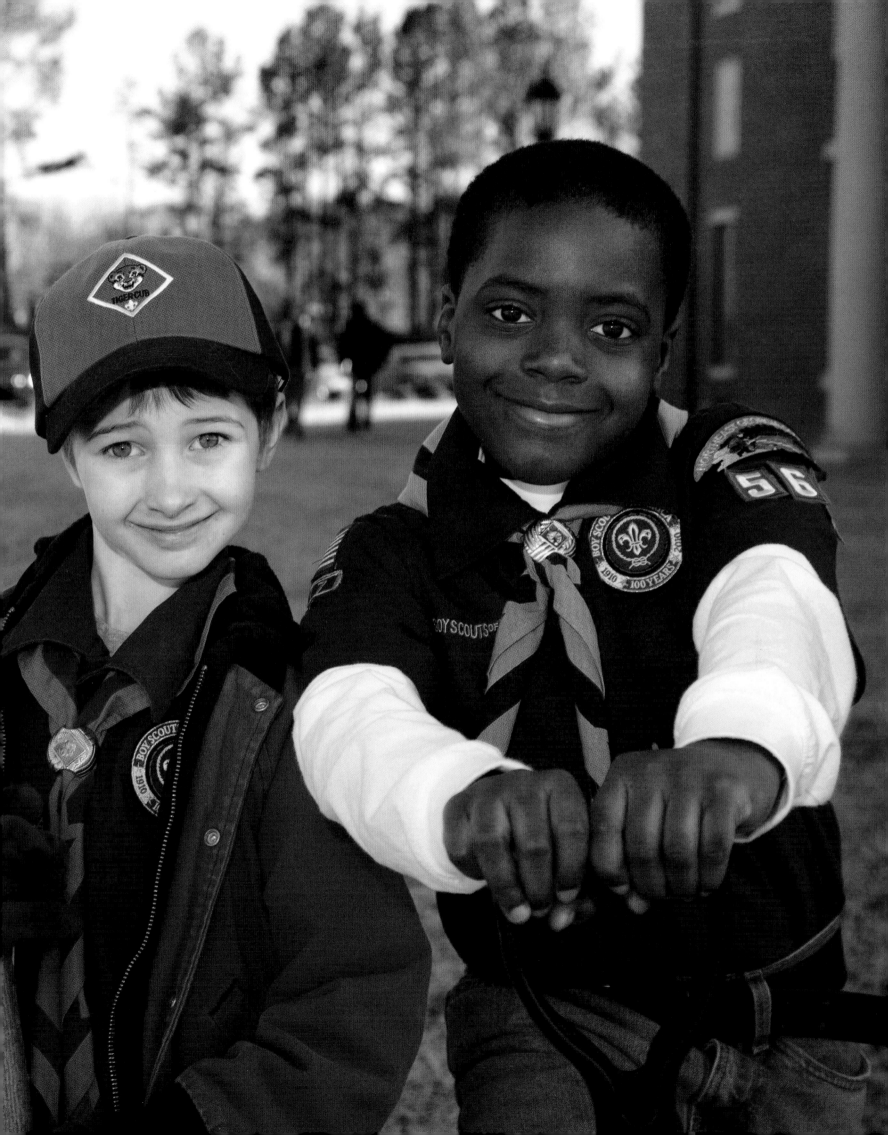

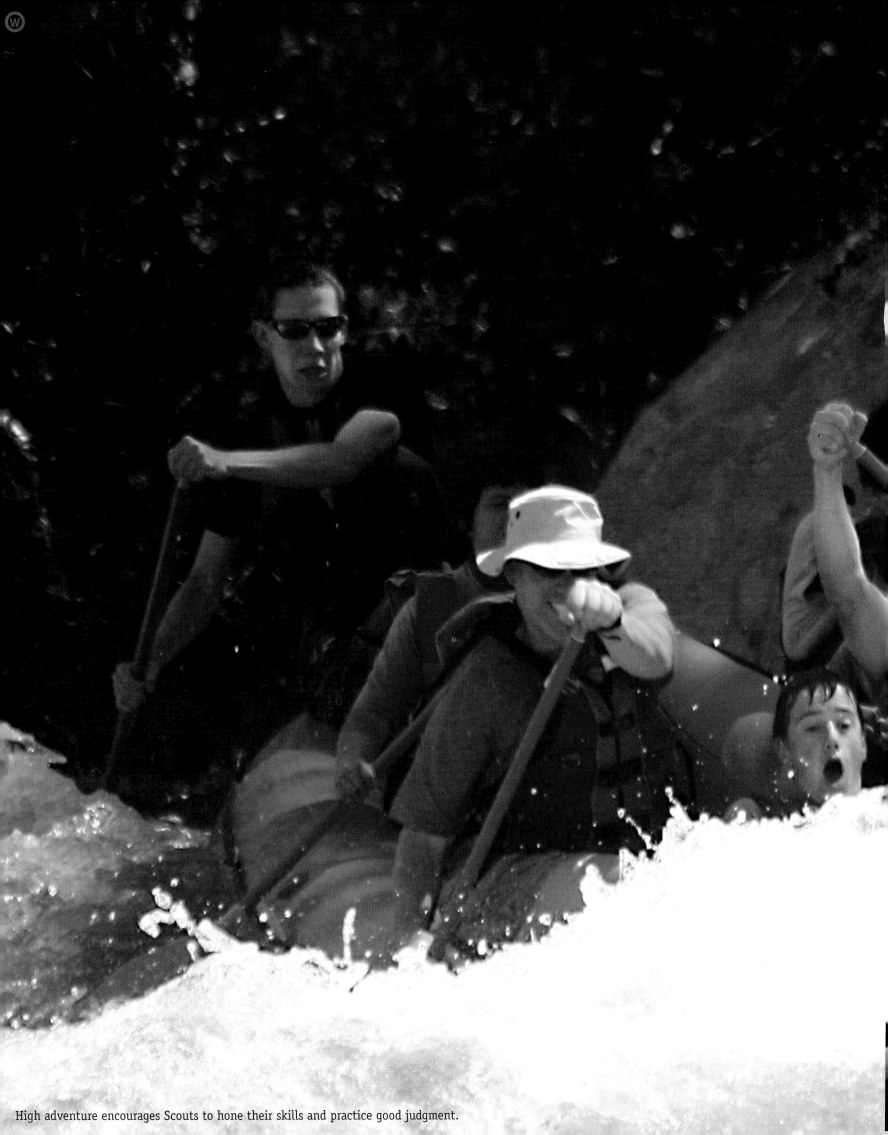

High adventure encourages Scouts to hone their skills and practice good judgment.

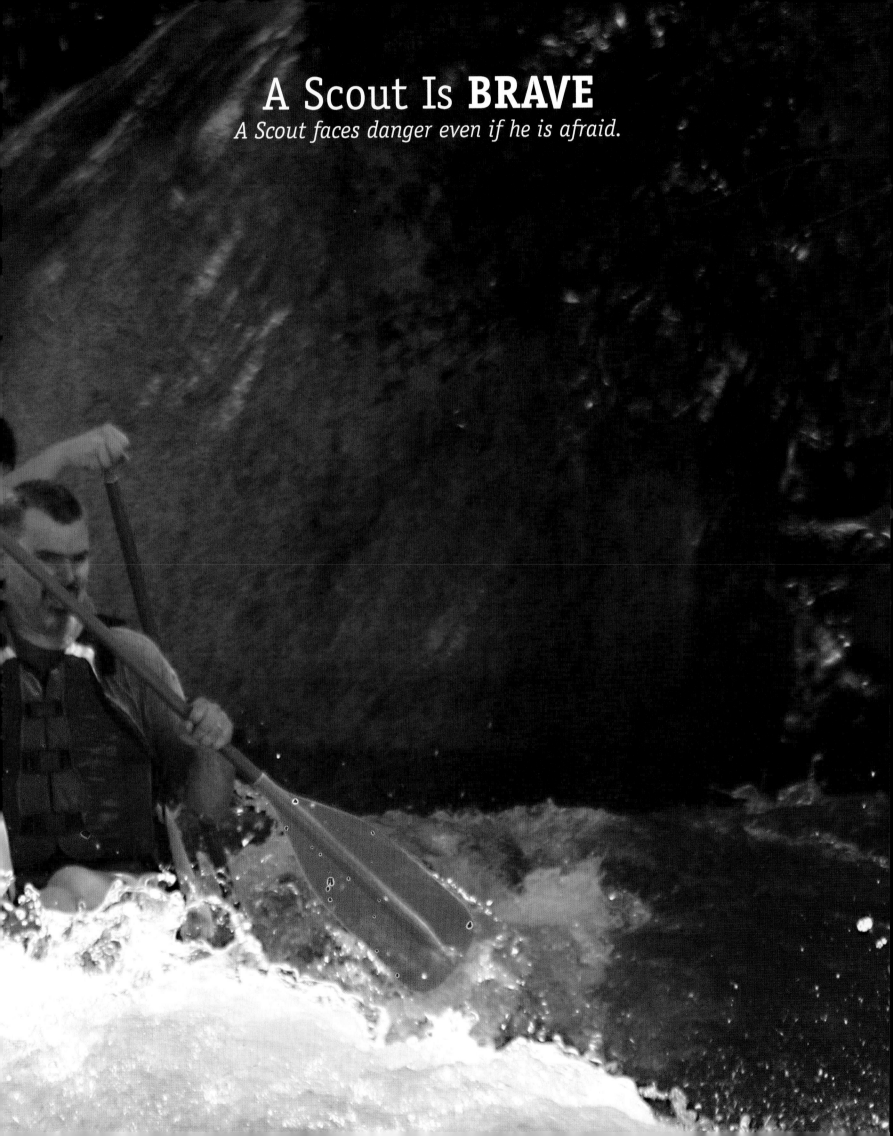

# A Scout Is **BRAVE**
*A Scout faces danger even if he is afraid.*

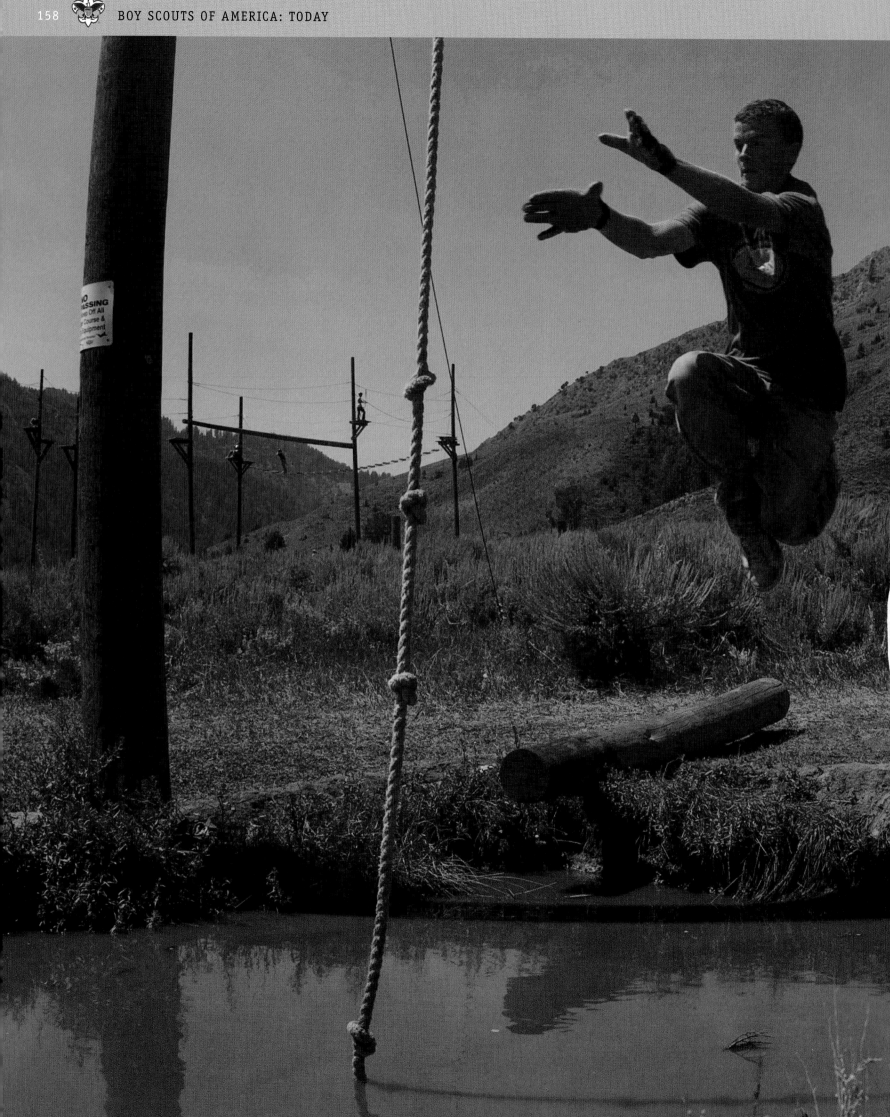

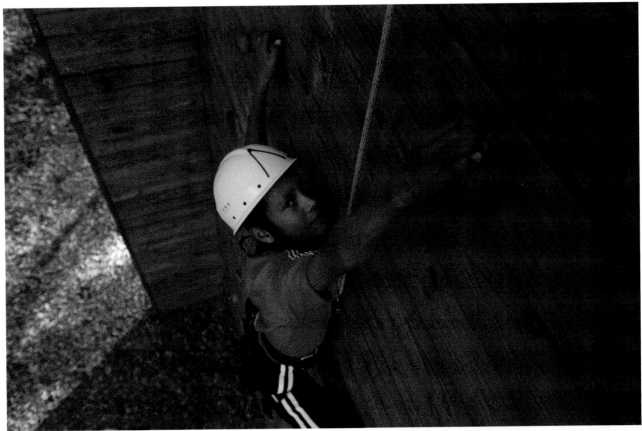

**▲ Upward progress**
The security of a belay rope gives a Scout confidence to challenge his limits and reach beyond what he thought possible.

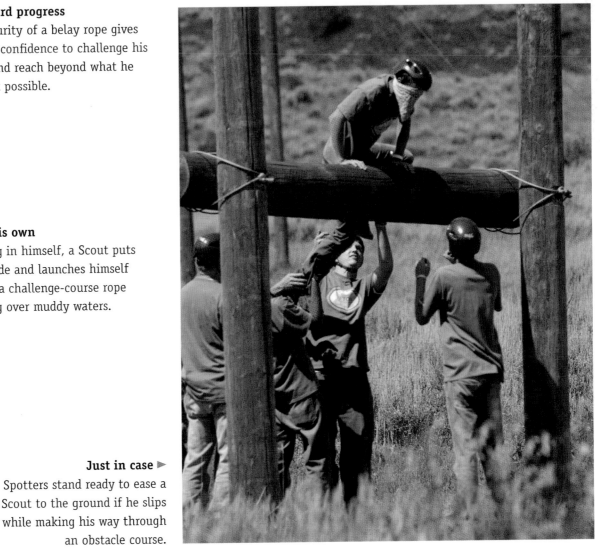

**◄ On his own**
Trusting in himself, a Scout puts fear aside and launches himself toward a challenge-course rope hanging over muddy waters.

**Just in case ►**
Spotters stand ready to ease a Scout to the ground if he slips while making his way through an obstacle course.

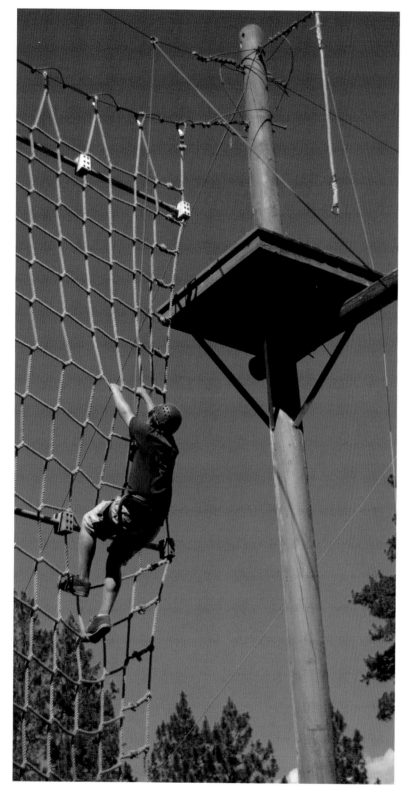

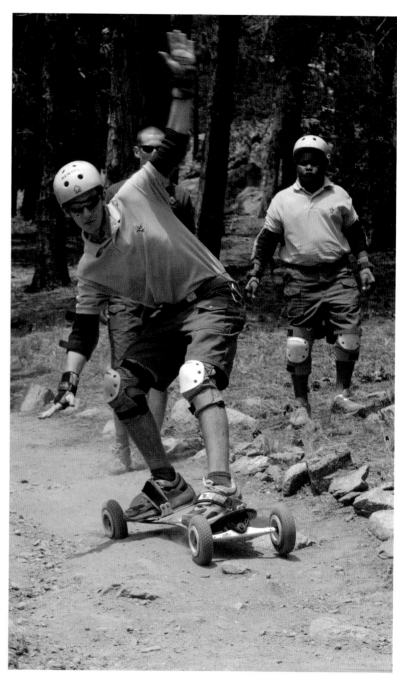

▲ **A balanced attitude**
Edging the curve of a trail in the Rocky Mountains,
a Scout riding a mountain board drops in.

▲ **Scrambling toward the sky**
A cargo net leads Scouts toward the next
element of a course designed to expand
their problem-solving skills.

**Spar climber's progress** ▶
Sharpened spurs strapped to his boots, a Scout at
a Philmont Scout Ranch interpretive camp belts
himself into the lumberjack life.

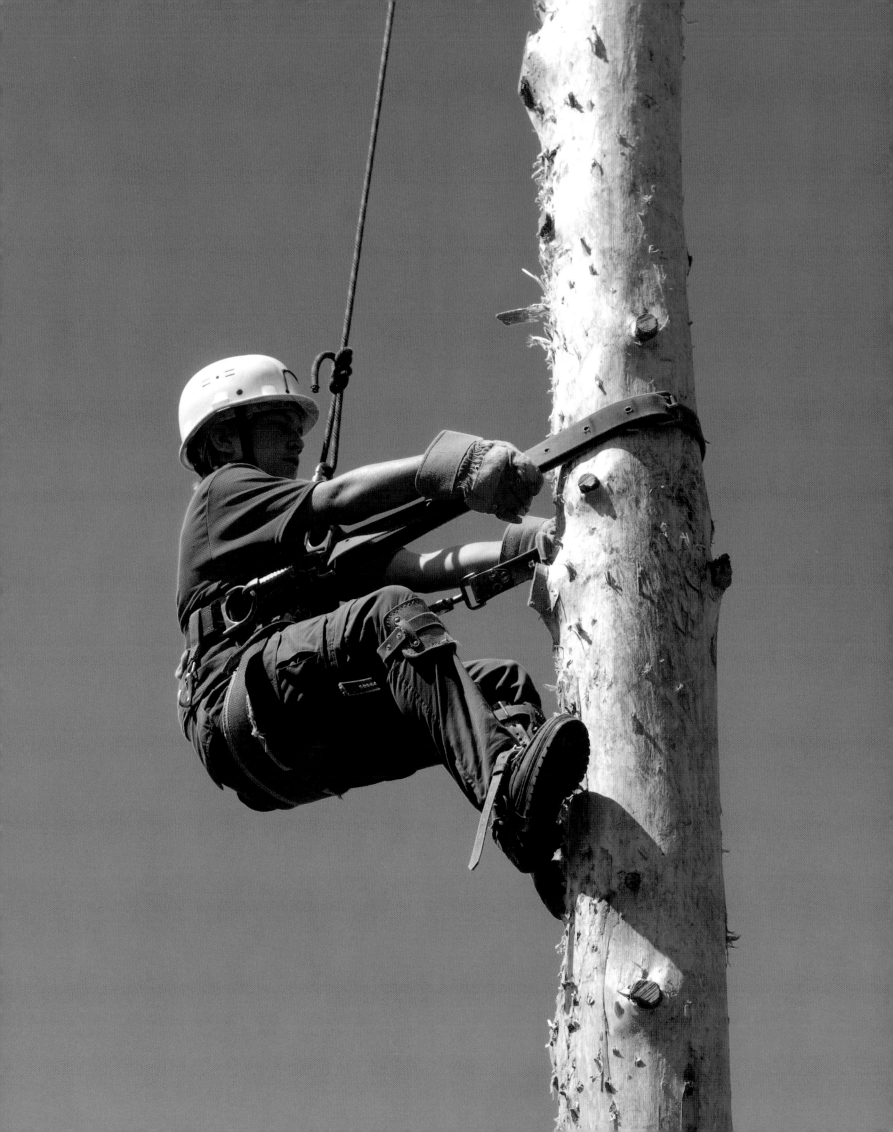

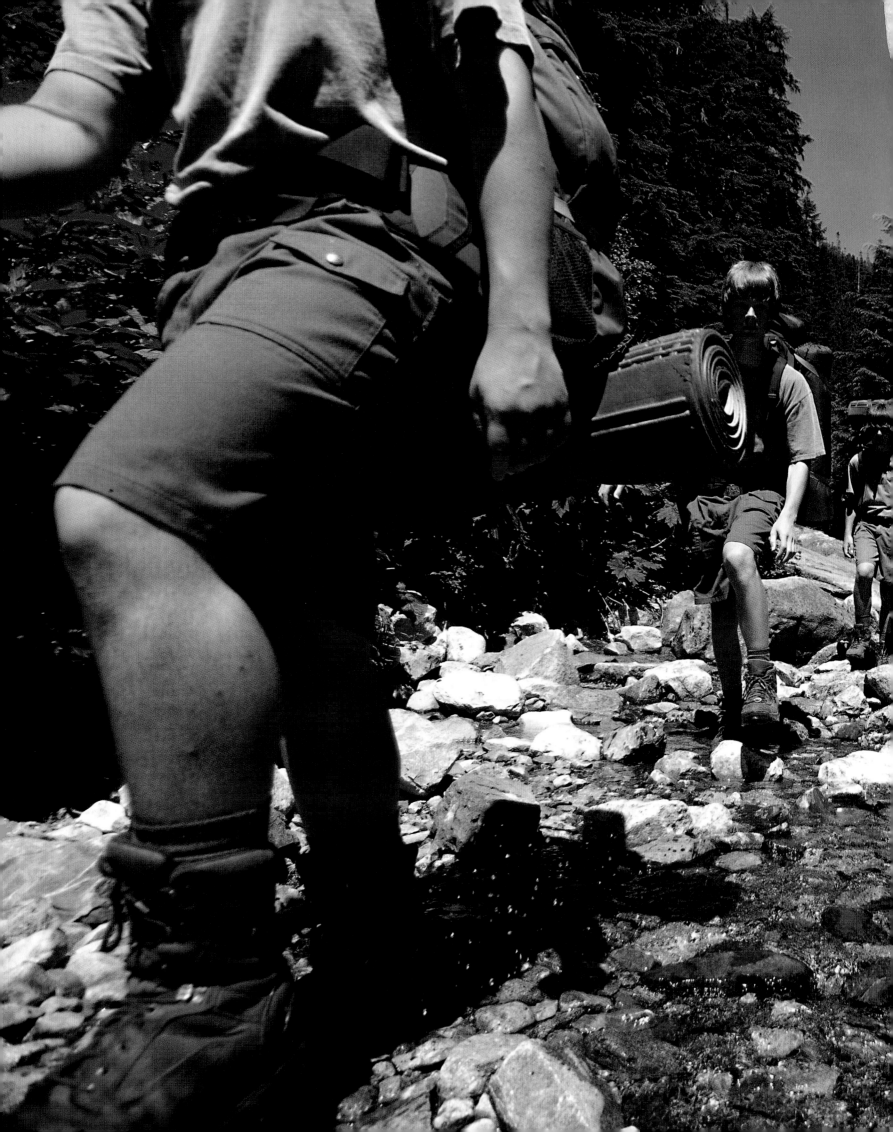

**A trail less taken** ▶
Scouts and leaders of Troop 652, Rancho Cucamonga, California, make their way deep into the San Bernardino National Forest.

◀ **Leave No Trace**
Streamside stones offer backpacking Scouts a durable walking surface that lightens their impact on the land.

**Plan ahead** ▶
Knowing how to hike, camp, and use a lightweight stove allows Scouts to be kind to the environment wherever they go.

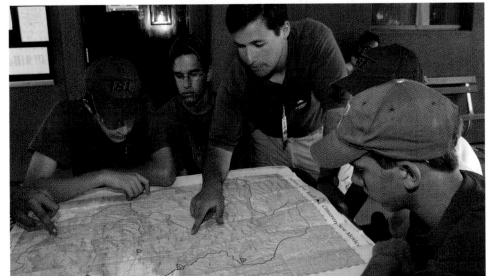

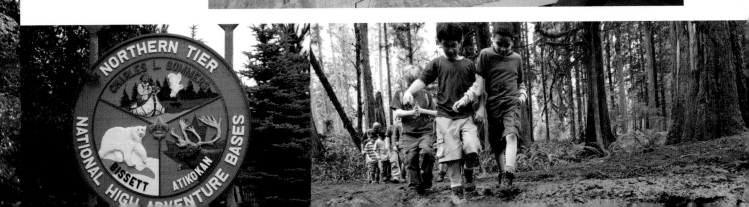

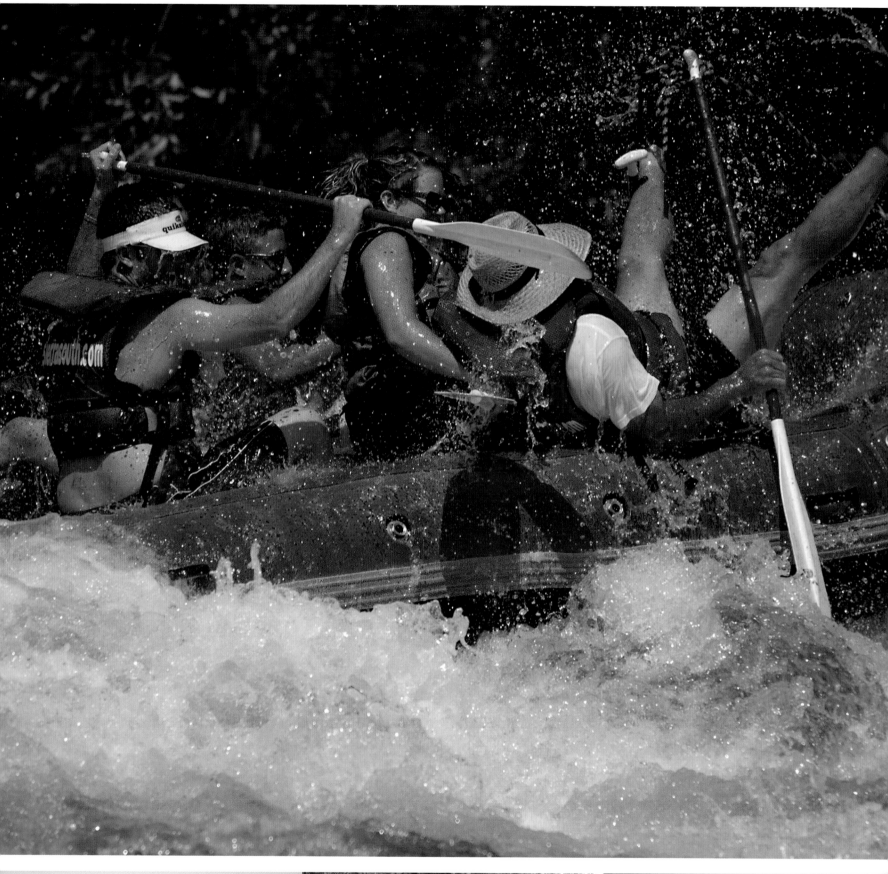

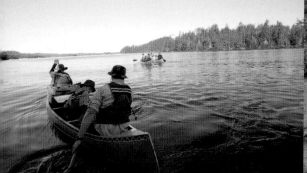

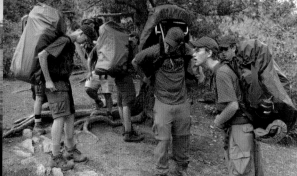

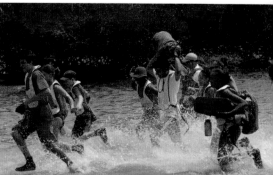

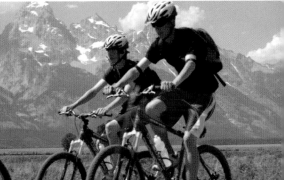

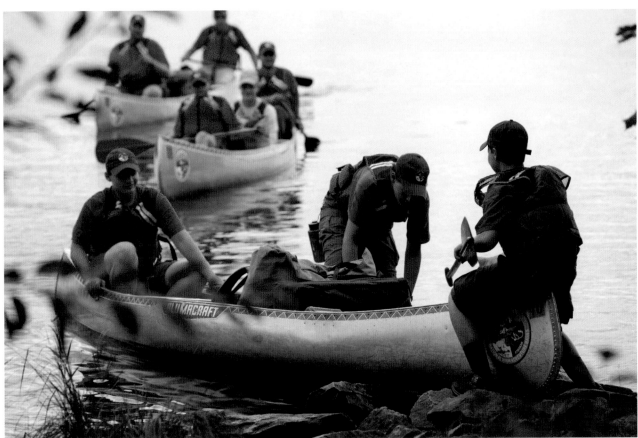

▲ **Carrying on**
A crew at a Northern Tier
National High Adventure Base
prepares to portage packs and
canoes toward the next lake on
their wilderness route.

◄ **Ride the wild wave**
With daring and skill,
rafters shoot the rapids of
a swift whitewater river.

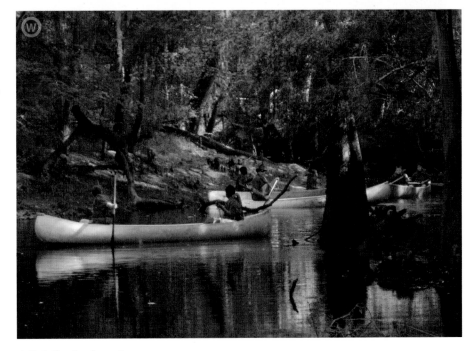

▲ **Subtle shades of green**
The glassy calm of the Canoochee River invites
Troop 500 of Hinesville, Georgia, to glide
through a rich and varied environment.

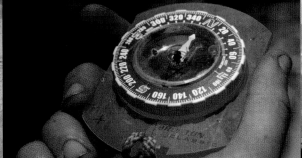

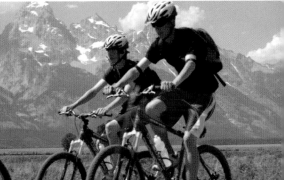

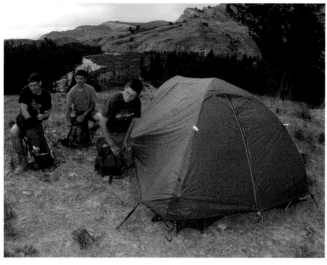

▲ **Pack it in, pack it out**
Checklists in the *Boy Scout Handbook* ensure that
wilderness travelers carry everything they need
and not an ounce more.

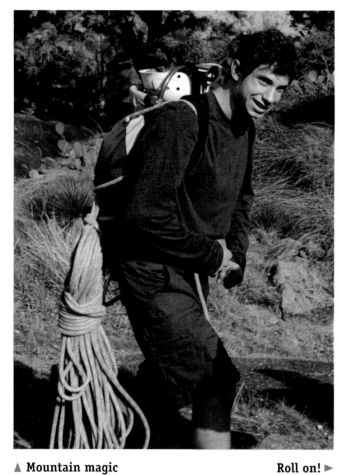

▲ **Mountain magic**
Hauling his share of rope
and safety gear, a Scout
sets off with fellow Texans
for a day of climbing on
Enchanted Rock.

**Roll on!** ►
The spirit of adventure
gains traction as a band
of Scouting brothers
cranks out the miles
beneath the hot, clear
skies of the desert
Southwest.

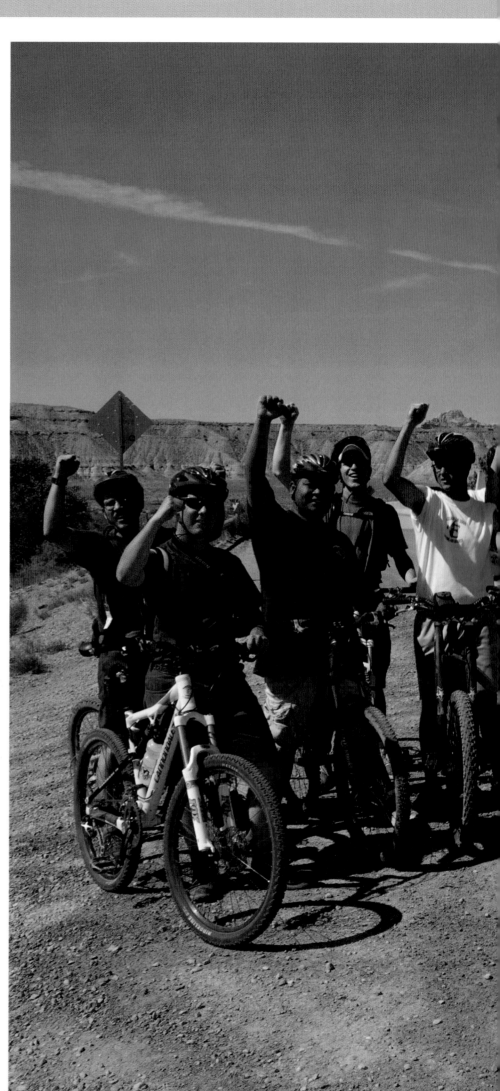

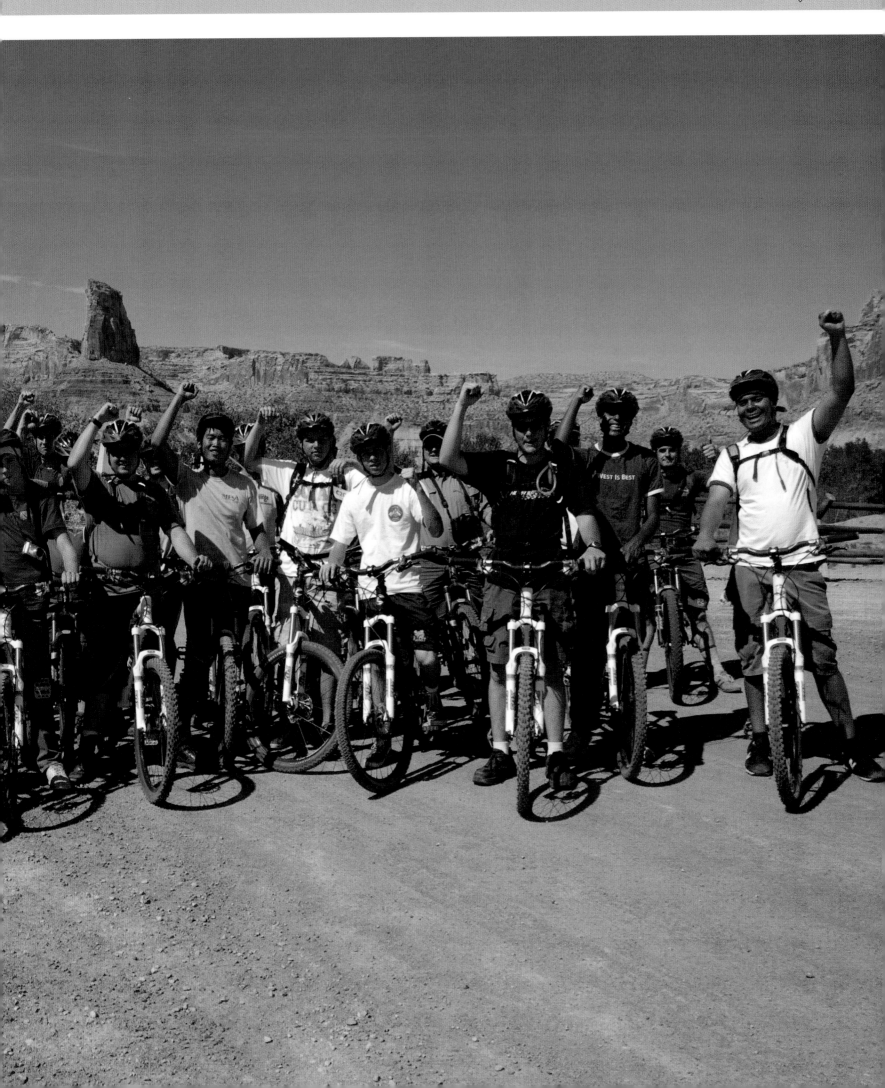

**Tradition at
the Yard of Bricks ▶**
Scouts follow the lead of
winning drivers and their
crews by kissing the bricks
forming the start/finish
line at Indianapolis
Motor Speedway.

**◀ On top of the
Scouting world**
Summiting 12,441-foot
Baldy Mountain is a peak
experience for Venturer
Tom Parsons of Chico,
California, and many
others trekking the
backcountry of Philmont
Scout Ranch.

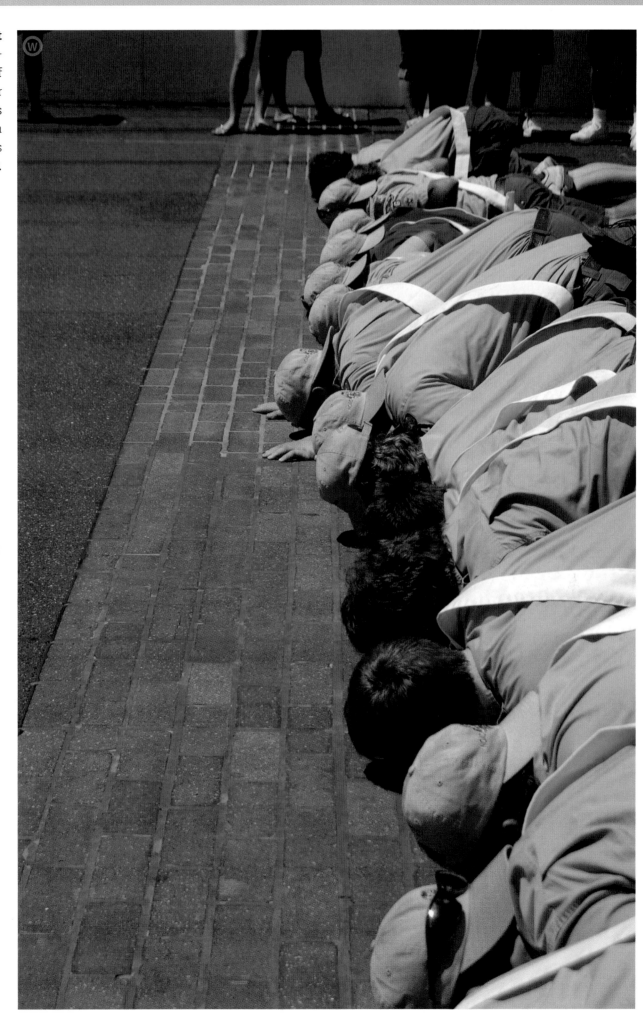

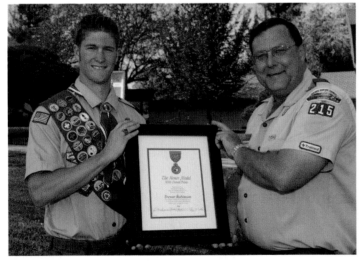

▲ **Pinned on Scouting**
The BSA recognizes accomplishments
with patches and pins, then encourages
Scouts to achieve even more.

**Barreling ahead** ▶
With ingenuity and determination,
Scouts at summer camp fashion rafts for
a raucous race across a cool lake.

◀ **In praise of valor**
Scouting values shone through for Eagle
Scout Trevor Robinson of Gold River,
California, when his quick action saved
the life of another.

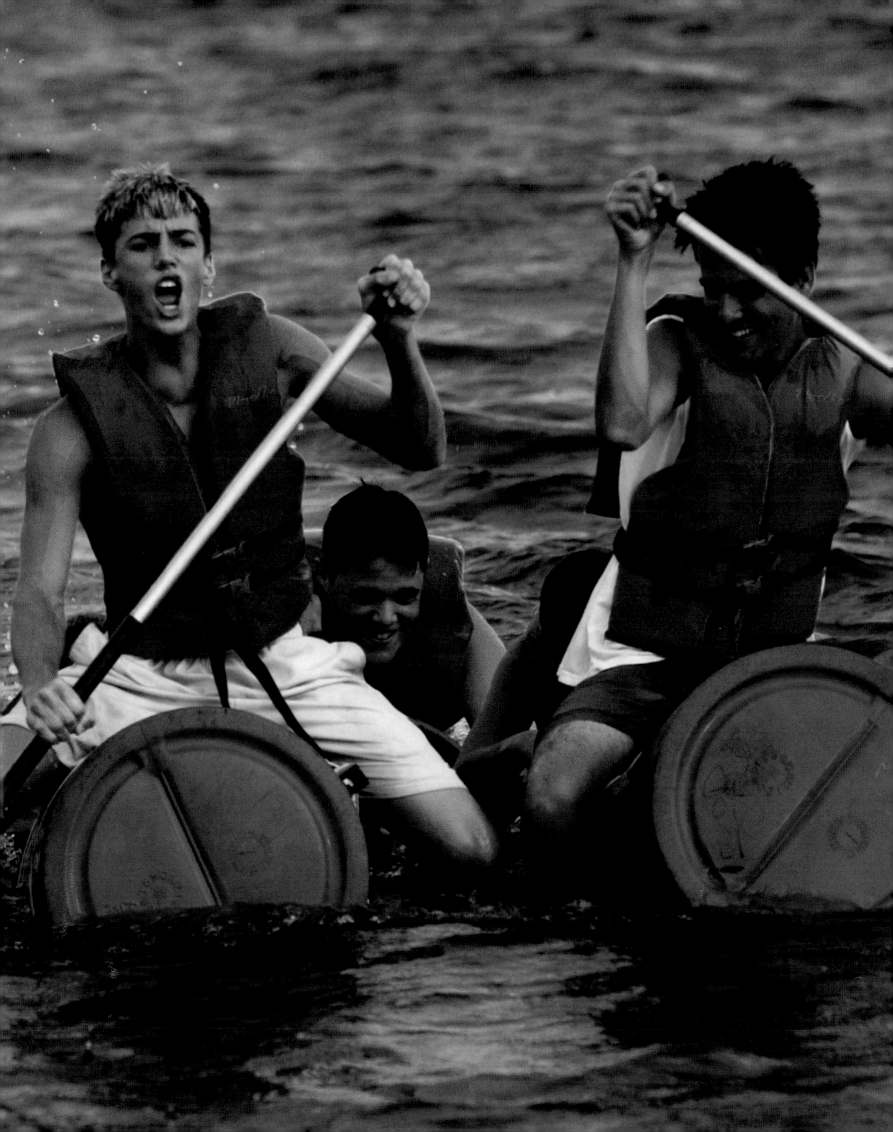

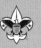
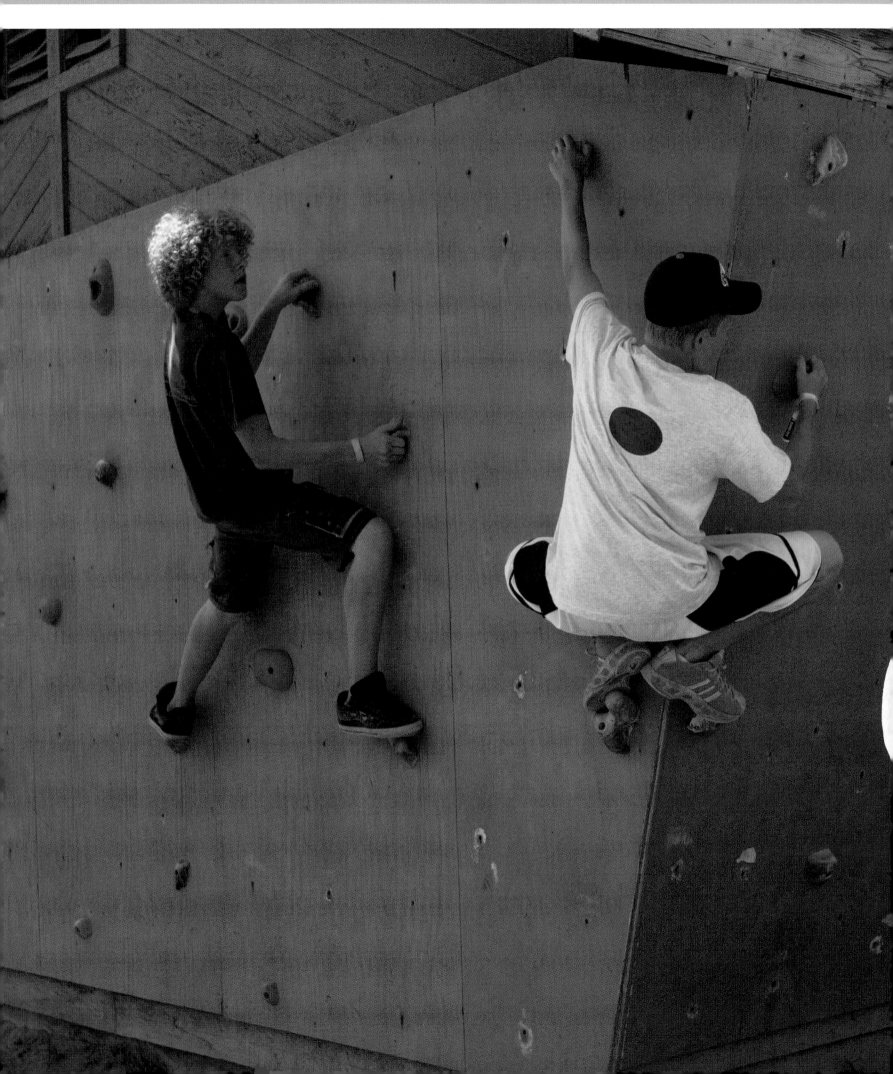

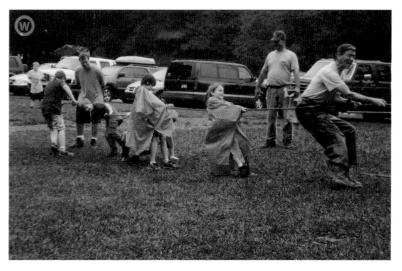

**▲ Laughing in the rain**
Webelos Scouts of Pack 535, Loganville, Georgia,
lend their weight to the fact that Scouting thrives
in all places and all kinds of weather.

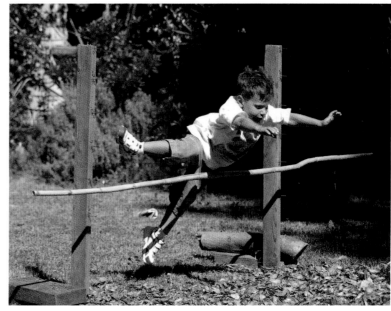

**▲ Over the top**
A young Scout leaping to his personal best is well on his
way to a lifetime of satisfaction in staying healthy and fit.

**◄ Get a grip!**
Practice in planning and carrying out
the steps for reaching goals translates to
success on a climbing wall and beyond.

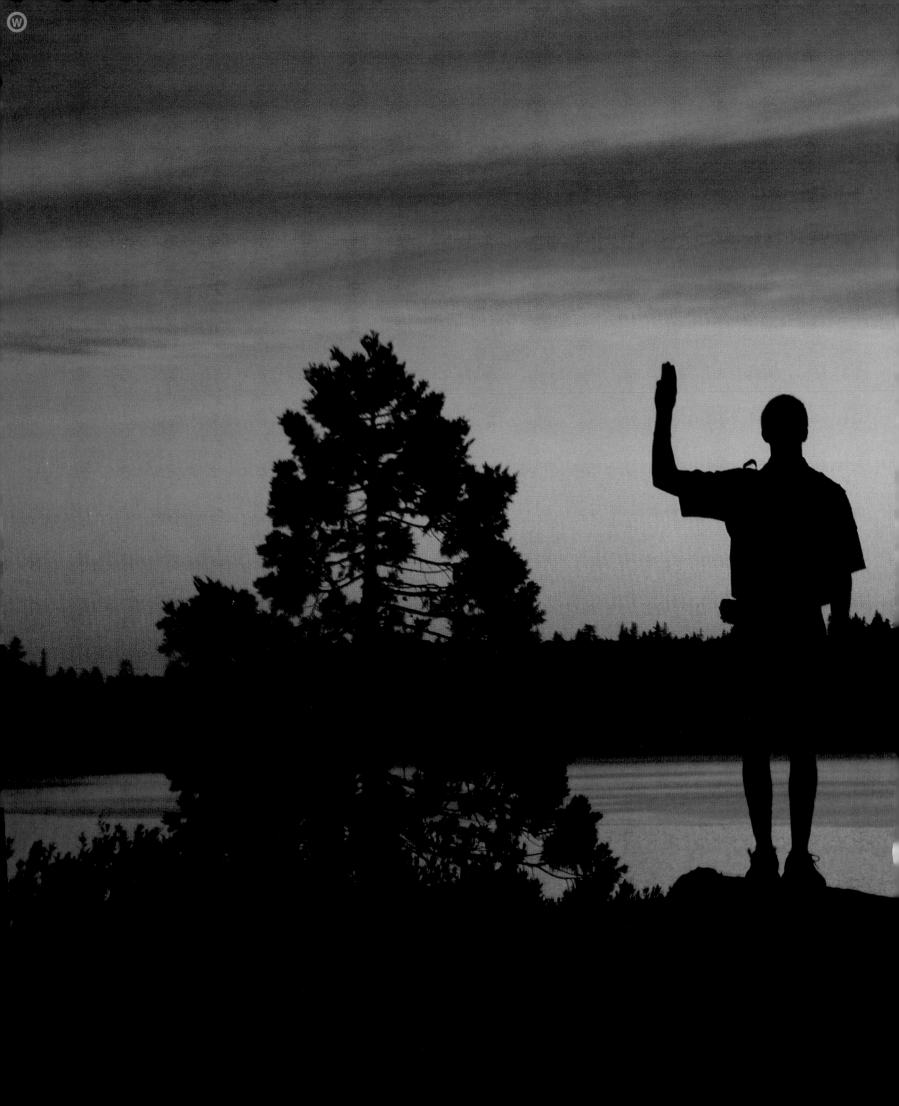

A Scout at sunset reflects on the values that have guided his day.

# A Scout Is **CLEAN**

*A Scout keeps his body and mind fit. He chooses friends who also live by high standards. He avoids profanity and pornography. He helps keep his home and community clean.*

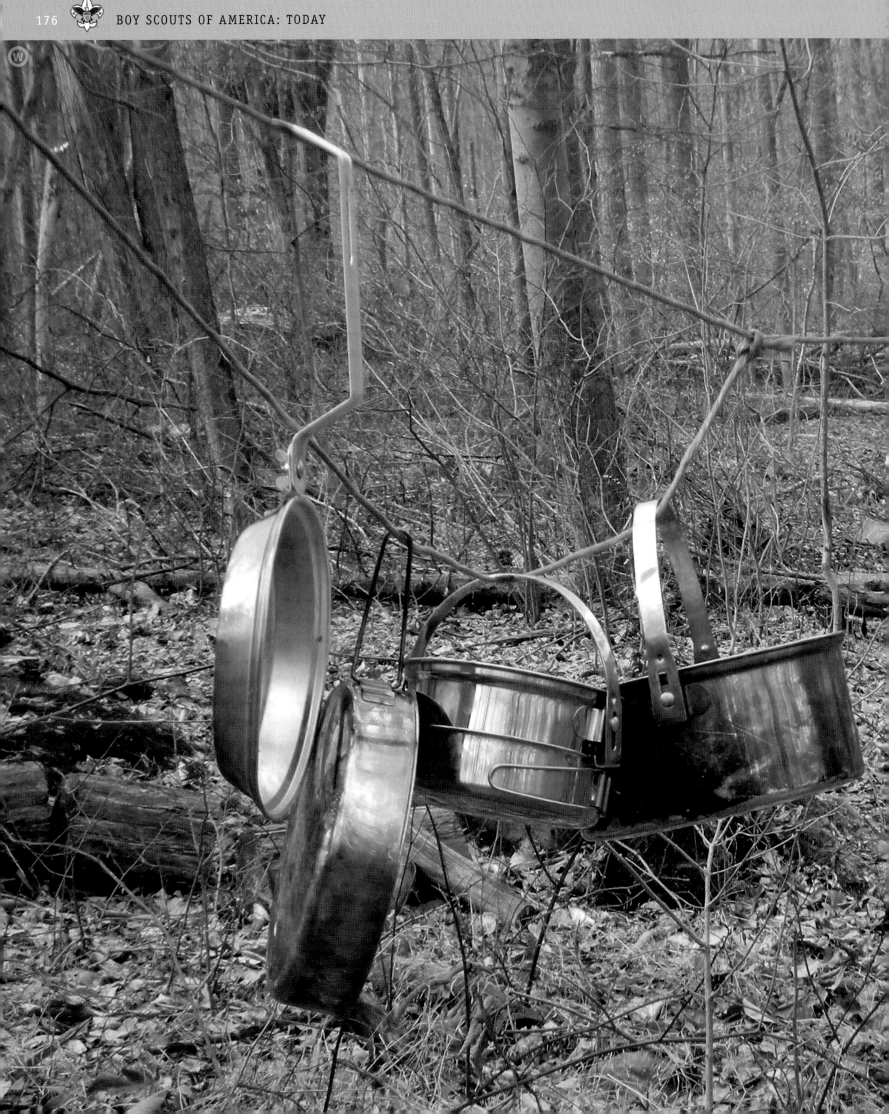

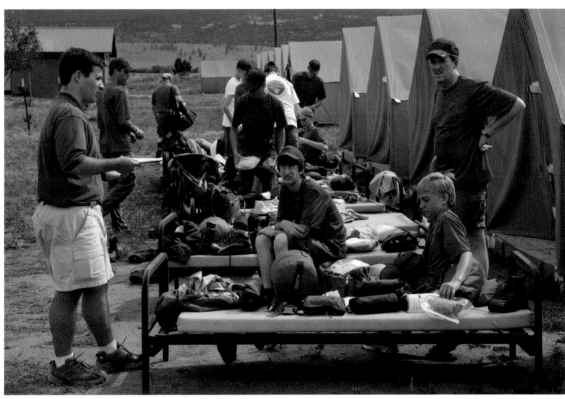

▲ **Base camp shakedown**
A ranger's check of gear enables crews going into the backcountry
of Philmont Scout Ranch to carry just what they need.

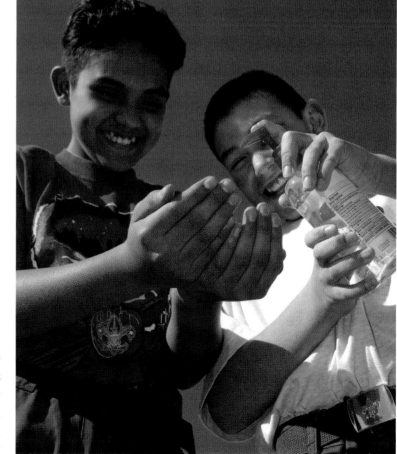

◄ **Hung out to dry**
Pots and pans scrubbed
after a troop cookout dry
in the autumn breeze.

**Keeping germs at bay** ►
The Scout *Fieldbook* reminders
for backcountry health?
"**1.** Wash your hands.
**2.** Wash your hands.
**3.** Wash your hands."

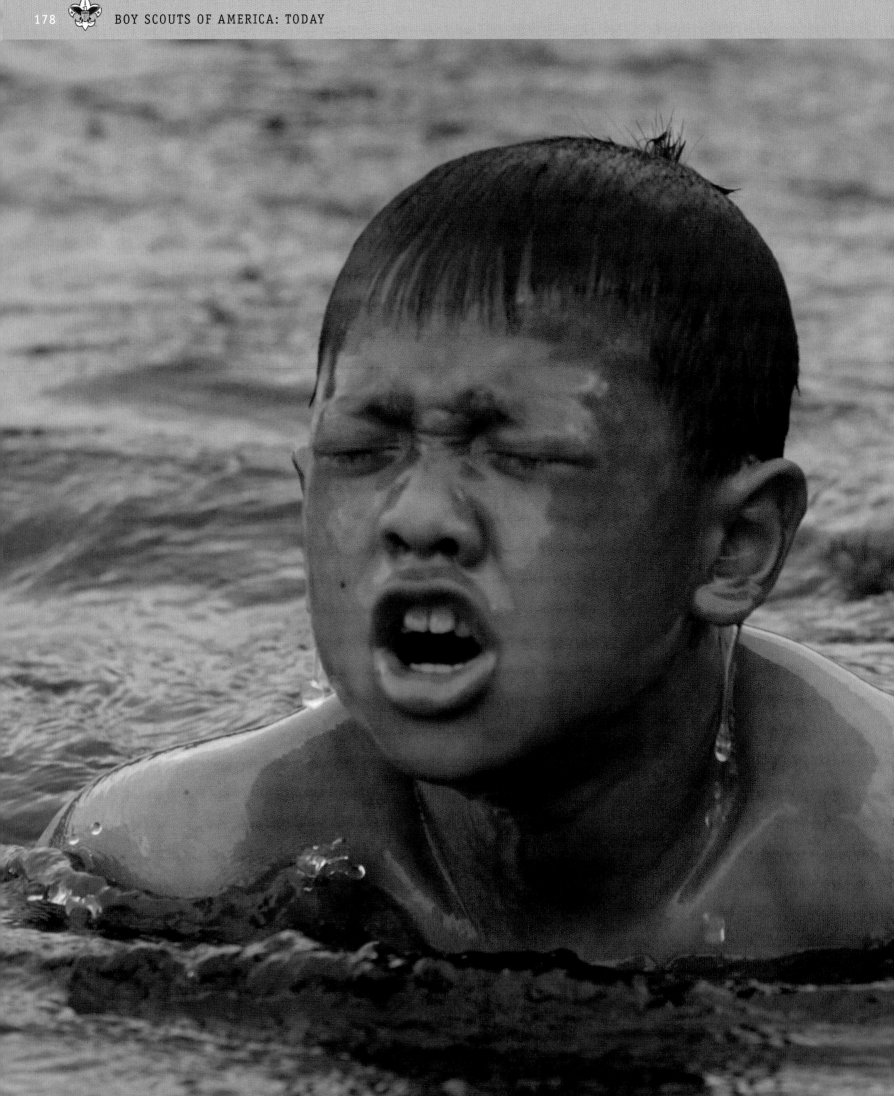

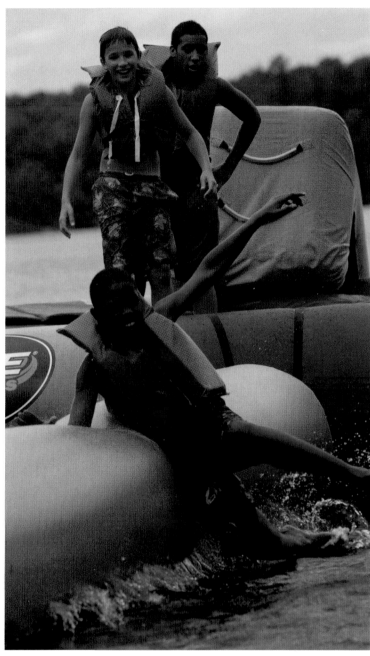

**▲ Come on in...**
Matching aquatic activities with the skills of each youth gives Scouting a wide range of activities for learning and fun.

**◄ ...the water's fine!**
The BSA encourages everyone to learn to swim, both for personal safety and as preparation for fun and adventure in and on the water.

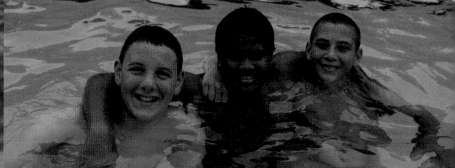

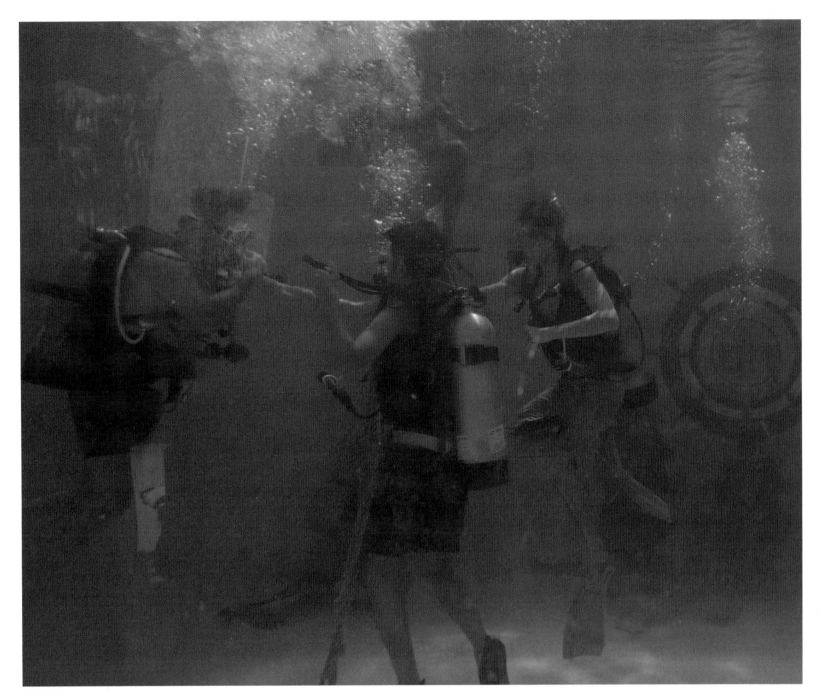

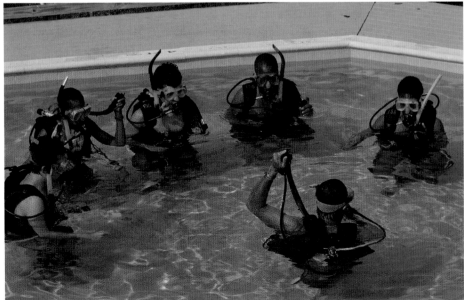

▲ **The depth of the matter**
Florida Sea Base instructors introduce novice divers to the basics of breathing underwater with scuba gear.

**Don't hold your breath!** ▶
Masks and flippers open underwater vistas for Scouts snorkeling in lakes, streams, and coastal waters.

◀ **Explorations of a watery world**
Sea Base Scouts who have mastered scuba skills can join experienced divers visiting coral reefs off the Florida Keys.

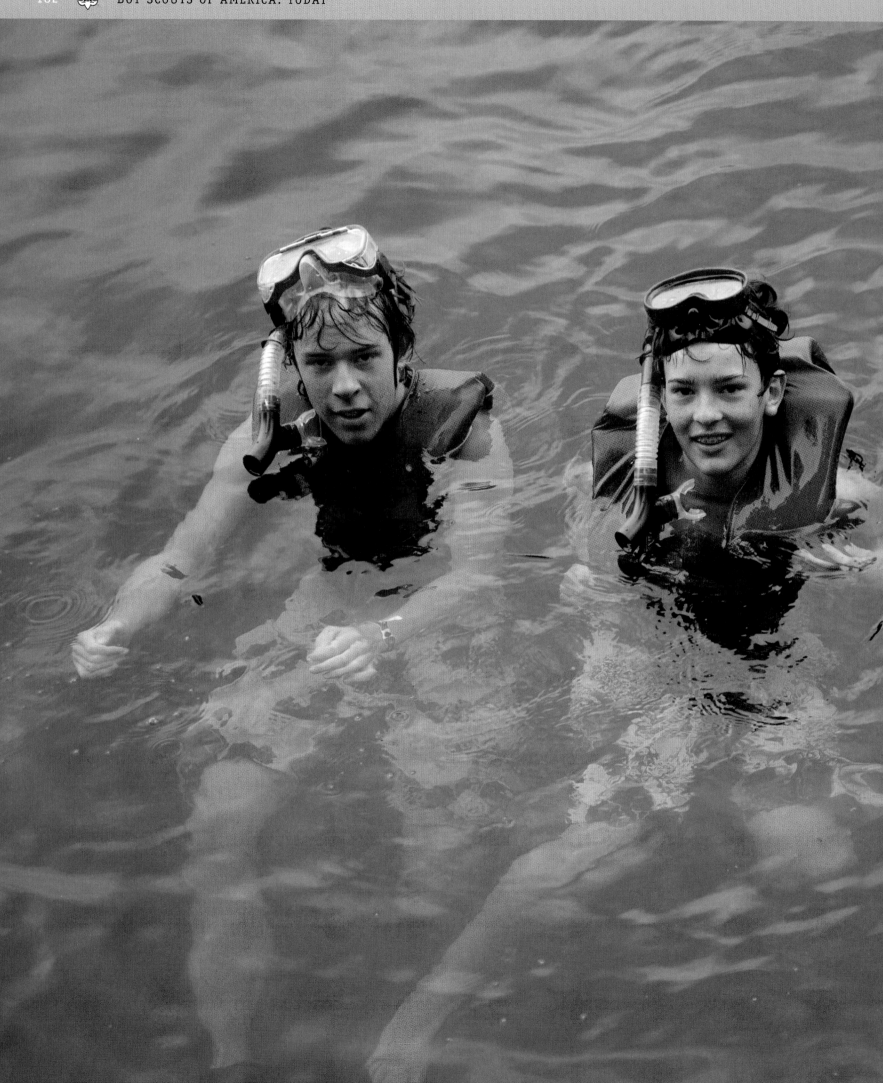

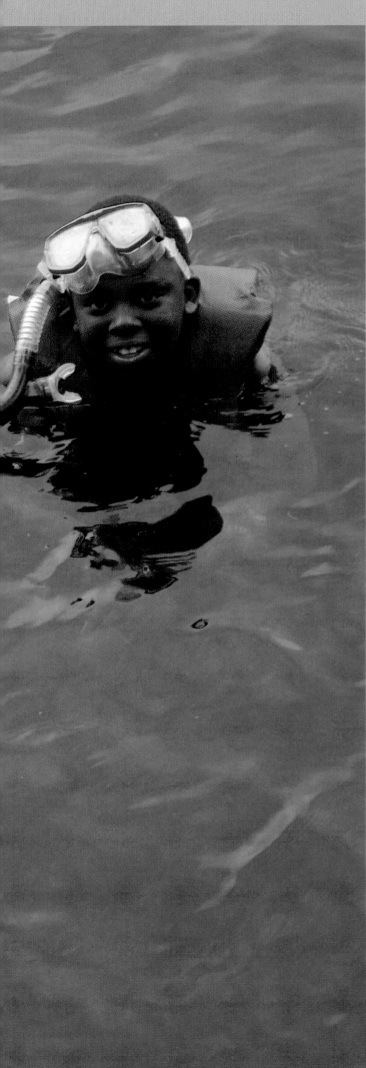

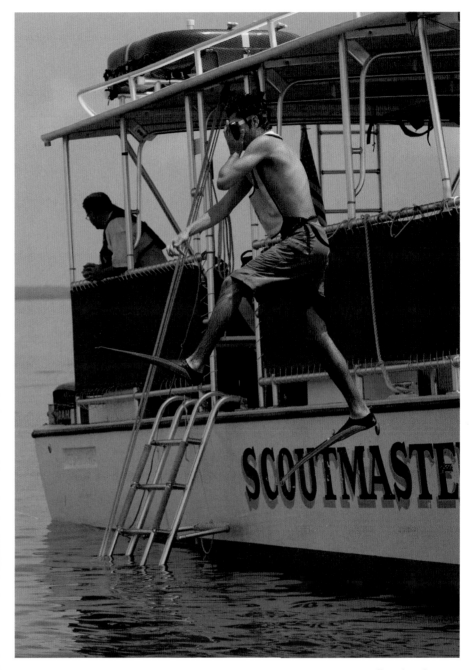

◄ **Swimming for life**
Survival floating, swimming
strokes, and lifesaving
practice provide Scouts with
skills for years of preparedness
and pleasure in the water.

▲ **Home sweet floating home**
*Scoutmaster*, a Florida Sea
Base pontoon boat, serves
as a long-range dive platform
for Scouts and leaders
exploring the Florida Keys.

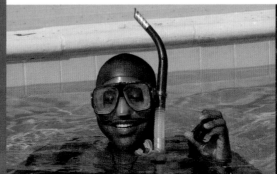

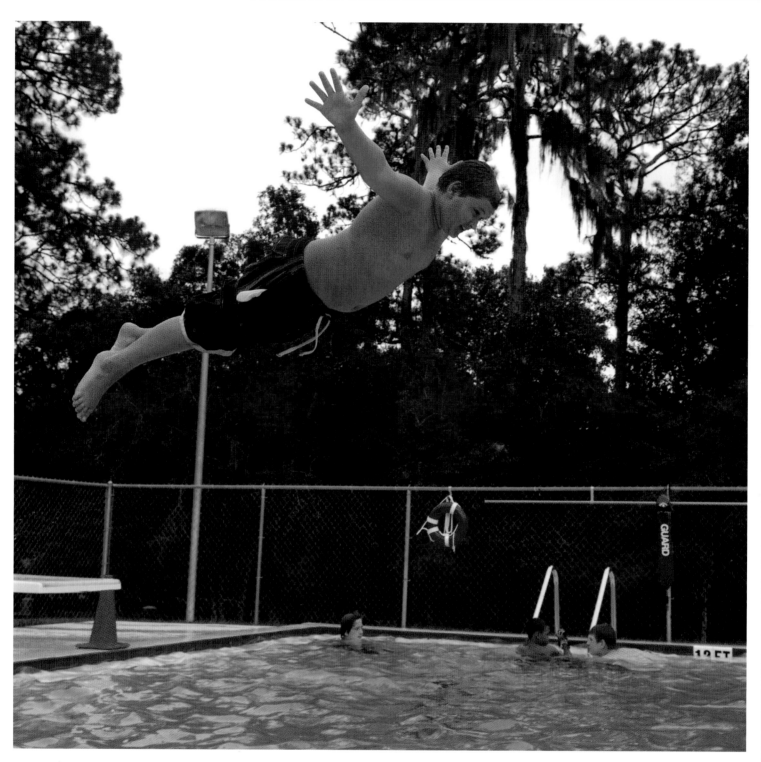

**▲ Freedom of flight**

Off the board at a summer
camp pool, a Scout
transforms from swan
diver to belly flopper.

**Toes up! ▶**

Careening around quick, wet
turns highlights a week at the
Greater New York Council's
Ten Mile River Scout Camps.

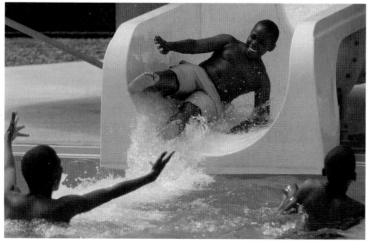

**◀ Swirl, shout, splash, and repeat**

Mix good friends with a steep, twisting water
slide—that's a recipe for magnificent Scouting
fun on a hot summer day.

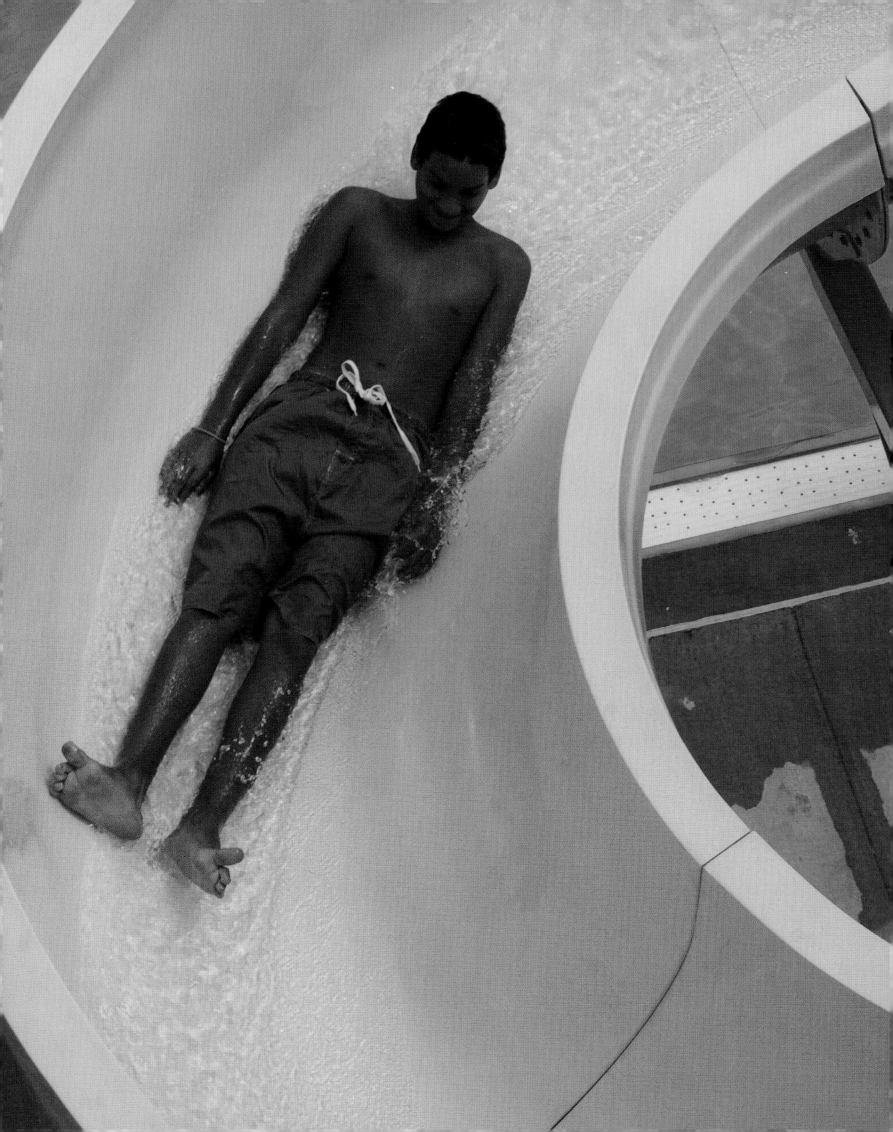

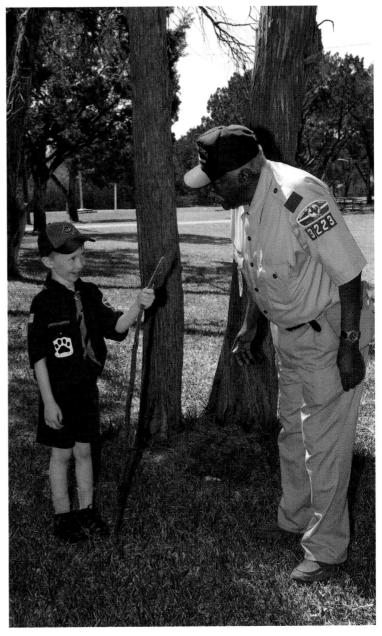

▲ **Share the moment**
The values and lore of Scouting pass both ways
between those who have seen much of life and
those just starting out.

◄ **Plan good works**
Being of service to others can grow
out of developing effective plans.

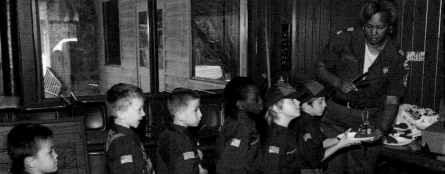

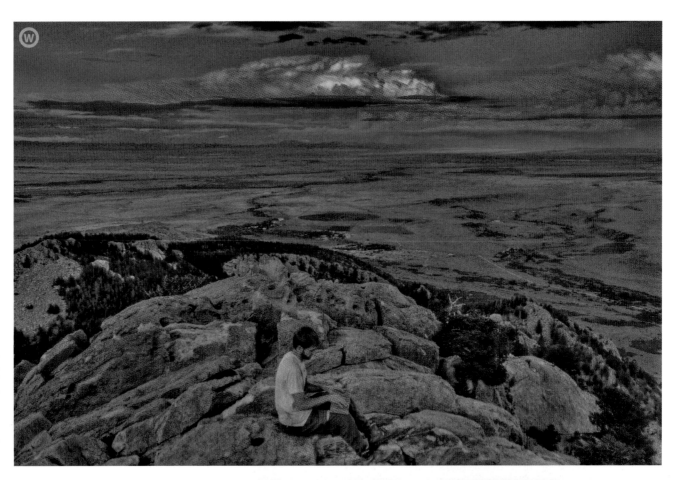

**▲ Day is done**
Luminous notes from a hiker's keyboard drift into the New Mexico evening from atop Philmont's Tooth of Time.

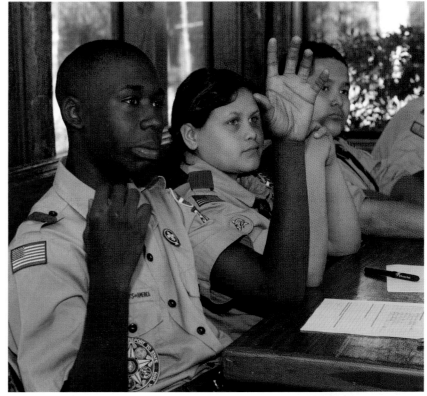

**Making good decisions ▶**
Youth leaders of Scout troops and Venturing crews gain valuable experience making choices that affect themselves and others.

**◀ The value of helping others**
Scouts carry bags of canned goods they have collected to resupply a St. Louis, Missouri, food bank.

Sharing the beliefs of Scouting's founder, a modern-day Robert Baden-Powell steps out of the past.

# A Scout Is **REVERENT**

*A Scout is reverent toward God. He is faithful in his religious duties. He respects the beliefs of others.*

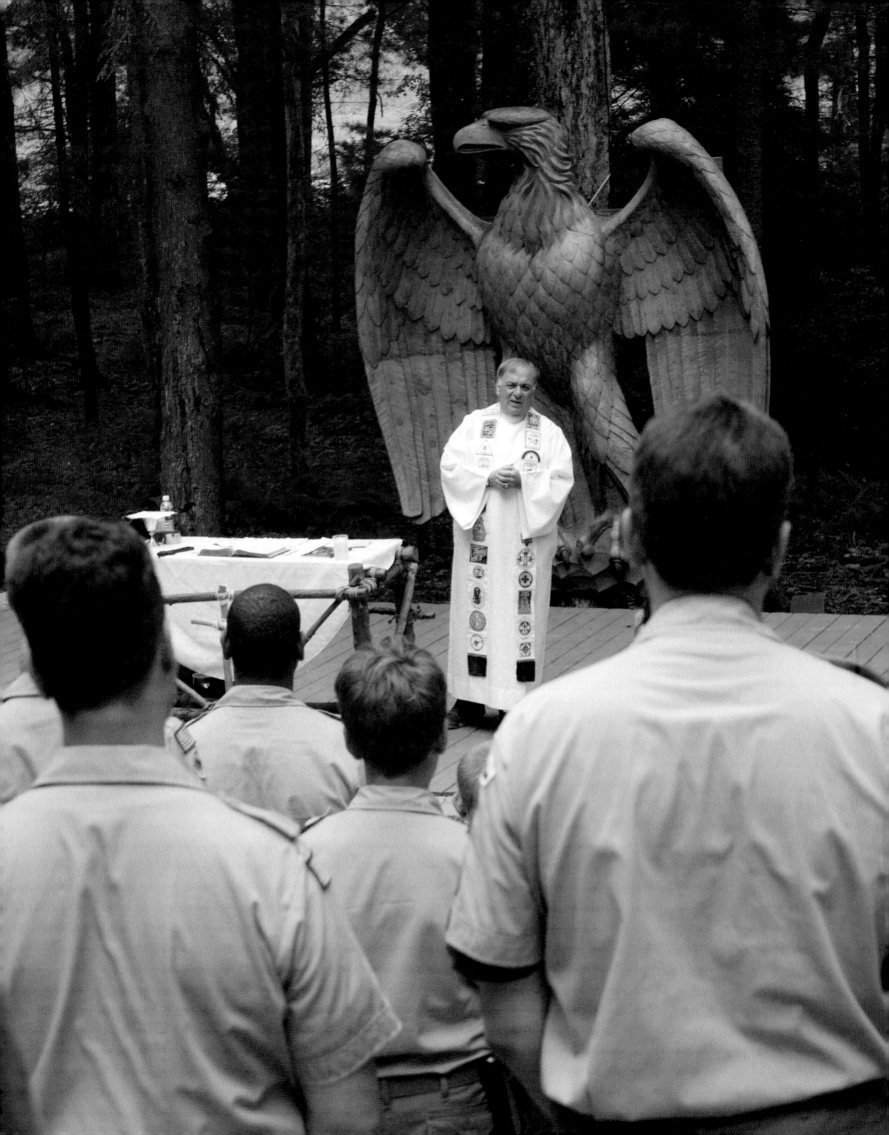

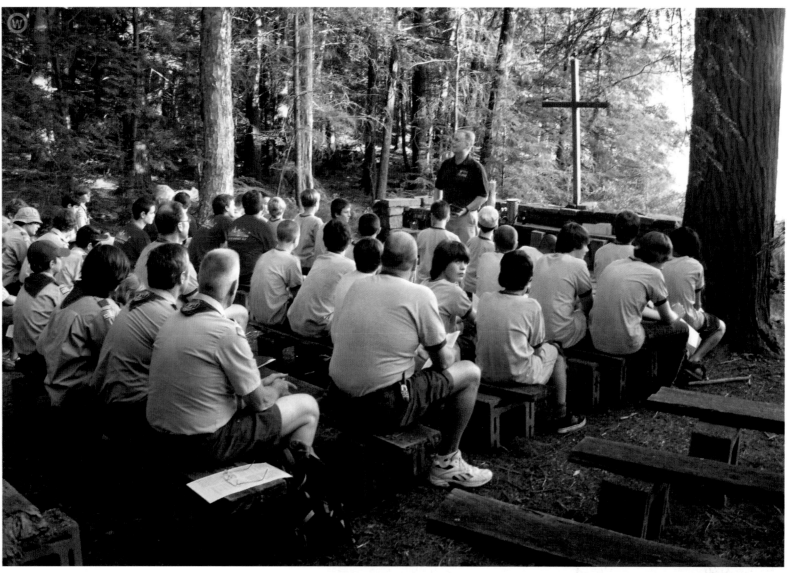

**▲ Worship in the woods**
Scouts and leaders ponder a Sunday morning
message at the Forestburg Scout Reservation
chapel in New York's Catskill Mountains.

**◄ Sacred settings, holy words**
The BSA encourages Scouts of all religions
to practice their faith both in camp and
throughout their lives.

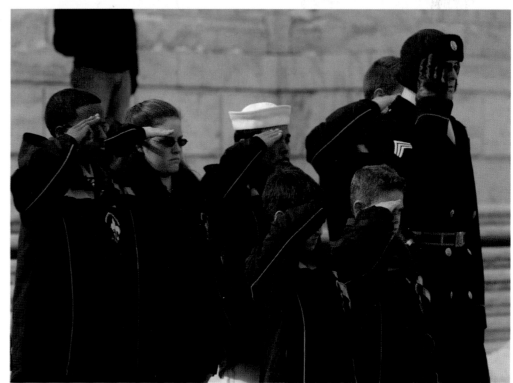

**Honoring sacrifice ►**
In Washington, D.C., to deliver the
BSA's annual Report to the Nation,
Scouts salute America's heroes at
the Tomb of the Unknowns.

**▲ Pause for thought**

A Scout takes a personal moment for reflection during a sunrise hike at Catalina Island, Avalon, CA.

**Giving thanks ▶**

"For food, for raiment, for life and opportunity..." Wherever they find themselves, Scouts give thanks before every meal.

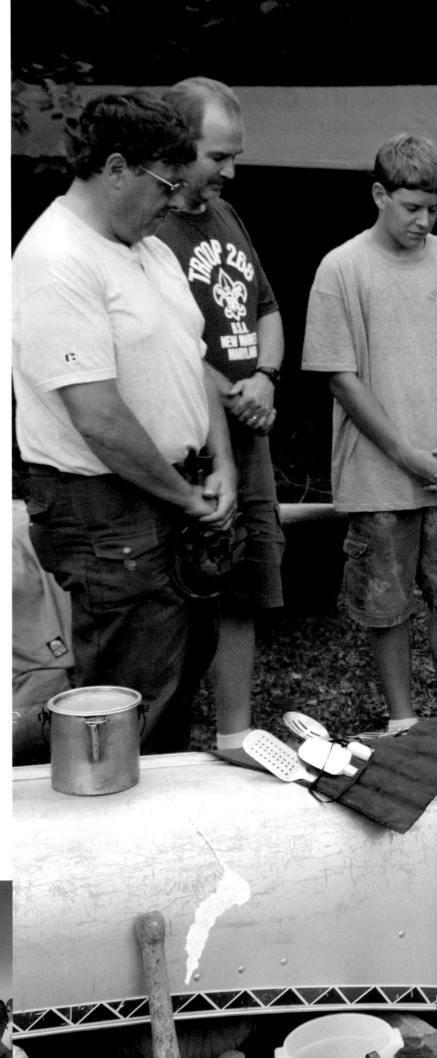

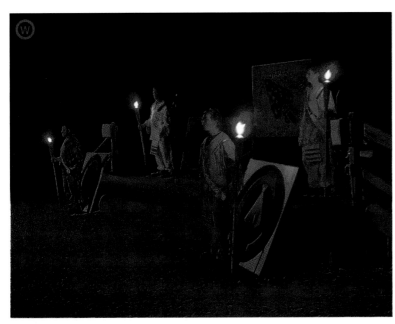

**▲ In the midst of this great forest**

Brotherhood members of the Order of the Arrow light the stage for ceremonies at Indiana's Ransburg Scout Reservation.

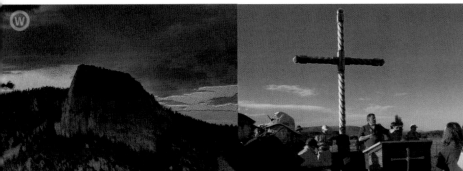

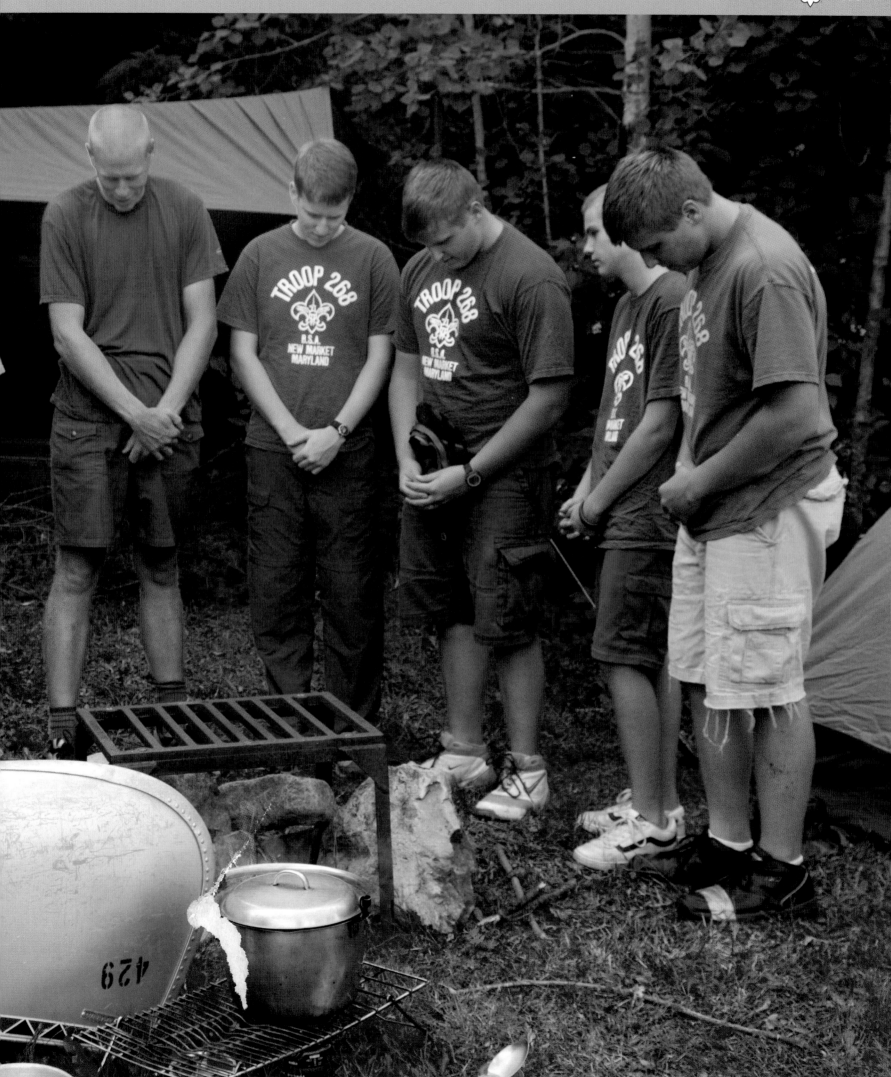

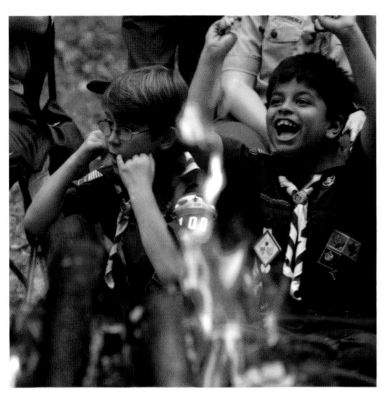

**▲ Who's got marshmallows?**
Memories of Scouting find warm beginnings in
songs and cheers shared around a campfire.

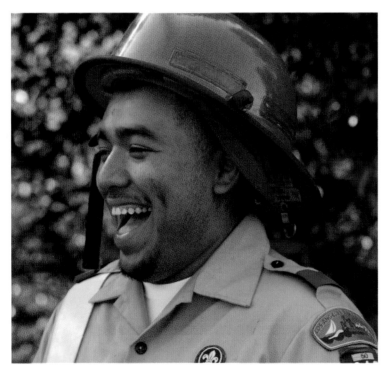

**▲ Rolling up their sleeves**
Hands-on projects that
protect the environment
have a positive impact on
the land and upon those
completing good work.

**Keeper of the flame ▶**
"Mr. Vick" to the boys,
F. Willard Vickery became
Scoutmaster of Troop 10,
Pensacola, Florida, after
37 years as a Scout executive.

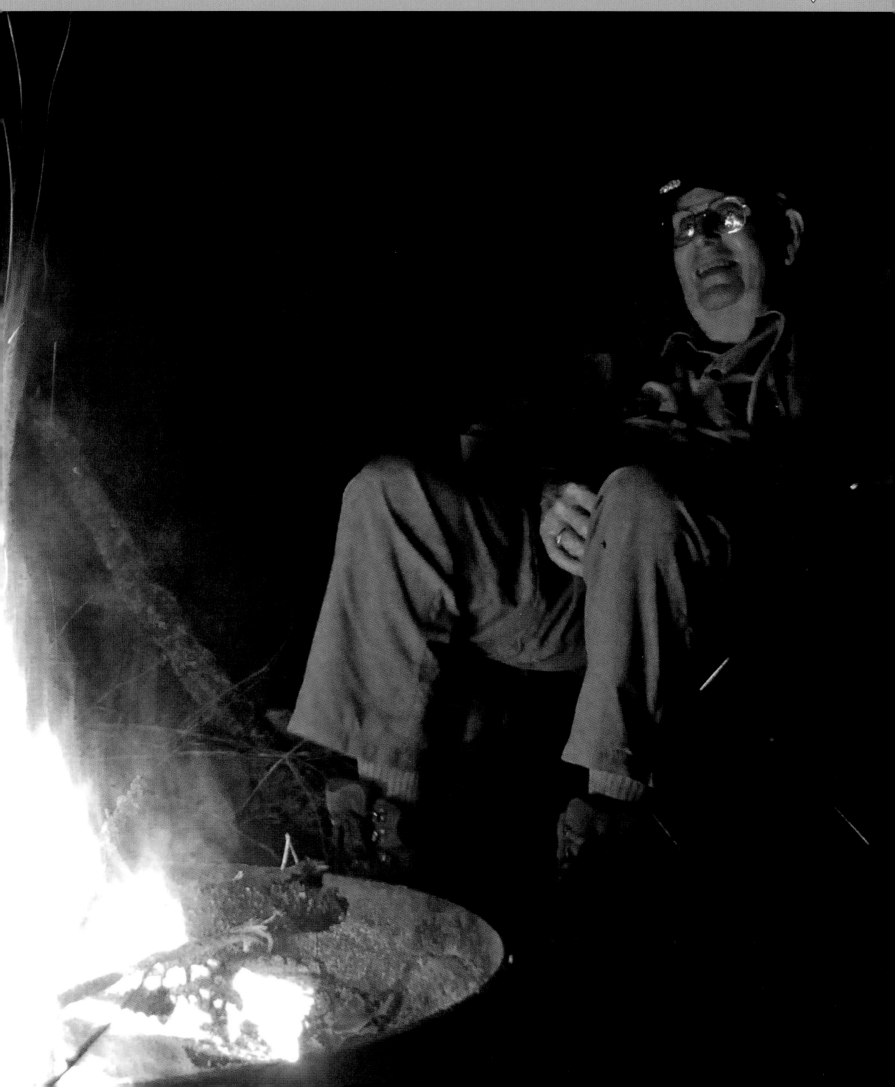

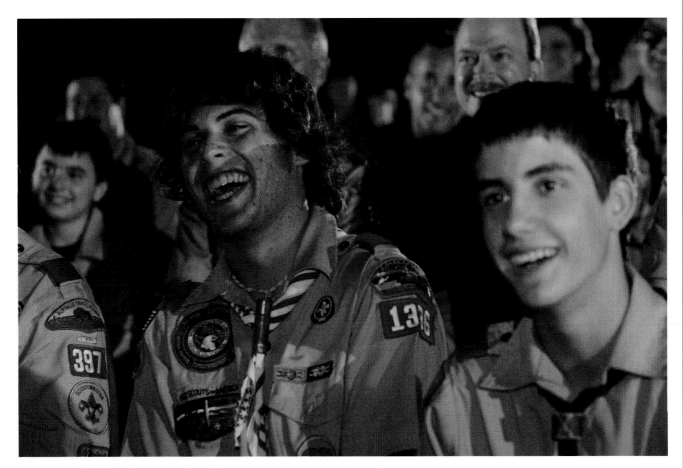

### ▲ We will do our best
By instilling the values of the Scout Oath and Scout Law, the BSA prepares young people to make ethical and moral choices over their lifetimes.

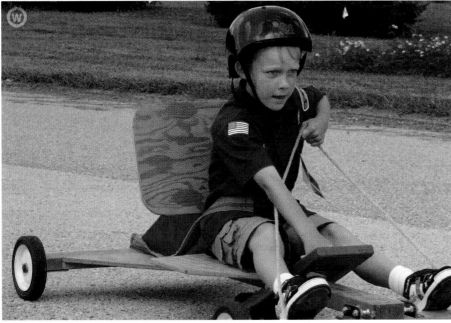

### Powering ahead ▶
The pull of Scouting attracts youth of many backgrounds to share great adventures and opportunities for leadership and growth.

### ▲ Race day
With focus and determination, Cub Scout Garrett Gajewski from Shrewsbury, Pennsylvania, makes Pack 90 proud as he urges his cart to the finish line.

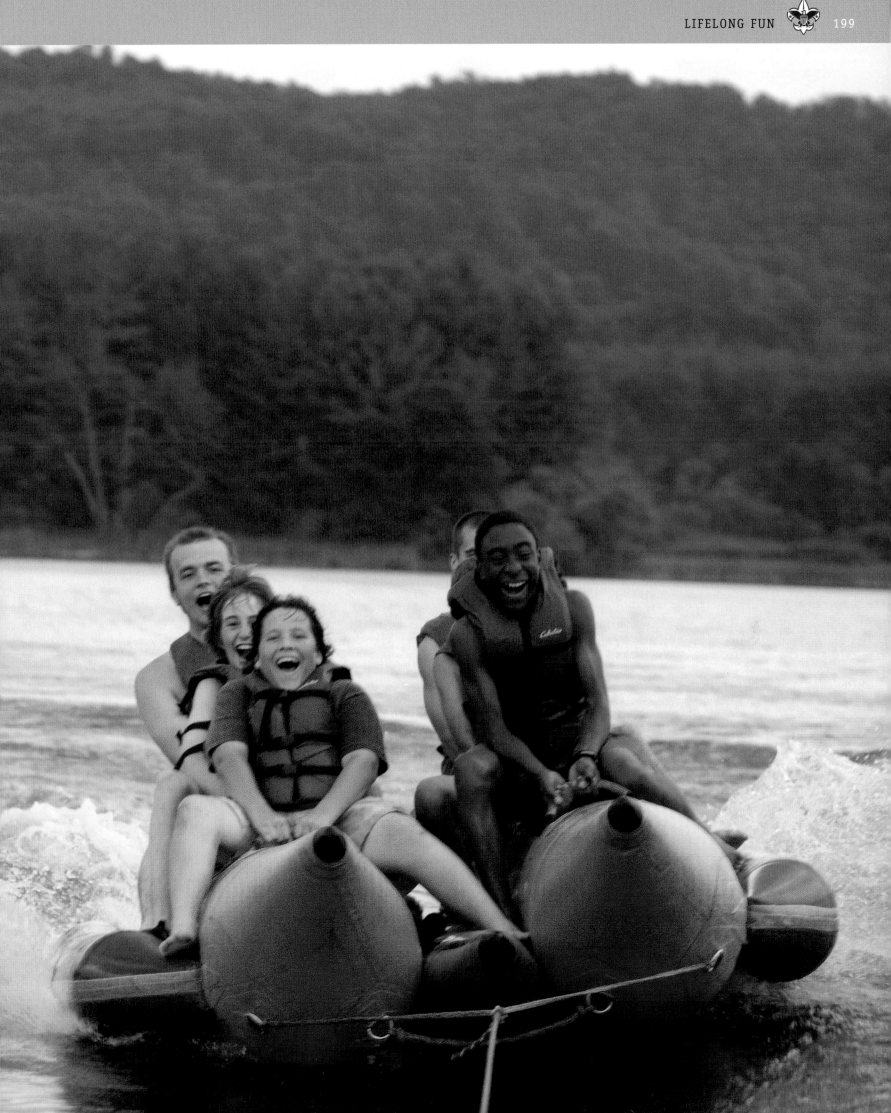

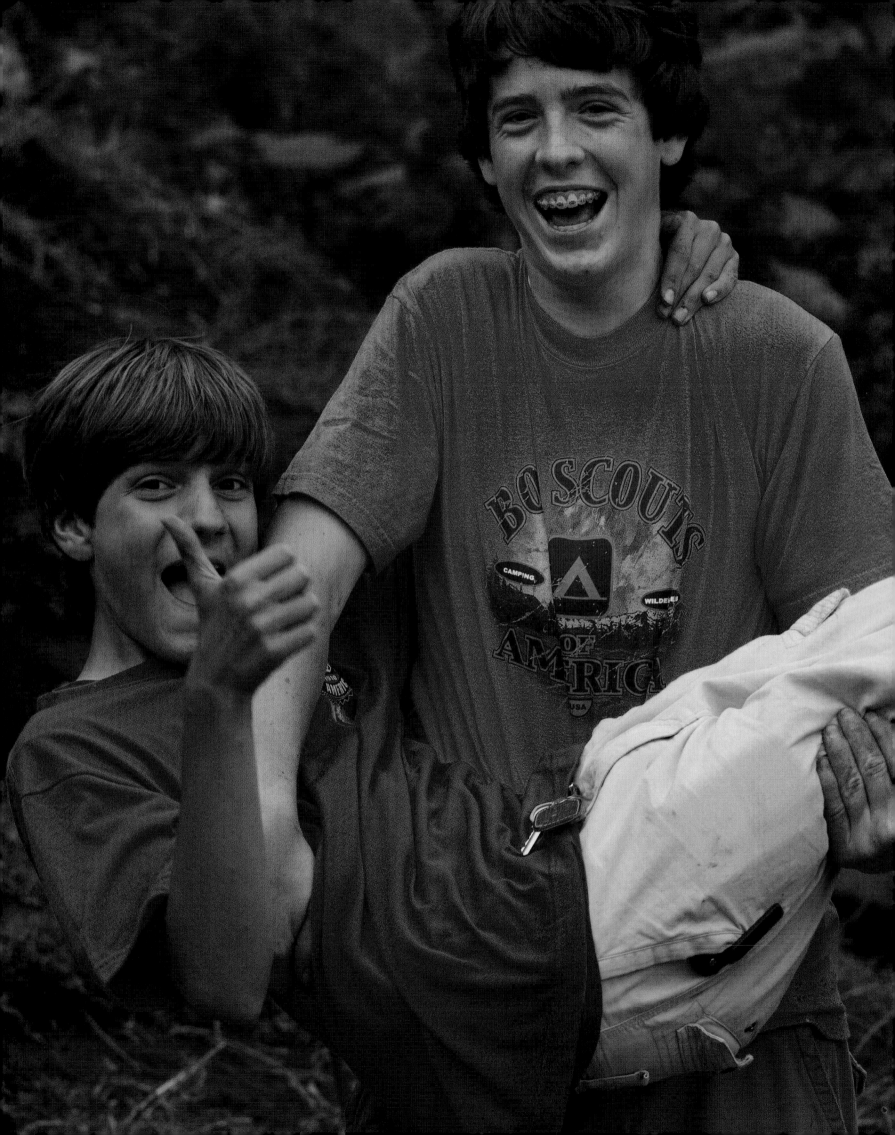

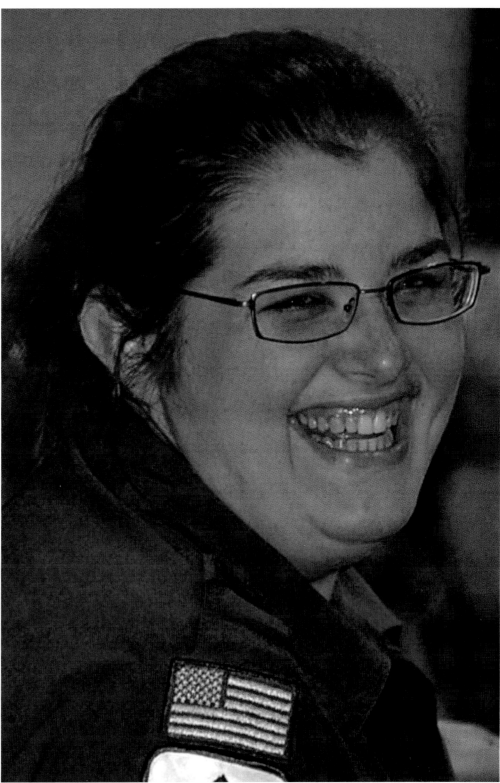

◄ **Supporting each other**
Shared goals and teamwork, two
hallmarks of the BSA, form the
glue of friendships and open up
pathways to success.

▲ **The face of Venturing**
Katy Harkins, a member of South
Carolina's Venturing Crew 250,
enjoys a moment with friends at
a district awards banquet.

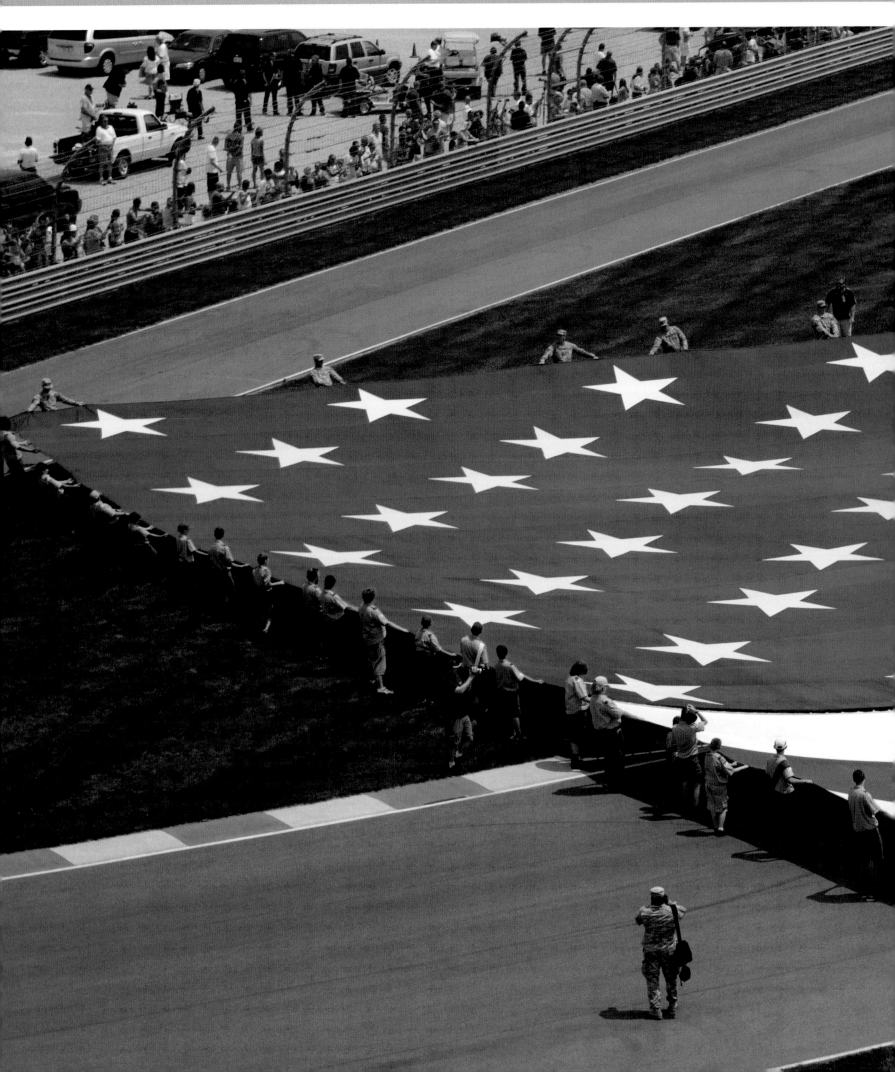

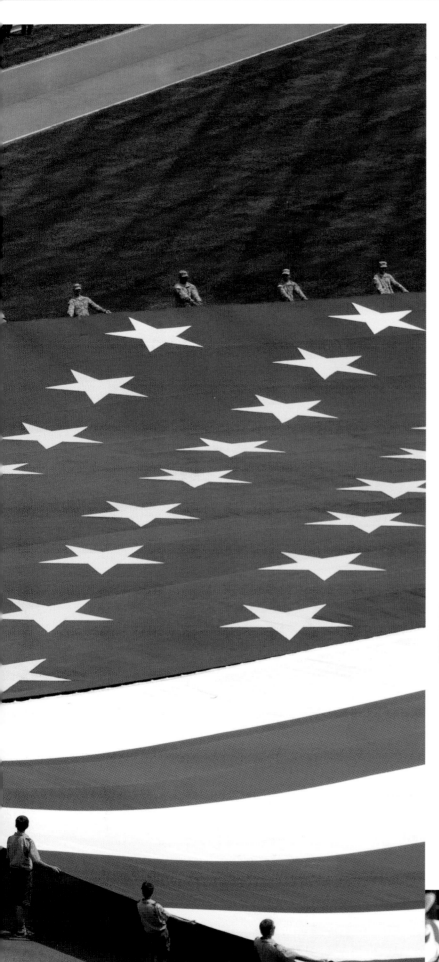

**◄ Star-spangled spectacle**
Boy Scouts assist with unfurling a giant American flag during auto racing's Grand Prix of Long Beach, California.

**▲ High speed highlight**
Driver Alex Lloyd helps celebrate Scouting's centennial by steering the BSA's entry through a season of Indy Car Series events.

**▲ Ready for the green flag**
A happy Cub Scout settles behind the wheel of No. 19, the BSA car featured in partnership with Dale Coyne Racing.

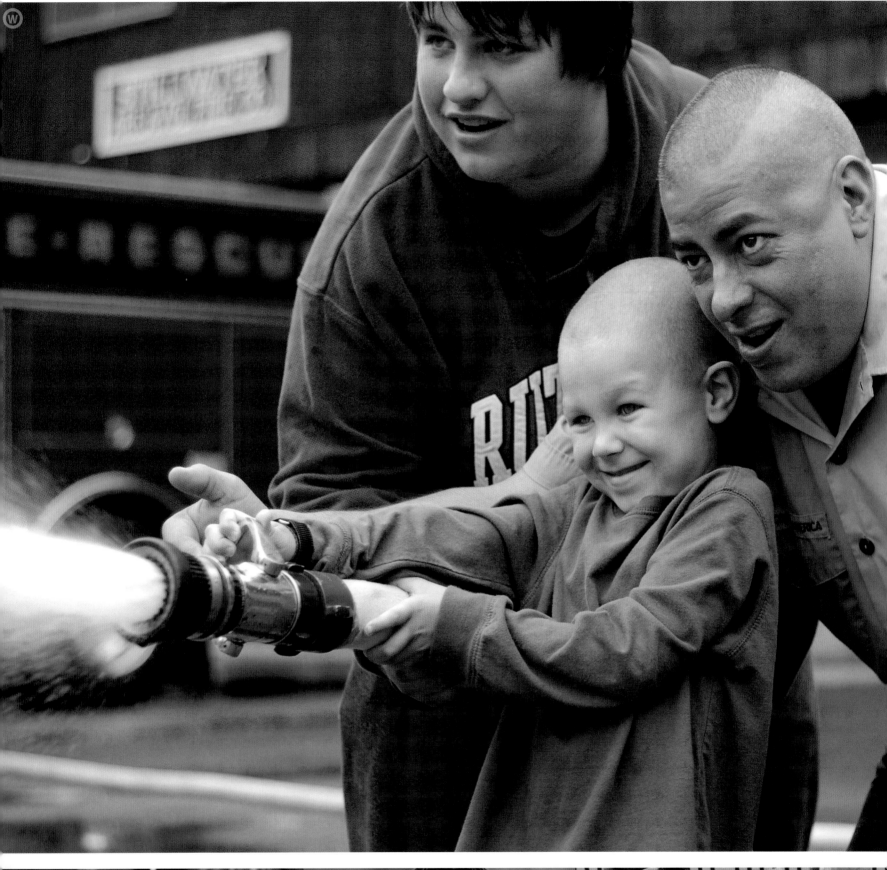

**Thrill of the chill** ▶
Troop 570 committee
member David Patterson
poses for the photo
he'll send at Christmas
to his Caro, Michigan,
Scouting friends.

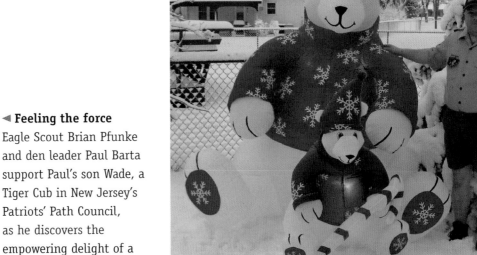

◀ **Feeling the force**
Eagle Scout Brian Pfunke
and den leader Paul Barta
support Paul's son Wade, a
Tiger Cub in New Jersey's
Patriots' Path Council,
as he discovers the
empowering delight of a
fire hose blast.

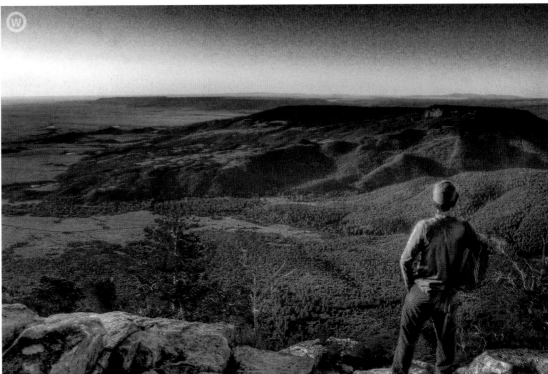

▲ **Scouting paradise**
The view of Urraca Mesa and beyond is reason enough
to call Philmont Scout Ranch "God's Country."

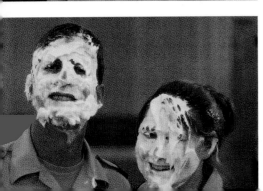

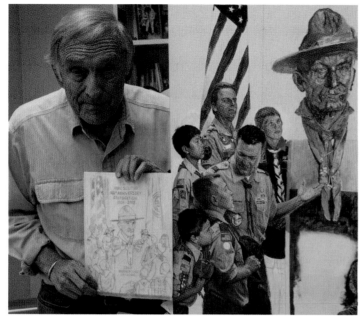

**▲ A master of art**
With bright hues and
brilliant brush strokes,
artist Joseph Csatari
illuminates canvas with
the true spirit of Scouting.

**On track for the
centennial ▶**
Cub Scouts cheer the
arrival of a Union Pacific
locomotive honoring the
100th Anniversary of the
Boy Scouts of America.

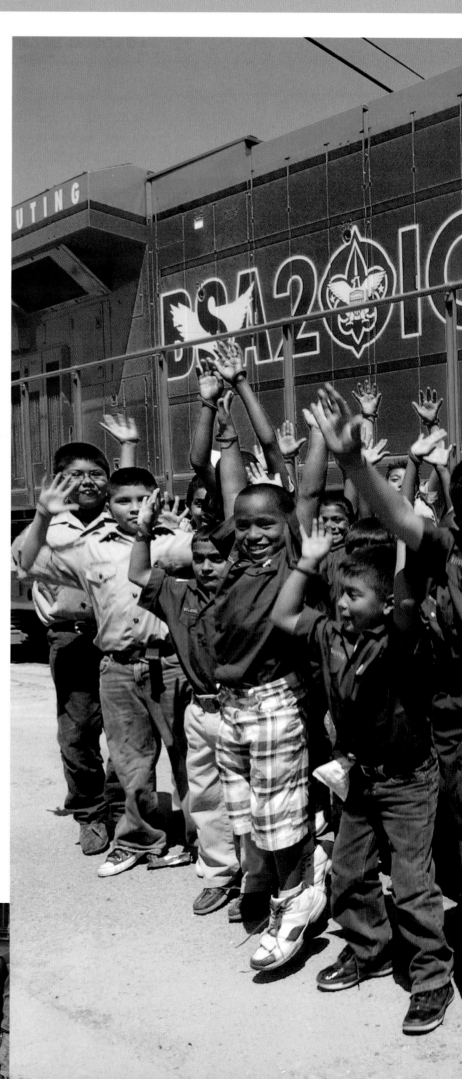

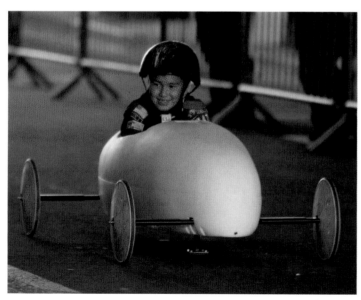

**▲ The race is on!**
A Cub Scout behind the wheel of his
gravity-powered car flashes a grin as he
imagines the thrill of winning the big race.

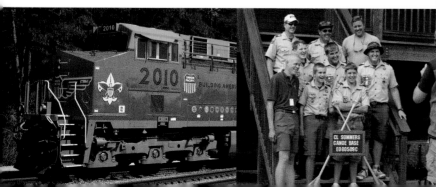

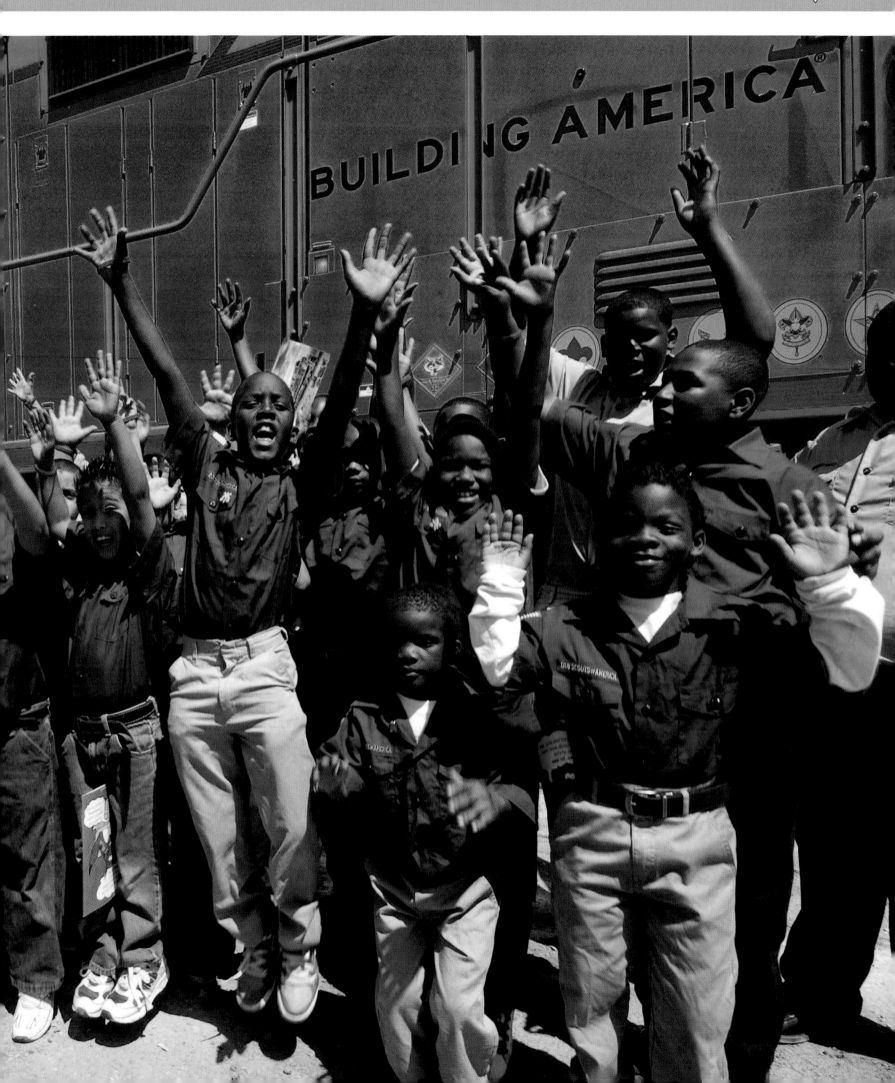

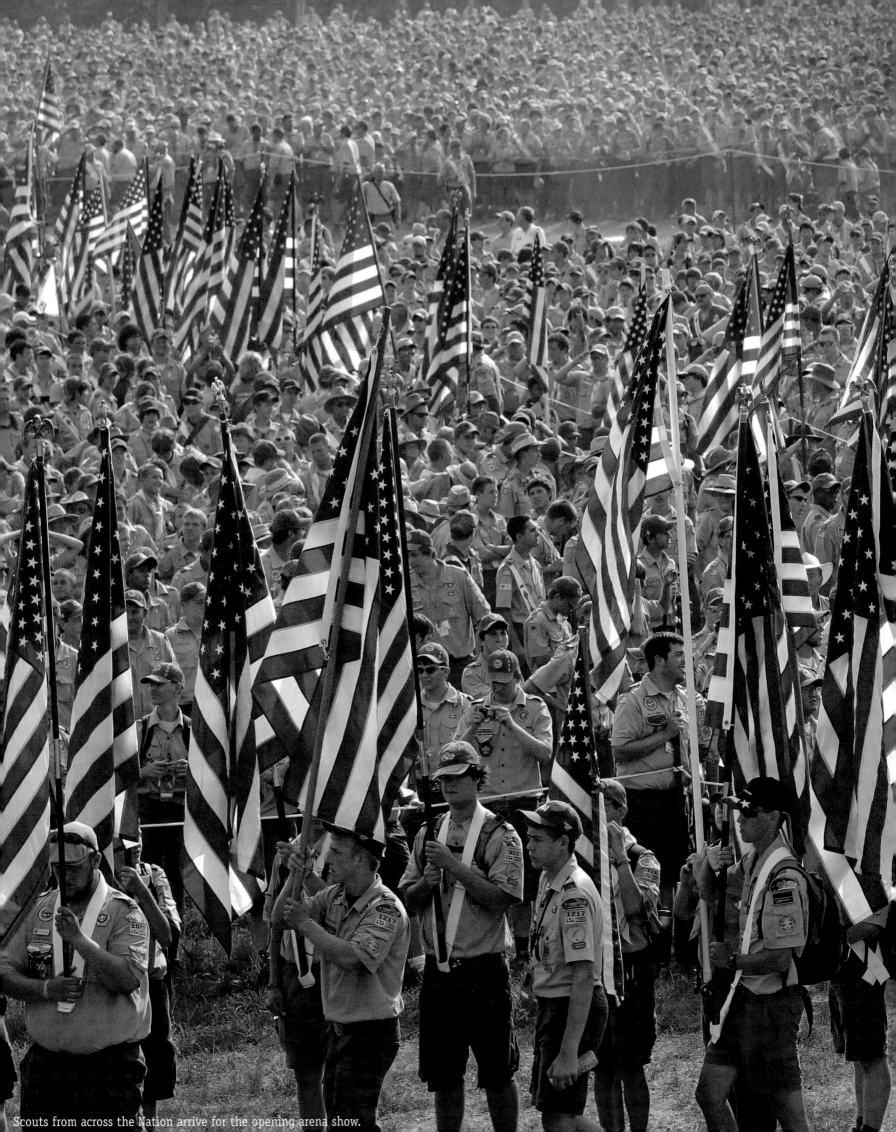
Scouts from across the Nation arrive for the opening arena show.

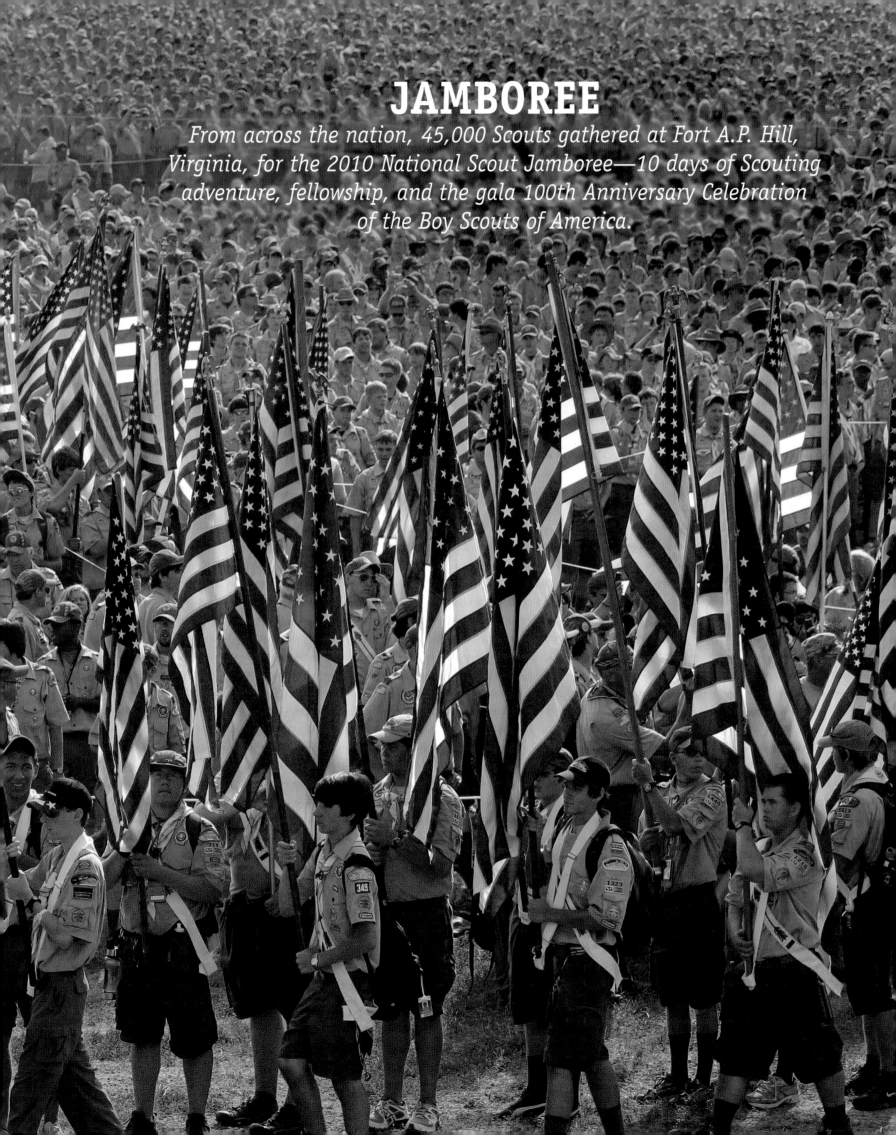

# JAMBOREE

*From across the nation, 45,000 Scouts gathered at Fort A.P. Hill, Virginia, for the 2010 National Scout Jamboree—10 days of Scouting adventure, fellowship, and the gala 100th Anniversary Celebration of the Boy Scouts of America.*

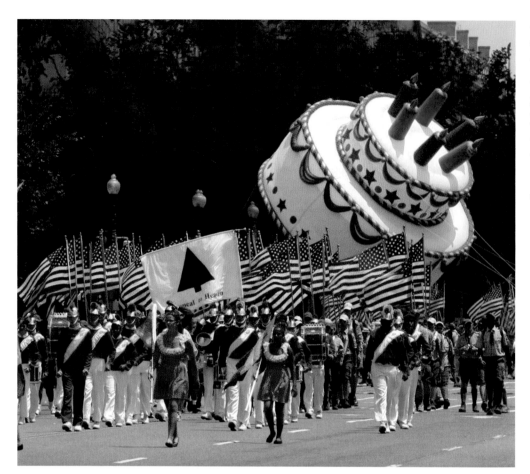

◀ **Scouting on the move**
The BSA's Grand Centennial Parade in Washington, D.C., kicks off birthday celebrations leading to the opening of the 2010 National Scout Jamboree.

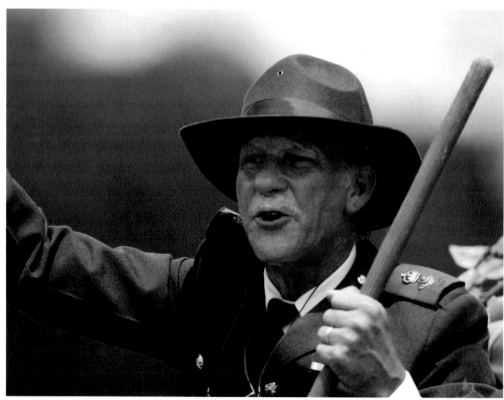

◀ **The spirit of B-P**
With a uniform and good cheer worthy of Scouting's founder, a modern-day Scout leader greets parade viewers as Lord Robert Baden-Powell.

**Eagles in the wings** ▶
Eagle Scouts passing the White House join the estimated 10,000 members of the BSA marching through the nation's capital.

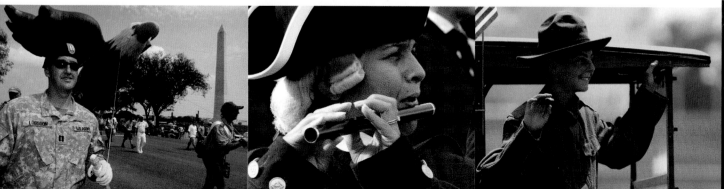

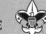

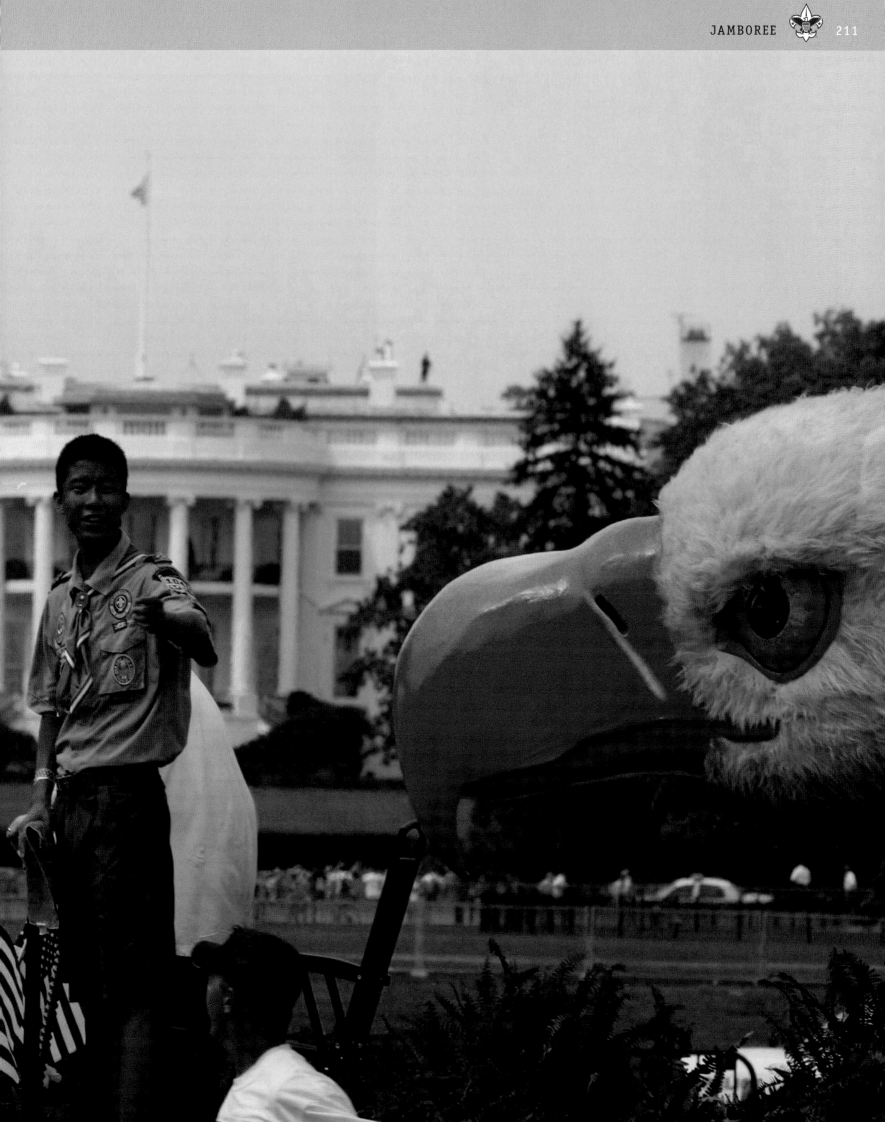

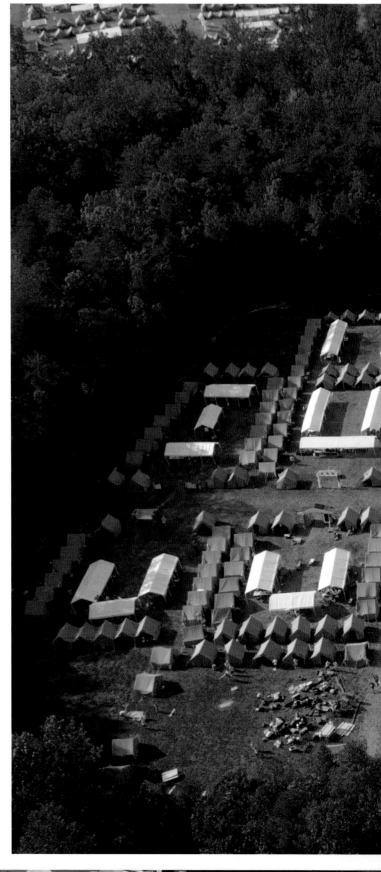

◄ **Becoming prepared**
Workers toiled for months to transform Fort A.P. Hill near Fredericksburg, Virginia, into an encampment fully equipped to support thousands of jamboree Scouts and visitors.

**Home sweet tent** ►
Troops arriving at the jamboree use skills learned as Scouts to pitch tents and dining flies in campsites that will be home for the next 10 days.

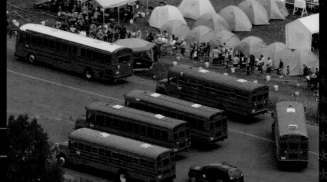

BOY SCOUTS OF AMERICA ★ IOO YEARS OF SCOUT

BSA2OIC

CELEBRATING THE ADVENTURE ★ CONTINUING THE JOUR

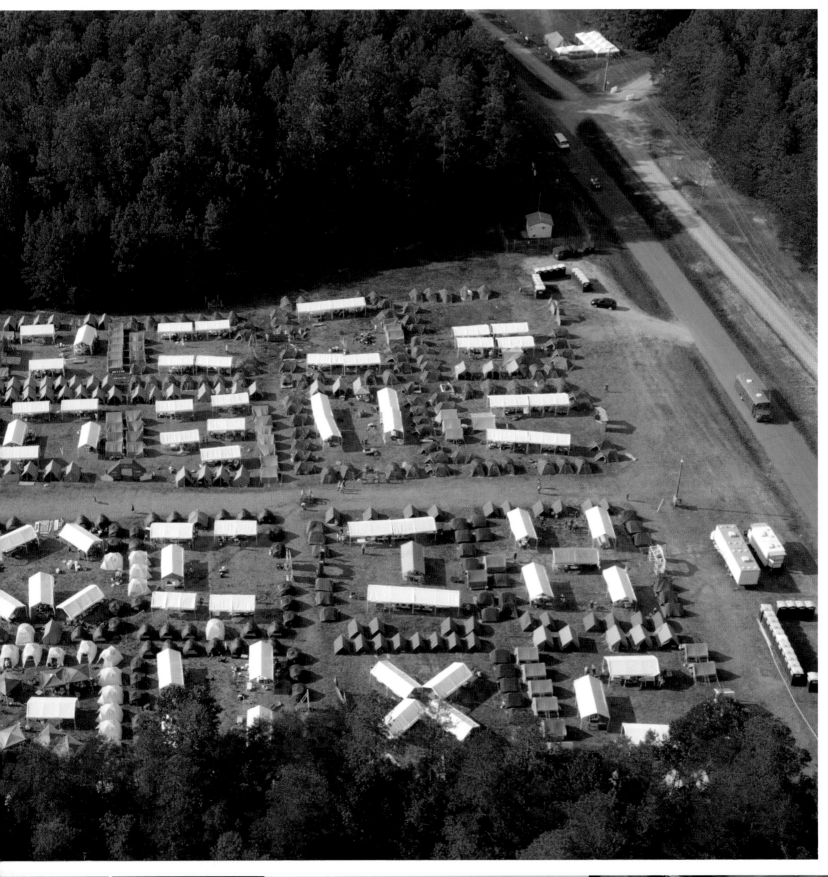

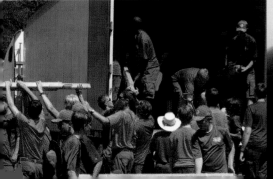

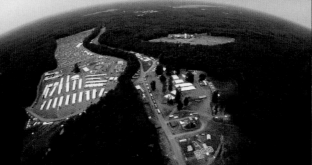

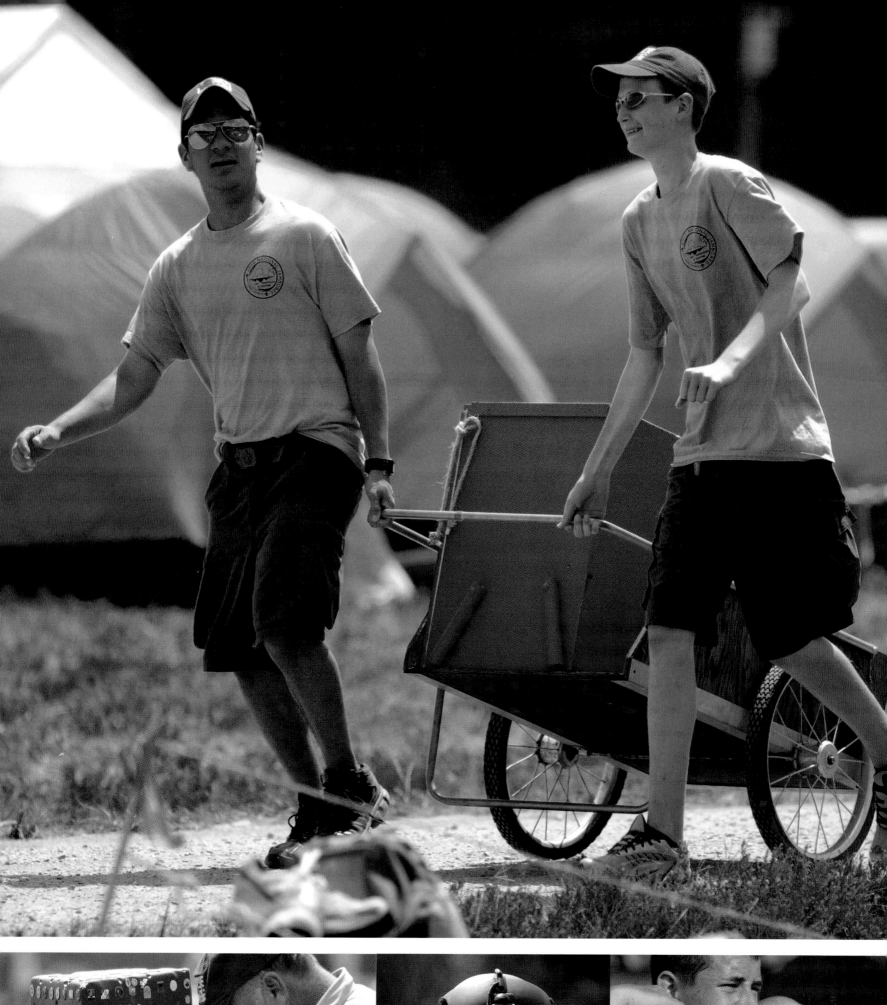
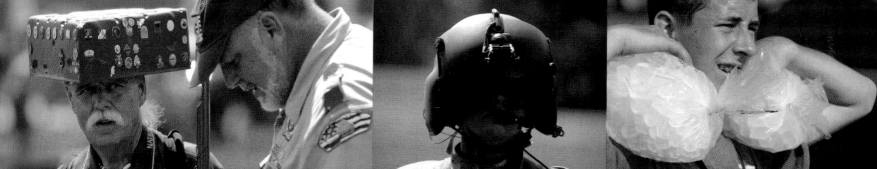

**◄ Getting work done**
Scout ingenuity
rolls out solutions
to challenges—from
moving heavy boxes
to staying cool in the
summertime heat.

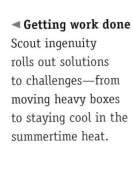

**Air power ►**
The jamboree's own
radio station booms
out music, interviews,
and updates on
events occurring
across the 4,000 acres
of jamboree grounds.

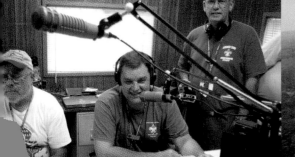

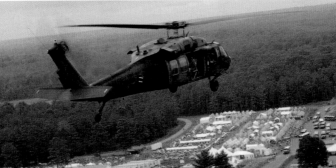

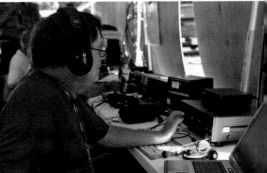

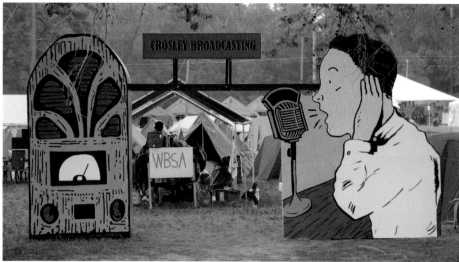

**▲ Hometown pride**

Ohio Scouts set up a display at their camp to bring attention to a Cincinnati radio station that has been on the air since 1922.

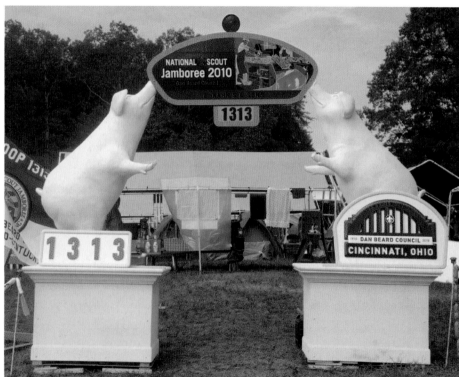

**▲ Entry to a time and place**

The tradition of building campsite gateways gives Scouts colorful ways to celebrate their troops, councils, cities, and states.

**Still going strong ▶**

Established in the early days of the BSA, Troop 540 celebrates its hundred-year history with a trip to the 2010 National Scout Jamboree.

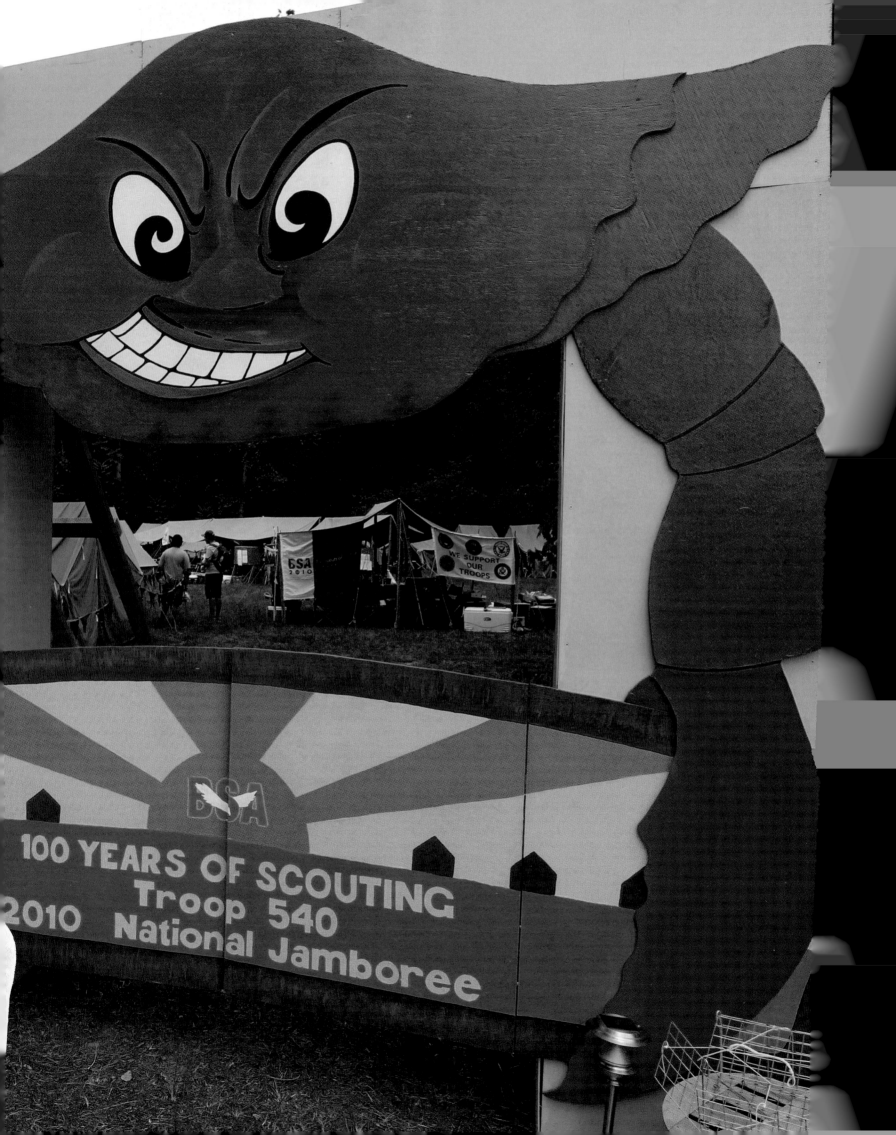

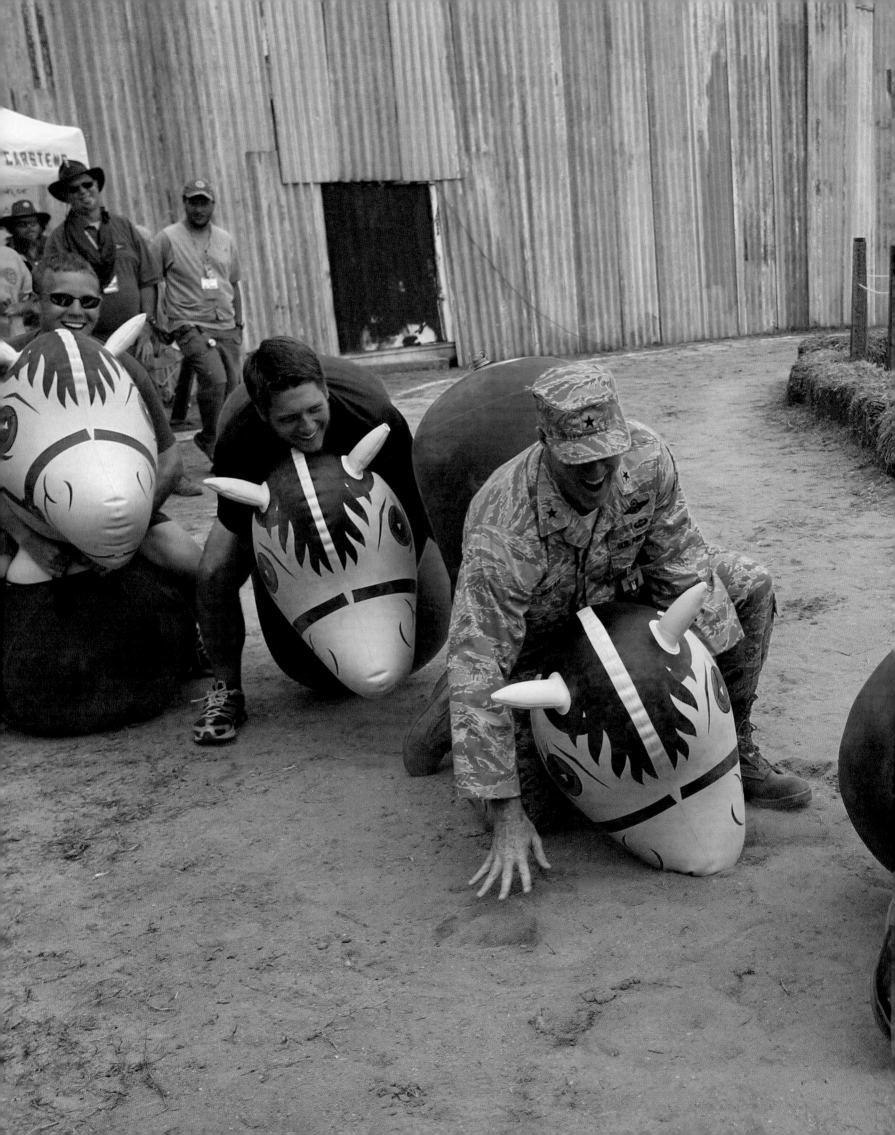

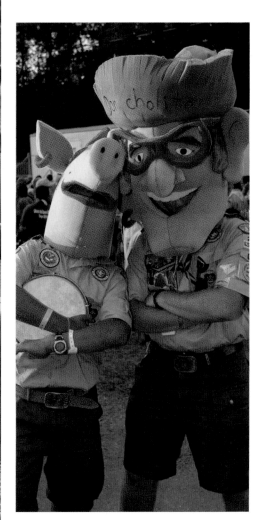

◄ **And they're off!**
Officers in support of Scouting saddle up to bounce inflated horses around a course at the Venturing program's jamboree center.

▲ **Laughing it up**
Cartoon characters of many sizes and shapes enliven scheduled stage shows and spontaneous events along jamboree thoroughfares.

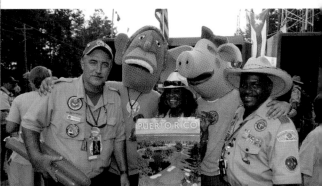

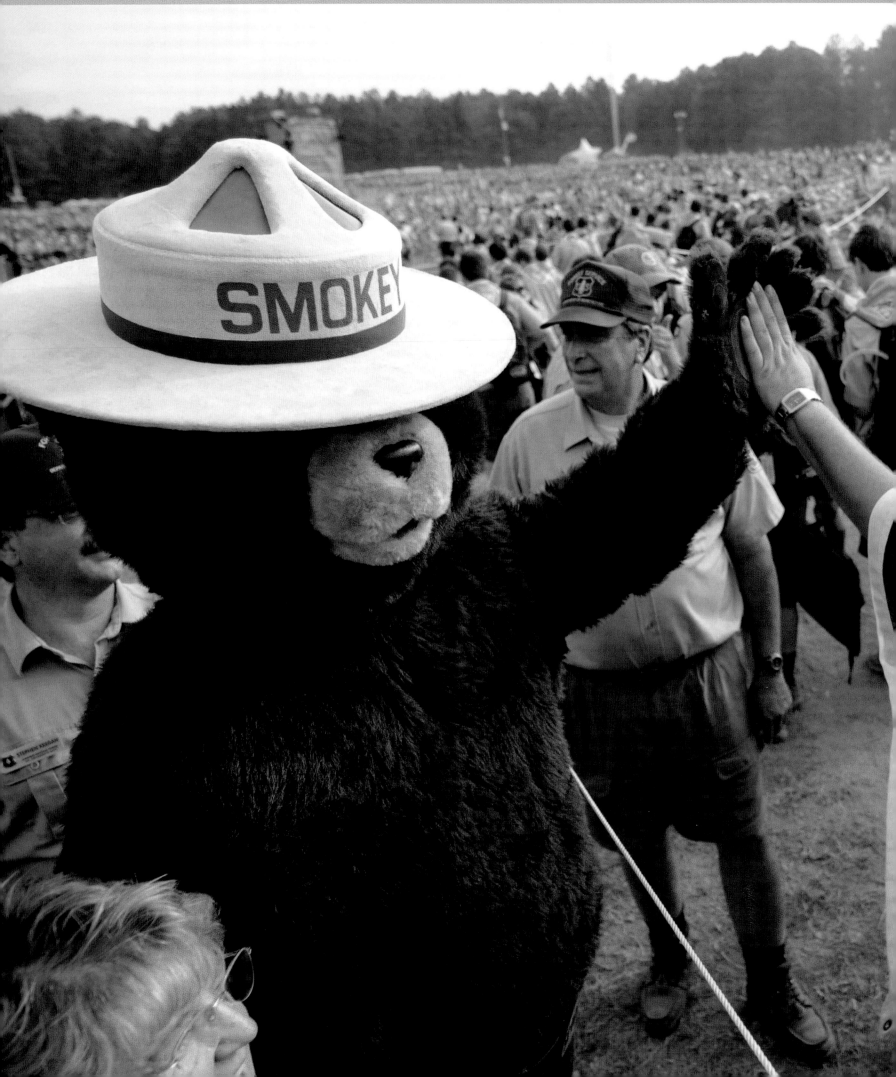

▲ **Here, there, and everywhere**
Jamboree attendees hail from every state of the union and from many foreign nations sending representatives of their own Scouting organizations.

**One and all** ▶
Scouts hike toward an arena show bringing jamboree participants together for entertainment and inspiration.

◀ **Longtime friends**
A jamboree Scout greeting Smokey Bear grasps the importance of the BSA's long heritage of supporting agencies that manage America's public lands.

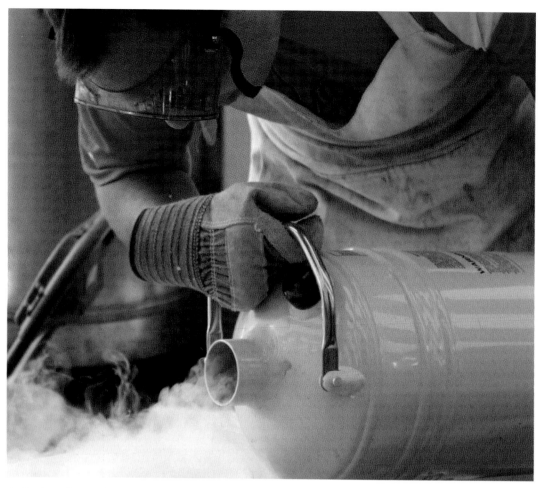

**▲ Merits of Scouting**
From archaeology to wilderness survival, the Merit Badge Midway offers hands-on introductions to more than a hundred subject areas.

**The laps of luxury ▶**
Cooperation comes into play for Scouts at one of six stages where daily programs feature music, celebrities, and audience-participation skits.

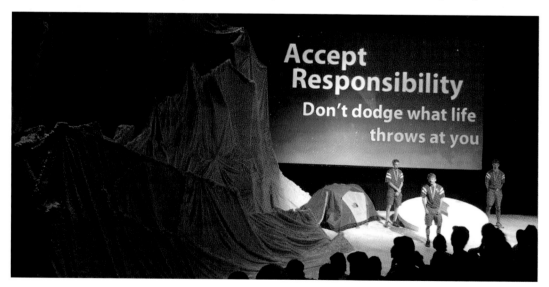

**▲ The Mysterium Compass**
The Order of the Arrow's exciting, interactive presentation challenges jamboree visitors to test their responses to some of life's big questions.

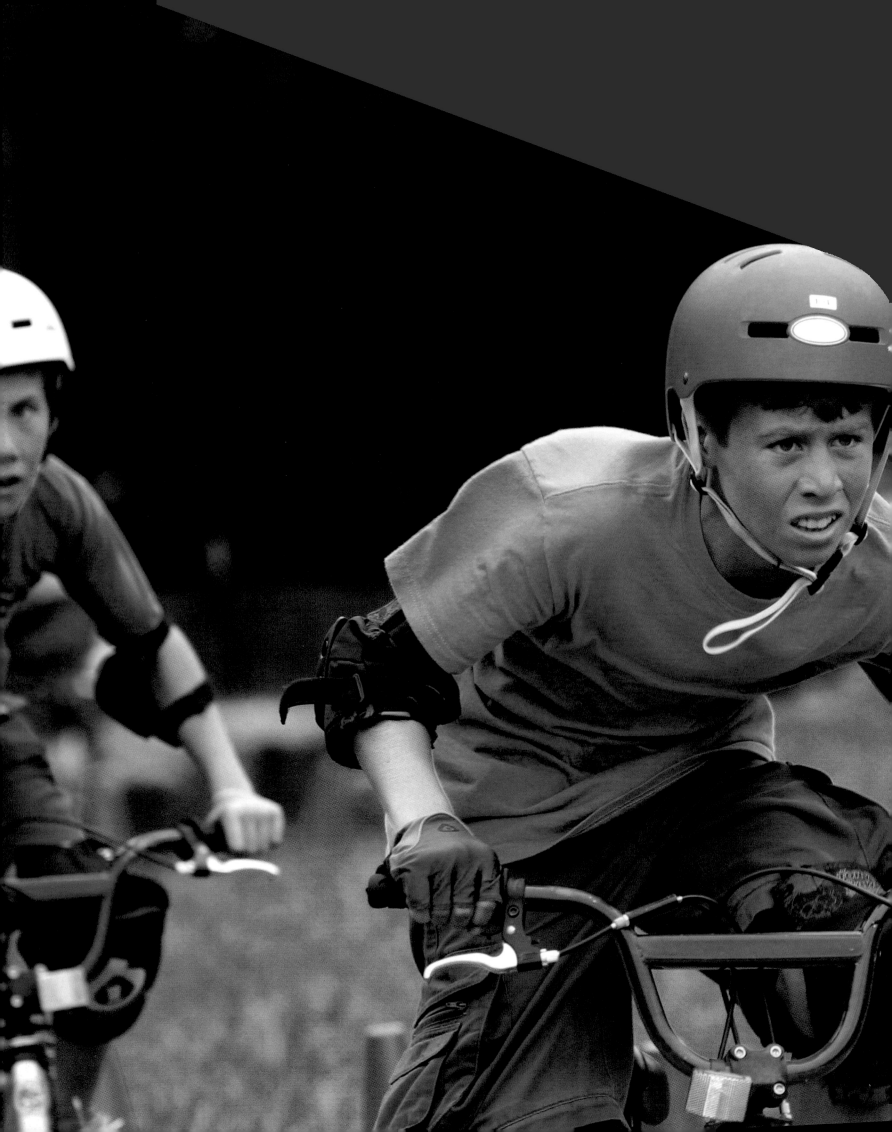

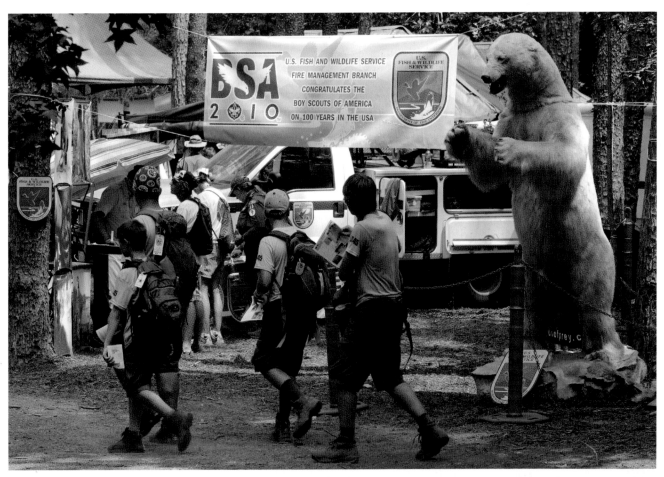

**▲ Green path to knowledge**

A mile-long trail through the Conservation Environment Area invites hikers to explore exhibits sponsored by 26 federal and state agencies.

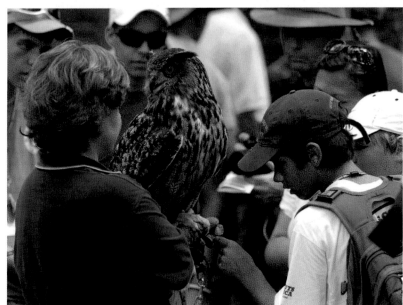

**◄ Forcing the pace**

Boys, bikes, and BMX—riders on the jamboree's bicycle motocross course crank hard toward personal bests.

**▲ Sharp study**

Inspecting the talons of a bird of prey, a Scout is entranced by one of the jamboree's many close encounters with the natural world.

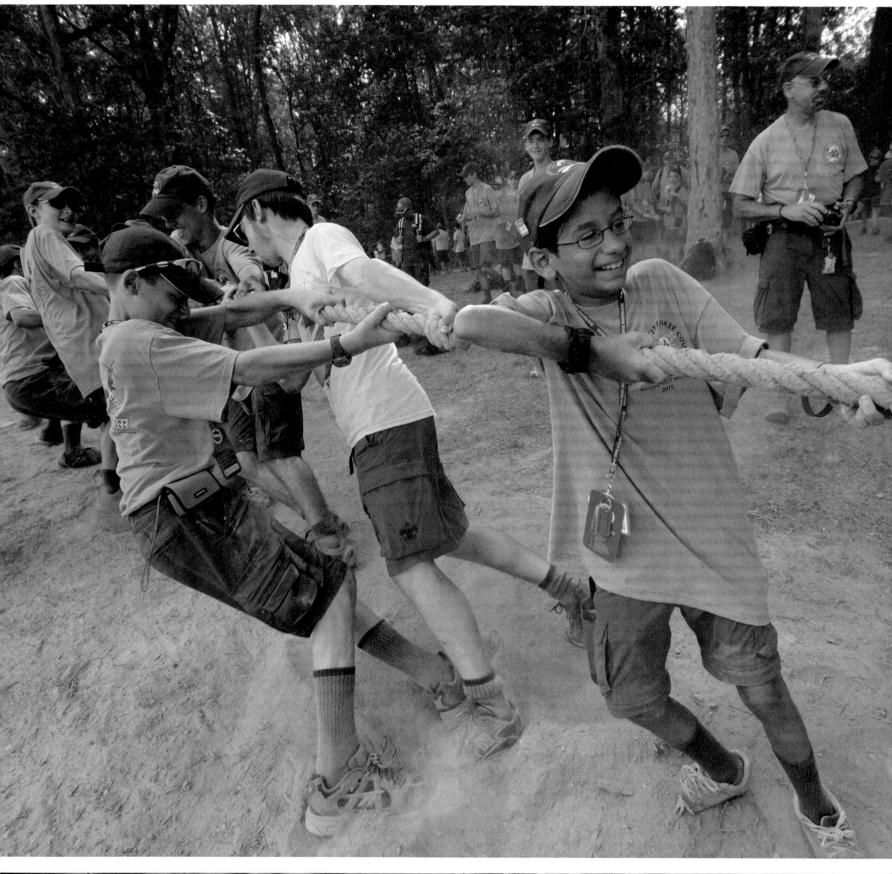

**◄ Ready, set, haul!**
An old-fashioned tug-of-war pulls together boys from different parts of America in a friendly competition with just one goal—have fun!

**In the swim of things ►**
Plunging into the jamboree Aquatics Center refreshes a Scout who can also try canoeing, kayaking, sailing, snorkeling, and scuba diving.

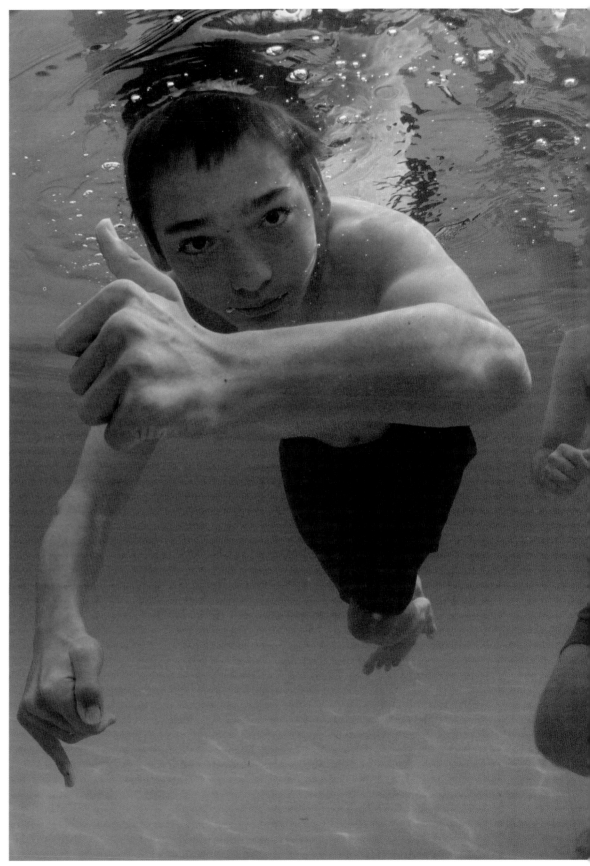

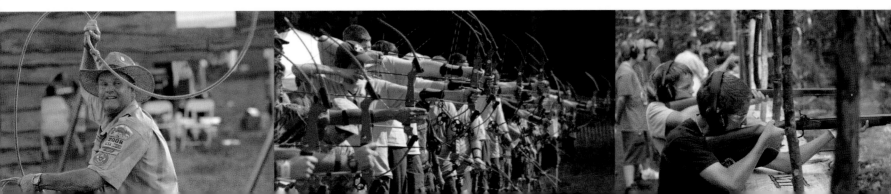

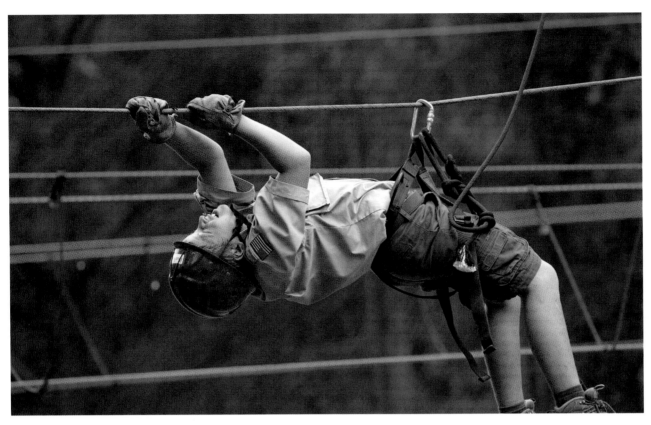

### ▲ Hanging around

Action Alley gives jamboree Scouts all the challenge they can handle as they make their way over, around, and under a series of obstacles.

### ◄ OK for the 5K

While many of the 25,000 participants complete the course on foot, a Scout catches a ride during the 2010 National Scout Jamboree 5K Run/Walk.

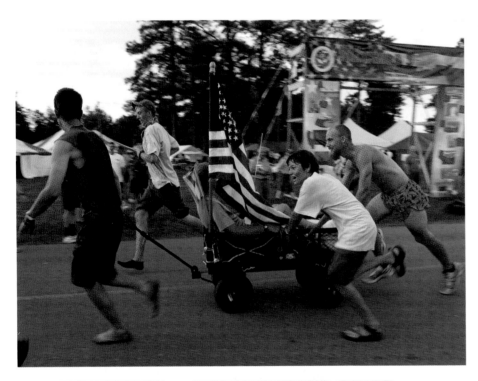

### Defying gravity ►

Flights through the forest on a high-speed zip line give Scouts plenty of memories to take home after the jamboree.

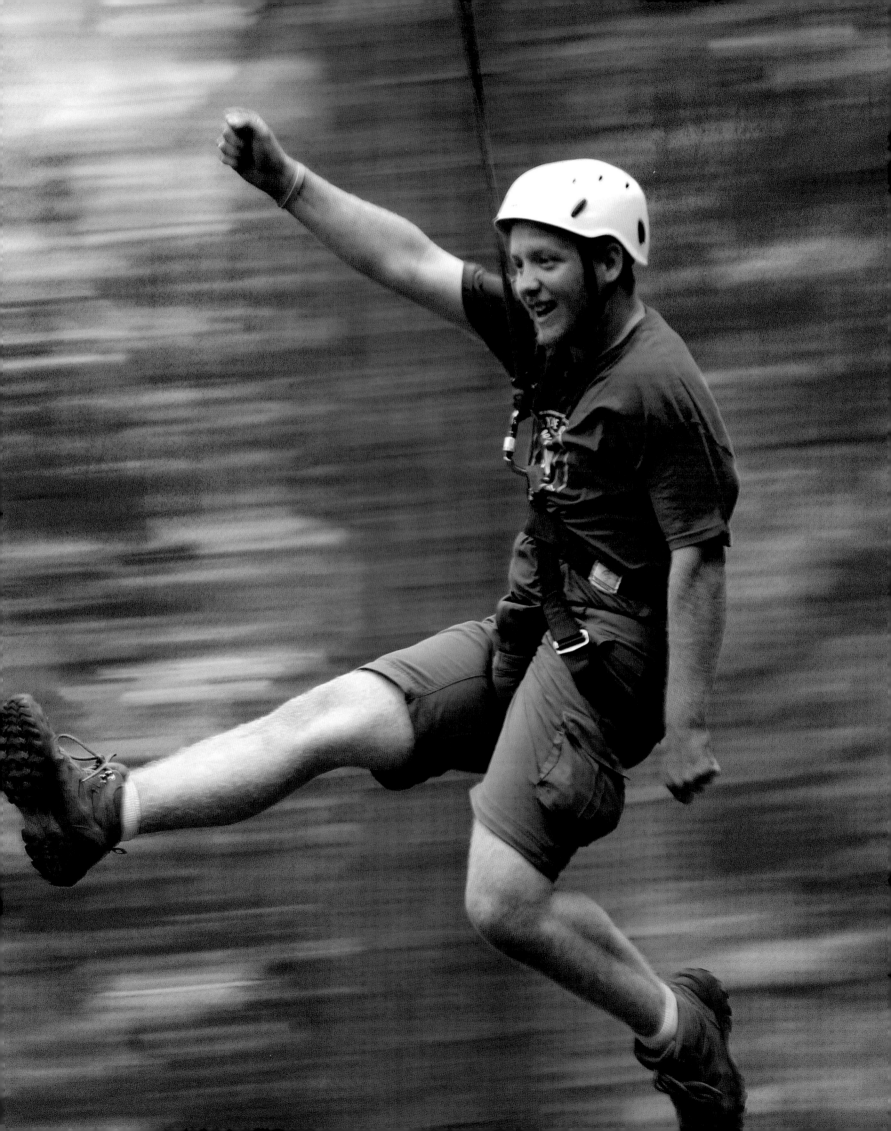

▲ **Something for everyone**

Opportunities to complete merit badge requirements abound at the jamboree as Scouts dig into subjects they know well and discover others for the first time.

**Relaxing afloat** ▷

A light breeze fluttering the sail of their boat, boys find a rare moment of calm in the midst of the jamboree.

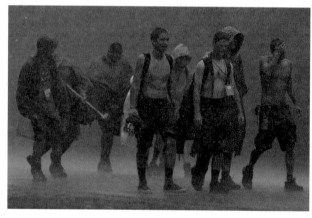

▲ **Water, water everywhere**

Heavy afternoon rains fail to dampen spirits as Scouts take a cheerful approach to what they cannot change.

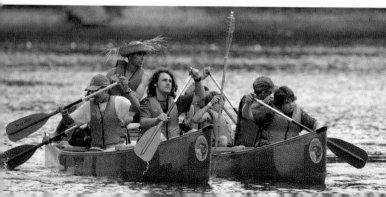

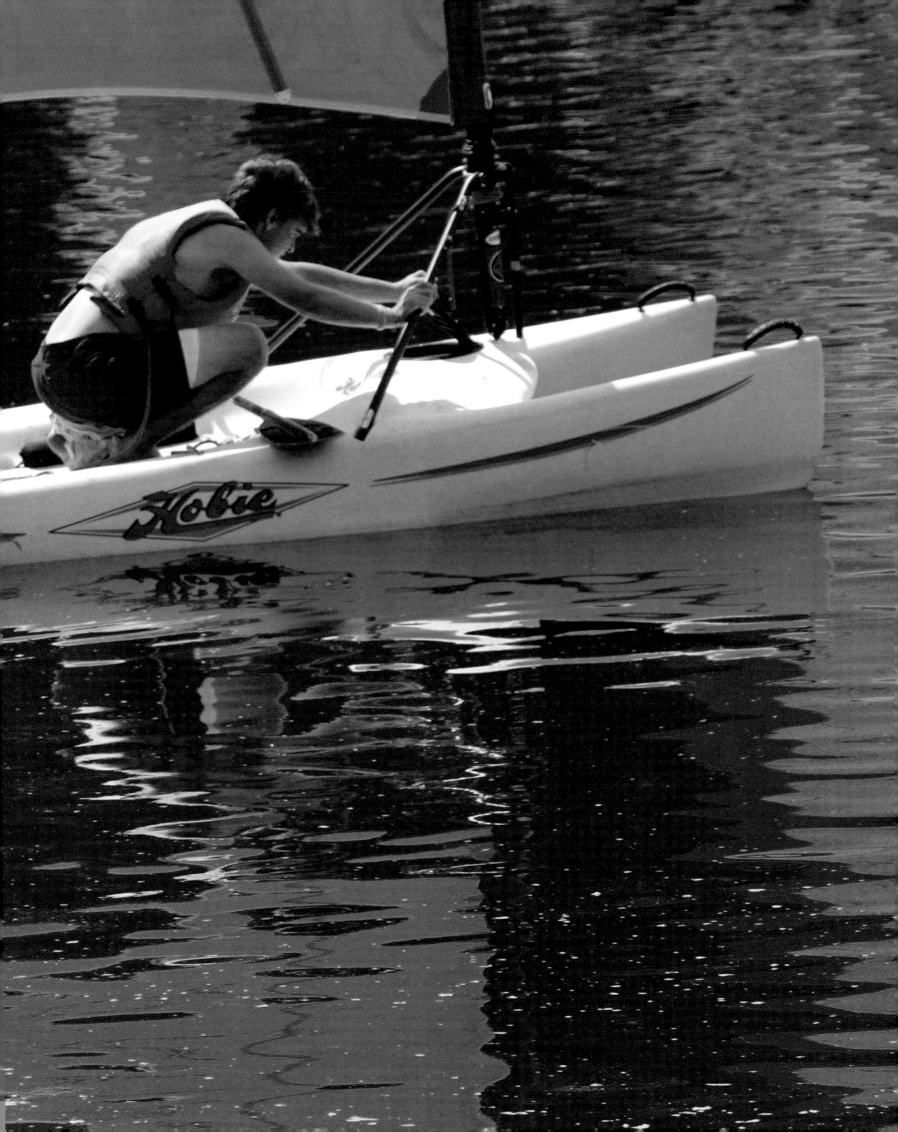

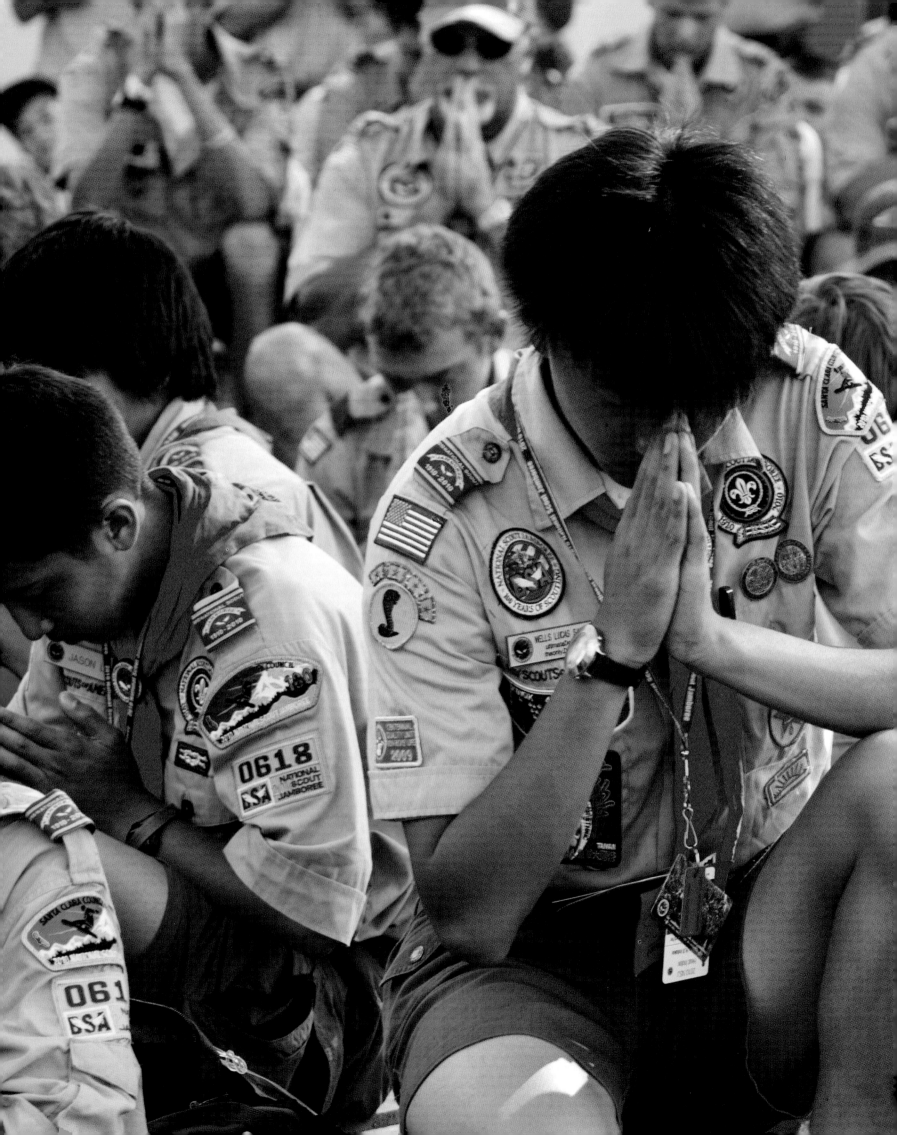

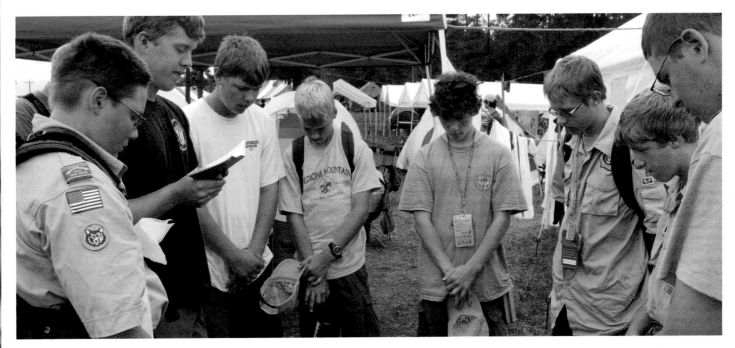

**▲ Finding faith**
Services during the jamboree encourage Scouts to fulfill their religious obligations even when far from home.

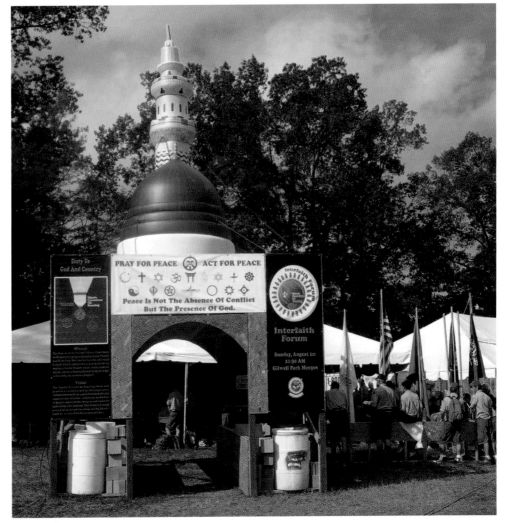

**◄ A Scout is reverent**
Scouts of many beliefs share reflection and prayer at arena shows and throughout the jamboree.

**A mosque for the moment ►**
Muslim Scouts find a place to pray, and those of other faiths discover a space to learn, at a mosque near the center of the jamboree.

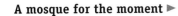
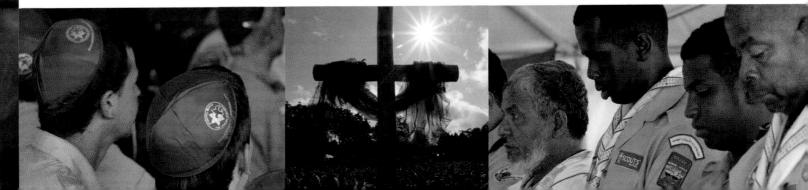

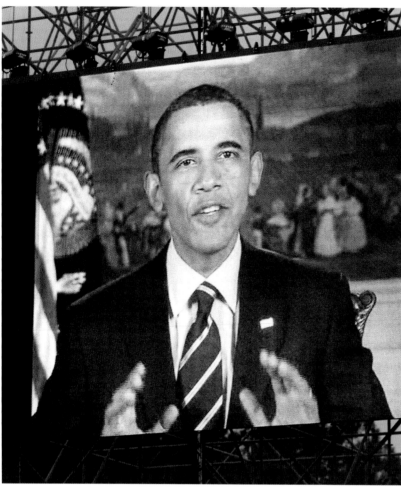

▲ **Presidential address**
In a congratulatory video message, President Barack Obama encourages Scouts to continue serving their communities and their nation.

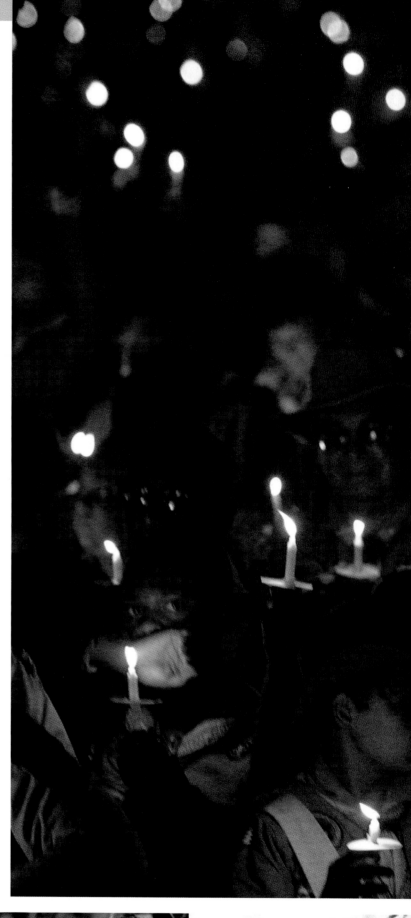

**All aglow** ▶
Scouts pass a flame from one candle to the next 45,000 during "A Shining Light Across America," the 2010 National Scout Jamboree's closing arena show.

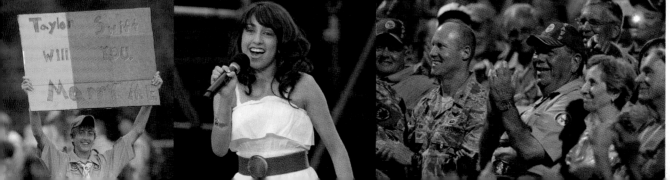

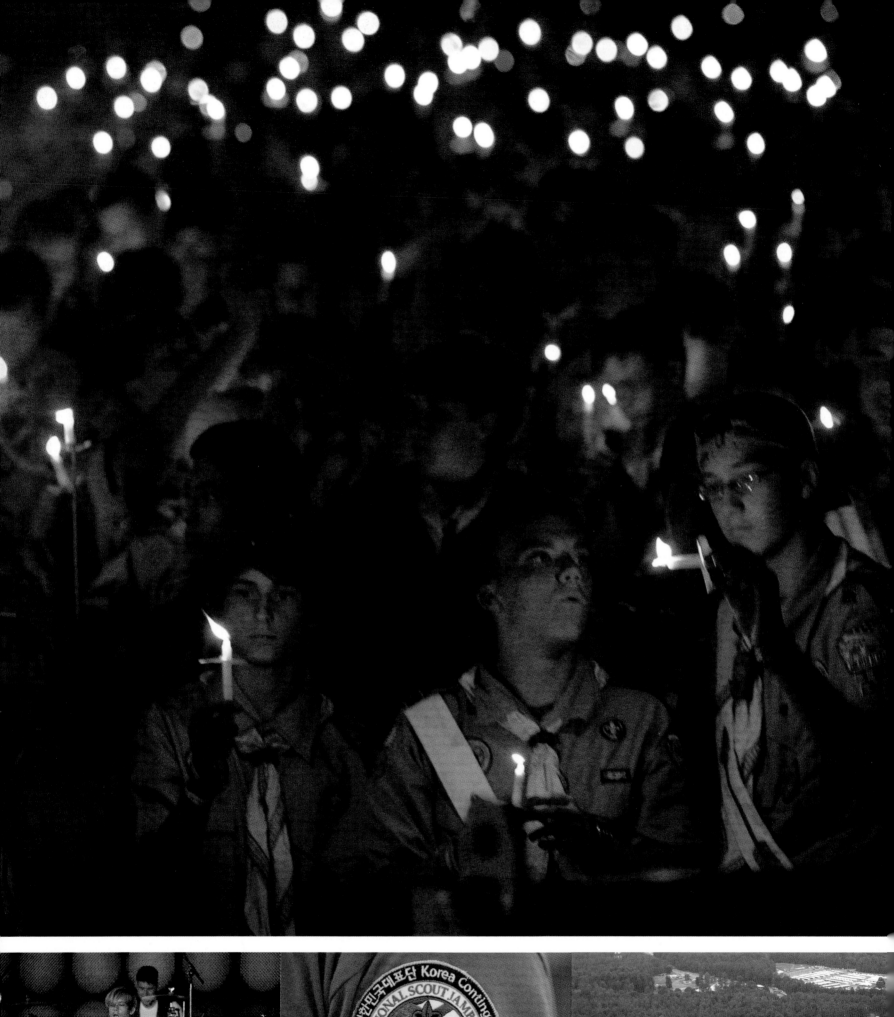
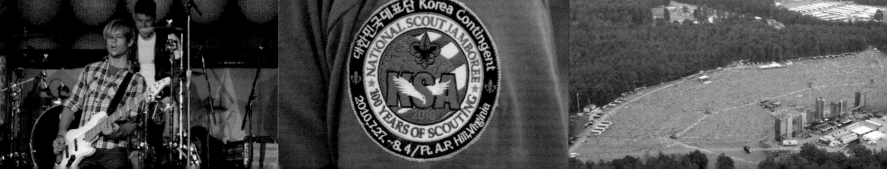

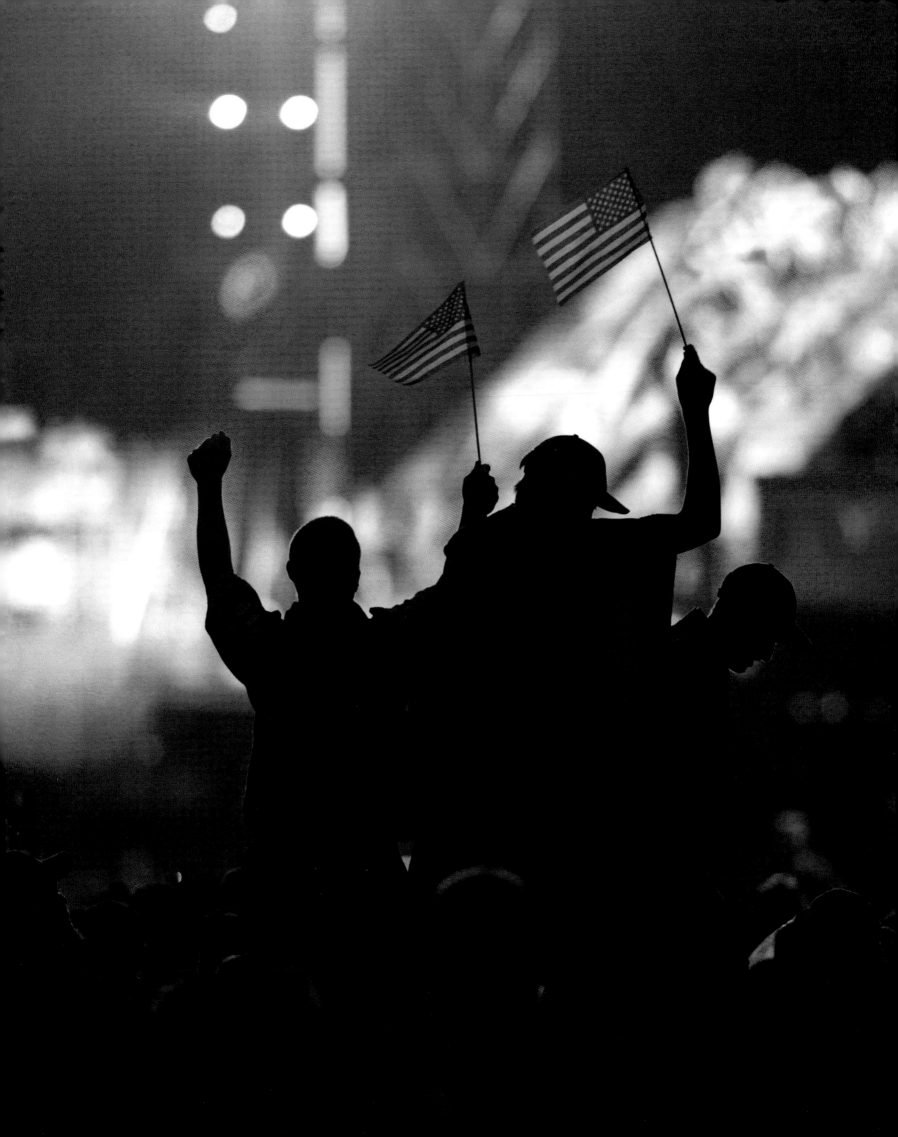

**Spotlight on Scouting ▶**
The Centennial Celebration show illuminates the BSA's birthday with a spectacle worthy of an event that happens just once every hundred years.

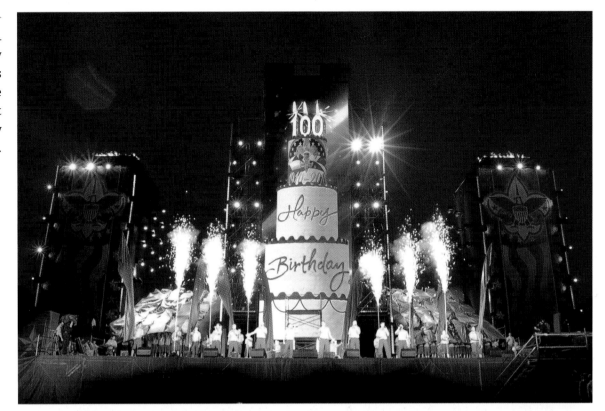

**Sparking hope ▶**
Scouting's biggest-ever fireworks display ushers in the future as the Boy Scouts of America embarks on its second century.

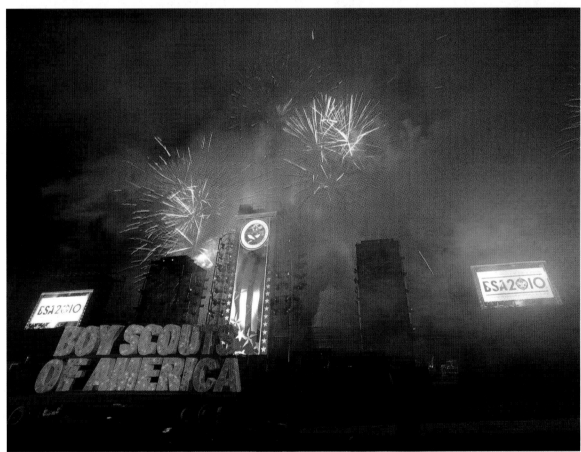

**◀ A vision of what is to come**
Jamboree Scouts pay final tribute to the BSA's past and commit themselves to the exciting possibilities and challenges ahead.

# Boy Scouts of America: Today— National Photo Contest

*As the Boy Scouts of America's members, alumni, and admirers prepared to celebrate the organization's 100th Anniversary, they wanted to reflect what Scouting looks like in the communities across America. Everyone with a passion for photography was invited to submit photo entries for this book. In the year of the 100th Anniversary, it is fitting to select and present 100 of these photographs. The Boy Scouts of America commends all the contest entries and congratulates those whose photographs were selected for this book. Winning photographs are marked with a Ⓦ in the top left-hand corner.*

**Abbreviation Key:** t-top, b-bottom, r-right, l-left, c-center

| | | |
|---|---|---|
| **Adrienne Appleby-Bures** 16-17<br>Medina, OH | **Dell Carson** 86tr<br>Vancleave, MS | **Adrian Delarosa** 165cr<br>Hinesville, GA |
| **Wallace Ashley** 134-135<br>Albuquerque, NM | **Vern Caturia** 37t<br>Menomonie, WI | **Paul Dockins** 144-145<br>La Grange, IL |
| **Bruce Babbitt** 37br<br>Broken Arrow, OK | **Verine Cheesbro** 20cl<br>Lynn Haven, FL | **Mark Doescher** 43br<br>Norman, OK |
| **Keith Backman** 81tr<br>Hanford, CA | **Jack Clancy** 19br<br>Elkton, MD | **Trish Edwards** 52tl<br>Franklin, VA |
| **Mike Barbour** 32-33<br>Los Molinos, CA | **Paula Clark** 20bcr<br>Clayton, NC | **Christy Eimen** 70-71<br>Alta Loma, CA |
| **George Birsic** 42-43<br>Ashburn, VA | **Bobby Collins** 71bcr<br>London, England | **Christy Eimen** 163tr<br>Alta Loma, CA |
| **Donald Brockel** 198bc<br>Allenhurst, NJ | **Doug Cook** 19tr<br>Guthrie, OK | **Lana Emerson** 58-59<br>LaSalle, MI |
| **Donald Brockel** 193t<br>Allenhurst, NJ | **Christine Crews** 119tr<br>Macclenny, FL | **Thomas Fahs** 70br<br>Levittown, PA |
| **Joseph Buda** 51tr<br>Westland, MI | **Donna Cronwell** 50bcr<br>Panama City, FL | **Sheila Floyd-Evans** 170bcr<br>Columbia, SC |
| **Jim Carleton** 48-49<br>Richmond, VA | **Donna Cronwell** 66tl<br>Panama City, FL | **Elizabeth Foster** 71bl<br>Alexandria, VA |
| **Jim Carleton** 106cl<br>Richmond, VA | **Donna Cronwell** 78-79<br>Panama City, FL | **Raymond Gajewski** 198cl<br>Shrewsbury, PA |
| **Jim Carleton** 14bl<br>Richmond, VA | **Donna Cronwell** 138-139<br>Panama City, FL | **Bob Geiser** 174-175<br>Chico, CA |
| **Kim Carroll** 173tr<br>Loganville, GA | **Donna Cronwell** 205bl<br>Panama City, FL | **Joan Godlewski** 71cr<br>Crown Point, IN |

## BOY SCOUTS OF AMERICA EMPLOYEE PHOTO CONTEST WINNER

# Picture Credits

**Abbreviation Key**
t-top, b-bottom, r-right, l-left, c-center,

The following images are courtesy of the Boy Scouts of America, credited to:

**Boy Scouts of America:** 8, 41br, 78bl; **Robert Birkby:** 230tl; **Jim Brown:** 216bl, 216-217, 224-225, 225bcr, 226-227; **David Burke:** 204br, 213br, 212-213; **Tom Copeland Jr:** 210tl, 210cl, 210bcl, 210-211, 212br, 213bc, 218-219, 219tr, 219br, 222bl, 225bcl, 226bl, 228cl, 228bcr, 230cl, 233bcr, 235br, 237bcr; **Greg Crenshaw:** 213bl, 215bl, 215tr, 221tr, 222br, 223bl, 222bc, 222br, 230-231, 233bcl, 234br; **Kathy Disney:** 232-233, 233tr, 237br; **Mark Duncan:** 208-209, 212l, 214bc, 214br, 216tl, 216cl, 216bc, 222-223, 225tr, 225cr, 226br, 227bl, 227bc, 227tr, 228tl, 228-229, 230bl, 233cr, 233br, 234bl, 234bcl, 235bl, 235bc, 234-235, 237tr, 237cr; **Daniel Giles:** 1, 20bcl, 45bc, 56cl, 61t, 61bl, 68br, 129cr, 130-131, 198tl, 198bcr, 210bl, 210bcr, 228bcl, 234tl, 234bcr, 237bcl, front cover bl; **David L. Harkins:** 22bcl, 45tr, 96tl, 170bl, 201tr; **Franklyn Harvell:** 215br, 222tl, 225br; **Mark Humphries:** 73bc; **Roy Jansen:** 69bcr, 74-75, 90-91, 92-93, 160tl, 164-165, back cover br; **Michael King:** 212bc, 214-215, 214bl, 215bc, 220-221, 221br, 226bc,

236-237; **Roger Morgan:** 5, 7, 9, 10, 11tl, 12-13, 17bc, 20tl, 20bl, 20br, 21br, 22tl, 22bl, 24-25, 25tr, 25cr, 25bc, 27tr, 27cr, 27bc, 27bcr, 27br, 28tl, 28bl, 33bc, 35tr, 35br, 37bcr, 38bc, 38br, 39bl, 39bc, 39br, 39tr, 39cr, 40-41, 41tr, 44-45, 45bcl, 45br, 46bl, 46bc, 50br, 51bl, 52bl, 54, 55t, 55cr, 55bl, 55br, 56bcl, 56bcr, 56-57, 58tl, 58cl, 60, 61cr, 61bc, 61bcr, 62-63, 63tr, 63cr, 66cl, 68bl, 69bl, 69bcl, 69br, 70bl, 71bcl, 71br, 71tr, 72; 73br, 73tr, 77tr, 77br, 81cr, 84-85, 85tr, 87bc, 89cr, 89bc, 91cr, 95c, 95bcr, 95br, 96-97, 100-101, 101tr, 105tr, 106t, 106bl, 106br, 107, 108-109, 110-111, 111tr, 111cr, 111br, 113t, 113cr, 113bl, 113bc, 113br, 114tl, 114bl, 116-117, 117tr, 117bc, 117br, 118-119, 119br, 120-121, 125br, 126c, 126bcl, 126br, 130cl, 132, 135tr, 136tl, 139cr, 145bcl, 145bcr, 145br, 146tl, 146bcl, 146bcr, 148tl, 148cl, 148bl, 148bcl, 148-149, 150-151, 152, 153t, 153br, 154t, 154c, 154bl, 154bcl, 154bcr, 154-155, 160tr, 161, 163cr, 163bc, 164bl, 164bc, 164br, 165bl, 165br, 165tr, 166cl, 170t, 170cl, 171, 173cr, 173bc, 177tr, 178-179, 179tr, 180tl, 180bl, 181, 183tr, 183bc, 183br, 184bl, 184-185, 187tr, 187br, 188-189, 189cr, 189br, 192, 194bc, 194-195, 196tl, 196bl, 198bl, 200-201, 202-203, 203tr, 203cr, 203bc, 203br, 204bl, 206tl, 206cl, 206bc, back cover bl, bc, front cover tl;

**Brian Payne:** 2-3, 14-15, 22bc, 28cl, 33br, 56tl, 68bc, 70bcr, 91bc, 96bl, 98-99, 101b, 106bc, 112, 133tl, 133tr, 136bc, 136-137, 145tr, 145cr, 146-147, 151tr, 158-159, 159br, 165bc, 166tl, 166-167, 177br, 182-183; **Randy Piland:** 21bl, 52-53, 56bl, 73bl, 114-115, 120tl, 120bl, 160bc, 170br, 172-173, 189bcl, 193br, back cover tl, front cover br; **Charity Robison:** back cover tc; **Michael Roytek:** 19bc, 22c, 25br, 26-27, 34-35, 35bc, 43tr, 46-47, 51bl, 70bcl, 78cl, 78bc, 88-89, 89tr, 89br, 91tr, 91br, 93tr, 93cr, 94-95, 95tr, 95bcl, 99tr, 99cr, 117cr, 126t, 126bcr, 128-129, 129tr, 129bc, 129br, 130bc, 133bl, 133br, 135br, 142-143, 159tr, 162-163, 163br, 170bcl, 179br, 184tl, 190-191, 198-199, 204bc, 206bl, 206-207, back cover tr, front cover tc, tr, bc; **Pete Souza:** 17br, 85br; **Vernon Tate:** 18-19, 21bc, 38bl, 73cr, 125tr, 130tl, 130bl, 133bc, 136cl, 146bl, 186-187.

Every effort has been made to trace the copyright holders, and the publisher apologizes in advance for any unintentional omissions. We will be pleased to insert the appropriate acknowledgment in any subsequent edition of this publication.

# Acknowledgments

**From the BSA**
The amount of work and coordination that goes into producing a book like *Boy Scouts of America: Today* is unbelievable. Countless hours have been devoted to the coordination and management of the photo contests, the supervision of photographers, photoediting, and copy review. Under normal circumstances such a book would be a huge undertaking; to pull this off in less than six-months—complete with photographs from the 2010 National Scout Jamboree—is nothing short of incredible.

We offer special thanks to Jim Wilson, director of Communication Services, BSA, who conceived the idea for this book; Michael Vaccaro, director, DK Business Development who helped to get the project off the ground; Tim Murray and Therese Burke of DK and Doug Marshall of the BSA who helped us overcome numerous hurdles in finalizing our production arrangements; Robert Birkby, who has a way with the written word that adds depth to the feelings conveyed through the photography; and Sophie Mitchell, Stuart Jackman, and Richard Czapnik of DK, whose editorial, production, and design talents have helped to create a book that will undoubtedly be cherished by Scouts and Scouters for a lifetime.

The Boy Scouts of America would also like to acknowledge, with gratitude, the following individuals for their support, dedication, and contributions, which have made this book a reality.

**Operations management:** *Provided daily coordination of the project from initial concept to the published work*: David L. Harkins, team leader/associate director Business Development, Business Development Department, BSA; Dan Buckhout, team leader, Media Studio, Media Services and Public Relations Department, BSA

**Photography management:** *Managed and prepared the BSA's photography that has been used in the book*: Roger Morgan, photography manager, Media Studio, BSA; Christy Batchelor, digital asset manager, Media Studio, BSA; Jack Brown, photography coordinator

**2010 National Scouting Jamboree photography team:** Randy Piland, jamboree photography chairman; Keith Bilbrey, jamboree photography director, Media Studio, BSA

**National photo contest coordination and management** *Coordinated the online photo contests, managed image releases and communications*: Mallori Morris, marketing coordinator, Merchandising, Marketing and Global Sourcing Department, BSA; Denis Szabaga, e-commerce operations specialist, Merchandising, Marketing and Global Sourcing Department, BSA; Burgin Hardin, compliance specialist, Business Development Department, BSA; Madison Porter, business development intern, Business Development Department, BSA; Kristi Smith, licensing coordinator, Business Development Department, BSA.

**From DK**
DK would additionally like to thank Frances Howes and Heather Jones for editorial assistance.